THE PAINTINGS THAT REVOLUTIONIZED ART

THE PAINTINGS
THAT REVOLUTIONIZED ART

PRESTEL

Munich · London · New York

CONTENTS

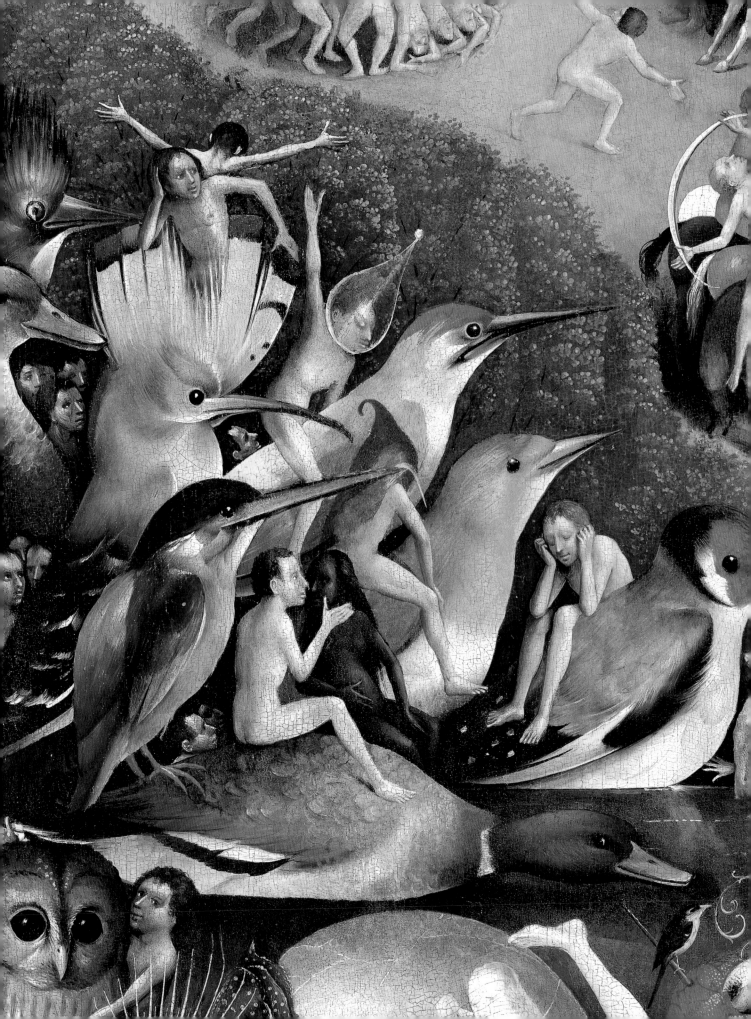

FOREWORD

Art is a universal expression of humanity, and simultaneously a meaningful mirror of the time and culture in which it is created. Like humankind itself, art, too, is subject to constant change, as it follows an urge towards new and previously undiscovered areas, toward new forms and new perspectives. A painting will often speak to us more directly than any kind of written document ever could. It exposes us to a story, a person, or perhaps to nothing but an emotion, with which we can feel a sense of connection and gain access to eras and concepts beyond our own present time.

The present volume assembles 100 paintings that revolutionized art, standing out in the history of art because they transcended boundaries and laid the foundation for that which was new and had never before been seen. This applies to Giotto's frescoes in the Arena Chapel, in which he liberated the figures he painted from the constraints of traditional representational norms for the first time, breathing life into them. It is equally true of Wassily Kandinsky's painting *Impression III,* in which painting fuses with music. Other works captivate the viewer with bold technical innovations, such as the use of oil paint in Jan van Eyck's *The Arnolfini Portrait* or the advances in perspectival representation in Paolo Uccello's *Saint George and the Dragon.* Last but not least, there are paintings which have become part of the collective pictorial memory, but which to this day have not given up their last secrets, such as Leonardo's smiling *Mona Lisa,* Vermeer's mysterious *Girl with a Pearl Earring,* Edvard Munch's *The Scream,* and Edward Hopper's *Nighthawks.*
Quiet paintings less often discussed outside the realms of expert opinion have also been made part of this selection: the Late Gothic painter Konrad Witz audaciously set his interpretation of the Miraculous Draft of Fishes on Lake Geneva. In doing so, he created the first landscape depiction that clearly referred to a precise location. Chardin confronted the frivolous world of the sumptuous Rococo paintings of his time with the humble activity of a washerwoman. And with his small-format collage *Just What Is It That Makes Today's Homes So Different, So Appealing?* the British artist Richard Hamilton presented one of the first works of Pop Art, long before Andy Warhol and Jasper Johns.
A compilation of 100 revolutionary masterpieces must always be subjective, even if it follows objective criteria. Humankind's artistic creation is too extensive and too varied, the discussion of originality and ingenuity too complex. Chronologically, our selection traces art history from the early Middle Ages to the recent past, and concentrates on the Western world: with the exception of Hokusai's *The Great Wave Off Kanagawa,* the works of art reproduced here were created in Europe or America. Sculpture, the arts and crafts, and new media from the modern age are not taken into account here, in favor of a stringent focus on the medium of painting (and one woodcut). Paul Klee's recognition of the fact that "art does not reproduce the visible, but makes visible" neatly summarizes the difference between art and mere reproduction. In the same vein, the following selection offers more than just a sequence of art-historically significant works of art. It makes visible the ways in which artists over the centuries have followed their visions, dared to experiment, bravely stood in opposition to the tastes of their times—in which they have taken courageous steps into new terrain, and against all odds have been able to express that which lies beyond the scope of words.

Prestel editorial department

1

ICON OF CHRIST PANTOKRATOR

In the 1950s Greek art historians George and Maria Soteriou made a remarkable discovery. In the remote Saint Catherine's Monastery on Mount Sinai in Egypt they came across 200 icons dating from between the end of the 5th century and the 13th century, including the icon of Christ depicted here, which probably dates from the 6th century. One of the oldest surviving icons, it is a supreme example of Byzantine art.

It is a representation of Christ as "Pantokrator," ruler of the world. We see a frontal, half-length portrait of a bearded Jesus, his right hand raised in blessing, his left hand holding a richly ornamented book of the Gospels. His imperial purple clothing and the semi-circular niche around him emphasize his role as ruler. This Sinai icon of Christ is unusual in that the strictly frontal nature of the traditional image is more relaxed; the unknown painter has positioned the figure slightly off-center and has brought the face to life through the depiction of asymmetrical features and shading. The technical expertise displayed in the encaustic painting employed to make this icon, suggests it was created in the Byzantine capital, Constantinople. The motif of Christ Pantokrator emerged during the first flourishing of art in the Byzantine Empire under Justinian I (r. 306–337), which also saw the building of the magnificent new basilica of Hagia Sophia. Some scholars have even suggested it was intended as a votive image for the Emperor himself.

It was a happy stroke of historical luck that this icon was preserved in a monastery on Sinai, whose isolated location guaranteed its survival over the centuries. Icons (from Greek *eikon*, "image") were considered a way of reaching contact with the saints: they were not just an image of a heavenly authority, but a means of providing access to the person represented. People prayed in front of devotional images, kissed them, and kneeled before them: the front-facing position of the figures thus provided immediate communication with the viewer. Ultimately, this image worship led to violent theological disputes, to the iconoclasm of the 8th and 9th centuries, and for a time to the prohibition of any images of saints in the Byzantine Empire. However, being on Sinai protected this icon not only during the iconoclastic controversy: in 1453 Constantinople was captured by the Ottomans Turks and the Byzantine Empire (though not its cultural influence) was brought to an end.

ENCAUSTIC PAINTING

The technique of encaustic painting has been known of since the time of Ancient Greece. Colored pigments are mixed with wax and applied or burnt onto the painting's support (wood panel) while still hot; the term comes from the Greek *enkauston*, "burnt in." The most famous examples of encaustic painting are Late Egyptian mummy portraits, which are remarkable for their unique state of preservation. Only a few icons made using this technique, including the early Sinai icons, have survived; many were destroyed during iconoclastic periods. During the Middle Ages, tempera and oil paints replaced encaustic painting as the principal painting techniques.

"I AM THE LIGHT OF THE WORLD:
HE THAT FOLLOWETH ME SHALL NOT WALK IN DARKNESS,
BUT SHALL HAVE THE LIGHT OF LIFE."

Gospel of John 8:12

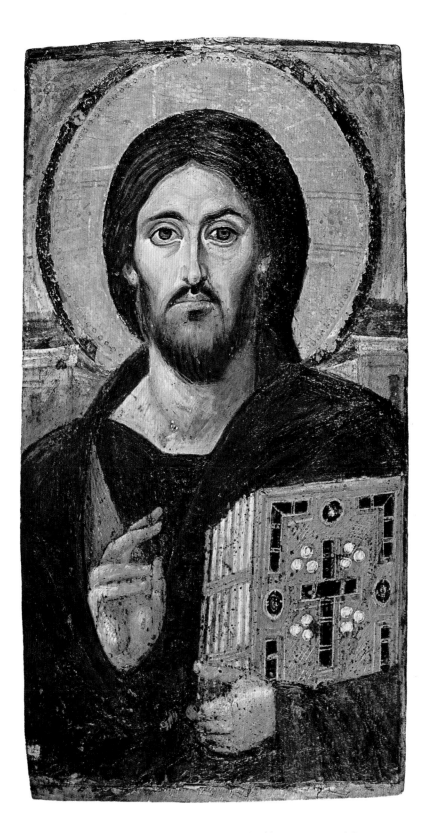

ICON OF CHRIST PANTOKRATOR

6th century (?), Encaustic on wood, 84 x 43.5 cm,
Monastery of Saint Catherine, Mount Sinai, Egypt

2

THE BOOK OF KELLS

The Book of Kells contains the four Gospels in Latin, as well as some prefaces and tables. It was written and decorated around AD 800 and takes its name from the Abbey of Kells, in Ireland. Written on vellum, the book is famous for the intricate, complex, swirling patterns of its Celtic decoration.

Although nothing is known definitively of its history, the Book of Kells was probably begun in the monastery of Iona in Scotland, founded in AD 563 by Saint Columba. We know nothing of the monks who wrote or decorated its pages, though it was written by at least two different hands. After a particularly devastating Viking raid in 806, during which 68 people were killed, the monks relocated to the Abbey of Kells, in County Meath. The Book of Kells represents the highpoint of "Insular" illumination, a style that emerged in the British Isles after the retreat of the Romans and that ended with the beginning of the Viking raids on Britain around AD 800. Mostly produced in monasteries as manuscripts, or on metalwork and stone crosses, this style differed markedly from that of the rest of European art. To illustrate and decorate the Gospels, the pages of the Book of Kells combine traditional Christian subjects with Insular art—humans, animals and mythological beasts composed of interlacing Celtic forms in vibrant colors. The illustration of Christ Enthroned demonstrates this combination of Christian themes with birds and interlacing circles. Christ appears seated in the center, with smaller figures (possibly angels) around him. While the depiction of the human form is flat and simplified, with no attempt at showing depth, the birds and interlacing lines have fine detail and bring life to the image. Even the curls of Christ's hair end in Celtic swirls. Every bit of background is filled with color and with interconnected patterns executed in minute detail. The colors used in the Book of Kells include purple, lilac, red, pink, green, and yellow, more than appear in most other surviving manuscripts. The pigments needed to create these colors included red ochre, yellow ochre, green copper, indigo, and lapis lazuli. Some of these had to be imported from as far away as the Mediterranean and even Afghanistan. These pigments were used to create the most lavishly decorated Gospel book to have survived. Such a large and beautifully decorated Gospel would have been kept on the high altar and removed only for the reading of the Gospels during Mass. The Book of Kells remains the ultimate example of Christian symbols combined with the intricate knot work and interweaving patterns of Celtic art. The patterns and images continue to be admired and have inspired artists to this day.

Created in Scotland around AD 800, the Book of Kells was removed to the Abbey of Kells in Ireland, where it remained for hundreds of years. It was stolen in the 11th century, though later found in a ditch with its cover torn off. The cover, which probably included gold and gems, was never found. The pages, somewhat water-damaged but otherwise fine, were returned to the Abbey. In 1541, during the English Reformation, the Roman Catholic Church took the book for safekeeping. It was not returned to Ireland until the 17th century, when it was given to Archbishop James Ussher. He in turn presented it to Trinity College, Dublin, where the book remains today.

"LOOK MORE KEENLY AT IT AND YOU WILL ...
MAKE OUT INTRICACIES, SO DELICATE AND SUBTLE,
SO EXACT AND COMPACT, SO FULL OF KNOTS AND LINKS,
WITH COLORS SO FRESH AND VIVID THAT YOU MIGHT SAY
THAT ALL THIS WAS THE WORK OF AN ANGEL AND NOT OF A MAN."

Giraldus Cambrensis

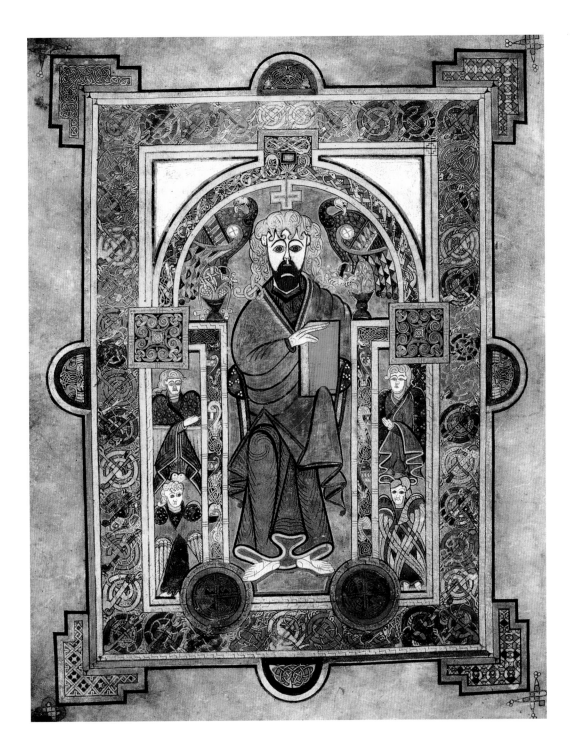

THE BOOK OF KELLS

Christ Enthroned, c. AD 800, iron-gall ink and pigments on vellum,
33 x 24 cm, Trinity College, Dublin

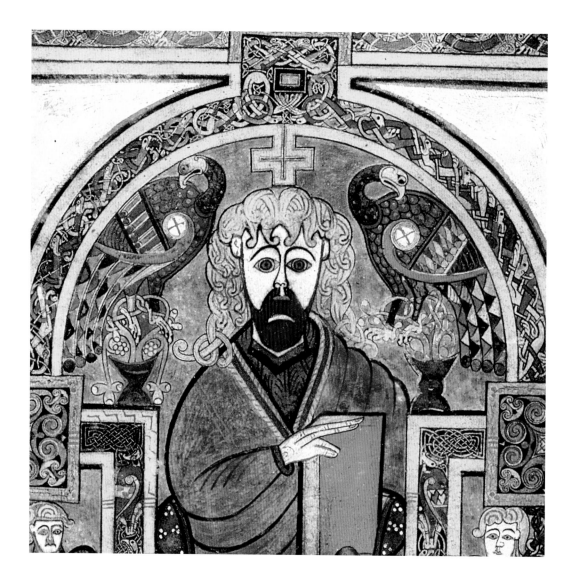

above The face of Christ is greatly simplified, with only a few lines used for the eyes, eyebrows, and nose. The hair, however, shows the influence of Insular art with the use of Celtic knots.

right The Chi-Rho page, from the Book of Kells, c. AD 800, iron-gall ink and pigments on vellum, 33 x 24 cm, Trinity College, Dublin

THE BOOK OF KELLS

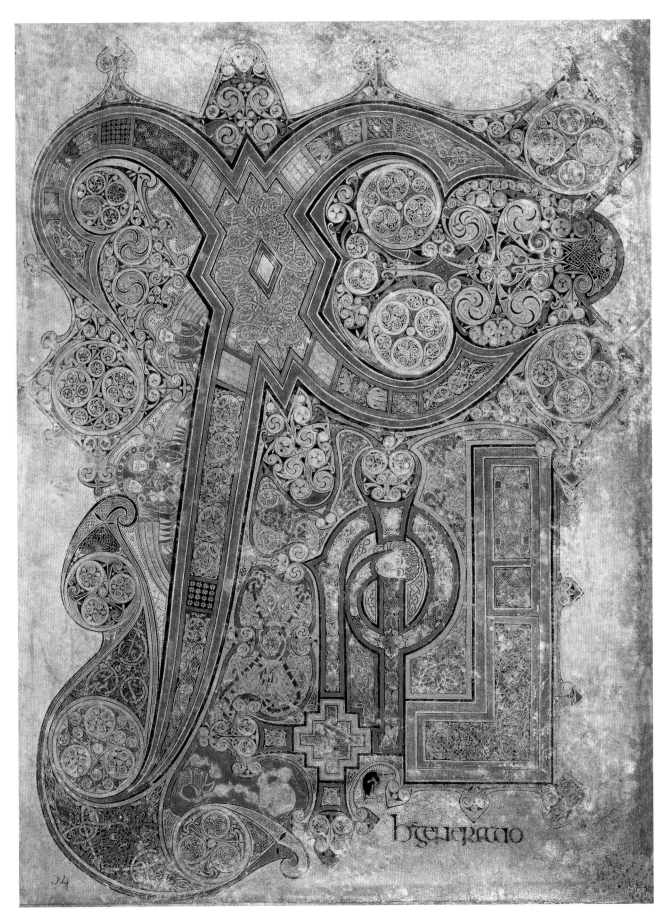

3

GIOTTO

FRESCOES IN THE ARENA CHAPEL (CAPELLA DEGLI SCROVEGNI)

Italy in 1300 was moving away from its medieval past. In Padua, frescoes for a newly built chapel were commissioned not by the Catholic Church, but by a very "modern" sort of client—the banker Enrico Scrovegni. And to decorate his chapel, Scrovegni chose a new kind of artist, Giotto. His frescoes brought a revolutionary sense of realism and emotion to European art that would inspire painters for centuries to come.

The Scrovegni family in Padua had acquired a controversial reputation. They had made a fortune in banking, yet many accused them of charging their clients usurious interests rates—a sin in medieval Europe. Despite these allegations, around 1300 Enrico Scrovegni extended his family's fortunes by purchasing land in Padua that had once been part of an ancient Roman arena. On that land he rebuilt a small church, transforming it into a grand family chapel. Many conservative citizens of Padua saw the building as a monument not to piety but to family pride. But it soon became a place of pilgrimage for the remarkable frescoes it contained. Scrovegni's painter, Giotto, was among a small group of Italian artists who were beginning to reject the flat, emotionless styles of their day. These artists had begun to rediscover the naturalistic art of ancient Rome. Giotto himself was developing a style that rendered figures in a more three-dimensional manner and with a greater variety of everyday human emotions. This new art would achieve its greatest flowering in Scrovegni's chapel.

Giotto created his frescoes as a series of panel-like zones that cover the walls of the chapel. The panels tell the story of Jesus in chronological order, beginning with an image of God the Father over the chancel arch and ending with the Last Judgment, an image that covers the entire entrance wall. Each of Giotto's story panels depicts a particular biblical scene. The outdoor scenes are set in relatively barren landscapes with deep blue skies. Indoor scenes typically take place plain rooms with unadorned walls. Giotto's unfussy backgrounds heighten the intensity of the human activities that take place in his scenes— activities that the painter captures with unprecedented naturalism. In the panels depicting the Crucifixion and the Lamentation, Giotto's dead Christ resembles a real cadaver, while Mary and the other witnesses express true agony in their facial expressions. Other frescoes feature characters that people of Giotto's day would have recognized—street musicians, nursemaids, and household servants. The artist even includes a portrait of Enrico Scrovegni on the Last Judgment wall. The patron, who is shown dedicating his chapel to God, is given quite distinctive facial features: this may be one of the first true portraits created since antiquity.

GIOTTO DI BONDONE was born c. 1267, either in or near Florence. The Renaissance artist and biographer Giorgio Vasari wrote in his *Lives of the Most Excellent Painters, Sculptors, and Architects* (1550) that Giotto served as an apprentice to the Florentine master Cimabue. Vasari also writes that Giotto helped create the famous Life of St. Francis paintings in the Basilica of St. Francis in Assisi. Many modern scholars, however, dispute Vasari's story. By about 1300, Giotto's growing fame as a painter earned him commissions in many parts of Italy. Aside from his work on the Arena chapel in Padua, he created important frescoes in Naples and Rome. He also worked as an architect, designing the elegant campanile of Florence's cathedral. Giotto died in 1337 in Florence.

"GIOTTO RESTORED PAINTING TO ITS FORMER WORTH AND
GREAT REPUTATION. FOR IMAGES FORMED BY HIS BRUSH
AGREE SO WELL WITH THE LINEAMENTS OF NATURE
AS TO SEEM TO THE BEHOLDER TO LIVE AND BREATHE."

Filippo Villani, 1381/82

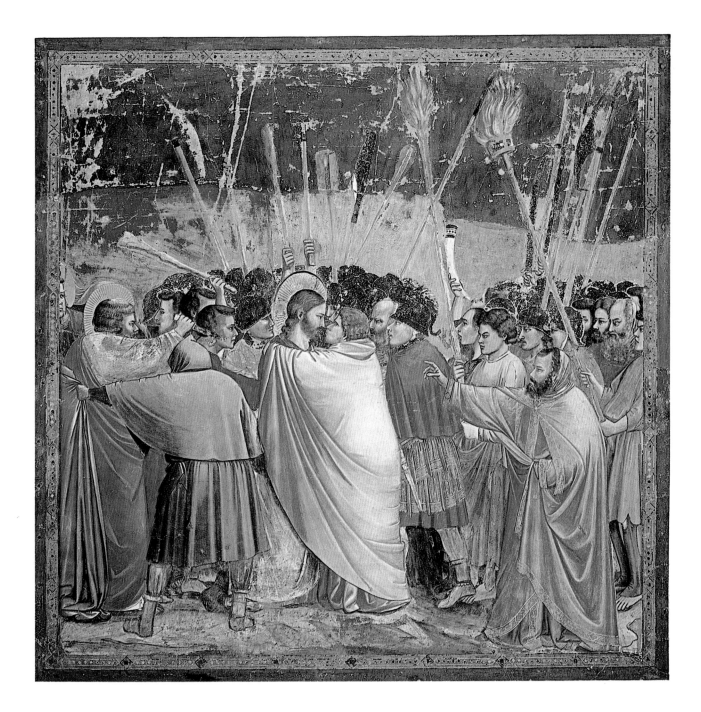

GIOTTO **FRESCOES IN THE ARENA CHAPEL
(CAPELLA DEGLI SCROVEGNI)**

The Betrayal of Christ, c. 1305, fresco, 185 x 200 cm,
Capella degli Scrovegni, Padua

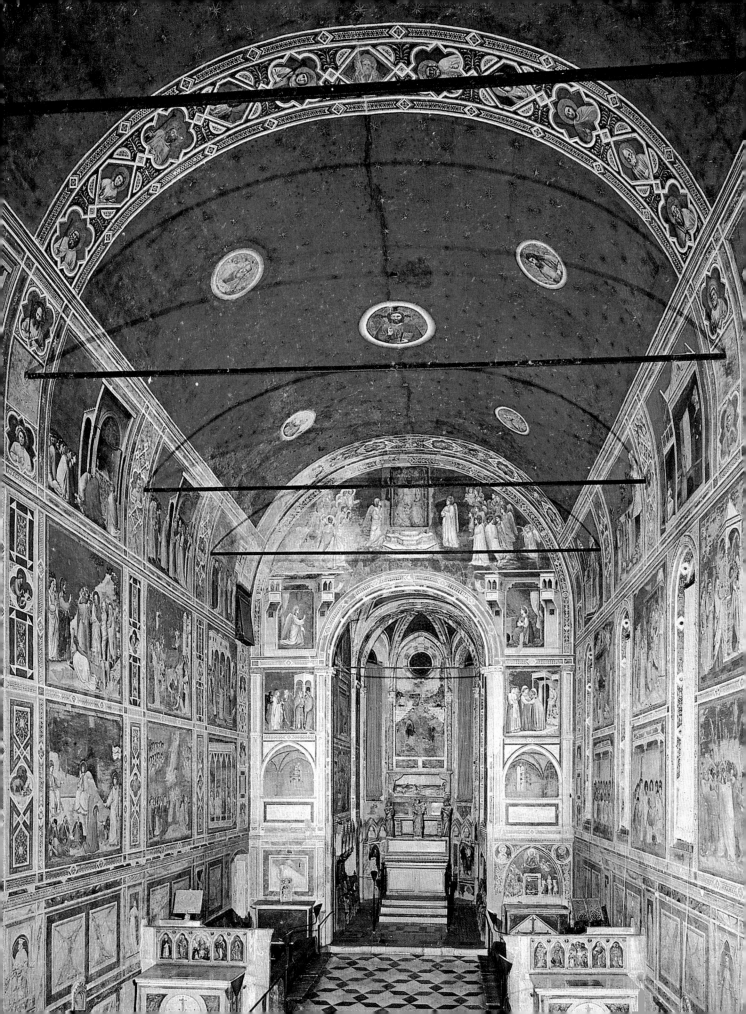

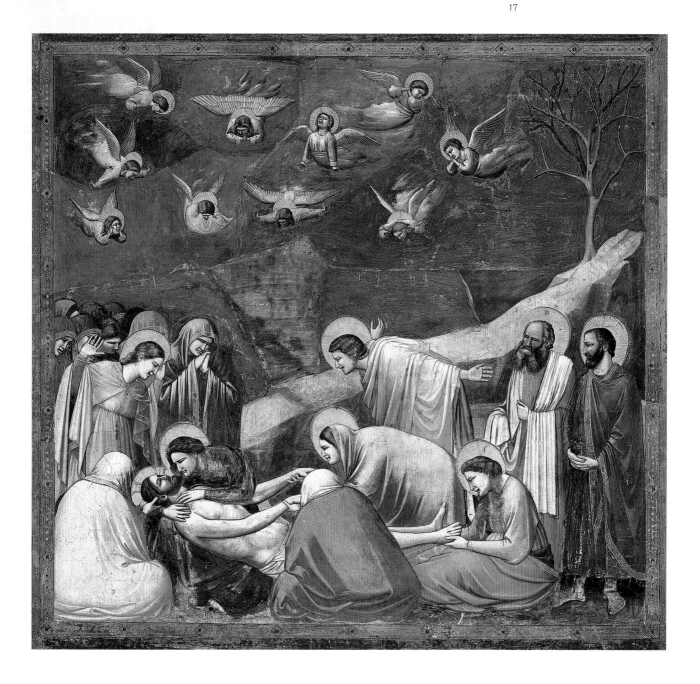

left View of the Arena Chapel (Capella degli Scrovegni) in Padua with Giotto's fresco cycle, c. 1305, overall dimensions of chapel: 12.80 x 20.82 x 8.42 m

above Giotto di Bondone, *The Lamentation of Christ*, c. 1305, fresco, c. 185 x 200 cm, Capella degli Scrovegni, Padua
Twisted, grimacing faces and dramatic postures express the agony of the Lamentation. Giotto transforms the remote biblical event into an emotionally gripping story taking place in the here and now.

GIOTTO **FRESCOES IN THE ARENA CHAPEL (CAPELLA DEGLI SCROVEGNI)**

"ON THE DAY ON WHICH IT WAS CARRIED TO THE DUOMO,
THE SHOPS WERE LOCKED UP AND THE BISHOP ORDERED A GREAT AND DEVOUT
COMPANY OF PRIESTS AND BROTHERS WITH A SOLEMN PROCESSION,
ACCOMPANIED BY ... ALL THE OFFICIALS OF THE COMMUNE, AND ALL THE POPULACE ...
AND THEY ACCOMPANIED IT RIGHT TO THE DUOMO ... SOUNDING ALL THE BELLS IN GLORY,
OUT OF DEVOTION FOR SUCH A NOBLE PANEL AS WAS THIS."

Sienese chronicler Agnolo di Tura, 1350

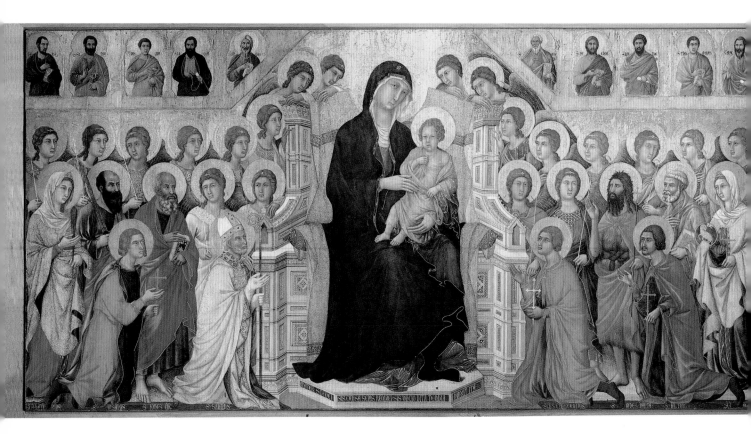

DUCCIO **MAESTÀ** 1308–1311, tempera and gold on wood, 213 x 396 cm,
Museo dell'Opera Metropolitana del Duomo, Siena

4

DUCCIO
MAESTÀ

Most European artists of the Middle Ages worked anonymously in the service of the Church. But during the 1200s, individual painters and sculptors began to create art that was distinctively their own … and to achieve personal fame as a result. Duccio di Buoninsegna was one of these artists. His masterwork, the *Maestà*, is a traditional type of sacred image. But Duccio infused it with his own personality, and he became one of the first great "names" in European art.

Medieval Siena was a vibrant society of bankers, politicians, wool traders, and artists. Its commercial wealth produced strong-willed men and women, and the painter Duccio was among its most fiercely independent characters. Records indicate that as early as 1280 he was fined by the city government for offenses ranging from refusal to carry out his military service to "sorcery." Yet despite these run-ins with the law, Duccio remained a highly valued citizen. As Siena's newly constructed cathedral, the Duomo, was being decorated, Duccio helped determine where church furnishings would be placed. He also designed one of the building's giant stained glass windows. Then, in 1308, he was commissioned to produce the Duomo's central altarpiece: the *Maestà*.

The Maestà image features Mary and Jesus enthroned "majestically" and surrounded by angels. Early Maestàs were richly colorful, yet their figures were also rigid and flat in appearance. This formulaic way of painting had its origins in ancient Byzantine art. But 13th-century Italian artists were beginning to break free from Byzantine traditions. Duccio himself developed a highly personal style in which hands and faces appear soft and naturalistic. His Madonnas became famous for their "sweet" and gentle countenance. So when Sienese leaders needed a new altarpiece for their cathedral, they requested something more than a painting—they requested a Duccio!

In his completed *Maestà*, Duccio's Madonna and Child adopt the traditional Byzantine pose. But their faces have a supple quality that resembles real skin. Even Christ's robes possess naturalistic folds and a lacy, silk-like appearance. Duccio also expanded the traditional Maestà format by including images of Siena's four patron saints kneeling next to the throne. Thus the city itself became an integral part of the sacred work. On the reverse of his *Maestà*, Duccio painted numerous smaller panels depicting scenes from the New Testament. Many of these panels, including one of King Herod ordering the slaughter of newborn children, fully capture the drama of the scene portrayed. They also present spaces and buildings that begin to look truly three-dimensional.

Duccio's altarpiece became an instant success when it was completed in 1311. Sienese leaders were so impressed with the work that they ordered a public holiday during which Duccio's *Maestà* could be processed through the city streets and formally placed in the Duomo. This kind of civic pride engendered through art would gradually become more common in Italy, especially in Renaissance Florence. Over the following centuries, the artist would become transformed from an anonymous tradesman into a cultural celebrity.

DUCCIO DI BUONINSEGNA was born in Siena, probably in the late 1250s. His earliest documented work dates from around 1280, and he quickly became one of the most sought-after artists in Tuscany. In addition to his commissions for Sienese clients, Duccio painted the famous *Rucellai Madonna* (1285, Uffizi, Florence) for the church of Santa Maria Novella in Florence. This altarpiece depicts the enthroned Madonna and Child surrounded by six angels. Documents indicate that Duccio had a large family with seven children. He died in 1318 or 1319 in Siena, only a few years after completing his great *Maestà*.

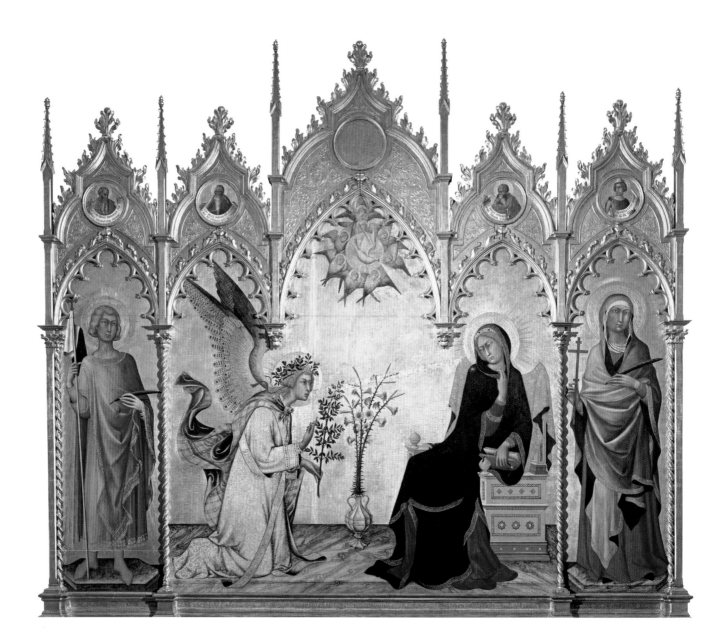

SIMONE MARTINI **ANNUNCIATION WITH SAINT MARGARET** 1333, tempera and gold on panel, 265 x 305 cm,
(AND LIPPO MEMMI) **AND SAINT ANSANUS** Uffizi Gallery, Florence

5

SIMONE MARTINI (AND LIPPO MEMMI)
ANNUNCIATION WITH SAINT MARGARET AND SAINT ANSANUS

As more and more artists achieved personal fame during the 14th century, some of them began to attract clients far from their place of birth. The Sienese painter Simone Martini served many Italian princes. He even plied his trade in southern France, becoming one of the first great "international" artists. Yet Martini's most famous work, the *Annunciation with Saint Margaret and Saint Ansanus*, was created for the cathedral in his home city. It displays the energy and courtly grace that made him so successful.

During the 1300s, Siena's cathedral, the Duomo, reflected the city's wealth and prestige. Blazing green-and-white-striped marble covered its walls and giant bell tower, while its façade was adorned with intricate carvings. Striped marble also adorned the interior, along with soft-colored light that emanated from the stained-glass windows. But the Duomo's most remarkable decorations were its altarpieces. Along with Florence, Siena was the most important center of painting in 14th-century Europe. And unlike most religious art at that time, Sienese altarpieces were valued for the artists who made them as well as for their holy images.

Duccio, the "father" of Gothic Sienese painting, painted the *Maestà* as the cathedral's main altarpiece. It was installed in 1311 with remarkable public fanfare. Soon afterward, the cathedral would sponsor four more painted works dedicated to Mary and to the city's four patron saints. All four commissions would go to leading artists from Siena: Bartolomeo Bulgarini, Pietro and Ambrosio Lorenzetti, and the city's most famous painter, Simone Martini. Martini had helped to spread the Sienese style througout Italy. The subject for Martini's new altarpiece would be the Annunciation, and the work he produced would reflect Sienese culture at its creative peak. Yet Martini would not paint the work alone. His brother-in-law and assistant Lippo Memmi painted a significant portion of the image. Memmi had learned to imitate Simone's style with great accuracy. Even today, scholars are uncertain which sections of the work were painted by Simone and which by Lippo. Despite this problem of attribution, the altarpiece remains among the greatest examples of Martini's art. The Virgin Mary seems to recoil from the Archangel Gabriel, who announces her divine pregnancy. Gabriel, too, is painted in a way that emphasizes movement. His windblown mantle and wings suggest that he has just landed in Mary's presence. Martini also endows the work with rich detail, including Mary's lavishly decorated throne and Gabriel's colorful wings. Simone's imagery marks an important transition in Western art. His figures sometimes have the two-dimensional quality of Byzantine painting and medieval French manuscript illuminations. Yet his flair for drama, movement, and detail were entirely "modern".

SIMONE MARTINI was born c. 1284 in Siena. He was one of many painters from Siena whose graceful style was influenced by Duccio. Like the older artist, Martini was popular and versatile. He became a master of everything from tiny manuscript illuminations to large-scale frescoes. One of his earliest documented works is the great *Maestà* (c. 1315, Palazzo Pubblico, Sienna), or the *Enthroned Madonna and Child*, in the city's town hall, the Palazzo Pubblico. Martini's triumphs in Siena led to major commissions in Pisa, Assisi, Orvieto, Naples, and elsewhere in Italy. Towards the end of his life, around 1340, Simone traveled to Avignon, France—the head-quarters of the papacy at that time. He would spend the rest of his life there. He died in 1344 in Avignon. Lippo Memmi, Martini's assistant and most important follower, was born c. 1291 in Sienna and died there in 1356.

6

AMBROGIO LORENZETTI
ALLEGORIES OF GOOD AND BAD GOVERNMENT

Siena's Palazzo Pubblico was more than a town hall. It was designed to be a powerful symbol of its city's stature … and of the beneficence of Siena's republican government. Local painter Ambrogio Lorenzetti was commissioned to depict these ideas in the Palazzo's Sala dei Nove (Room of the Nine). His work remains one of the first great examples of secular political art since antiquity.

Italian city-states of the 14th century ranked among the largest and wealthiest in medieval Europe. These communities often established independent "republican" governments run by councils of wealthy citizens. During the early 14th century, the city-state of Siena had a governing council called the "Nove," or the "Nine." It was under this governance that Siena created some of its greatest artistic monuments. One was directly commissioned by the Nine: Ambrogio Lorenzetti's decoration of the Sala dei Nove, the Nine's council chamber in the Palazzo Pubblico. Lorenzetti's frescoes were designed as a visual "argument" for his clients' government. The artist divided his paintings into two basic parts: representations of "Good" and "Bad" government. Each part covers two walls of the Sala dei Nove, and each includes depictions of a grand court chamber, a cityscape, and a surrounding landscape. In the Good Government frescoes, the "court" is overseen by a saintly bearded figure representing the "Common Good" of the people. He is surrounded by female figures that represent Peace, Temperance, Justice, and other virtues. In contrast, the Bad Government court on the opposite wall is overseen by a demonic, horned figure of Tyranny. He is surrounded by personified images of Furor, Fraud, and the deadly vices.

But the most famous images in the Sala dei Nove depict the chief benefits of good government: the Good City and its surrounding landscape. Lorenzetti's cityscape is clearly based on real-life Siena, a happy jumble of towers, windows, arcades, and streets. The painter also includes a remarkable variety of medieval characters. Street performers, roof tilers, shoemakers, and teachers all ply their trade peacefully. Outside the walls of the city, a hilly countryside spreads majestically across the wall. The fields are dotted with farmhouses, people tilling the soil, and travelers progressing "in safety." The corresponding Bad City—which is rather poorly preserved—has a more cramped appearance. Violence and thievery take place in the streets, while productive activity is suppressed. The Bad landscape too is in disarray, filled with burning farmhouses and drought-stricken fields. Such imagery likely reminded medieval viewers of the Last Judgment—with the angels of heaven and the devils of hell replaced by their secular counterparts. Yet Lorenzetti's frescoes represent the beginnings of a shift in European art from religious themes towards more political ones. Governments from Louis XIV's monarchy in France to Franklin Roosevelt's New Deal democracy in the United States would use political art to bolster their own ideas of "Good" and "Bad" government.

AMBROGIO LORENZETTI was born c. 1290 in Siena. Little is known about his early years or his training, but records indicate that he lived in Florence as early as 1319. His earliest documented work, a *Madonna and Child* (1319), dates from this period. He also joined a prominent Florentine guild in 1327, indicating that he spent much of his adult career in Florence as well as Siena. One of Lorenzetti's most prominent early frescoes was completed in the Basilica of San Francesco in Siena. Entitled *The Investiture of Saint Louis of Toulouse* (1329), it depicts a realistic architectural space—foreshadowing his work ten years later in the Palazzo Pubblico. Ambrogio and his brother Pietro (born c. 1280), another famous painter, died in 1348, both probably victims of the Black Death that ravaged Siena that year.

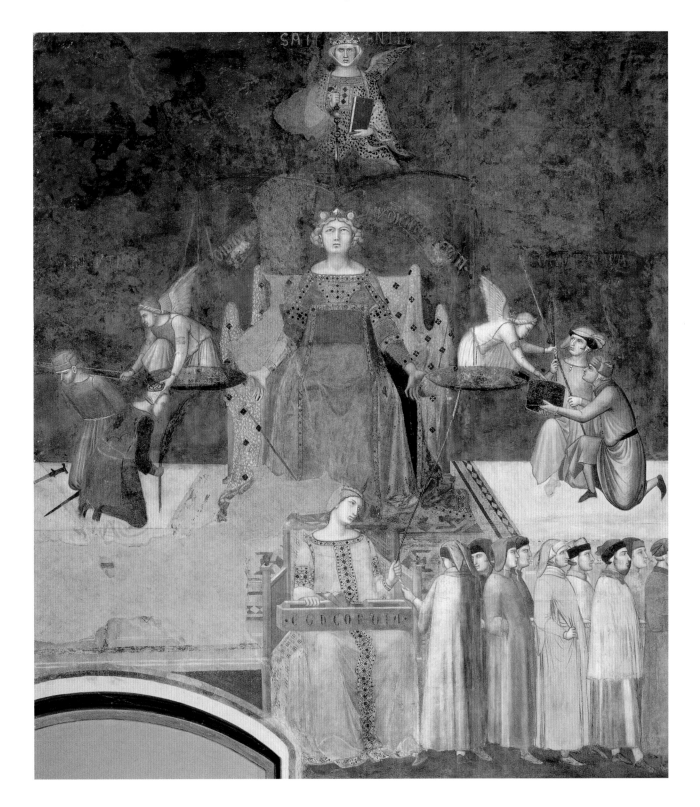

AMBROGIO LORENZETTI **ALLEGORIES OF GOOD AND BAD GOVERNMENT** *Allegory of Good Government* (detail): Wisdom (above); Justice (center), Concord (below), c. 1340, fresco cycle, overall dimensions of room: 14.04 x 7.70 m, Sala dei Nove, Palazzo Pubblico, Siena

right Lorenzetti used texts to explain and enforce the messages of his artwork. Here a winged figure of Justice holds up a banner declaring that her "sovereignty" (the rule of Justice) enables people to farm their lands and travel in safety.

below Lorenzetti's "Good City" resembles real-life Siena in many ways. The cathedral in the upper left-hand corner has the same dome and tower as Siena's Duomo (Cathedral). Ambrosio also captured the diversity of Siena's population, depicting people in the garments of aristocrats, entertainers, shopkeepers, and laborers.

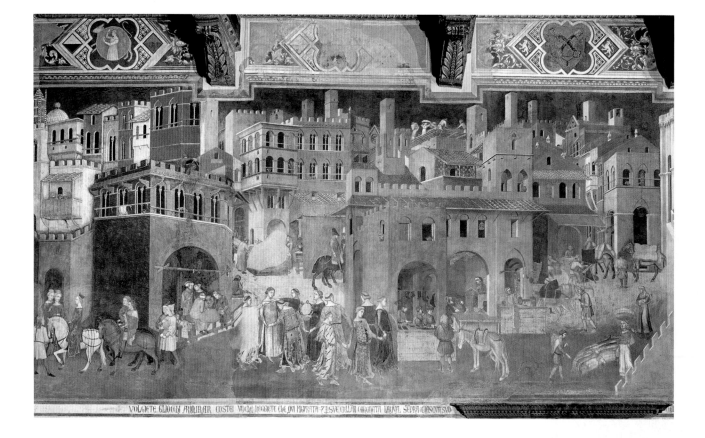

AMBROGIO LORENZETTI **ALLEGORIES OF GOOD AND BAD GOVERNMENT**

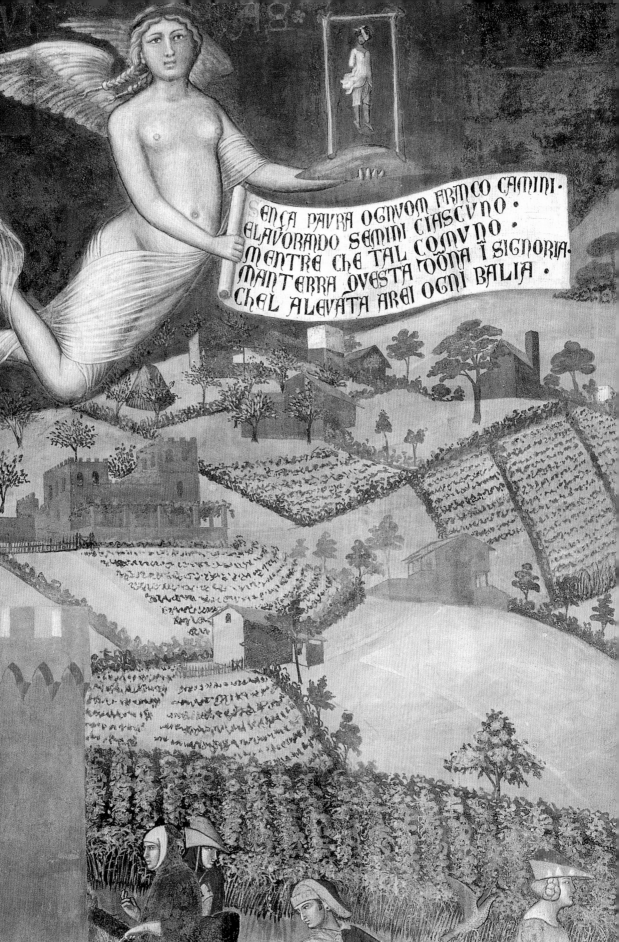

SENÇA PAVRA OGNVOM FRMCO CAMINI·
ELAVORADO SEMINI CIASCVNO·
MENTRE CHE TAL COMVNO·
MANTERRA QVESTA DONNA T SIGNORIA·
CHEL ALEVATA AREI OGNI BALIA·

7

THE WILTON DIPTYCH

The origins, use, and even the iconography of *The Wilton Diptych* are obscure—even today it still presents a mystery. But one thing we know for certain: the kneeling king at the center of the image is Richard II of England, who can be recognized by his royal cloak, his brooch with the white hart, and his gold collar decorated with the seedpods of the broom plant.

The three saints depicted behind the king are also clearly identifiable: John the Baptist, standing closest to Richard II (r. 1377–1399), and acting as his patron saint, followed by two English saints, Edward the Confessor and Edmund the Martyr. They all point to the king, interceding on his behalf before the Virgin, who holds the Christ Child's right foot, perhaps offering it to be kissed. The Christ Child himself turns to the king and the saints, his right hand raised in blessing. Eleven angels, dressed in the blue of the Virgin, surround the Madonna and Child. The predominant colors are gold and blue—precious materials, as blue pigment in particular was extremely expensive. It is not known who painted the image nor who commissioned it, though given its specific subject and its quality we can safely assume it was King Richard or someone close to him. What is clear is that *The Wilton Diptych* is a product of the so-called International or "Soft" Style of the Late Gothic period, which dominated art across Europe from the end of the 14th century onwards. It is characterized by particularly fine filigree depictions of delicate figures whose clothing is draped into soft folds, and who show refined facial features. The S-shaped curve of the figures' posture, as in the case of the Virgin shown here, is also typical.

The practical format of the diptych (a painting formed of two hinged panels that can be closed shut) meant that the king could take it with him on his travels to use in his private devotions. However, it is not clear that Richard actually used the painting in this way: the fact that Richard II himself is at the center of the image was unusual for a classic devotional picture. The portrait of Richard shows him quite young, and so the altarpiece must date from between 1395 and 1399, that is, during the last five years of his reign. The king's youthful appearance might possibly mean that this is a depiction of his accession to the throne, when he was only 11 years old. Another theory posits other reasons for Richard's beardless state: in the 1360s the French, whose fashions influenced trends throughout Europe, abandoned the custom of wearing beards. Is the solution to the mystery ultimately just a question of fashion?

The title of this work relates to Wilton House near Salisbury, the country residence of the Earls of Pembroke, where it was kept before it was transferred to the National Gallery in 1929. It is believed that the artist who created the diptych was of English or French origin. At the end of the 14th century there was a lively Europe-wide cultural exchange of artists and artisans, who traveled from place to place, and whose work was reflected in the International or "Soft" Style. It is possible that this treasure was created by a French master working in England, though British scholars tend to ascribe it to an English painter.

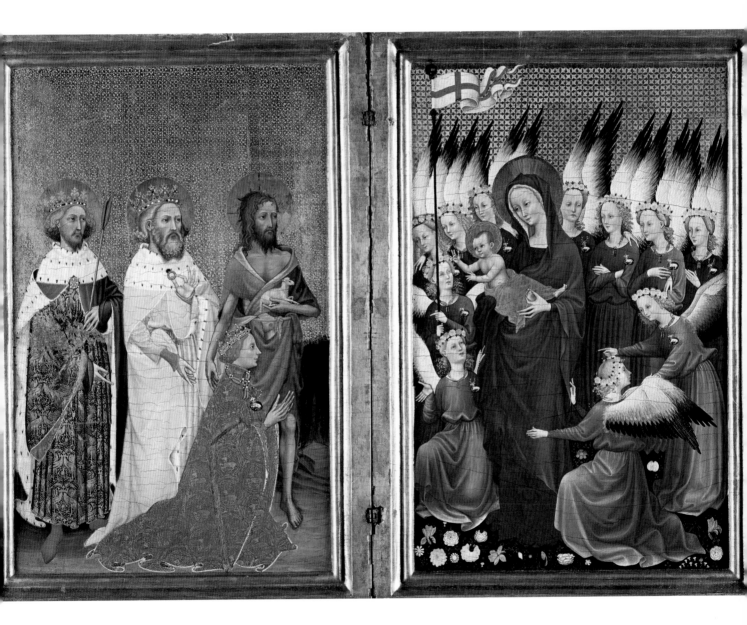

THE WILTON DIPTYCH

c. 1395–1399, egg tempera on oak panel, 53 x 37 cm,
The National Gallery, London

8

LIMBOURG BROTHERS
TRÈS RICHES HEURES OF JEAN, DUKE OF BERRY

Commissioned by Jean, Duke of Berry, the *Très Riches Heures*, a private book of prayers to be said at the liturgical hours, is one of the most famous and exquisite illuminated manuscripts of the 15th century. It was created by the Limbourg Brothers between 1412 and 1416, and is among the finest examples of French Gothic manuscript illumination.

Jean, Duke of Berry, loved jewels and works of art, including beautiful books. He owned other illuminated manuscripts, but the *Très Riches Heures* was his prized possession. The calendar pages at the beginning of the book are its best-known images today. Working in the early 15th century, the Limbourgs lived in a period in which the world, and how to portray it in art, were being intensively explored. They, more than other artists of the period, painted contemporary France as it had never been seen before. The images are full of details but also work together as a group. They also benefitted from a new form of patronage, with patrons such as the Duke asking for books that combined private devotion with artistic appreciation. For the first time, the patron appears in the calendar scenes, as well as the actual French countryside. There is a strong sense of the seasons of the year, of time and change, in the sacred stories as well as the calendar cycle. Part of the sense of reality comes from an attempt by the Limbourgs to use perspective, if a little inaccurately. Certainly the change of scale throughout the scenes helps make them seem more naturalistic, though still idealized. The world of the *Très Riches Heures* is a peaceful garden, safe and secure under a bright sun. Nevertheless, the calendar pages in particular represent a source, not only for art historians, but also for social historians. Here we can see the details of daily life in the early 15th century, of both the aristocracy and the working people: their clothing, tools, food, and furniture. Rarely had so much of contemporary life in France been so accurately portrayed. The scene for August, for example, is set at Étampes, which belonged to the Duke of Berry. The Château d'Étampes rises in the background, with its towers, chapel and other buildings. Peasants bind up the newly mown hay on the hills and some have cooled off by swimming in the River Juine. In the foreground, the nobility set out on their horses for a hunt, with a falconer leading the way. A sacred scene, the *Annunciation to the Shepherds,* while following the Bible description, also contains naturalistic details. The Shepherd's black-and-white dog rests at his feet, and his sheep graze on the hill. The buildings on the hill, while supposed to represent Bethlehem, are similar to actual buildings the Duke of Berry was fond of, possibly in Poitiers and Saint-Hilaire. The Limbourgs created highly original works that combined a feeling for the countryside, the common people as well as the courtiers, with classical allusions and religious iconography. With their rich details and their luminous, vibrant colors, the images speak to us even today.

The three **LIMBOURG BROTHERS** grew up in the town of Nijmegen in the Duchy of Guelders (now the Netherlands), and they were usually referred to as "German." Paul (Pol) and Jean worked for Philip the Bold, Duke of Burgundy, for four years. By 1410 the three brothers, Paul, Herman and Jean, were at work for the Duke of Berry. The Duke must have held the brothers in high esteem, for there are records of gifts to them of jewels and money and he eventually gave Paul the title of *valet de chambre*. Documents mention the deaths of Paul, Herman and Jean together, and they may have died at the same time, in 1416, perhaps in an epidemic.

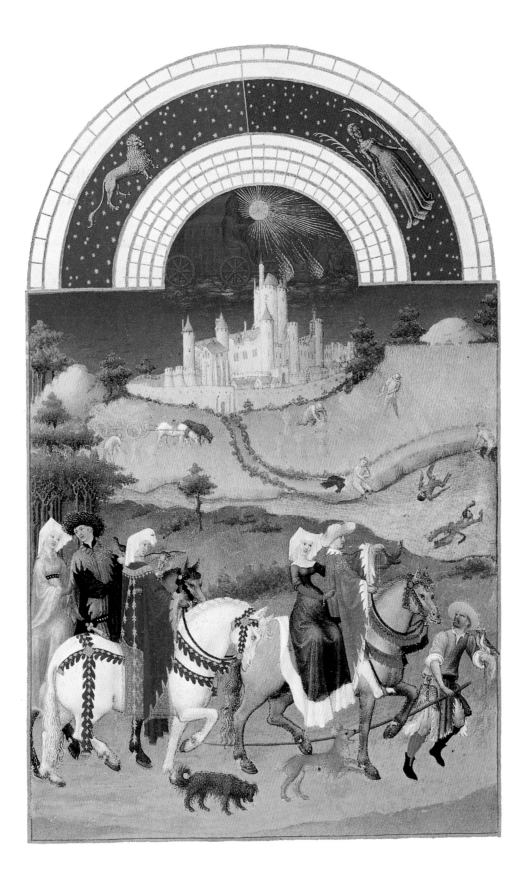

LIMBOURG BROTHERS **TRÈS RICHES HEURES OF JEAN,** *August,* 1412–1416, ink and pigment on vellum, 29 x 21 cm,
 DUKE OF BERRY Musée Condé, Chantilly

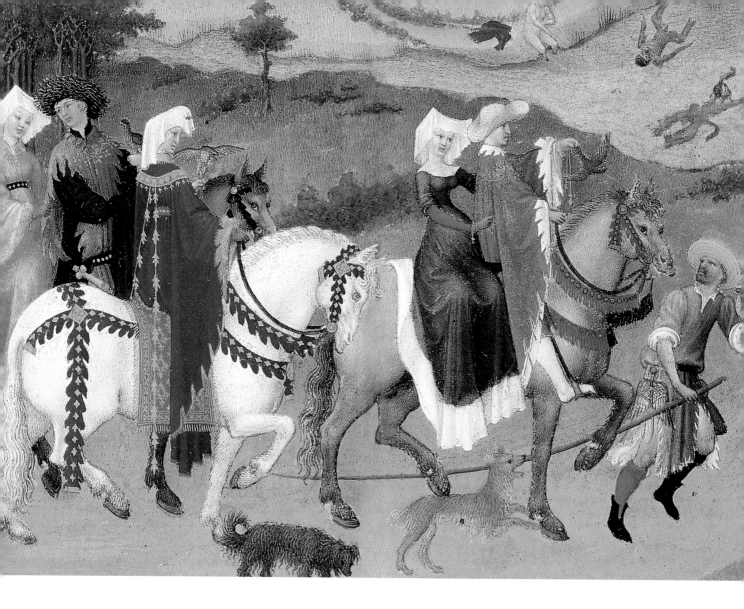

above While the nobility are off to hunt, the peasants are at work in the fields, but cool off from their labors in the nearby river. The Limbourgs observed the refraction of water and attempted to show it with the swimmers' bodies.

right *The Annunciation to the Shepherds*, from the *Très Riches Heures of Jean, Duke of Berry*, 1412–1416, ink and pigment on vellum, 29 x 21 cm, Musée Condé, Chantilly The Limbourg Brothers depict a religious scene but bring in details from contemporary life, such as the clothes, the dog, the sheep grazing, and buildings that were probably based on places actually known to the Duke of Berry.

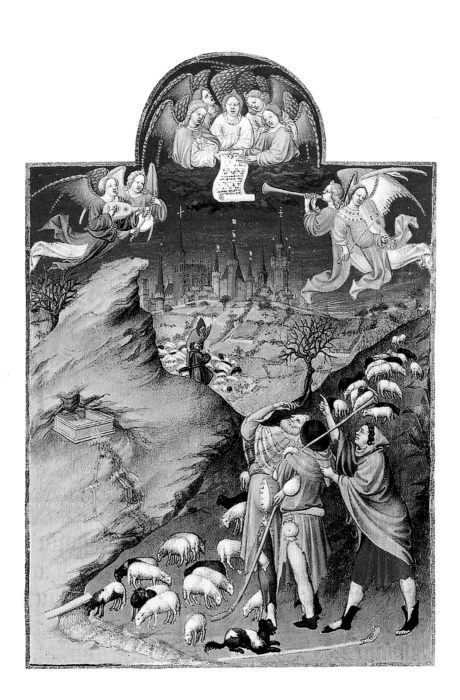

LIMBOURG BROTHERS **TRÈS RICHES HEURES OF JEAN, DUKE OF BERRY**

"TOMMASO OF FLORENCE, NICKNAMED MASACCIO,
SHOWED BY HIS PERFECT WORKS HOW THOSE
WHO TAKE FOR THEIR STANDARD ANYONE BUT NATURE,
THE MISTRESS OF ALL MASTERS, WEARY THEMSELVES IN VAIN."

Leonardo da Vinci

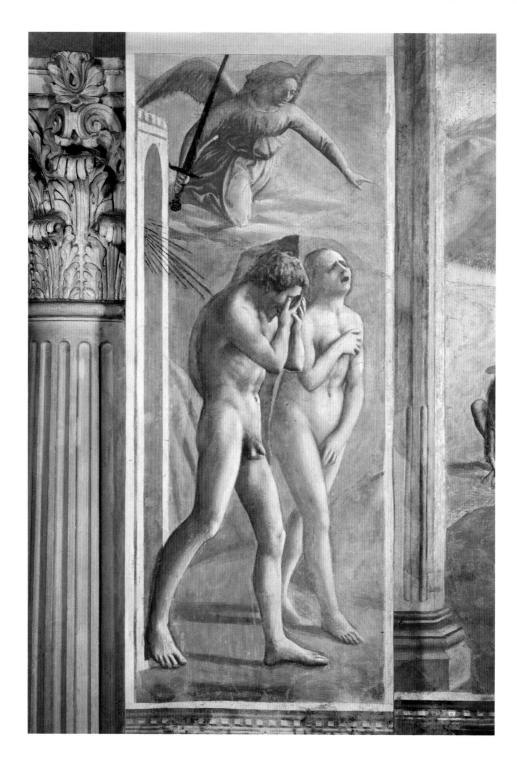

MASACCIO **FRESCOES IN THE BRANCACCI CHAPEL** *Expulsion from the Garden of Eden,* 1424–1425, fresco, 208 x 88 cm,
Brancacci Chapel, Santa Maria del Carmine, Florence

9

MASACCIO
FRESCOES IN THE BRANCACCI CHAPEL

The frescoes in Florence's Brancacci Chapel represent one of the most famous collaborations in the history of art. Two great painters, Masaccio and Masolino, worked closely together on the project. Yet their differing styles reveal the turbulent changes that were shaking up the art world in the early 1400s. Masolino's refined images retain echoes of the medieval Gothic past, but the work of young Masaccio helped Florence move boldly forward into the Renaissance.

The Brancacci Chapel forms part of the transept in Florence's church of Santa Maria del Carmine. It received its name from its long-time patron family, the Brancacci. In 1423 Felice Brancacci commissioned a cycle of frescoes on the life of Saint Peter to adorn his chapel. Ultimately, the commission was awarded to two independent artists who were working together: an established middle-aged painter named Masolino da Panicale and a 21-year-old wunderkind called Masaccio.

Masolino and Masaccio likely developed the plan for their fresco cycle together, and they shared the work equally—an unusual arrangement for the time. What remains of their paintings today shows the dramatic revolution that was taking place in Florentine art during the early 1400s. Masolino's paintings reflect the more conservative, fashionable style of the day. His delicately modeled figures adopt restrained poses and facial expressions. Thus his pictures' dramatic impact is sacrificed in order to preserve a sense of decorum and refinement. Masaccio, on the other hand, approached his work from a very different perspective. He was familiar with the most progressive Renaissance art of the time. Sculptors such as Donatello were depicting human bodies and emotions in daringly realistic ways. Masaccio had begun exploring similar ideas in paint; ideas he would use in the Brancacci chapel.

In his *Saint Peter Healing the Sick with His Shadow*, Masaccio depicts two beggars—one lame and one elderly—with unflinching realism. The desperate facial expression of the lame man and the shivering, half naked body of the elderly man contrast markedly with the solemn figure of Saint Peter. In a larger-scale painting called *The Tribute Money*, Masaccio creates another radical image using his knowledge of perspective. Here the story of Saint Peter and the tax collector is set against a vast mountain landscape, one of the first to display an accurate sense of space and natural atmosphere. But the most remarkable of Masaccio's frescoes is generally considered to be his *Expulsion from the Garden of Eden*. In it the artist portrays Adam and Eve's grief with shocking directness.

Later Renaissance artists, including Michelangelo, would study Masaccio's images closely, and European art in general would incorporate Masaccio's mastery of space, anatomy, and human expression.

MASACCIO was born Tommaso di Ser Giovanni di Simone in 1401 in San Giovanni Valdarno, a small Tuscan village about 50 kilometers (30 miles) north of Florence. Masaccio likely studied in Florence, as he joined the painters guild there in 1422. Around this time he began working collaboratively with Masolino da Panicale (c. 1383– c. 1447), first on altarpieces and then on the Brancacci Chapel. Masaccio possibly acquired his nickname ("Big" or "Clumsy" Tom) to distinguish him from Masolino ("Little Tom"). Though unfinished, Masaccio's work on the Brancacci Chapel made a strong impression in Florence, and he soon received more commissions. The most famous of these was the *Holy Trinity* fresco in the church of Santa Maria Novella, which shows the artist's mastery of linear perspective and human anatomy. Masaccio died in 1428 in Rome.

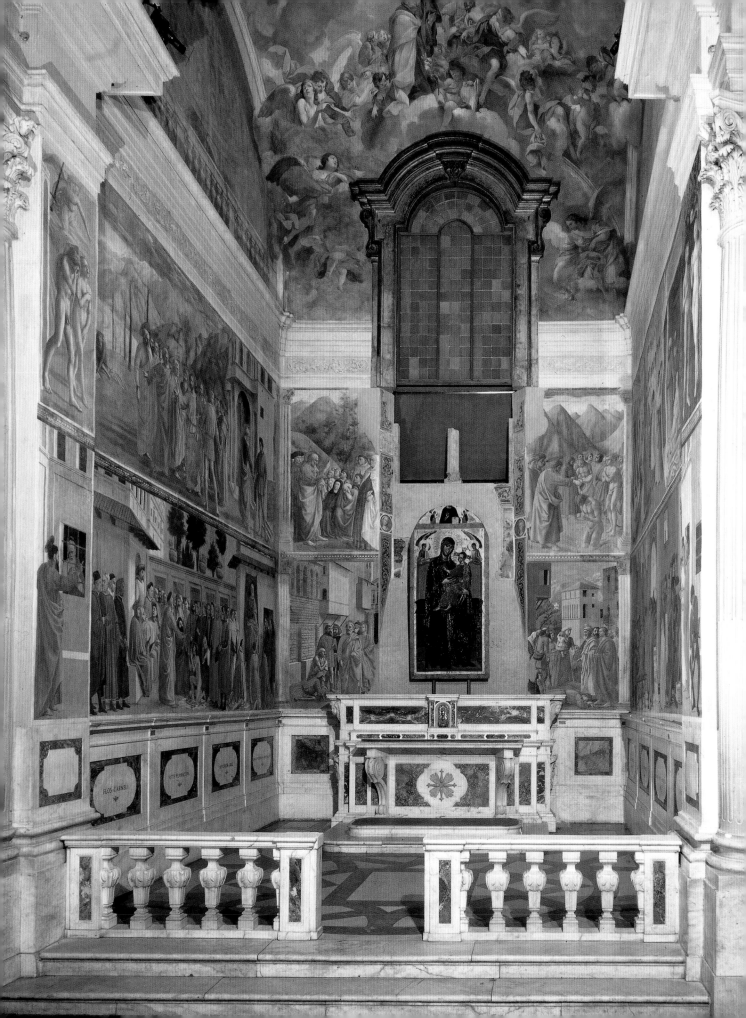

previous page In the remarkable *Expulsion from the Garden of Eden*, Adam buries his face in his hands while Eve appears to shriek in pain. Masaccio further emphasizes his character's plight through the bold modeling of their naked bodies, the dramatic shadows on the barren landscape, and the ominous hovering angel that directs the couple out of Eden.

left Masaccio, frescoes in the Brancacci Chapel, 1423–1427 and later, overall dimensions of chapel: 5.68 m wide x 6.84 m deep, Santa Maria del Carmine, Florence

right To better understand how revolutionary Masaccio's *Expulsion* was, we can compare it with Masolino's image of Adam and Eve on the opposite wall of the chapel. The latter's *Temptation of Adam and Eve*, though gracefully painted, has none of the emotional power of Masaccio's work.

10

JAN VAN EYCK
THE ARNOLFINI PORTRAIT

One of Jan van Eyck's most famous works, this double portrait very probably depicts the Italian merchant Giovanni di Nicolao Arnolfini and his wife, who lived in Bruges. However, whether this is actually a wedding picture, as has often been accepted, cannot be substantiated. Nevertheless, details such as the couple's gestures appear to hint at a meaning that is hidden, at least from the modern viewer.

In the early 15th century, a completely new kind of painting was emerging in the Burgundian Netherlands, one characterized by a focus on depicting reality. Up till then, the subject of a painting had been set against unreal, abstract backgrounds, and with little regard for relationships of space, scale, or time. By contrast, Jan van Eyck's *Arnolfini Portrait* locates his subjects in the realistic interior space of a closely observed bourgeois house. And when the artist wanted to introduce a spiritual aspect to the painting, it was not allowed to disturb the scene's natural appearance: so the image of Saint Margaret fighting off the dragon could no longer just appear in the Arnolfini's well-appointed interior, and so it was turned into a carving on the bedpost, and the traditional hound, a symbol of fidelity, appears as a lapdog.

From the fabrics and fur trimming of the clothes to the wooden window frame and the bull's-eye windowpanes— everything is depicted using a degree of detailed realism that makes objects seem almost tangible. It was only the introduction of oil paints, which unlike tempera can be applied in many transparent layers one on top of the other, that made this particularly subtle representation of details and surface effects possible, creating an image that is luminous, intensely colored, precise, and without visible brushstrokes. Van Eyck used this technique to represent the natural light that enters through the window, which gently illuminates the facial features of his subjects, casts soft shadows on their bodies, and reflects off the smooth metal of the chandelier. The painting's realism goes ever further. On the far wall a mirror shows what cannot actually be seen in the picture: in front of the depicted couple—more or less in the position of the viewer—two people are standing in a doorway. In the reflection, which renders everything with utmost precision, though distorted by the convex curve of the round mirror, van Eyck not only shows his mastery of three dimensions, he also plays with this, further demonstrating his technical—and intellectual—brilliance. This self-confidence is also expressed in the prominent position of his Latin signature, written in Burgundian script above the mirror: "Jan van Eyck was here 1434."

JAN VAN EYCK was born c. 1390 in Maaseik (in present-day Belgium). From 1422 to 1424 he was working in The Hague for Count John of Holland, and in 1425 he was made court painter to the Duke Philip the Good of Burgundy (r. 1419–1467), then one of the most culturally important courts in Europe. He lived and worked in Lille 1425–1429, and in Bruges from 1430. He was greatly valued by Philip the Good, who also sent him on diplomatic missions. Such was his skill in using oil paints that he achieved international acclaim and was (incorrectly) credited with the invention of oil painting. He died in 1441 in Bruges.

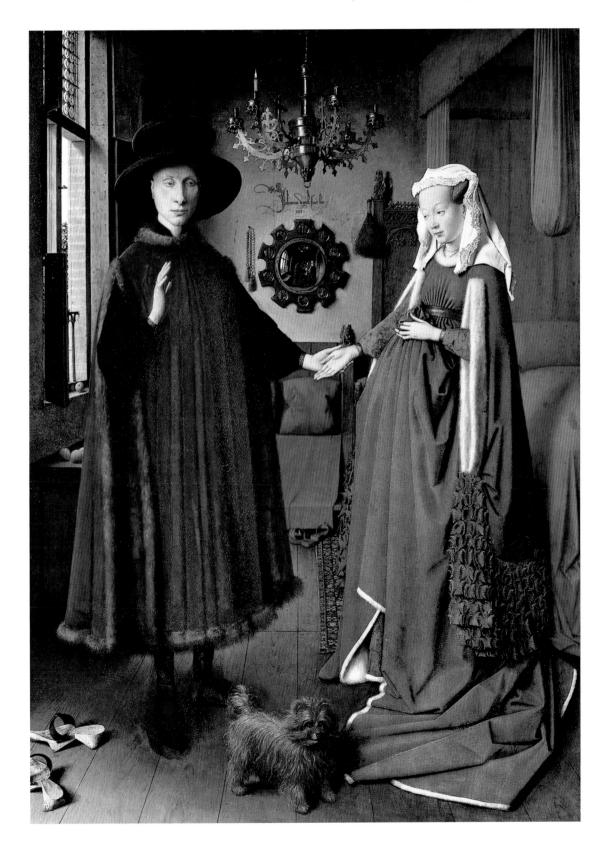

JAN VAN EYCK **THE ARNOLFINI PORTRAIT** 1434, oil on oak wood, 82.2 x 60 cm,
The National Gallery, London

11

ROGIER VAN DER WEYDEN
DESCENT FROM THE CROSS

The *Descent from the Cross* by Rogier van der Weyden is possibly the most influential Netherlandish painting of the Crucifixion of Christ. Van der Weyden was known for the individuality of his portraits, as well as the drama of his religious subjects. They are considered some of the finest works of Netherlandish art.

The *Descent from the Cross* was commissioned by the Crossbowmen's Guild of Louvain for the church of Notre-Dame-hors-les-murs about 1435. Small crossbows can be seen in the side spandrels as a reference to the Guild. The figures appear within a shallow, gilded wooden frame with tracery in the corners. Van der Weyden created the scene as if it were a "Schnitzaltar," a scene of carved, polychromed figures set in a gilded shrine. These figures bear no resemblance to statues, however, but appear to be living characters, almost a *tableau vivant* or figures on a stage. What sets van der Weyden's *Descent* apart from the work of his contemporaries is his ability to depict movement and emotions. The two curved outer figures of Saint John and Mary Magdalene form a sort of parenthesis that contains the scene. The parallel curves formed by the bodies of Christ and Mary, as she faints with sorrow, bring out their relationship in a pose not used before. Van der Weyden depicted emotions as no previous Netherlandish painter had. Feelings of sorrow, loss, and grieving are clearly evoked. He also allowed the donors to participate directly in sacred scenes. Although painted early in his career, his *Descent* is remarkable for the sense of energy flowing through the figures, as expressed through their gestures and garments. It creates a rhythm moving through the work, a feature that had not been seen before in Netherlandish painting. Although the space is narrow, van der Weyden built many layers into the composition, from Christ and Mary in the front to the man on the ladder at the back. The painting remained in Louvain until around 1548, when Mary of Hungary, sister of the Holy Roman Emperor, Charles V, acquired it in exchange for a copy by Michael Coxcie and "an organ." It initially hung in Mary's castle at Binche. It passed from Mary to her nephew, Philip II of Spain, and was eventually displayed in the Escorial. In 1939, it was transferred to the Prado Museum, in Madrid, where it remains.

ROGIER VAN DER WEYDEN was born in 1399 or 1400 in Tournai, now in Belgium. Nothing is known of his youth, but he married Elisabeth Goffaerts, from Brussels, in 1427. The following year he entered the workshop of painter Robert Campin (c. 1375–1444) and left as "Master Rogier" on August 1, 1432. He was successful from the outset and eventually settled in Brussels as the City Painter. He received commissions from as far away as Spain and Italy. He was also, apparently, considered a man of integrity and was often requested to arbitrate disputes between other painters and their clients. He died in 1464 in Brussels, a successful and admired artist.

"IT WAS THE BEST PICTURE IN THE WHOLE CASTLE AND EVEN, I BELIEVE,
IN THE WHOLE WORLD, FOR I HAVE SEEN IN THESE PARTS MANY GOOD PAINTINGS
BUT NONE THAT EQUALED THIS IN TRUTH TO NATURE OR DEVOUTNESS.
ALL THOSE WHO HAVE SEEN IT WERE OF THE SAME OPINION."

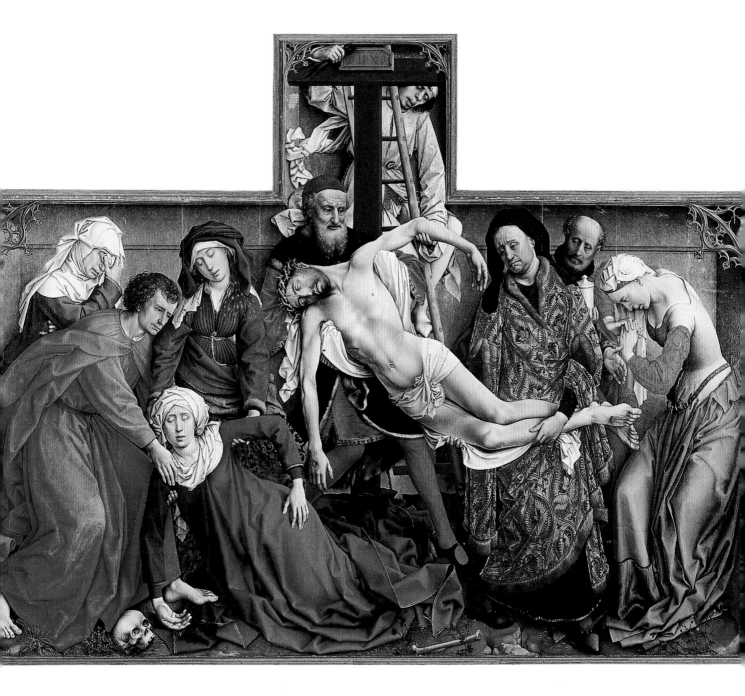

ROGIER VAN DER WEYDEN **DESCENT FROM THE CROSS** c. 1435, oil on oak panel, 220 x 262 cm,
Museo Nacional del Prado, Madrid

12

KONRAD WITZ
THE MIRACULOUS DRAFT OF FISHES

Konrad Witz was the first artist in the German-speaking world to combine native traditions with innovations emerging from Netherlandish painting. In his realistic compositions he broke away from the idealizing forms of representation characteristic of the Late Gothic International or "Soft" Style.

Among Witz's surviving paintings this one, originally part of an altarpiece dedicated to Saint Peter in Geneva Cathedral, depicts the Miraculous Draft of Fishes. This is not only a striking interpretation of this biblical subject, it is also one of the first true landscape paintings of the early modern era. Witz shows the story of the Apostles whose unsuccessful fishing trip at night on the Sea of Galilee turns into a huge catch of fish through their unexpected encounter with the Risen Christ (Gospel of John 21:1–14). The right-hand side of the painting is dominated by the monumental figure of Christ wearing red robes, who appears to float above the shallow water of the lake. On the left, three Disciples are hauling a heavy, full net into the boat. Dressed in blue, Saint Peter is helping them, simultaneously turning in astonishment and surprise towards Christ. But Witz also paints Saint Peter a second time: hands outstretched in front of him, he swims excitedly away from the boat towards the figure of Christ, whom he has recognized, and who stands motionless on the surface of the lake.

From the look of the harbor warehouses and the city walls in the background, we can see that Witz painted the landscape surrounding Lake Geneva with almost topographical accuracy: this is a landscape populated with tiny people working in the fields and meadows on the fertile mountain slopes. The striking, pointed silhouette of the mountain known as Le Môle, together with the mountain chain of Chamonix with Mont Blanc in the distance, is part of a superb panorama of the Swiss landscape that forms the backdrop to this biblical scene. And in the foreground too there are remarkable examples of Witz's interest in depicting reality in precise detail, for instance in the closely observed water plants, in the air bubbles that form around the submerged rocks near the shore, and even in the reflections on the calm surface of the lake. The sharp outlines of the Apostles, and the charismatic, almost chiseled figure of Christ seem to have been grafted on to the landscape, which reaches seamlessly into the distance, rather than being incorporated into the setting. However, this does not detract from a vivid representation of the landscape around Geneva that has abandoned all the constraints of late medieval forms of representation.

KONRAD WITZ was born in 1400–1410 in Rottweil am Neckar, Germany. He was admitted to the Basel painters' guild "Zum Himmel" in 1434, and in 1435 became a citizen of the city. It is not known for certain if he was active in Constance before this, but in any case his name appears in the Constance tax records for the years 1418–1444. He created around 20 paintings, mostly during the time of the Council of Basel (1431–1449). His earliest surviving work is the *Heilspiegel Altarpiece*, which was commissioned by the Augustinian monastery of Saint Leonhard in Basel. Only 12 known paintings by Witz survive, and their realistic style of depiction shows the early influence of Netherlandish art. He died c. 1446 in Basel or Geneva.

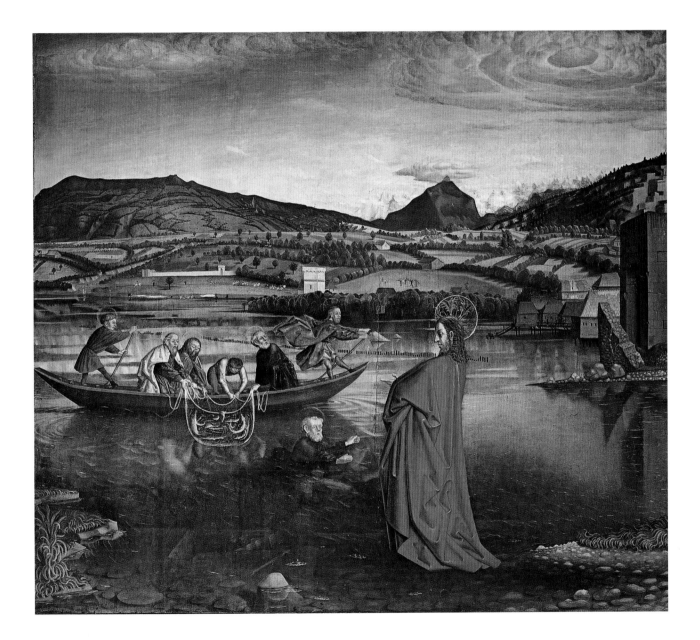

KONRAD WITZ **THE MIRACULOUS DRAFT OF FISHES** 1444, tempera on wood, 132 x 154 cm,
Musée d'Art et d'Histoire, Geneva

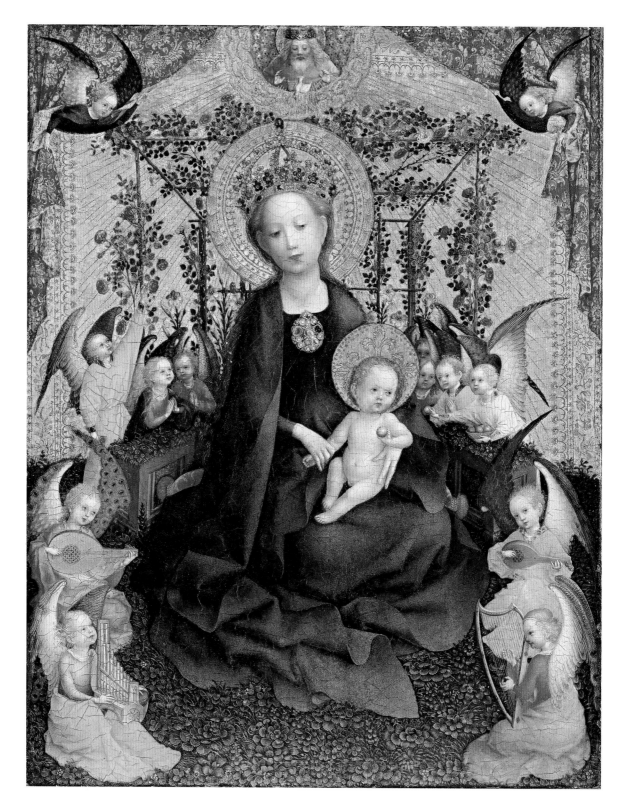

STEFAN LOCHNER **MADONNA OF THE ROSE BOWER** c. 1450, oil and tempera on wood, 50.5 x 39.9 cm,
Wallraf-Richartz Museum & Fondation Corboud, Cologne

13

STEFAN LOCHNER
MADONNA OF THE ROSE BOWER

Stefan Lochner is the outstanding master of the late medieval group of painters known as the Cologne School. His altarpieces and devotional images display the very beginnings of a style that sought to depict the physical presence of things in space. However, his paintings are still characterized by figures whose importance is denoted by their scale, a symbolic form of pictorial geometry, and by an attention to detail influenced by Netherlandish painting.

Because of the compositional harmony and the technical brilliance of his altarpieces, Stefan Lochner's fame spread far beyond the city of Cologne. His *Madonna of the Rose Bower*, a devotional image for a merchant's house or perhaps a monk's cell, was probably both his last work and also the highpoint of his artistic career.

In the top corners of this private devotional image, two angels draw back a gold-embroidered red curtain to reveal a girlishly young Madonna, who is sitting outdoors on a lush carpet of plants in front of a low, semi-circular wall topped with plants, the Christ Child on her lap. Behind her, red roses and white lilies grow up a trellis set against a richly stippled gold background; these are symbols of love and of the Passion of Christ, as well as of the Madonna's virginity.

In the foreground on each side, angels playing music, along with angels who are leaning over the low wall, frame the figure of the Madonna, who appears as the Queen of Heaven in her richly draped, outspread blue mantle, her sumptuous brooch and crown set with pearls and precious stones. Her halo just touches the circle of the domain from which God the Father, actually the smallest figure in the scene, and visible in the center of the top edge of the picture, sends the dove of the Holy Spirit down to earth. The Christ Child on the Virgin's lap holds an apple in his left hand, while an angel offers him another apple from a brimming bowl, a reference to Christ's significance as the "New Adam," the Savior of mankind.

With his luminous, subtly harmonious use of color, and a rendering that is at once elegant and precise, Lochner skilfully combined the dominant tradition of the International or "Soft" Style with the new realistic style of detailed representation that originated in the Netherlands.

STEFAN LOCHNER was born in 1410 in Meersburg am Bodensee (?). Little is known of his education and his years spent traveling. It is highly probable that he spent time in the Netherlands in the circle of Jan van Eyck, and in Westphalia, where Conrad von Soest (c. 1370–after 1422) was active. In June 1442, "Master Steffen" was paid for his work on decorations for the visit of Emperor Friedrich III (r. 1440–1493). In October 1442, he bought a house, which was sold again in 1444 to finance new acquisitions. In 1447 he became a town councilor in Cologne. The entry for his second year as a councilor, beginning in December 1450, is marked with a cross, indicating that he died in 1451 in Cologne.

14

PIERO DELLA FRANCESCA
FLAGELLATION OF CHRIST

Along with Leonardo's *Mona Lisa*, the *Flagellation of Christ* by Piero della Francesca ranks among the most enigmatic works of the Renaissance. Art historians have spent countless hours developing theories to identify the painting's figures and to determine its hidden meaning. Piero's work is a complex allegory, with the artist using linear perspective—a newly developed technique in his day—to give the image a captivating and mysterious quality.

Piero della Francesca grew up in the small northern Italian hill town of Borgo Santo Sepolcro. Yet he would become one of the most cosmopolitan painters of his day, studying and working in Florence, Rimini, Urbino, Ferrara, and Rome. Renaissance artists like Piero immersed themselves in Humanism. This involved the study of anatomy, mathematics, spatial perspective, and ancient Greek and Roman culture. Piero became familiar with the works of the architect Leon Battista Alberti, who was designing elegant palaces and churches based on ancient theories of proportion, and who elaborated his influential theory of linear perspective in his treatise *Della Pittura* (On Painting) of 1436. Piero also studied the expressive, naturalistic paintings of Masaccio in Florence, as well as imported artworks by Rogier van der Weyden and other Flemish masters. These latter artists, whose oil paintings were being collected by Italian patrons, became famous for their rich colors and for their incredible attention to detail, capturing with minutest precision the textures of plants, clothing, and human skin. Piero della Francesca would combine all of these influences to produce one of the most striking painting styles of the 1400s.

A work that perfectly exemplifies Piero's art is his *Flagellation*. He created the painting around 1460 while in Urbino at the court of Federico da Montefeltro. On the surface, Piero's image displays all the technical elements that he had mastered as an artist. His admiration for Alberti's architecture is shown in the elegant, classical-style temple—its columns receding sublty into the distance to create a convincing sense of space. The precisley rendered clothing and architectural details reflect the influence of Netherlandish art, while the golden sculpture on top of the column reveals a keen interest in the effects of light. Piero fuses these elements into an image that is difficult to interpret. The left-hand scene depicts the Flagellation of Christ before he is crucified. Yet Piero sets this brutal story in the most serene of classical environments. He also places it well in the background, juxtaposing it against the three elegantly dressed men in the right foreground. This strange spatial arrangement gives the work a unsettling, dreamlike quality, and it suggests to the viewer that the people and actions being displayed are allegorical.

Piero's subtle visual puzzle was largely ignored for many centuries after his death. But in the early 20th century, its mysterious nature and sophisticated use of space and light became admired by artists, art historians, and writers.

PIERO DELLA FRANCESCA was born c. 1415 in Borgo Santo Sepolcro (now Sansepolcro), near Arezzo in northern Tuscany. Historians believe he was apprenticed to Antonio d'Anghiari, a painter working in Santo Sepolcro, during the 1430s. Piero earned one of his earliest commissions in Florence, where he was able to see and study the works of Masaccio, Donatello, and other early Renaissance masters. Over the course of his career, he worked for some of the most powerful men in Italy, including Sigismondo Pandolfo Malatesta in Rimini and Federico da Montefeltro in Urbino. Piero created masterful small works for these local rulers, including the *Flagellation* and several portraits. His grandest commission, however, was the cycle of frescoes he painted for the cathedral at Arezzo in the 1450s. He died in 1492 in Borgo Santo Sepolcro.

"... A MYSTERIOUS UNION OF MATHEMATICS AND PAINTING."

Roberto Longhi on the *Flagellation*

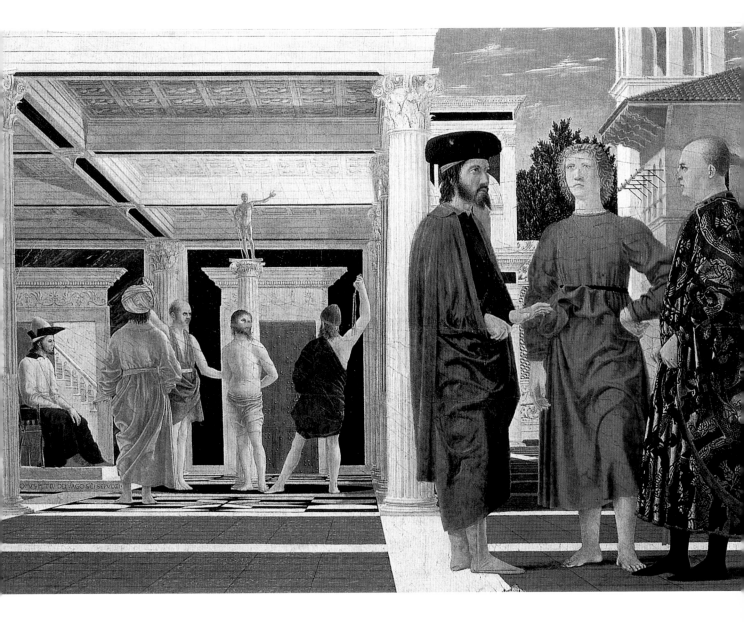

PIERO DELLA FRANCESCA **FLAGELLATION OF CHRIST** c. 1460, oil and tempera on panel, 58.4 x 81.5 cm, Galleria Nazionale delle Marche, Urbino

below Piero depicts the Flagellation of Christ in a strangely unemotional way. The characters seem to perform their actions as if rehearsing for a play. According to British art historian Kenneth Clark, the seated figure here represents both Pontius Pilate and John VIII Palaeologus, one of the last Byzantine emperors of Constantinople. When Piero created the work, Christian Constantinople had recently fallen to the Muslim Ottoman Turks. The *Flagellation*, Clark argued, symbolizes the struggles that Christianity was undergoing at that time.

right Piero displayed his talent for rendering fine detail in the elegant silk damask clothes of the figure on the right.

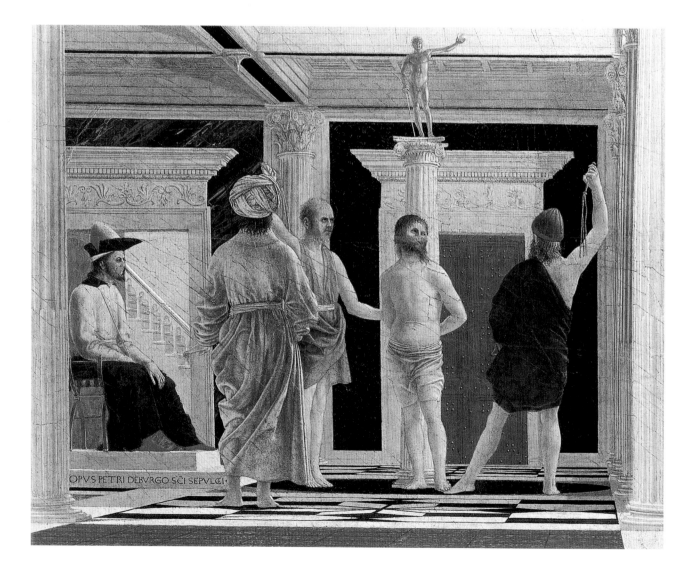

PIERO DELLA FRANCESCA **FLAGELLATION OF CHRIST**

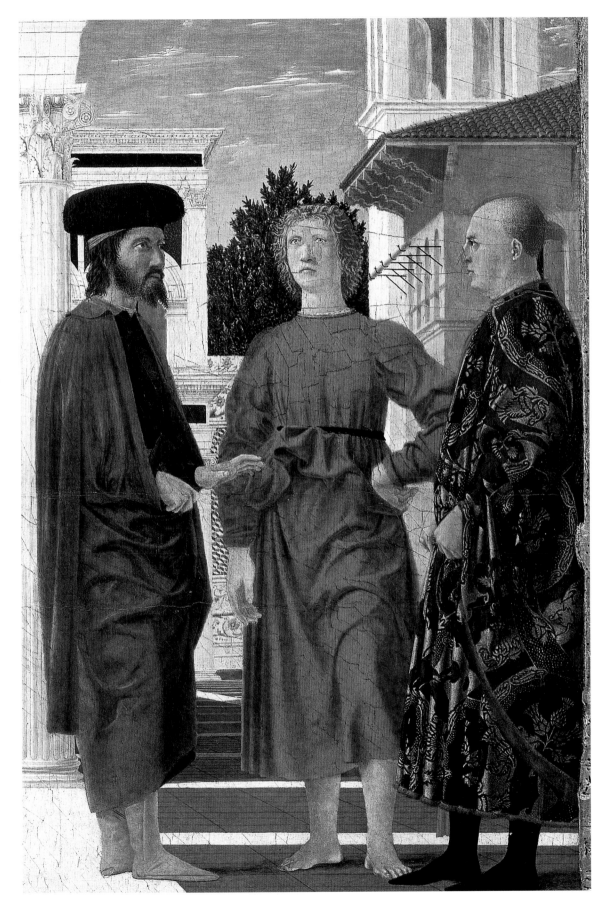

PIERO DELLA FRANCESCA **FLAGELLATION OF CHRIST**

15

PETRUS CHRISTUS
PORTRAIT OF A YOUNG GIRL

Petrus Christus made portraits, as well as religious subject, more human and accessible. He simplified compositions, making them more readable, and although his ability to create the sumptuous images of his Netherlandish predecessors was somewhat lacking, he moved the art of portraiture towards greater realism and psychological insight.

The *Portrait of Young Girl* was one of the last works of Petrus Christus, painted around 1470. Tradition says the sitter was a daughter of John Talbot, 2nd Earl of Shrewsbury, possibly Anne or Margaret, but this cannot be proved. The family may have traveled to Bruges, home of Petrus Christus, to attend the wedding of Margaret of York to Charles the Bold, Duke of Burgundy, in 1468. Bruges was a thriving commercial center by 1440 and local businessmen, foreign merchants, and bankers were potential clients for portraits. Whoever she may be, the young sitter is dressed in expensive, elegant clothes and jewelry. She looks out at a slight angle, creating a subtle relationship between her and the viewer. With her pale skin, almond-shaped eyes, and slightly petulant mouth, the girl appears to be self-aware but reserved. Her eyes are not quite in alignment, which adds to her expression—she makes the viewer want to know who she is and what she's thinking. In a development new to portraiture in the Netherlands, Christus set his model not against the traditional dark background, but in a real interior. She is framed by architecture, a wooden dado below with a wall above. Not only has Christus depicted real objects, he has also depicted them casting real shadows. The girl looks as though she might be sitting in her own home, rather than isolated against a flat, dark space, as in the portraits of Jan van Eyck or Rogier van der Weyden. Not much is known of the whereabouts of the painting until it was acquired by the Medici family in Florence and listed in an inventory as "a small panel painted with the head of a French Lady, colored in oil, the work of Pietro Cresci from Bruges." The Medici did not appear overly concerned about the identity of the sitter, and were probably more interested in the painting for its artistic qualities than the significance of the person depicted. The painting entered the Prussian royal collection in 1821 and is now in the Gemäldegalerie of the Staatliche Museen, in Berlin.

Very little is known of the life of **PETRUS CHRISTUS.** He was born c. 1410/1420 in Baerle-Duc (Baarle-Hertog), in what is now Belgium. Nothing is known of his early years or training, but on July 6, 1444, it is recorded that he applied for citizenship at the burgher's lodge in Bruges. He also had to become a member of the local painters' guild in order to work as a painter in Bruges. He died in 1475 or 1476 in Bruges.

"A POLISHED PEARL, ALMOST OPALESCENT,
LYING ON A CUSHION OF BLACK VELVET."

Joel Upton

PETRUS CHRISTUS **PORTRAIT OF A YOUNG GIRL** c. 1470, oil on oak panel, 29 x 23 cm,
Gemäldegalerie, Staatliche Museen, Berlin

16

PAOLO UCCELLO
SAINT GEORGE AND THE DRAGON

The story of George and the Dragon appears in the medieval collection of religious stories known as *The Golden Legend,* which relates how Saint George rescued a fair maiden and liberated a town by defeating a dragon. This ancient struggle between good and evil was often represented in medieval art to symbolize the victory of the Church over infidels.

This painting depicts a celebrated episode in the legend of Saint George, in which a dragon terrorizes a pagan town. With one blow George, on horseback, triumphs over the beast, frees the princess, who was to be sacrificed, and converts the town to Christianity. While we can clearly identify George through his armor, his horse, and his lance, Uccello's painting is free from overt religious symbolism—for example, George's saintly halo is missing. Uccello departed from traditional forms of representation in order to tell the story in a more realistic and dynamic way: the princess and the dragon might be drawn rather statically, but Uccello depicts George in mid-action, his horse leaping forwards and his lance bearing down on the dragon's jaws from a great height. Uccello's manipulation of perspective emphasizes the sense of power as George attacks. The wild storm behind the saint, as well as the rebelliously rearing forehand of the horse with its neck arching into a wave, intensify the impression of diagonal movement from top to bottom. Behind George, the lance points up towards storm clouds that create a "halo" above the knight; and at the lance's other, lower end, the bloodied creature bellows in front of its angular, dark grotto, a symbol of the Underworld. The distant town is positioned exactly in the middle of the image, behind the lance, and between the dragon's head and the storm. Uccello's manipulation of foreground and background, of diagonals and vanishing points, creates the impression of a unity of space underscored by carefully calculated foreshortening. In this way, he makes the space appear three-dimensional, its linear perspective indicated on the ground in the geometrical patches of grass.

According to the legend, when the battle was over the princess put her girdle on the monster to lead it through the town. But Uccello foregrounds a non-chronological representation which gives the scene greater expressiveness. The resulting highly imaginative world inspired Cubists and Surrealists in equal measure, and it was they who were the first to rediscover Uccello's work in modern times.

Paolo di Dono, better known as **UCCELLO** ("Bird," after his apparent fondness for depicting birds), was born in 1397 in Florence. He trained alongside Donatello as a painter, sculptor, and architect under the Florentine master Lorenzo Ghiberti (1378–1455). In 1425 he began a series of major religious commissions that took him to several Italian cities. He was one of the pioneers of linear perspective, the development of which had a great influence on the early Italian Renaissance. He mastered this technique while working on his frescos for the dome of Florence cathedral and on a series of paintings, including a set of three paintings, *The Battle of San Romano* (London, Florence, Paris). According to legend, he became obsessed with complicated geometrical systems involving perspective, finally dying (it is claimed) of exhaustion through overwork. He died in 1475 in Florence.

"HE LEFT ... A WIFE, WHO WAS WONT TO SAY
THAT PAOLO WOULD STAY IN HIS STUDY ALL NIGHT,
SEEKING TO SOLVE THE PROBLEMS OF PERSPECTIVE,
AND THAT WHEN SHE CALLED HIM TO COME TO BED,
HE WOULD SAY: 'OH, WHAT A SWEET THING IS THIS PERSPECTIVE!'"

Giorgio Vasari

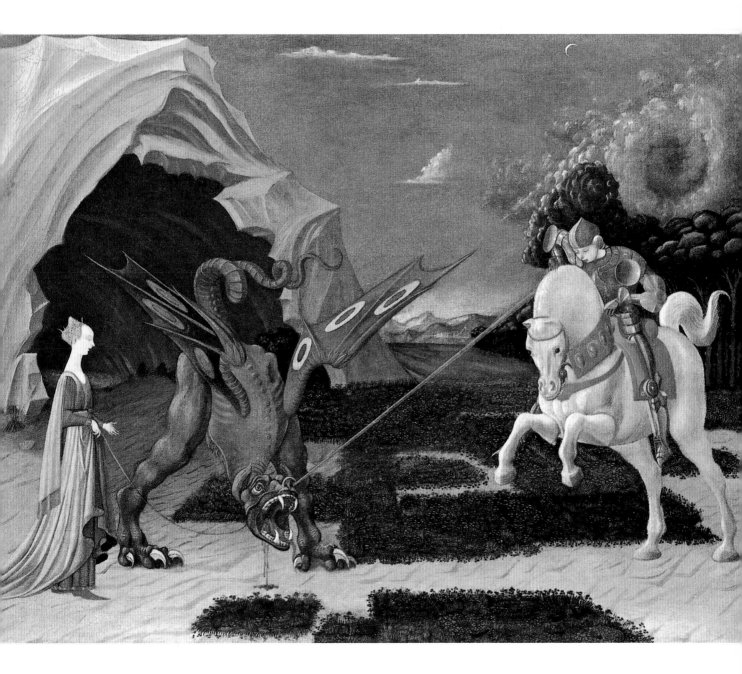

PAOLO UCCELLO **SAINT GEORGE AND THE DRAGON** c. 1470, oil on canvas, 55.6 x 74.2 cm,
The National Gallery, London

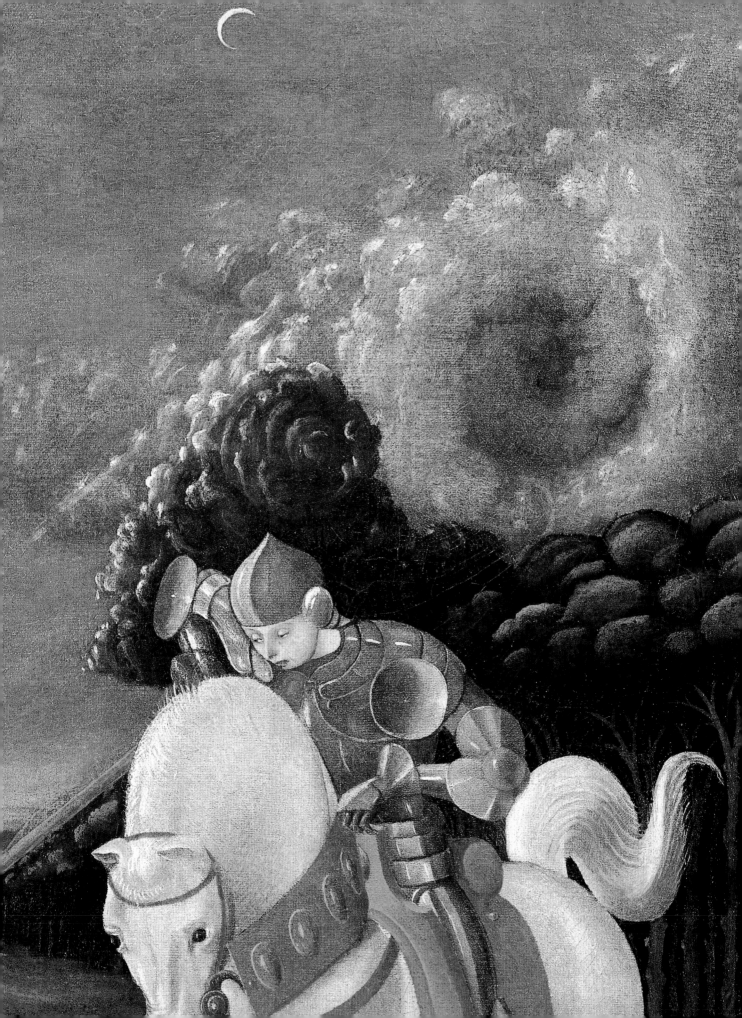

left The storm clouds in the top right-hand corner indicate that George's battle against the monster has divine support. The many curves and spirals in this part of the painting contrast with the jagged, angular shapes of the dragon and his cave.

below This is an earlier version of the same subject, painted by Uccello in 1430–1435 (Musée Jacquemart-André, Paris). The picture has three different vanishing points, as if the scene had been painted from various positions. Here the positioning of the protagonists, who are seen in profile, is not as complex as in Uccello's second version.

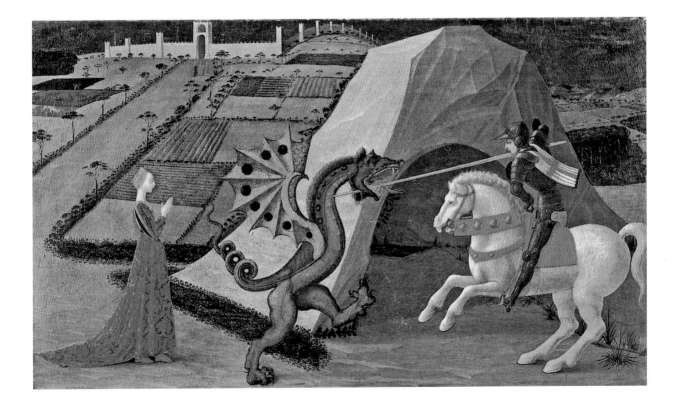

PAOLO UCCELLO **SAINT GEORGE AND THE DRAGON**

17

BOTTICELLI
BIRTH OF VENUS

Sandro Botticelli was a painter of the Florentine school, working under the patronage of the wealthy and influential Medici family. His painting the *Birth of Venus* is considered one of the finest—and most enigmatic—examples of the graceful, linear style of the Early Italian Renaissance.

The *Birth of Venus* is thought to have been inspired by a poem by Angelo Poliziano on the same subject, part of the enthusiasm at this time for classical themes. Unlike much of Early Renaissance painting, which depicted solid, naturalistic forms, the *Birth of Venus* is executed in a more linear, stylized, almost flat style. Botticelli may have employed this style in order to recall ancient Greek vase painting. *Venus* can be read on many different levels and was probably always intended to have mythological, political, and religious meanings. In the painting, Venus, born from sea foam, almost hovers over a conch shell as she is blown to the sacred island of Cyprus by Zephyrus (the west wind). On land, the nymph Pomona (who represents fruitful abundance) waits with a brocaded mantle. To depict a nude figure was something new and daring, for in the past nude figures appeared almost exclusively in paintings of Adam and Eve, and so were associated with sin. Botticelli used as his model for the figure an ancient Roman statue of Venus in the Medici collection. The laurel bushes on the island may be a reference to the Medici family. The Florentine Neoplatonic school of thought was also a strong influence. According to this philosophy, Venus could be seen in two ways, as an earthly goddess arousing physical love or as a heavenly goddess inspiring spiritual love. Therefore, contemplating Venus, the most beautiful of the ancient goddesses, would initially appeal to the physical side of love, but eventually lead the viewer towards spiritual, divine love, with Christ the ultimate embodiment of love. The Medici family may also have seen the painting as a reference to a lost masterpiece of ancient art recalled by Pliny the Elder. The ancient Greek painting of *Venus Rising from the Sea* by Apelles, dedicated by Emperor Augustus to his father, Julius Caesar, according to Pliny, was damaged and no one could be found to repair it. Eventually it decayed away. Botticelli's image may have been seen as the Medici equaling or even surpassing the ancients. Today, the *Birth of Venus* is considered one of the greatest works of the Italian Renaissance, with its message that contemplation of beauty could lead the viewer to a higher, more divine beauty and then to the love of God.

SANDRO BOTTICELLI was born Alessandro di Mariano di Vanni Filipepi in 1444 in Florence. In 1462 he was apprenticed to the painter Fra Filippo Lippi (c. 1406–1469), from whom he acquired a linear, detailed style of painting. By 1470 Botticelli had his own workshop. He never married and some scholars believe he loved, unrequitedly, Simonetta Vespucci, a married noblewoman and favorite of the Medici. Before he died in 1510 in Florence, he asked to be buried at Simonetta's feet, and his wishes were carried out.

"IF BOTTICELLI WERE ALIVE TODAY,
HE'D BE WORKING FOR VOGUE."

Peter Ustinov

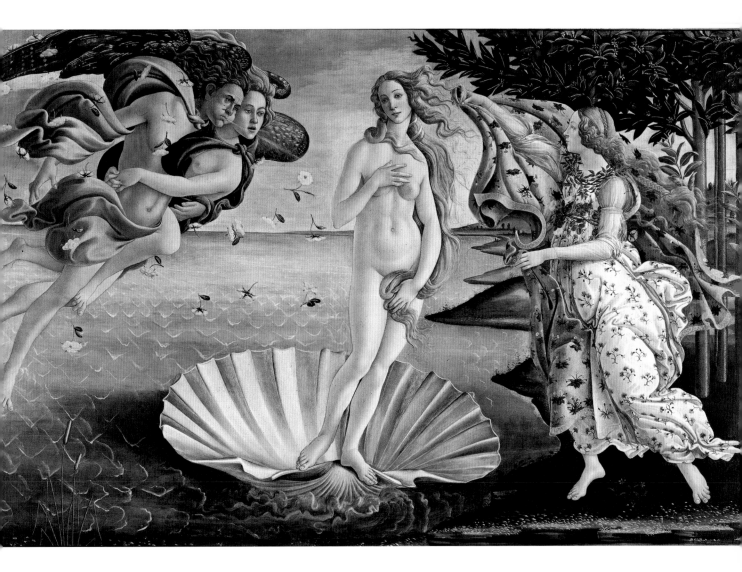

BOTTICELLI **BIRTH OF VENUS** 1468, tempera on canvas, 172.5 x 278 cm,
Uffizi, Florence

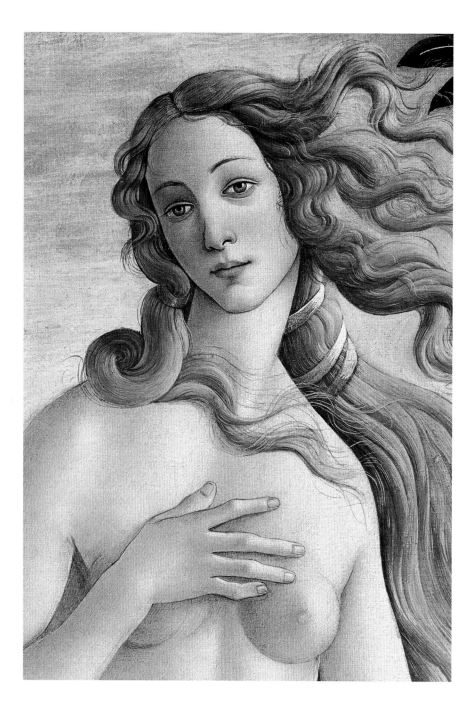

left Many believe that Simonetta Vespucci was the model for the face of Venus. The linear quality of the painting recalls the style of ancient Greek vase painting and Etruscan tombs.

right The richly decorated gown of the nymph Pomona, who holds out a cloak to cover Venus, contrasts with the rather barren background.

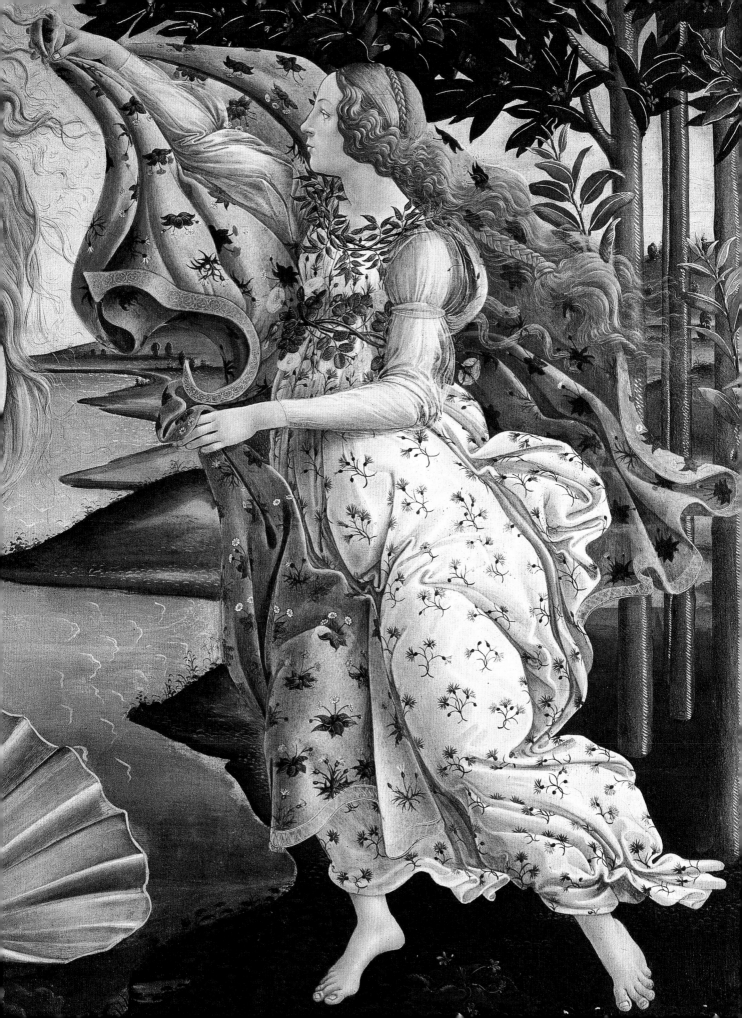

18

ANDREA MANTEGNA
LAMENTATION OVER THE DEAD CHRIST

During the Renaissance there was a flourishing of learning in the sciences, scholarship, and the arts, particularly in Italy. One of the first to use perspective in painting to create the illusion of objects receding into space was Andrea Mantegna, who was also influenced by the growing interest in classical forms. His *Lamentation over the Dead Christ* strikingly exemplifies both his dramatic use of perspective and the influence of classical antiquity.

Andrea Mantegna was apprenticed to Francesco Squarcione in Padua. From him Mantegna acquired a love of classical archaeology and the use of perspective. A late work by Mantegna, completed around 1480, the *Lamentation* reflects his masterful use of strong foreshortening and his love of ancient Greek and Roman forms. The painting shows a close view of the dead figure of Christ, laid out on a marble slab, with the Virgin Mary and Saint John at the left side, weeping over him. The body is a cadaver, almost clinical in its representation of death, yet reminiscent of classical statuary in its carefully defined musculature. The strongly foreshortened figure fills up almost the entire space and brings us so close to the body that it seems we could reach out and touch the feet. There is no sentimentality or idealizing in this painting; it is an unflinching depiction of the reality of the death of Christ, and the wounds on Christ's hands and feet are realistically shown as torn skin. The sharp lines and tight folds of the drapery add to the dramatic effect. It was said that Mantegna studied paper drapery gummed in place on models to perfect his depiction of folds in cloth. Although his use of perspective creates a sense of monumentality, it is not in fact perfect, for the feet are too small and the head is too big. But larger feet would block the view of the rest of the body and a large head creates a focal point, so these "errors" may well have been intentional. The realism of the image brings out the tragedy of the event, and with such a truly dead body the Resurrection would seem even more miraculous. Mantegna probably painted the *Lamentation over the Dead Christ* for his own funerary chapel. It was found by his sons in the artist's workshop after his death and sold off to pay debts. A poignant study of physical and emotional pain, the *Lamentation* is also a brilliant example of the growing use of perspective in Italian Renaissance painting.

ANDREA MANTEGNA was born in 1431 near Padua. At the age of 10 or 11 he was taken into apprenticeship by the painter Francesco Squarcione (c. 1395–after 1468) in Padua. Mantegna ended his apprenticeship when he was 17, setting out on his own but also involved in a court case against Squarcione, apparently citing exploitation. In 1453 he married Nicolosia Bellini, whose brothers were artists. The couple remained in Padua until 1459, when Duke Ludovico Gonzaga persuaded the artist to move to Mantua. Mantegna worked for the Gonzaga family for the rest of his life. He created the first perspective ceiling for the Gonzaga, with figures looking down from a painted balustrade. He died in 1506 in Mantua.

"THIS MASTER SHOWED PAINTERS A MUCH BETTER METHOD OF
FORESHORTENING FIGURES FROM BELOW UPWARDS,
WHICH WAS TRULY A DIFFICULT AND INGENIOUS INVENTION."

Giorgio Vasari

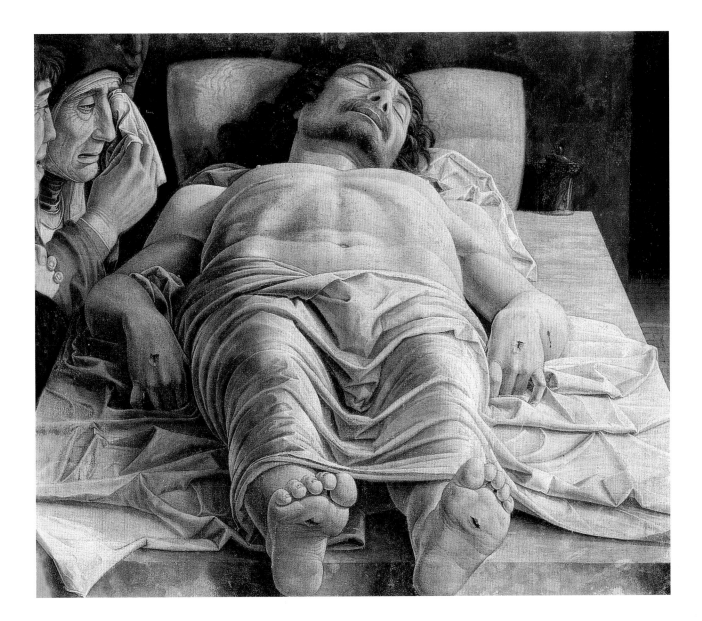

ANDREA MANTEGNA **LAMENTATION OVER
THE DEAD CHRIST** c. 1480, tempera on canvas, 68 x 81 cm,
Pinacoteca di Brera, Milan

19

HIERONYMUS BOSCH
THE GARDEN OF EARTHLY DELIGHTS

What would the human race look like if Adam and Eve had not eaten of the forbidden fruit? What kind of world would we be living in? How would we interact with each other and with nature? In his richly detailed, sensuous and fantastical *Garden of Earthly Delights*, Hieronymus created a utopian image of humanity that delights, fascinates, and disturbs.

In the Garden of Eden (left-hand panel), God brings Adam and Eve together. In this poetic landscape, animals thrive and plants grow rampantly. We are looking at the beginning of all things, at the infinite possibilities of the Creation, with no idea of how human history will play out—only the lust to kill of a few fantastical animals casts a shadow over the scene. By contrast, in Hell (right-hand panel), Man lives in a sinister civilization of his own making, far removed from nature. The world is laid waste and naked souls are tormented in a dark and cold world while the Prince of Hell watches over the apocalyptic chaos.

We want to live in another world: in a world that exists nowhere, that has never become reality, a magnificently blooming garden, the "Garden of Earthly Delights," always green and fertile, inhabited by happy people (central panel). Here they move like animals in the water or on the grass, crawling out of pods and mussel shells, fed by giant birds. In this imaginary world, all living things are unlike any we know on earth. Birds live in the water, fish inhabit the air and the land. The symbiosis between human beings and the natural world reaches its peak, a vision of a harmonious existence of humans in nature that is not possible in reality. People are young, carefree, and sensual, freed from all earthly torments, from birth and death—time stands still. The figures are slight and puppet-like, their bodies lacking specific features. Their nakedness is so shameless and casual that the effect is childlike rather than erotic. We are looking at a kind of human being that is unknown to us. As art historian Hans Belting writes: "This is not an image of redemption and death overcome, but a utopian vision of a world that never existed."

HIERONYMUS BOSCH was born Jheronimus van Aken c. 1450 in 's-Hertogenbosch, the Netherlands. Bosch was the son of the painter Anthonius van Aken (died c. 1478), so probably learned his trade from him, and was said to have been one of the most prosperous citizens of his hometown. He was a member of a religious brotherhood, for which he carried out several commissions. None of his works is dated or reliably documented. His mature work shows the development of a highly original imagery that had a major influence on Pieter Bruegel the Elder, and in the 20th century the Surrealists cited him as an important precursor. He died in 1516 in 's-Hertogenbosch.

"WHO WILL BE ABLE TO TELL OF ALL THE WEIRD AND STRANGE IDEAS
WHICH WERE IN THE MIND OF JERONIMUS BOS, AND HIS EXPRESSIONS
OF THEM BY HIS BRUSH? HE PAINTED GRUESOME PICTURES."

Karel van Mander, 17th century

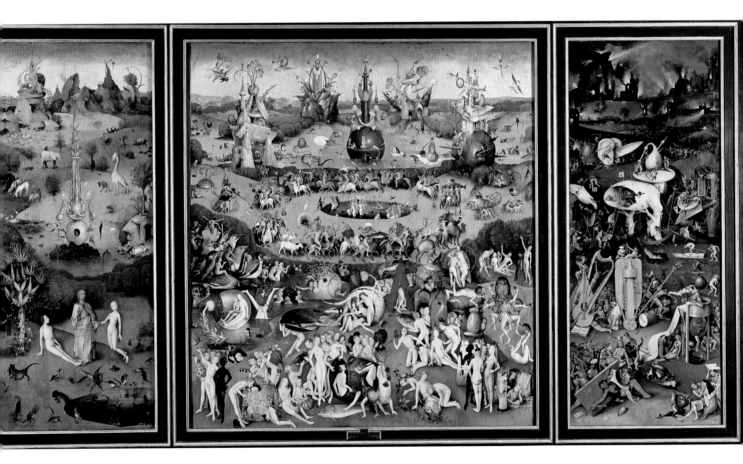

HIERONYMUS BOSCH · **THE GARDEN OF EARTHLY DELIGHTS** · 1500–1505, triptych, oil on wood, 220 x 389 cm,
Museo Nacional del Prado, Madrid

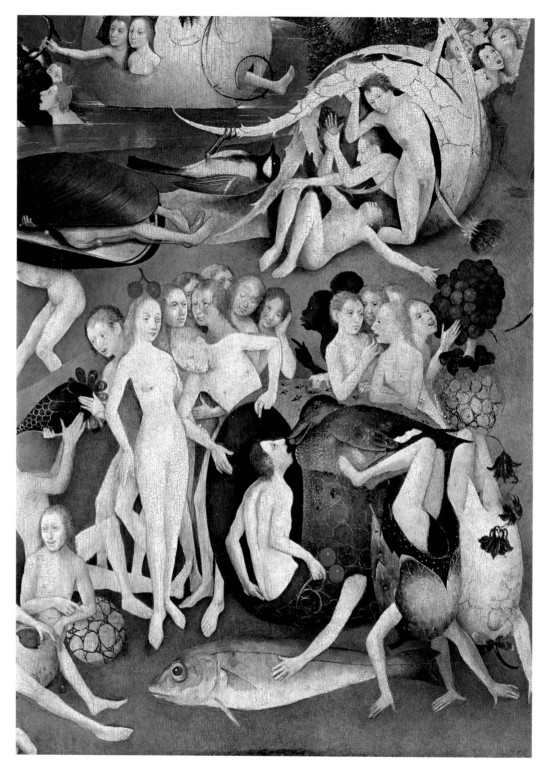

above The Garden of Earthly Delights
is spared the torments of both birth
and death: people crawl fully grown
out of hybrid plants, in the prime of life,
and remain forever young.

right The Prince of Hell eats people,
and excretes them at the same time,
while watching over the devastation
of his realm.

HIERONYMUS BOSCH **THE GARDEN OF EARTHLY DELIGHTS**

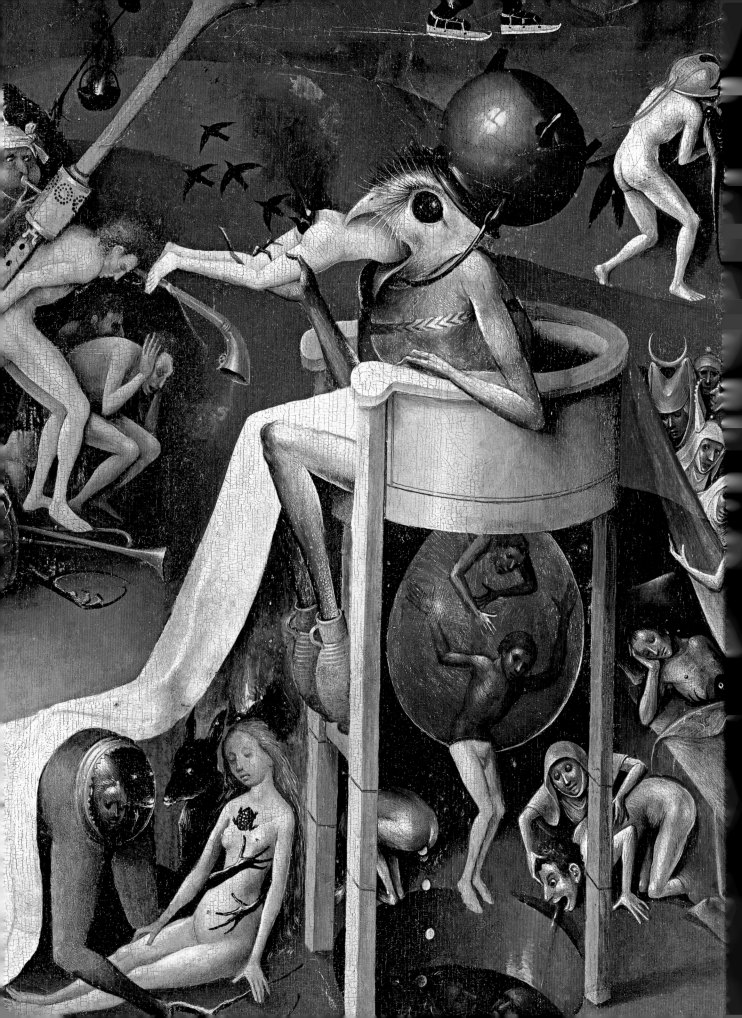

20

ALBRECHT DÜRER
SELF-PORTRAIT

One of the greatest artists of the Northern Renaissance, Albrecht Dürer was a painter, printmaker, engraver, art theorist, and mathematician. At an early age he established his reputation throughout Europe as a master printmaker. His portraits reveal strong personalities, and his religious works display a remarkable synthesis of Italian and North European traditions. Among his striking self-portraits, the one he painted in 1500 is the most famous.

Dürer is credited with bringing the Italian style to Northern art. He considered the traditional art forms of the north old-fashioned and clumsy and was the first northern artist to travel to Italy specifically to study its art. The Italian influence may be seen particularly in the second of his self-portraits (1498), where he appears in a three-quarter pose and set against an open window, a proud young man in splendid clothes. The portrait of 1500, painted only two years later, is very different. Here Dürer gazes directly at the viewer, in a frontal pose and emerging out of a black background. In 1500 a frontal pose was very unusual for a secular portrait, being associated with images from medieval religious art, particularly with images of Christ. Dürer deliberately chose this pose, with his hand at his chest, reminiscent of Christ giving a blessing. Compare this self-portrait to the 6th-century icon of Christ (see page 9), and the parallels are striking. His bearded face with long hair, staring straight out at the viewer, the hand gesture, the black background, all recall images of Christ. Dürer looks to be outside of time or place, with inscriptions seemingly floating in space, giving the viewer the feeling that the image has symbolic meaning. Several interpretations have been suggested. It may simply be the arrogance of a young, very successful artist, or a statement of the artist's role as a creator. The Latin inscription to the right of the figure tends to lend some support to this second interpretation. It reads: "I, Albrecht Dürer of Nuremberg, portrayed myself in everlasting colors aged twenty-eight years." It could be that he was following the tradition of paintings based on the *Imitation of Christ* (a celebrated devotional book), or that he was acknowledging that his talent was God-given. We will never know for sure, but whatever his motives, Dürer created a complex and compelling image that has not ceased to fascinate.

ALBRECHT DÜRER was born in 1471 in Nuremberg. He had several years of school before being taught the basics of goldsmithing and drawing by his father. His talent for drawing was so apparent that he was apprenticed to one of the leading artists of Nuremberg, Michael Wolgemut (1434–1519). After completing his apprenticeship, Dürer left Nuremberg for four years, returning aged 23, in 1494. He then married Agnes Frey, and three months later promptly left again for Italy. Back in Nuremberg in 1495, he set up his own workshop. His woodcuts and engravings were successful from the start and his reputation soon spread throughout Europe. He made several more journeys, including trips to the Netherlands and again to Italy. He died in 1528 in Nuremberg, leaving a large estate.

"I, ALBRECHT DÜRER OF NUREMBERG, PORTRAYED MYSELF
IN EVERLASTING COLORS AGED TWENTY-EIGHT YEARS."

Latin inscription on the painting

ALBRECHT DÜRER **SELF-PORTRAIT** 1500, oil on wood panel, 66.3 x 49 cm,
Alte Pinakothek, Munich.

left A gesturing hand, raised as if giving a blessing, is clearly reminiscent of images of Christ.

right Albrecht Dürer, *Self-Portrait at Twenty-Six*, 1498, oil on wood panel, 52.5 x 41 cm, Museo Nacional del Prado, Madrid
In this earlier self-portrait, Dürer portrayed himself in the traditional three-quarter pose as an elegant gentleman of fashion. The details of his clothing and gloves are emphasized, contributing to the feeling of an aristocratic, Italianate image.

ALBRECHT DÜRER **SELF-PORTRAIT**

21

GIOVANNI BELLINI
PORTRAIT OF DOGE LEONARDO LOREDAN

Giovanni Bellini created a style of Renaissance painting that was thoroughly Venetian, combining rich colors, exquisitely fine detail, and elegant composition. His portrait of Doge Leonardo Loredan possesses all of these qualities. The Doge's skin and clothes are strikingly lifelike. Loredan also has an air of calm assurance, making him resemble a heroic figure of Roman antiquity. Bellini's work would serve as a model of court portraiture for centuries.

Of all the Italian city-states, Venice was the wealthiest and most independent. Yet for much of the Middle Ages, Venetian artistic tastes were distinctly conservative. Most Venetians preferred the formal, aristocratic style of Byzantine art. Ironically, however, just as Venetian political power began to wane in the 1400s, Venetian artists developed their own distinctive Renaissance style. One painter in particular, Giovanni Bellini, became the chief exponent of this style.

Unlike many Renaissance artists, Bellini had the luxury of growing up in a household of wealthy and successful painters. His father Jacopo, who set up the family workshop in 1424, created some of the earliest Venetian cityscapes—images famous for their dramatic use of linear perspective. Giovanni would incorporate and build on his father's innovations. He would also study the great works of art from throughout Europe that made their way to Venice. By the late 1400s, Bellini had developed a style that mixed the soft, three-dimensional modeling of northern Italian painting, the intricate detail of Jan van Eyck and Netherlandish art, and a glowing color palette that seemed to reflect Venice itself.

Bellini's portrait of Doge Leonardo Loredan nicely exemplifies his mature style. Records indicate that Loredan was a somewhat difficult, prickly individual; the Venetian historian Marino Sanuto the Younger referred to him as "rather choleric." Giovanni's portrait, however, does not attempt to express these real-life character traits. Instead, it symbolizes the power of the Doge as an institution. Bellini presents Loredan's bust in a "classical" format, his head shown in three-quarter profile: earlier portraits had always depicted their subjects in profile. Giovanni also lavishes attention on the doge's intricately brocaded silk mantle and cap, as well as his subtly weathered skin. The "choleric" doge has been transformed into a symbol of magnanimous, confident leadership.

Bellini's pioneering image would become a model for portraitists well beyond the Renaissance. Rulers from Louis XIV in France to Victoria in Great Britain would rely on their own artists to produce works that linked the royal visage with the power of the state.

GIOVANNI BELLINI was born in 1430 in Venice, and he was raised in a family of artists. His father Jacopo (c. 1400–c. 1470) helped bring Renaissance painting to Venice, and his brother Gentile (c. 1429–1507) became a prominent international portraitist. Giovanni's own prosperous career began around 1450. His earliest images often featured religious scenes, depicting figures with expressive yet somewhat rigid modeling. By the late 1400s, however, his style had become softer and more subtle, with a rich, vibrant color palette. Giovanni received major commissions from the Venetian government, including the lucrative position of conservator of paintings at the Doge's Palace. He also became famous as teacher, apprenticing two of the greatest high Renaissance Venetian masters, Titian and Giorgione. He died in 1516 in Venice.

"THOUGH HE IS VERY OLD, HE IS STILL
THE BEST PAINTER HERE."

Albrecht Dürer on Bellini's status
among Venetian painters, 1506

GIOVANNI BELLINI **PORTRAIT OF DOGE
LEONARDO LOREDAN** 1501, oil on panel, 61.6 x 45.1 cm,
The National Gallery, London

22

LEONARDO DA VINCI
MONA LISA (LA GIOCONDA)

Leonardo da Vinci is considered one of the greatest geniuses that ever lived, and his *Mona Lisa*, or *La Gioconda*, is possibly the most famous portrait ever painted. Leonardo was a true "Renaissance man," a painter, sculptor, architect, musician, scientist, mathematician, engineer, anatomist, geologist, botanist, mapmaker, and writer.

The portrait is thought to be that of Lisa Gherardini, wife of banker Francesco del Giocondo, Gioconda being the feminine form of the name. The title *Mona Lisa* comes from Giorgio Vasari, who wrote a life of Leonardo first published in 1550. In it he recounts that "Leonardo undertook to paint, for Francesco del Giocondo, the portrait of Mona Lisa, his wife…" In Italian, the term *ma donna*, which was eventually shortened to *mona*, was a polite form of address, such as ma'am or madam in English. Leonardo began the portrait in 1503 or 1504 in Florence, but Vasari wrote that it was never finished. Mona Lisa sits with her face to the front, her shoulders at a three-quarter angle to the viewer, and her hands folded in a reserved gesture. It came to be considered the prototype Renaissance portrait. What sets Leonardo apart is that he did not use outlines to form the figure, but instead was a master of sfumato, the soft blurring of edges, and chiaroscuro, the use of light and dark tones to create shapes and volumes. *Mona Lisa* was one of the first portraits to show the sitter in front of an imaginary landscape and to depict it as if viewed from a distance. Mona Lisa sits in what appears to be an open loggia with a vast landscape of valleys and rivers receding behind her. The figure forms a strong pyramid shape and the light on her face, in contrast to the darker tones of the background, helps to draw the viewer's attention to her. The myth of the "Mona Lisa smile" began in the 19th century, with the Romanticism of the time exaggerating the mysterious qualities of the painting over the artistic. Leonardo's skill in creating the ambiguous expression, the subtle modeling of the forms, and the illusion of atmosphere are qualities that make the figure seem more alive.

The portrait of Mona Lisa was never delivered and Leonardo kept it with him until he died, in France in 1519. It eventually became part of the collection of the Musée du Louvre and was made even more famous after it was stolen in 1911. It took two years to discover that the thief was a Louvre employee, an Italian patriot who believed the portrait should be returned to an Italian museum. He kept the painting under his bed before offering to sell it to the Uffizi Gallery in Florence, when he was finally apprehended. The portrait was shown all over Italy and returned to the Louvre in 1913. Today, the image of Mona Lisa has been mass produced, merchandised, lampooned, and wondered over, and is one of the most widely reproduced images ever created.

LEONARDO DA VINCI was born in 1452 in Vinci, near Florence, the illegitimate child of lawyer and a maid. He received some education in writing and mathematics, and in 1466, at the age of 14, was apprenticed to the artist Andrea del Verrocchio (c. 1435–1488), who at that time maintained one of the most famous painting and sculpture workshops in Florence. By 1472, Leonardo was a qualified master and his father set him up with his own workshop. Over the years he was often hired as a civil or military engineer (notably for Cesare Borgia) as much as an artist, working in Milan, Venice, Florence, and Rome. He painted his celebrated *Last Supper* c. 1495 in the refectory of the convent of Santa Maria delle Grazie in Milan. In 1516 he entered the service of François I, King of France, who gave him the use of a manor house, where Leonardo spent the last three years of his life. He died in 1519 in Amboise, France, at the age of 67.

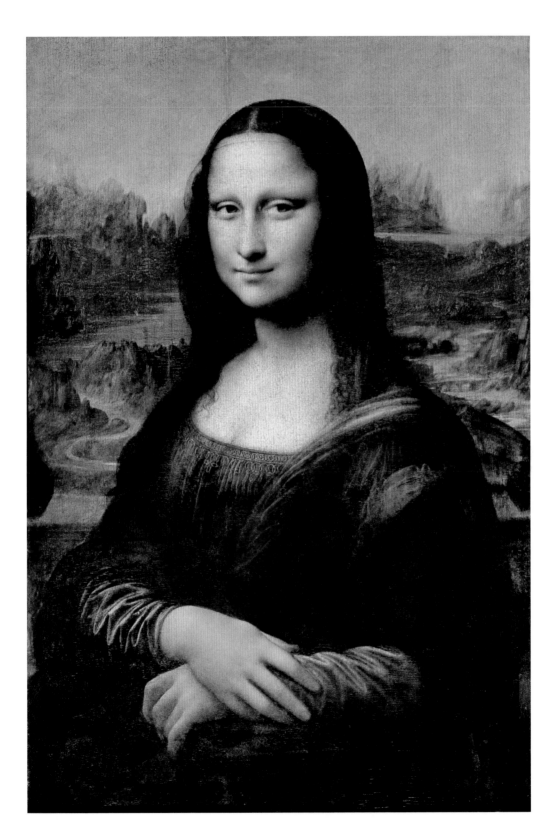

LEONARDO DA VINCI **MONA LISA (LA GIOCONDA)** c. 1503–1506, oil on panel, 77 x 53 cm,
Musée du Louvre, Paris

23

GIORGIONE
THE TEMPEST

Even today, *The Tempest* is still considered one of the great unsolved mysteries in the history of art: a comparatively small, early 16th-century painting, not very remarkable at first sight, created by the Venetian painter Giorgione, it has produced diverse interpretations.

At the time when this work was painted, it was not uncommon to paint a subject encrypted in such a way that its meaning was accessible only to those with education and refined artistic taste. The story Giorgione is telling in *The Tempest* may have been familiar to contemporary viewers, but in the absence of any traditional account of the painting's content, subsequent generations were faced with a mystery. A man in Venetian costume, a half-naked woman nursing a child, broken columns, a river, a city, and above it all a storm breaking—these are the central elements in the scene. Over the course of time, many interpretations have been put forward, none of which has been universally accepted. Broadly speaking, opinion falls into two camps: those who refuse to see a deeper theme in the painting and argue that it should be regarded largely as an early form of lyrical landscape painting; and those who posit a religious, mythological, or allegorical message as the basis of the work. Subjects proposed by the second camp include classical mythology (Paris and Oenone, Hermes and Io, Deucalion and Pyrrha, and the birth of Apollonius of Tyana) and Christian themes (the Fall of Adam and Eve, the Rest on the Flight to Egypt, and the Legend of Saint Theodore); others suggest the subject is Giorgione's own family, the Family of Man, the Marriage of Heaven and Earth, or a symbolic representation of strength, temperance, and happiness. To make things even more difficult, X-ray analysis has revealed that there was a second naked female figure where the man now stands. As art historian Hanno Rauterberg commented on the 500th anniversary of Giorgione's death in 2010, it is "almost as if Giorgione hadn't actually painted a picture at all, but as if he had presented us with a blank canvas on which anyone can project their ideas to their heart's content." It remains to be seen whether Giorgione's mystery is ever solved.

GIORGIONE was born Giorgio Barbarelli da Castelfranco in 1478 in Castelfranco, near Venice; his nickname Giorgione means "Big George." He probably served an apprenticeship with Giovanni Bellini, alongside Titian. Little is know of his life and only six works have been safely attributed to him, including the *Castelfranco Madonna* (c. 1504, Cathedral of Castelfranco) and the *Three Philosophers* (c. 1505–1509, Kunsthistorisches Museum, Vienna). He is also known to have painted exterior frescoes (now almost entirely lost) for the Fondaco dei Tedeschi (German Merchants' Hall) in Venice. Though he had a short life and produced few works, his influence was immense, both in terms of style (instead of working with clear contour lines, he exploited color intensity and painterly effects) and through a focus on poetic mood rather than subject or story, thus creating an *arte moderna* never seen before. He died in 1510 in Venice.

"I FOR MY PART HAVE **NEVER UNDERSTOOD IT,**
NOR HAVE I EVER FOUND **ANYBODY WHO DID.**"

Giorgio Vasari

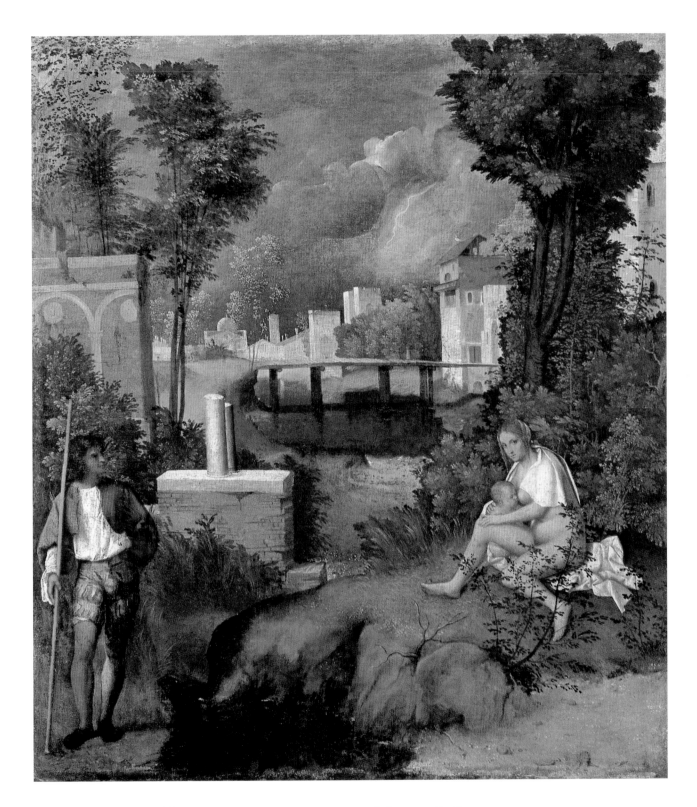

GIORGIONE **THE TEMPEST**

c. 1508, oil on canvas, 82 x 73 cm,
Gallerie dell'Accademia, Venice

GIORGIONE **THE TEMPEST**

left Who is the young man in contemporary military costume? X-ray analysis has revealed the figure of a second woman hidden beneath that of the man, further deepening the picture's mystery.

below The approaching storm, a single white bird on the roof, the faded painting (a coat of arms?) on the wall of a small castle are just a few of the elements whose precise significance has yet to be discovered.

GIORGIONE **THE TEMPEST**

"A FIGURE OF SUCH A KIND IN ITS BEAUTY,
IN THE ATTITUDE AND IN THE OUTLINES,
THAT IT APPEARS AS IF NEWLY FASHIONED
BY THE FIRST AND SUPREME CREATOR RATHER THAN
BY THE BRUSH AND DESIGN OF MORTAL MAN."

Giorgio Vasari on Michelangelo's Adam

MICHELANGELO **THE CREATION OF ADAM** 1510, fresco, 280 x 570 cm,
Sistine Chapel, Vatican, Rome

24

MICHELANGELO
THE CREATION OF ADAM

Michelangelo's decoration of the Sistine Chapel in Rome is one of the greatest and most widely known creations of the Renaissance. His masterful composition *The Creation of Adam* has lost nothing of its fascination, even 500 years after it was painted.

"I am not a painter." These were Michelangelo's words in 1506 on receiving the commission from Pope Julius II to provide images of the twelve Apostles for the ceiling of the Sistine Chapel, the ceremonial chapel of the papal curia. Primarily a sculptor, he accepted the commission reluctantly—he was inexperienced in the technique of fresco painting, and suspected a plot devised by the architect Donato Bramante to expose him to ridicule. Ever the unconventional artist, Michelangelo produced the complete design for the requested images as he worked on it. Between 1508 and 1512 there emerged a complex *trompe l'oeil* architecture, peopled with over 300 figures from the Old Testament: in the rectangular panels of the vaulting we can see scenes from the Book of Genesis, including the Creation, while the spandrels show episodes from Jewish history, and both the pendentives and the lunettes above the windows illustrate Christ's ancestors. Between the pendentives Michelangelo painted enthroned Old Testament Prophets (male) and classical Sibyls (female). They flank the smaller images in the vaulting, which in addition are each surrounded by four seated, naked young men, the *ignudi*, whose sometimes exuberantly twisted bodies paved the way for Mannerism.

In 1510 Michelangelo had to interrupt his work in the Sistine Chapel: he needed to move the scaffolding he had used to reach the ceiling, and this gave him the opportunity to look up from below at the overall effect of the compositions he had completed thus far. As a result, in the second phase of his work he reduced the number of figures and made the images more monumental. *The Creation of Adam* is the first scene to profit from this approach. Lying in a barren, rocky landscape is Adam's muscular but feeble body. He raises his left arm towards the outstretched right arm of God, who floats towards him, surrounded by a host of angels. What we see here is not the physical creation of the first human being, but rather the metaphysical moment when the spark of life is transferred to Adam: while in medieval images rays of light were still depicted radiating from God's eyes to the Son of Man, here Michelangelo created a new kind of dynamic composition whose focus is the highly expressive language of hands reaching out towards one other.

MICHELANGELO BUONARROTI
was born in 1457 in Caprese, near Florence. He trained in Florence under Domenico Ghirlandaio (1449–1494) and Bertoldo di Giovanni (c. 1435/1440–1491) at the court of Lorenzo de' Medici. After spending time in Venice and Bologna he moved to Rome in 1496. There he produced his two significant early works, the *Pietà*, today in Saint Peter's, and his famous *David*. After completing the Sistine ceiling in 1512, Michelangelo turned in the following years to various major projects, including the (unfinished) tombs for Julius II (r. 1503–1513) and the Medici family. In 1534 he moved definitively to Rome, where he took over the architectural direction of Saint Peter's and designed the cupola of the building we see today. He died in 1564 in Rome.

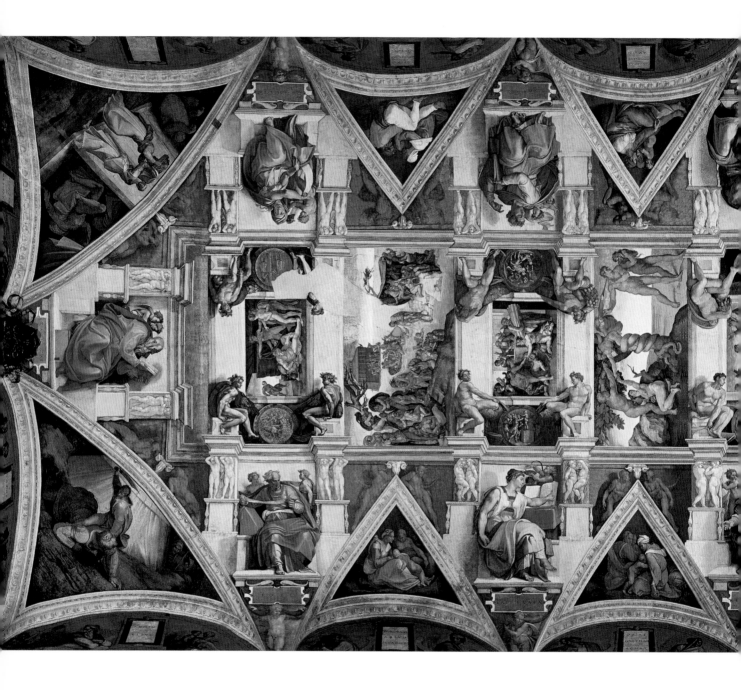

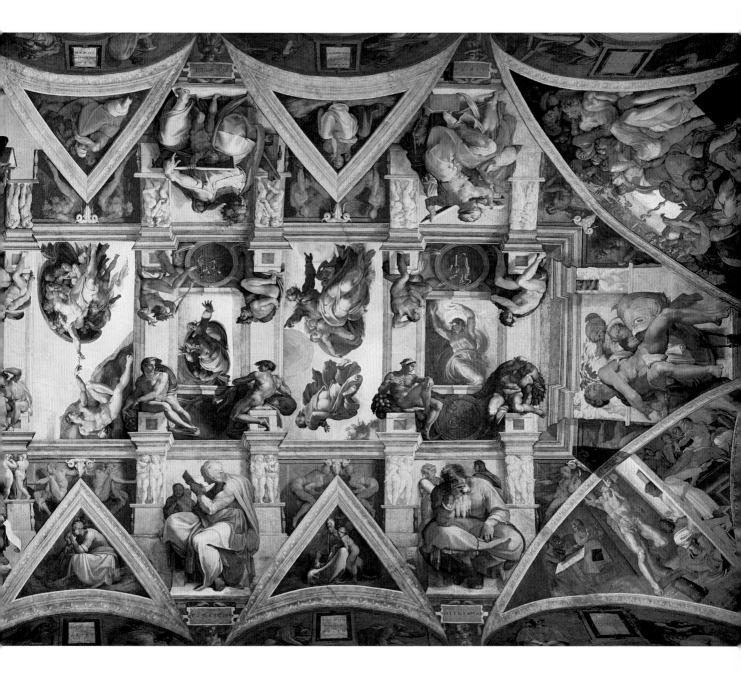

Michelangelo Buonarroti, ceiling
fresco in the Sistine Chapel,
1508–1512, 41 x 13.5 m, Vatican,
Rome

MICHELANGELO **THE CREATION OF ADAM**

"SAINT GEORGE WAS UPON HIS HORSE, AND DREW OUT HIS SWORD
AND GARNISHED HIM WITH THE SIGN OF THE CROSS,
AND RODE HARDILY AGAINST THE DRAGON WHICH CAME TOWARDS HIM,
AND SMOTE HIM WITH HIS SPEAR AND HURT HIM SORE
AND THREW HIM TO THE GROUND."

Jacobus de Varagine, *The Golden Legend*, 13th century

ALBRECHT ALTDORFER **SAINT GEORGE AND THE DRAGON** 1510, oil on parchment mounted on linden wood, 28.2 x 22.5 cm,
Alte Pinakothek, Bayerische Staatsgemäldesammlungen, Munich

25

ALBRECHT ALTDORFER
SAINT GEORGE AND THE DRAGON

Before the 16th century, painted landscapes were treated as historical or symbolic backdrops, and as such were subordinate to the religious or mythological scene that was the subject of a painting. In this small work by Albrecht Altdorfer, by contrast, a massive, impenetrable forest is the dominant feature, while the legend of the dragon slayer is restricted to one small, unobtrusive scene. More than in any of his other landscape paintings, in this example Altdorfer elevates nature to the central poetic theme of his work.

According to legend, in a lake near the town of Silena there lived a dragon whose noxious fumes plagued the entire landscape and posed a continual threat to the people living in the region. In order to appease the dragon, the people offered him a daily sacrifice of two sheep and, when they had no more sheep, they sacrificed their children. After the town had lost almost all its young men and women, it was the turn of the only daughter of the king, who was forced to send her to the monster. On her way to be sacrificed, the princess met George, who rode to her aid against the dragon, wounding the creature in battle. When he led the subdued animal into the town, George announced that God had sent him, and he would kill the dragon, if the townspeople would be baptized. Following the king's example, thousands of inhabitants converted to Christianity on that very day.

Emerging during the time of the Crusades, the legend of the dragon slayer was fed by heroic representations of the hero and his triumph. George was the essence of Christian bravery, and appeared as the patron and protector of many orders of knights and crusaders during the late medieval period. His triumph over the dragon is a metaphor for the triumph of Christianity over the forces of evil and of the Church over infidels. But Altdorfer accepts this idea of the hero only to a limited extent: remarkably, he omits the dramatic moment of the decisive blow against the dragon. He sends the knightly but courteous Saint George, clad in shining armor, towards the dragon with his lance lowered. His horse remains alert and wary, while George is calm and untroubled. The princess, who usually heightens the dramatic potential of the scene even more, is totally absent. The forest, rampantly impenetrable and thick as a wall, seems to present George with his greatest challenge. Only a small clearing in the distance allows a clear view of a mountain landscape. The worlds of monsters and of knightly purity are brought together in a poetic representation marked by an uncharacteristic mood of stillness and tranquility.

ALBRECHT ALTDORFER was born c. 1480 in Regensburg (or Altdorf). He worked in Regensburg as an engraver, architect, and town councilor, and as a painter of landscapes became one of the most important exponents of the so-called Danube School of landscape painting. From 1512 onwards he enjoyed the high regard of Emperor Maximilian I (r. 1486–1519), who gave him the majority of the commissions, after Dürer. He is also known to have worked for Duke William IV of Bavaria (r. 1508–1550), for whom he painted one of his major works, *The Battle of Alexander at Issus* (1529, Alte Pinakothek, Munich). He died in 1538 in Regensburg.

26

RAPHAEL
THE SISTINE MADONNA

Raphael is widely considered the artist who most fully realized the ideals of the High Renaissance. His reputation was based both on his grand decorative schemes (such as his frescoes for the Vatican *Stanze*) and on his smaller, more intimate paintings, notably his Madonnas.

The Sistine Madonna, one of Raphael's most famous altarpieces, was probably commissioned by Pope Julius II (Giuliano della Rovere, r. 1503–1513). Until well into the 18th century, this work was to be found on the high altar of the church of the monastery of San Sisto in Piacenza, which was built around 1513.

This Madonna shows a green velvet curtain drawn back to reveal a supernatural event. In the center, against a background of clouds formed of angels' heads, we see the Virgin Mary, holding the Infant Jesus in both hands. A gust of wind causes her golden veil to billow out and agitates the hem of her blue mantle, revealing a red garment beneath. Her expression is one of deep sadness, presaging the later sufferings of the Redeemer. The Christ Child too has a serious expression, his eyes gazing towards a tragic future. The figure of the Virgin is inscribed within a triangle whose base is formed by the two saints who kneel by her side: kneeling on banks of cloud we see Saint Barbara on the right, and on the left, bare-headed, the canonized Pope Sixtus II (r. 257–258), who wears a gold cloak with red lining and a white undergarment. He has placed his papal tiara on a balustrade at the bottom edge of the painting, from which two cherubs are looking up wistfully at the holy vision above them. Pope Sixtus II, whose relics were preserved alongside those of Saint Barbara in the monastery of San Sisto, was also the patron saint of the Della Rovere family. In this painting Raphael gave him the facial features of Julius II and depicted the heraldic device of the dynasty—oak-leaf and acorn—on his cape.

Before it was turned into an altarpiece for the high altar, *The Sistine Madonna* probably adorned the temporary tomb of Julius II, who died in 1513, a tomb located in the choir chapel of his uncle, Pope Sixtus IV, in Saint Peter's in Rome. Friedrich August II, Elector of Saxony, had seen the altarpiece in Piacenza before his conversion to the Catholic faith and in 1754, after some difficult negotiations, it became the showpiece of the Elector's collections in Dresden.

RAPHAEL was born Raffaello Sanzio in 1483 in Urbino. Around 1500 he began training as an assistant to Pietro Perugino (c. 1446/1450–1523). He moved to Florence in 1504, where he painted several works, including the *Madonna of the Meadow* (Kunsthistorisches Museum, Vienna). From 1508 to 1520 he lived in Rome at the papal court, working on the famous frescos in the Stanza della Segnatura (including the *School of Athens*) and the Stanza d'Eliodoro. In 1514 he succeeded Donato Bramante (1444–1514) as the architect in charge of Saint Peter's, and in 1519 became Prefect of Roman Antiquities. He painted the frescos in the Villa Farnesina c. 1518, working at the same time on the design of the frescoes for the Vatican loggias. He died in 1520 in Rome and was buried in the Pantheon.

RAPHAEL **THE SISTINE MADONNA** c. 1512–1513, oil on canvas, 265 x 196 cm,
Gemäldegalerie Alte Meister, Staatliche Kunstsammlungen, Dresden

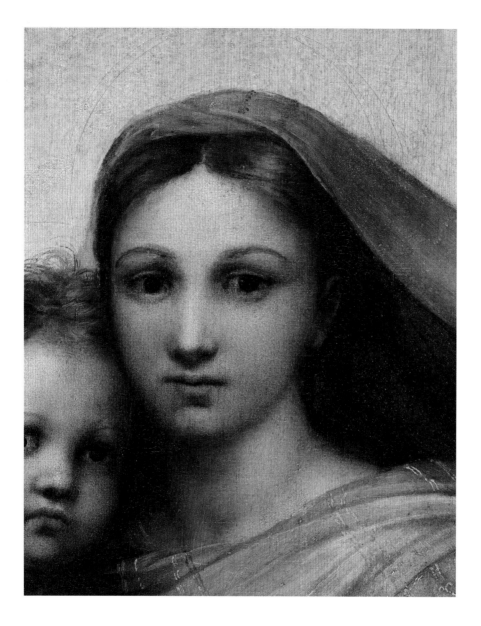

above A veil of sadness clouds the harmonious beauty of the Virgin's face, and seems to anticipate the later suffering of the Christ Child held in her arms.

right These cherubs, gazing wistfully at the vision above their heads, must be one of the most reproduced images in all art history—on cards, mugs, and T-shirts.

RAPHAEL **THE SISTINE MADONNA**

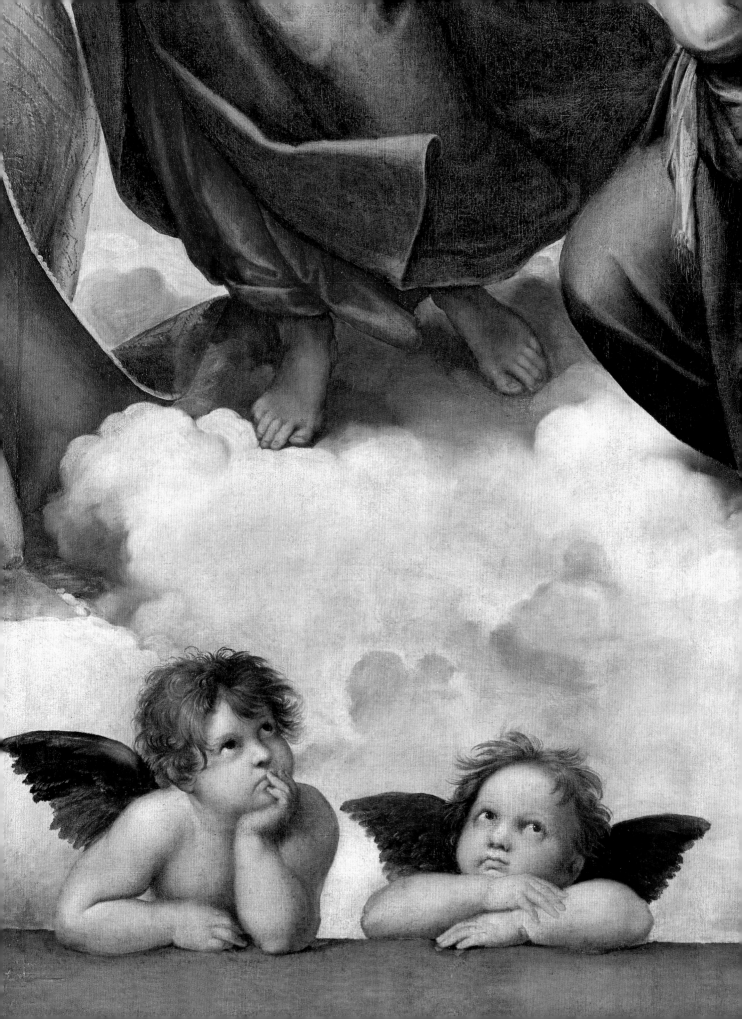

27

MATTHIAS GRÜNEWALD
ISENHEIM ALTARPIECE

Painted for the monastic hospital of the order of Saint Anthony at Isenheim, where it was placed in the hospital chapel, the *Isenheim Altarpiece* by Matthias Grünewald is one of the most original and striking works of the northern Renaissance. Grünewald's style and imagery are unique, quite unlike those of the traditional religious art of his time.

The Antonine monks were well known for their care of plague victims and the treatment of skin diseases, particularly Saint Elmo's Fire. This disease, now rare, caused painful skin sores, as well as spasms and convulsions, and was often fatal. Grünewald worked on the altarpiece from 1512 to 1516. Unlike most altarpieces, which have one set of wings that can be opened to reveal an inner scene, the *Isenheim Altarpiece* has two sets, creating three possible scenes, depending on how many of the hinged panels are open. When closed, the main scene depicts the Crucifixion in the center, possibly the most well-known image from the altarpiece. This is not the beautiful, classical Christ of the Italian Renaissance. Grünewald's figure, painted with a greenish tinge, is covered with sores, his hands and feet contorted and twisted. This is a Christ who has endured great pain, the image perhaps helping the sick to see that here was one who suffered even more than they did. When the first set of wings are opened, the panels reveal the Annunciation, the Nativity, and the Resurrection. Here again, Grünewald created a unique image, this time of the resurrected Christ. He emerges from the tomb in a burst of light so bright it almost dissolves his body. Gone are the sores, the contorted limbs. All that remains are faint marks on his hands, feet, and side. Christ rises into the night sky as a figure so majestic that it causes the guards to fall unconscious. This image may have given hope to the sick that all disease might be cured, if not in this world then in the next. The third view of the altarpiece reveals a gilded wood carving of Saint Anthony by Niklas Hagenauer (c. 1445/1460—before 1538), created in 1505. The carving is flanked by Grünewald's painted panels from the life of Saint Anthony. No other artist of the time produced images of Christ so painful or ultimately so triumphant. As the hospital became less important, so did the altarpiece. The panels were dismantled and the sculpted base and crown vanished. Two hundred years ago, the panels of the *Isenheim Altarpiece* were separated so that all the images could be seen at once, without opening or closing panels. It was not until the middle of the 19th century that a society of art lovers persuaded the city of Colmar to convert a Dominican convent, known as Unterlinden, into a museum to display the altarpiece and other works of religious art, where it can be seen today, although not in its original form.

MATTHIAS GRÜNEWALD'S identity is somewhat uncertain, but it appears he was born c. 1480 in Wurzburg, Bavaria. In 1511 he became court artist to the Archbishops of Mainz and in 1512 settled near Frankfurt. Work on the *Isenheim Altarpiece* began in 1512 (on which he may have worked with another artist, a Mathis Nithart, or Neithart; some suggest this is "other artist" was in fact Grünewald himself); he seems to have left suddenly about two years later. In 1527 he entered the service of the von Erbach family, who were members of the wealthy nobility. He probably died in 1528 or 1532.

"IT IS AS IF A TYPHOON OF ART HAD BEEN LET LOOSE
AND WAS SWEEPING YOU AWAY,
AND YOU NEED A FEW MINUTES
TO RECOVER FROM THE IMPACT."

Joris-Karl Huysmans

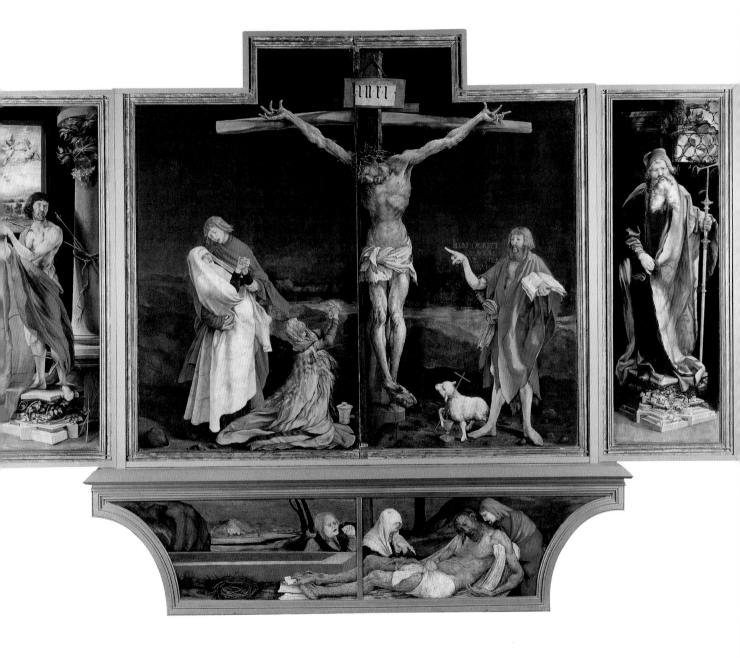

MATTHIAS GRÜNEWALD **ISENHEIM ALTARPIECE** 1512–1516, oil on wood, central panel 269 x 307 cm, side panels 232 x 75 cm,
Musée d'Unterlinden, Colmar

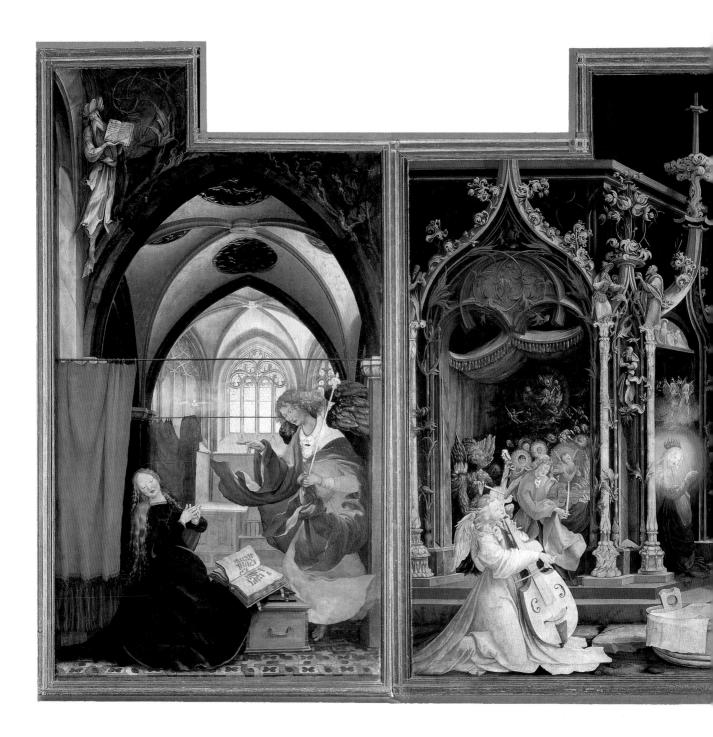

previous page The Crucifixion is visible when all the panels are closed. Christ appears twisted and full of sores, having suffered terrible pain.

MATTHIAS GRÜNEWALD **ISENHEIM ALTARPIECE**

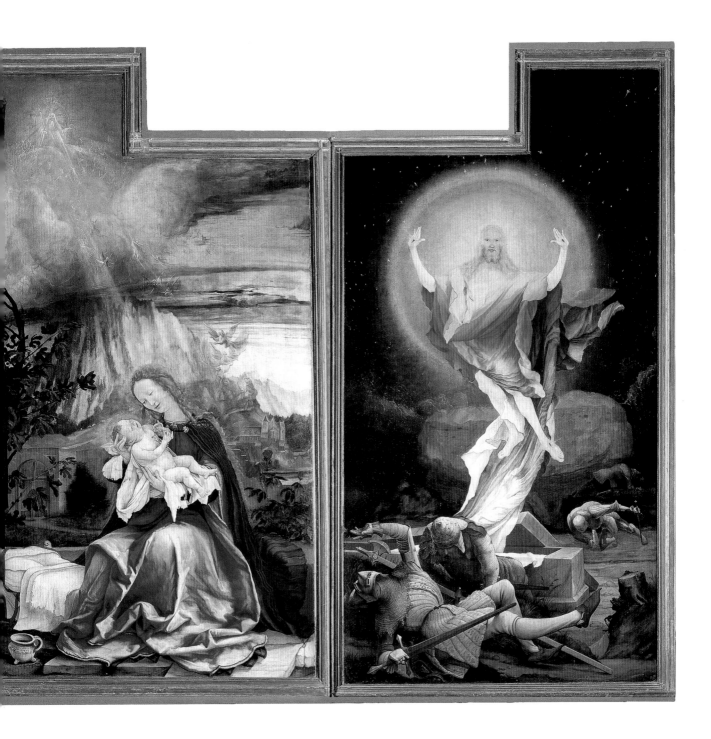

The second view of the *Isenheim Altarpiece* shows (from left to right) the Annunciation, the Nativity, and the Resurrection. This image of Christ, almost dissolved by the light emanating from him, is unique in Renaissance art.

28

TITIAN
ASSUMPTION OF THE VIRGIN (ASSUNTA)

Tiziano Vecellio, or Titian as he is known in English, is considered by many to be the greatest Venetian painter of the Italian Renaissance. His *Assumption of the Virgin,* or *Assunta,* painted for the church of Santa Maria Gloriosa dei Frari, in Venice, was his first important work. The composition breaks with tradition in its heroic size, its representation of movement, and its use of color, creating an image of the Assumption not seen before in Venetian painting.

The Frari is one of the most important churches in Venice. Titian painted the *Assumption* for its high altar, creating the largest altarpiece in Venice at that time. It was profoundly different from the traditional version of this theme, which featured rows of still figures. Titian painted his scene full of swirling movement and peopled by figures larger than life. The scene has three zones, the earthly below, the heavenly above, and a transitional zone in the middle. At the bottom are the Apostles, some kneeling, some reaching upwards. In the center the Virgin Mary, in a red robe with a blue mantle, stands on clouds. She is being lifted up to heaven by swarming cherubim. God the Father floats at the top, watching over the scene, his hair flying in the wind. Never before had the Assumption been depicted as three scenes on different levels united in one painting.

Titian used a more painterly approach than many of his contemporaries, who made meticulous drawings. Instead, he used his brush to create forms, and painted with stronger colors. He depicted movement through gestures and twisting figures, which move the eye through the painting. His technique was commented on in his own lifetime and was influential well into the 17th century. The *Assumption* was Titian's first major public commission and established his reputation as a leading painter in Venice and beyond. Some sources claim that the Franciscans who ran the Frari were not sure they wanted to accept such an unconventional altarpiece, but once installed the *Assumption* attracted a great deal of attention and so remained in the church. Titian was a versatile artist, able to paint portraits, landscape backgrounds, mythological, and religious themes all with equal skill, which made him one of the most important painters of his day and ours.

TITIAN, or Tiziano Vecellio, was born c. 1488 in Pieve di Cadore in the Republic of Venice. At the age of 11 or 12 he was sent, along with his brother, to an uncle in Venice to be apprenticed to learn painting. He initially joined the workshop of Gentile Bellini (c. 1429–1507), but later transferred to study with his master's younger brother, Giovanni Bellini (c. 1430–1516), both leading artists in Venice. By the early 1530s, Titian was the most famous and admired painter in the city and worked more and more for important patrons outside Venice. These included Federico Gonzaga, Duke of Mantua, the Farnese family in Rome, and, for the last 26 years of the artist's life, Phillip II of Spain. In 1560 he was awarded a government appointment and received a steady income for the remainder of his life. He died in 1576 in Venice, from plague.

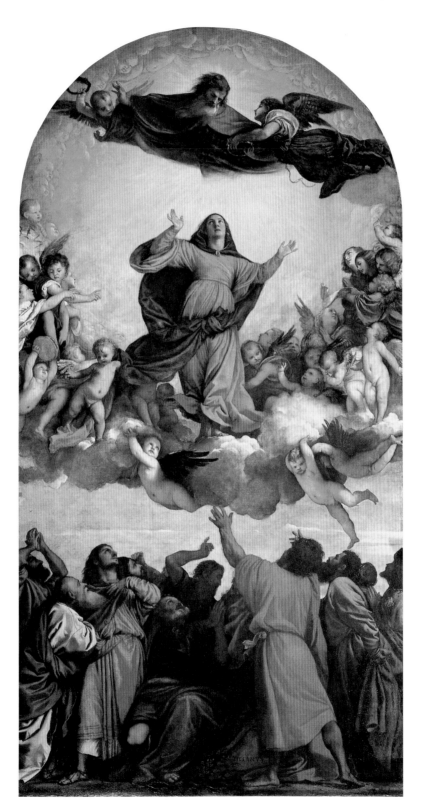

TITIAN **ASSUMPTION OF THE VIRGIN (ASSUNTA)** 1516–1518, oil on panel, 690 x 360 cm,
Santa Maria Gloriosa dei Frari, Venice

29

LUCAS CRANACH THE ELDER
PORTRAIT OF MARTIN LUTHER'S FATHER

In the early 1500s, the German duchy of Saxony became a focal point of the Protestant Reformation. Saxony's ruler, Elector Frederick III (Frederick the Wise), gave protection to Martin Luther, helping to initiate centuries of struggle between Catholic and Protestant Europe. Frederick's court painter was Lucas Cranach, a master portraitist who captured many of the Reformation's leaders with startling honesty. Among the greatest of these works was his image of Luther's strong-willed father.

The career of Lucas Cranach the Elder was remarkably stable. He worked for three different Electors of Saxony over the course of 50 years, outliving two of the men who served in that hereditary position. Yet this stability was vital for Cranach in an age of dramatic social and cultural change. When he began his career as court painter around 1505, Saxony was a remote, under-populated area of Catholic Europe. Twelve years later, a theology professor at Saxony's University of Wittenberg would forever change the region's fortunes. His *Ninety-Five Theses* (1517), an intellectual protest against the excesses of the Catholic Church, spearheaded the Protestant Reformation. It also made Saxony the epicenter of that revolution.

Luther's fame soon increased, especially after he was excommunicated by the Church in 1520. With the forces of Catholicism set against him, Luther relied on Frederick the Wise for protection. He befriended Cranach at this time, depending on the artist's inside knowledge of "gossip" from Frederick's court. Cranach also helped spread Luther's fame by crafting elegant portraits of the reformer. These images presented Luther as a plainly dressed "man of the people" and as a leader possessing a calm, keen intellect.

Cranach's connection with Luther gave him the opportunity to produce one of his greatest portrait studies. In 1527 Luther's parents visited Wittenberg, probably to attend the christening of Luther's newborn daughter, Elisabeth. Both Hans and Margarethe Luther likely sat for Cranach in his Wittenberg workshop. Cranach's preparatory study of Hans Luther still survives, and it is a remarkably candid image. The old man's dramatically wrinkled skin, rough features, and sharp gaze reflect his feisty, cantankerous spirit. Cranach further enlivens the image with his expressive brushwork and subtly detailed modeling of the skin. In many ways, Cranach's Hans Luther embodies the independent spirit of the Reformation—and the uniquely expressive achievements of the German Renaissance.

Portraits such as that of Hans Luther would inspire later generations of artists to explore the deeper recesses of the human character. The brutally honest self-portraits of Rembrandt van Rijn and Vincent van Gogh owe some of their power to Cranach's example.

LUCAS CRANACH THE ELDER was born in 1472 in Kronach (from which he took his name), in southern Germany. He studied under his father, Hans Maler, and probably with other local painters. By about 1505 the successful young artist had been appointed court painter in Wittenberg by Saxon ruler Frederick the Wise (r. 1483–1525). He would retain that position for the rest of his life, even after Frederick's death in 1525. Cranach became famous for his portraits, his mythological scenes (often featuring nudes), and for his expressive woodcut prints. Even though Cranach's work would become associated with Protestant Lutheran culture, he also received commissions from the Catholic Holy Roman Emperor Charles V (r. 1519–1556). He died in 1553 in Weimar. His son Lucas Cranach the Younger continued painting in his father's style.

LUCAS CRANACH THE ELDER **PORTRAIT OF MARTIN LUTHER'S FATHER** 1527, gouache on oiled paper, 21.8 x 18.3 cm, Albertina, Vienna

"STRANGER, YOU WISH TO SEE PICTURES
THAT PERFECTLY RESEMBLE LIFE?
BEHOLD THE WORK BY HOLBEIN'S NOBLE HAND."

Nicolas Bourbon, 1539

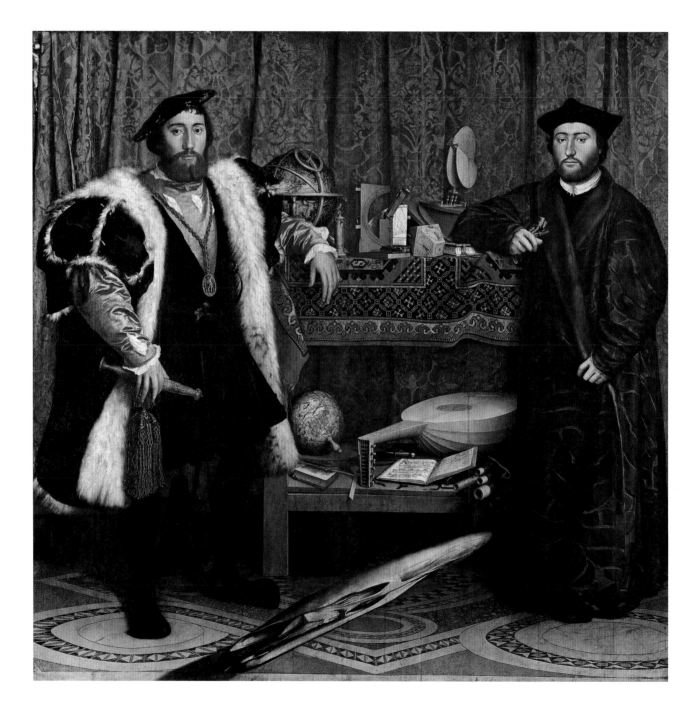

HANS HOLBEIN **THE AMBASSADORS** 1533, oil on panel, 207 x 209.5 cm,
The National Gallery, London

30

HANS HOLBEIN
THE AMBASSADORS

Hans Holbein was one of the greatest portraitists of the 16th century. Although he was born in Augsburg, he painted many of his works for the court of Henry VIII in England. *The Ambassadors,* executed in 1533, combines detailed figures with symbolic objects that tell us about the sitters and the times in which they lived.

The Ambassadors depicts two friends, Jean de Dinteville, aged 29, on the left, and bishop Georges de Selve, aged 25, on the right. Both were wealthy, educated men at the court of Henry VIII. Jean de Dinteville was the French ambassador to England. Georges de Selve, Bishop of Lavaur, who acted as ambassador for France to the Venetian Republic and the Holy See, was in England to observe Henry VIII's strained negotiations with the Catholic Church over his desire to divorce Catherine of Aragon in order to marry Anne Boleyn. The objects between the two men are as important and meaningful as the representations of the men themselves. On the top shelf are a celestial globe, a portable sundial, and other instruments for understanding the heavens and measuring time. The lower shelf contains a lute, a case of flutes, a terrestrial globe, a hymnbook, and a book of arithmetic. The tile pattern of the floor resembles a part of the floor in Westminster Abbey meant to represent cosmic order. Most striking of all is the strange distorted shape in the foreground. This is an example of anamorphic perspective, an invention of the Early Renaissance, a visual puzzle that becomes clear only when viewed from an oblique angle. Holbein's image, when seen from the side, becomes a skull, a *momento mori,* a reminder that death is always present. A tiny crucifix just visible on the upper left edge may mean that the two men recognize their mortality. The items on the top shelf appear to symbolize the heavens, those on the lower shelf the earth. The lute has a broken string, a common symbol for discord, and sits next to a hymnbook so clearly depicted that it can be read as one written by Martin Luther. Scholars suggest that these objects refer to the religious discord of the time, or possibly strife between the secular and clerical worlds. Holbein's portraits were admired in his time for their likeness and perception. It is through his eyes that we see many of the famous figures of his day, including Henry VIII. Yet, the portraits are not just detailed recreations of faces and sumptuous clothing: Holbein employed a refined symbolism to tell us even more about the sitters.

HANS HOLBEIN was born c. 1497 in Augsburg. As a young artist he worked mainly in Basel. One of his most important early works is a portrait of the humanist Desiderius Erasmus, which helped to build the artist's reputation. He traveled to England in 1526 in search of work. He carried letters of introduction from Erasmus to Thomas More and was welcomed into his circle. He returned to Basel for four years, then traveled back to England in 1532, where he remained for the rest of his life. By 1536 Holbein was made the King's Painter to Henry VIII (r. 1509–1547). He painted many members of the court, as well as religious scenes and also portrait miniatures. He died in 1543 in London, aged 45.

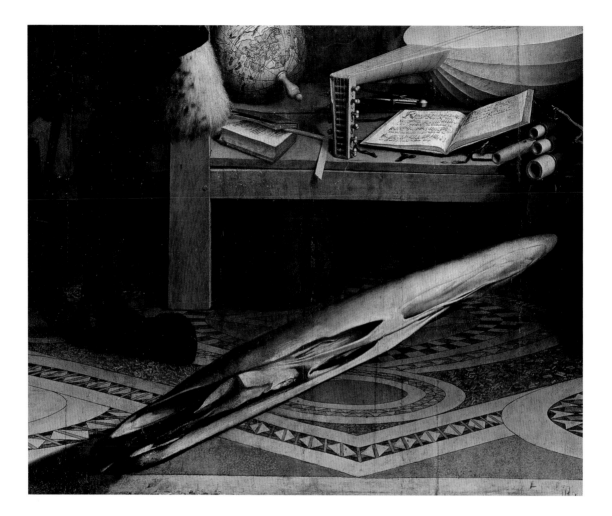

above The anamorphic skull becomes
clear when viewed from the side, while
the other elements of the painting
become distorted.

right A lute with a broken string, a
symbol of discord, next to a hymnbook
by Martin Luther suggest an allusion
to the religious discord during the
Reformation.

HANS HOLBEIN **THE AMBASSADORS**

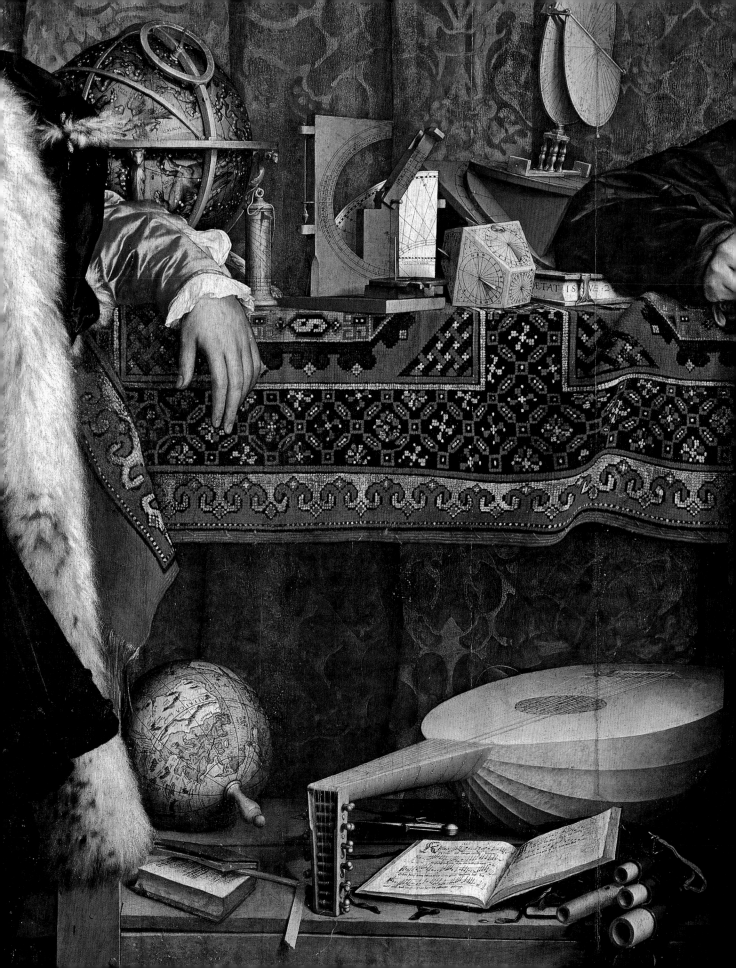

31

PARMIGIANINO
MADONNA WITH THE LONG NECK

As he was the leading Mannerist painter of northern Italy, Parmigianino's work held a powerful appeal for the refined artistic taste of the royal courts of Europe. The elegance of his paintings set the tone in all artistic centers that were influenced by court politics and values.

One of Parmigianino's most famous works, the *Madonna with the Long Neck* was commissioned by Elena Baiardi as an altarpiece for her chapel in the church of the Servites in Parma. Emphasized in her majestic appearance by the curtain and the tall column, the long-limbed Madonna is located at the center of the picture, set against the backdrop of a distant horizon and a hilly landscape at dusk. She is seated on a throne and gazes down, her head slightly inclined, at the Infant Jesus lying in her lap. His outstretched arms and closed eyes already allude to his later redemptive death. With her right hand, the Virgin points ambiguously at her breast, whose outline can clearly be seen underneath her pale, thin, shimmering dress, creating an intimate relationship between mother and child.

The angels crowding in on the left of the picture are presenting a vessel to the Virgin on which formerly (according to Giorgio Vasari) a red cross could be seen gleaming, another symbol of the Passion of Christ. The two angels who look directly out of the picture draw the viewer into the scene and so into the story of salvation. In the background, dressed only in a sheet, we can see the lonely figure of Saint Jerome, who seems to be declaiming the sacred message aloud to an unseen audience.

Although the painting was finished at Pentecost in 1535, it reached its intended destination only after Parmigianino's death. This probably explains the unfinished background and the Latin inscription (presumably added later) on the steps of the temple: "F[rancesco] Mazzoli of Parma, prevented by fate, could not complete the picture." After Parmigianino's death the painting became very famous, and was an object of fascination for Surrealist artists in the 20th century.

PARMIGIANINO was born Girolamo Francesco Maria Mazzola (or Mazzoli) in 1503 in Parma. He was probably trained by his two uncles, Michele and Pier Ilario Mazzola. Among his first independent works was the *Bardi Altarpiece* (c. 1521, Church of Santa Maria, Bardi). In 1524 he traveled to Rome to place his talents at the service of the pope, Clement VII (r. 1523–1534). However, during the Sack of Rome in 1527, the artist had to flee the city. After a period in Bologna (1527–1531), where he painted, among other works, an allegorical portrait of Charles V (private collection, New York), he returned to Parma to take up a commission for two altarpieces (it was at this time that he painted the *Madonna with the Long Neck*). However, these altarpieces were never finished, and in December 1539, under threat of arrest for breach of contract, he fled the city. He died in 1540 in Casalmaggiore, aged just 37.

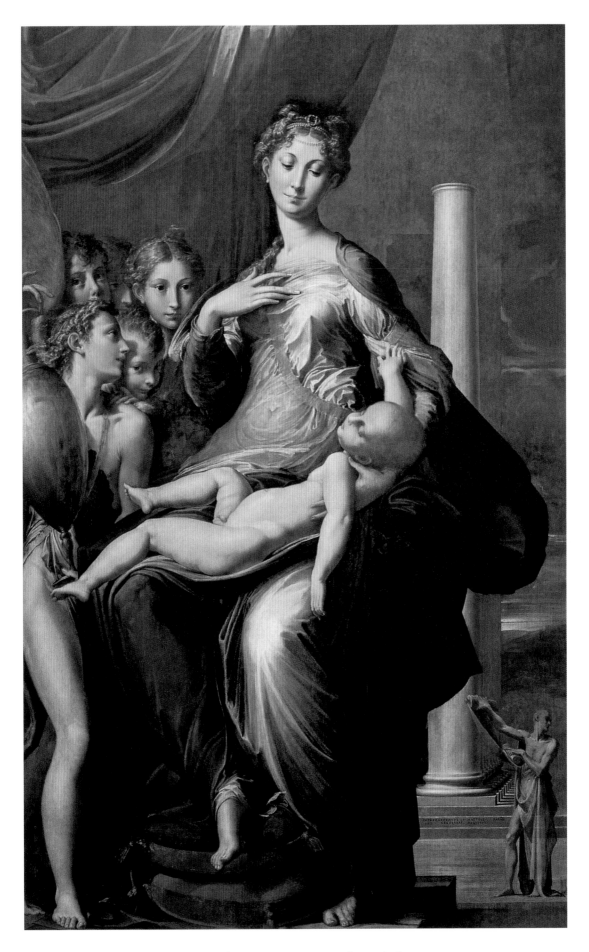

PARMIGIANINO **MADONNA WITH THE LONG NECK** 1535–1540, oil on panel, 216 x 132 cm,
Galleria degli Uffizi, Florence

32

AGNOLO BRONZINO
AN ALLEGORY WITH VENUS AND CUPID

Who is not familiar with the contradictions of love, the most ambivalent of human experiences? Bronzino fills his sumptuous and refined painting with the joys of love and sensuality, but also shows their physical and emotional reverse. Like love, this painting presents complexities that are worth exploring.

Are the two figures at the top of the painting covering up the scene, or revealing it? The man is bald-headed, with a furious expression on his face and a muscular upper body; he wears wings and carries an hourglass on his back. We can identify him as the personification of Time. The woman facing him, her face masklike but apparently youthful, seems to have no back to her head and remains a mystery. Both characters overlook a suggestive scene: Venus, the goddess of Love, is sitting naked on some elegant fabric, surrendering herself to her son, Cupid, who kneels on a cushion and caresses his mother, while turning his bottom provocatively towards us. As he bends forward to kiss her, she returns his kiss. While doing this, he does not realize that Venus has literally disarmed him: she holds Cupid's arrow aloft. A few other figures are crowded into the scene. A jolly, carefree putto prepares to shower roses on the couple, while behind him a chimera creeps forward, the creature innocently offering the couple a honeycomb, her face smiling sweetly, her lower body bestial. While we can easily recognize Venus, Cupid, and Time from their characteristic attributes, there is no clear allegorical correlation for the other figures.

An Allegory with Venus and Cupid was a gift from Cosimo I de' Medici to the French King François I. Although internationally known today, frequently reproduced, and often (over-)interpreted, in its day the painting was hidden away because of its powerful erotic overtones. When Charles Eastlake, the first director of the National Gallery in London, acquired the painting for the collection, he called it "a most improper picture," and felt obliged to have the detail of the Venus's tongue painted over, and her nipple between Cupid's fingers toned down visually. The Victorian enthusiasm for retouching paintings in the name of decency was merely a continuation of an earlier 17th-century campaign of censorship. Only in 1958 did restorers remove all the painting that had not been done by Bronzino, including a veil that covered up Venus's pubic area, and a myrtle branch that had been painted over Cupid's bottom.

AGNOLO BRONZINO was born Agnolo di Cosimo in 1503 in Florence. He trained under Pontormo (1494–1557), with whom he later worked, and like many artists of his generation was strongly influenced by Raphael and Michelangelo, and also ancient Greek sculpture. His Mannerist origins are expressed in the refined and stylish artificiality of his work. He is famous for his portraits, particularly those of Cosimo de' Medici, first Duke of Florence (r. 1537–1574) in 1537, and the Duke's family, for whom he worked as court painter from the late 1530s. His frescoes and religious paintings are created with at least as much style and care. In 1563 he became a founding member of the famous Accademia del Disegno in Florence. He died in 1572 in Florence.

"AND HE PAINTED A PICTURE OF SINGULAR BEAUTY THAT WAS
SENT TO KING FRANCIS IN FRANCE, WHEREIN WAS A NUDE VENUS,
WITH A CUPID WHO WAS KISSING HER, AND PLEASURE ON ONE SIDE
WITH PLAY AND OTHER LOVES, AND ON THE OTHER SIDE FRAUD
AND JEALOUSY AND OTHER PASSIONS OF LOVE."

Giorgio Vasari

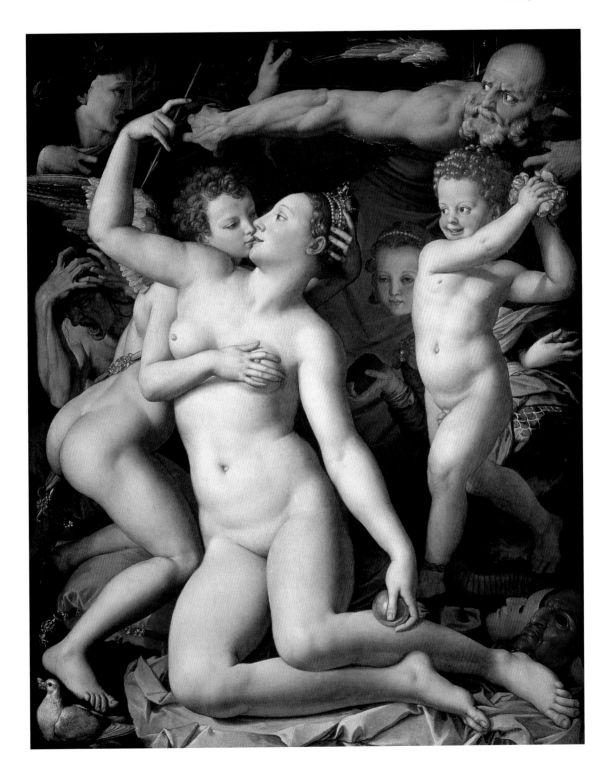

AGNOLO BRONZINO **AN ALLEGORY WITH VENUS
AND CUPID** c. 1545, oil on wood, 146.1 x 116.2 cm,
The National Gallery, London

33

PIETER BRUEGEL THE ELDER (?)
LANDSCAPE WITH THE FALL OF ICARUS

Landscape with The Fall of Icarus is an immensely popular painting, even though Bruegel's authorship is doubtful (it is very probably a close copy of an original by Bruegel). Perhaps the artist's humorous treatment of the ancient story has contributed to the painting's appeal: here the fall of Icarus has been relegated to the sidelines and daily rural life takes center stage. "The plow doesn't stop because someone dies," as the Netherlandish proverb says—nor for a failed dreamer.

Daedalus, the most ancient master of sculpture and architecture, as well as creator of many inventions, pushed his talented 12-year-old apprentice and nephew Talus off the Acropolis, for he was envious of the boy's abilities. As he fell, Athena changed the boy into a partridge—which from then on answered to the name Perdrix—and so saved his life. Daedalus was given the chance to escape punishment in Athens and sought refuge with King Minos in Crete, for whom he built the famous labyrinth. However, after a quarrel, Minos imprisoned Daedalus and his son Icarus. Using all his powers of invention, aged Daedalus made wings out of feathers fixed to a wooden framework with wax, and, with Icarus, took to the air. In his youthful enthusiasm, Icarus did not heed his father's warnings and flew so close to the sun that the wax in his wings melted; he fell into the sea and was drowned.

At first glance Bruegel's painting is merely a landscape by the sea, with a primary theme of rural daily life taking its natural course: a plowman tills a field, a shepherd tends his flock of sheep, a fisherman has just cast his line. The sun is setting, the boat follows its usual course, and in the background a Sicilian bay can be seen in the fading light—Bruegel knew that coastal region from his Italian travels. Then the inelegantly floundering legs in the water remind us of the picture's title and its real subject: Icarus has just fallen head-first into the sea, leaving individual feathers still spinning in the air. The partridge Perdrix has flown in and is sitting on a branch near the water, apparently the only witness to the tragedy. Is the fall of Icarus belated penance for Daedalus's attempt to murder Talus? Has Perdrix flown to the scene of the accident to admonish his tormentor? Or is the artist placing the indifference of the world above the fate of the individual? And what is the significance of the dagger at the edge of the picture, and the corpse in the bushes? This highly original interpretation of the ancient story has posed riddles that endure, and has made *Landscape with The Fall of Icarus* one of the most fascinating masterpieces in the history of art.

PIETER BRUEGEL THE ELDER was born c. 1525–1530; his place of birth has yet to be determined, though it may have been the village of Breugel (so spelled) near Breda in the Netherlands. He probably studied in Antwerp under Pieter Coecke van Aelst (1502–1550) from 1545 to 1550, and in 1551 he became a member of the Antwerp painters' guild. He is known to have traveled to Italy, where he worked briefly in Rome. In 1562 he settled in Brussels, and the following year married Mayken Coecke, the daughter of his former teacher. As an engraver and painter, he became famous for his landscapes and for rural scenes in which he depicted Netherlandish customs and proverbs (which probably accounts for his former name "Peasant Bruegel"), his imagery initially influenced by that of Hieronymus Bosch; *Landscape with The Fall of Icarus* is the only known example of his engagement with classical mythology. He died in 1569 in Brussels.

"NO ONE EXCEPT THROUGH ENVY, JEALOUSY OR
 IGNORANCE OF THAT ART WILL EVER DENY THAT PIETER BRUEGEL
WAS THE MOST PERFECT PAINTER OF HIS CENTURY."

Breugel's epitaph, written by Abraham Ortelius, 16th century

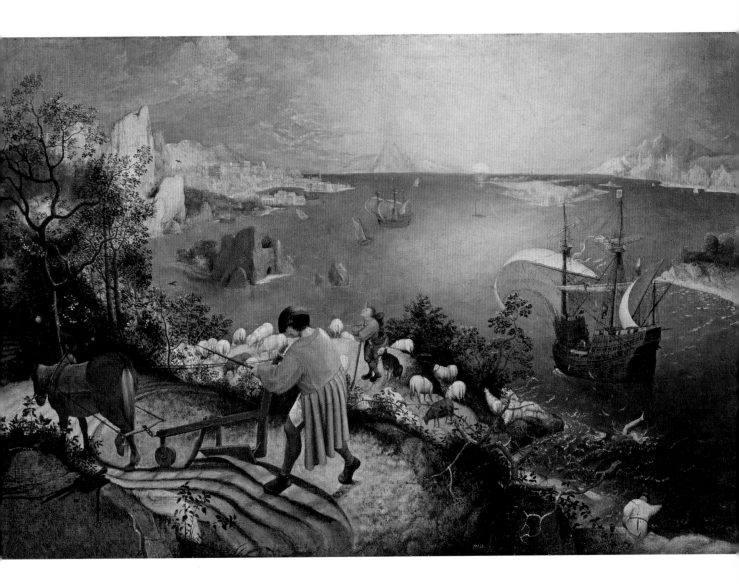

PIETER BRUEGEL
THE ELDER (?)

**LANDSCAPE WITH
THE FALL OF ICARUS**

1554–1555, tempera on canvas, 73.5 x 112 cm,
Royal Museum of Fine Arts of Belgium, Brussels

right This is a highly original pictorial concept: the sun is setting, a man plows a field, a sailboat follows its course, a fisherman casts his line, a shepherd gazes at the sky. Only Perdrix, who is seated on a branch just above the fisherman, bottom right, takes any notice of the fall of Icarus.

below Landscape painting is sometimes understood as illustrating the cycle of the calendar year: according to this tradition, the plowman stands for the months of May and June, or September and October. The time of year can also be deduced from other activities depicted in the painting.

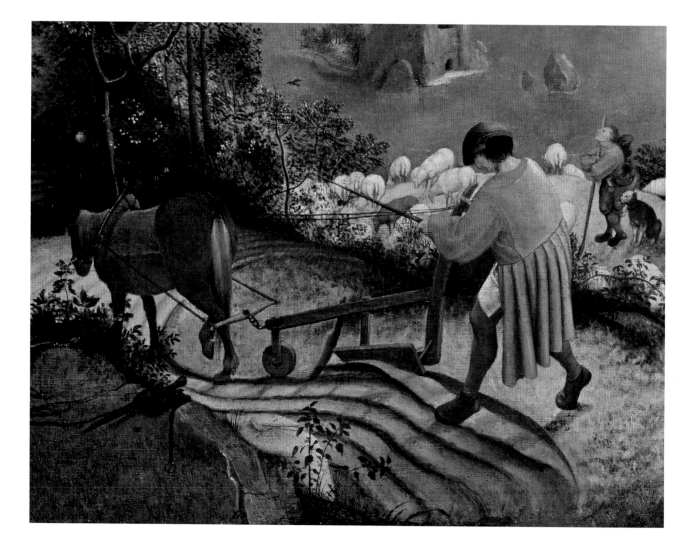

PIETER BRUEGEL THE ELDER (?) **LANDSCAPE WITH THE FALL OF ICARUS**

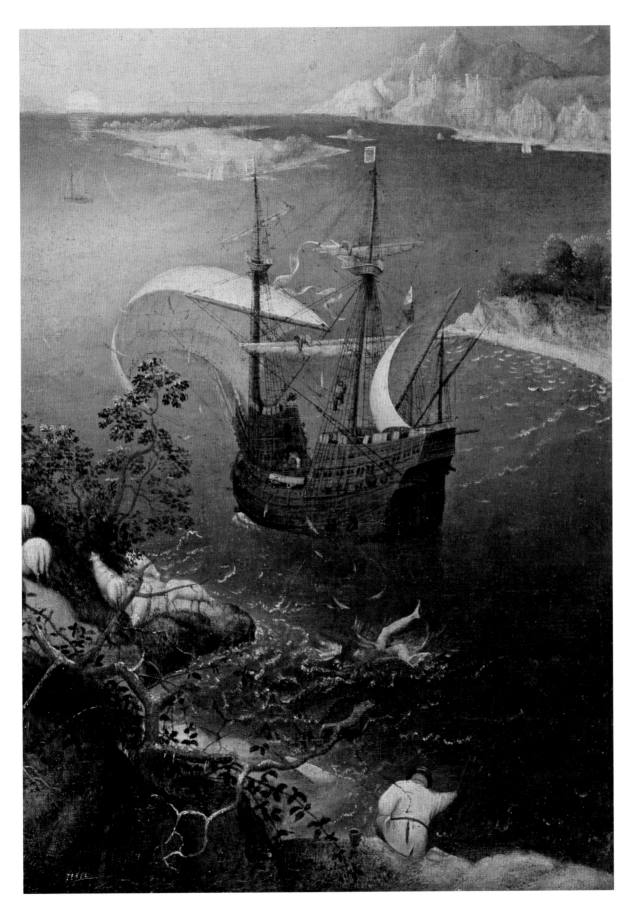

PIETER BRUEGEL THE ELDER (?) **LANDSCAPE WITH THE FALL OF ICARUS**

34

SCHOOL OF FONTAINEBLEAU
GABRIELLE D'ESTRÉES AND ONE OF HER SISTERS

Without a doubt this bathroom scene of two naked, aristocratic ladies is one of the most erotic in the history of European art, and is particularly famous because of the remarkably delicate pinching gesture. It is one of those mysterious paintings that everyone knows but that is surrounded by countless myths.

A pale cloth protects the two naked women from the cold marble bathtub. Well-coiffed and made-up, they sit in the tub, seemingly unconcerned, a heavy red curtain framing their playful, sensual games. The contours of their youthful bodies are delicately emphasized by the play of light and the contrast with the dark background. These daughters of a good family have been identified as Gabrielle d'Estrées (right) and one of her sisters, probably Julienne, duchess of Villars. Gabrielle holds a gold ring carefully between two fingers, while Julienne casually pinches her nipple. A scene of total contrast is taking place in the background, where a virtuous chambermaid is sitting at the hearth sewing. The painting was probably intended as the revelation of a secret, which for its contemporaries was actually no secret at all: Gabrielle was expecting an illegitimate child by her royal lover, the French King Henri IV (r. 1589–1610). The intimate pinching gesture is probably a reference to her pregnancy: while today the image of a round belly betrays a mother-to-be, at that time it was the ideal of beauty for all women, even virgins. As a symbolic gesture, artists would have the figures in their paintings point in the direction of the maternal breast in order to indicate a pregnant woman. Here the anonymous artist translates this code charmingly in a more provocative way. As Henri's favorite mistress, Gabrielle could have been queen, and the ring in the painting was probably a present from the king—it was the same ring that was entrusted to him on his investiture as king of France. But Henri finally agreed to marry his young lover only when she became pregnant for the fourth time. Gabrielle gave birth to their first child in 1594, with the second and third following soon after, and in 1599, on her last pregnancy, everything seemed to have been arranged: the necessary legal procedures undertaken, and the wedding all prepared. But the tragedy of this love story is that the young woman, then just 25 years old, died just before her long-awaited marriage.

The **SECOND SCHOOL OF FONTAINEBLEAU** espoused a Mannerist style of painting that was encouraged by Henri IV of France. This movement, which predominated until Henri's assassination in 1610, was primarily a combination of French and Flemish styles. It was preceded by the First School of Fontainebleau which, in the mid-16th century under the French King François I (r. 1515–1547), created a hybrid style mixing Italian Mannerism, French Gothic, and the personal tastes of François I. Famous artists of the Second School included Ambroise Dubois (1542–1614) and Toussaint Dubreuil (1561–1602). The painter of this portrait of the sisters remains unknown.

"THE LOVE THAT MADE THE KING GREAT."

Heinrich Mann

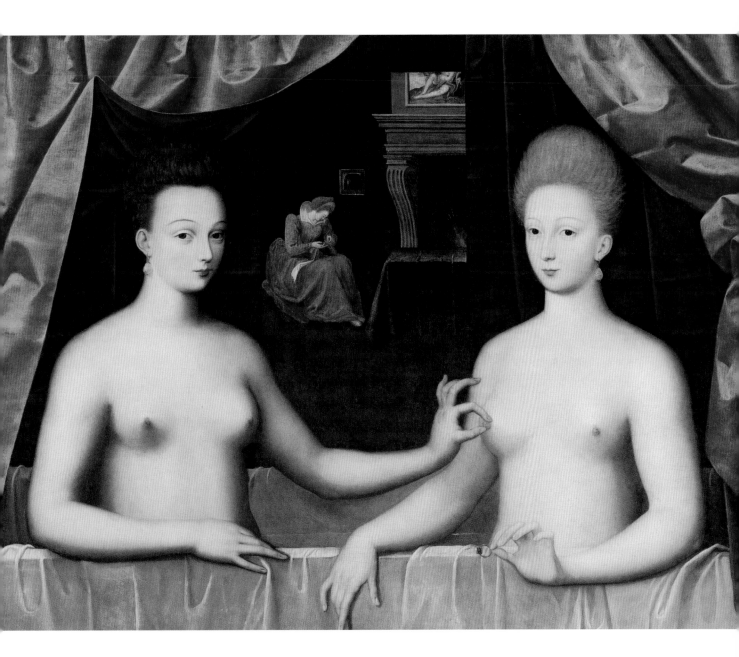

SCHOOL OF FONTAINEBLEAU **GABRIELLE D'ESTRÉES AND ONE OF HER SISTERS** c. 1594, oil on oak panel, 96 x 125 cm, Musée du Louvre, Paris

35

ANNIBALE CARRACCI

GALLERIA FARNESE

In 1597 Cardinal Odoardo Farnese commissioned Annibale Carracci to decorate a long, barrel-vaulted gallery in the Farnese family palace in Rome. The fresco cycle Carracci created, *The Loves of the Gods*, has come to be seen as a turning point in art, marking the end of 16th-century Mannerism and the beginning of 17th-century Baroque.

Annibale's brother, Agostino, worked with him on the Farnese gallery from 1597 until 1600, after which Annibale worked with artists from his workshop to complete the frescoes the following year. Carracci was influenced by Michelangelo's decoration of the Sistine Chapel and Raphael's *Stanze* in the Vatican, but these are nearly all religious in subject. The decoration of the Farnese gallery is purely classical and pagan. The Farnese collected classical antique statuary, so the Carracci brothers had many examples to study. The fresco cycle depicts scenes of the classical gods, mythological scenes that reflect Annibale's ability to combine the classical ideal with vivid colors and a sense of rapid movement. The classical tales are set within painted frames, some made to look like marble, some like gilded wood. Carracci also painted the illusion of architecture and nude figures, herms and putti, to "support" the painted frames. The central scene, *The Triumph of Bacchus and Ariadne*, depicts the lovers riding in chariots drawn by tigers and goats, accompanied by a crowd of nymphs, bacchants, and satyrs. There is a strong feeling of opulence, and Carracci successfully captures a sense of movement and the effects of light on the different forms. The Mannerist style, which had been in favor, used distortion and artificiality; Carracci's work marked a return to nature and the study of the great north Italian painters, particularly Correggio, Titian, and Veronese. This grand, classical yet dynamic manner of painting was influential in both easel paintings and frescoes in Rome throughout the 17th century. One of the most admired painters of his day, Carracci was an important figure in the renewal of the classical style. He and the painters trained in his workshop played a key role in the transition to the Baroque, with its exuberance, its use of color, and its dramatic use of light and shadow.

ANNIBALE CARRACCI was born in 1560 in Bologna. He traveled to Parma and Venice to study art, and in 1582 opened an influential art school in Bologna with his brother Agostino (1557–1602) and cousin Lodovico (1555–1619), also noted artists. In 1595 Cardinal Farnese summoned Annibale to Rome, where he and his brother started work on the Farnese gallery two years later, while their cousin Lodovico stayed behind to run the school. It is not clear how much Annibale painted after finishing the gallery for the Farnese. In 1606 the Cardinal wrote of Annibale's "heavy melancholic humor," which seemed to prevent him from painting. Annibale Carracci died in 1609 in Rome, and was buried next to Raphael in the Pantheon.

"NO ONE COULD IMAGINE SEEING ANYWHERE ELSE
A MORE NOBLE AND MAGNIFICENT STYLE OF ORNAMENTATION ...
AMONG MODERN WORKS THEY HAVE NO COMPARISON."

Giovanni Bellori on the frescoes of the Galleria Farnese, 1672

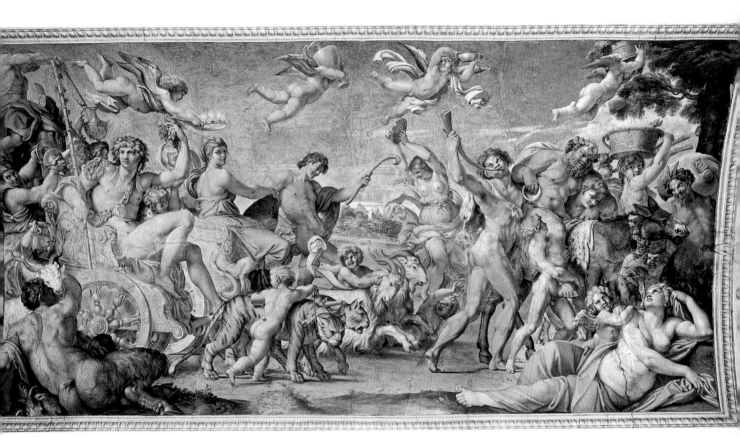

ANNIBALE CARRACCI **GALLERIA FARNESE** 1597–1601, *The Triumph of Bacchus and Ariadne,* fresco,
Palazzo Farnese, Rome

previous page The scene shows
the lovers being led off to bed.
It is full of movement and color,
while classical in theme.

left View of the Galleria Farnese,
with frescoes by Annibale Carracci,
1597–1601, Palazzo Farnese, Rome.

below *Diana and Endymion*, from
the Galleria Farnese. The framing
architecture is painted; some of
the figures are painted to resemble
marble, others to look life-like.

ANNIBALE CARRACCI **GALLERIA FARNESE**

EL GRECO **VIEW OF TOLEDO** c. 1595–1600, oil on canvas, 121.3 x 108.6 cm,
The Metropolitan Museum of Art, New York

36

EL GRECO
VIEW OF TOLEDO

It is not hard to see this painting as the product of more recent times, since the *View of Toledo* seems to be a plea for expressive artistic freedom as against the mere imitation of reality. It is not so much a view and more a poem dedicated to the city of Toledo, indeed a modern poem, which summarizes the place in a few striking, immediately recognizable images.

In the foreground, the vegetation blows in the wind. On the right, the city of Toledo sits on a hill, and a row of buildings runs along the side of the steep hill down to the Roman bridge of Alcántara. On the other side of the River Tajo lies the castle of San Servando. In the river people are bathing, and travelers are walking towards the bridge. It's a normal day in Toledo, and yet it isn't. Storm clouds are gathering on the horizon, or are they just passing over? It is neither day nor night—perhaps a flash of lightning has just lit up the landscape. The city seems an unreal, dark place beneath a dramatic, expressively painted sky, and yet it is also the scene of daily life. It is these contradictions that make the painting so compelling. El Greco depicts the eastern part of Toledo seen from the north, a view that excluded the cathedral. In order to integrate the cathedral into his cityscape, he moved it to the left of the striking royal palace of Alcázar. He was trying to capture the essence of the city, perhaps as a moment of emotion; he was not documenting its actual appearance. His more relaxed technique and powerful color palette, the jagged contours of the buildings and the dramatically lit sky, seem to anticipate the landscape paintings of German Expressionism. In another cityscape, *View and Plan of Toledo* (1610, Museo El Greco, Toledo), El Greco created a topographical depiction of the city, while in this view in the Metropolitan Museum he excluded the fortifications, gates, countless towers, and houses that existed in the real cityscape. He selected characteristic features, unmistakable landmarks, and striking country roads, and brought them together to create a poetic vision of Toledo. This painting is El Greco's subjective view, one that existed not in reality but in his imagination.

EL GRECO ("the Greek") was born Domenikos Theotokopoulos in 1541 in Crete, then under the rule of Venice. He trained in icon painting in Crete, but his style changed under the influence of Late Renaissance art during his visits to Venice (1558–1570, 1572–1576; Titian, Tintoretto, Bassano) and Rome (1570–1572; Raphael and Michelangelo). He moved to Toledo in Spain in 1577, where he lived until his death, primarily working to commissions from local religious institutions. Though typically described as a Mannerist, his dramatic, expressive style is so distinctive that his works cannot be categorized within a particular school of painting. He died in 1614 in Toledo.

37

CARAVAGGIO
AMOR VINCIT OMNIA

Shown as a naked boy drawn from life, his artificial wings stuck on, and adopting a provocative pose, this Amor is puzzling, even disturbing. The realism of the representation—the boy's smile, his direct gaze, and his exhibitionist pose as he faces the viewer—remove the mythical aspect from this subject and reveal this ethereal being to be all too human.

The representation of real people, and of street boys and prostitutes into the bargain, in the guise of mythical figures and saints contributed considerably to Caravaggio's reputation as a naturalist—and also brought him censure. The figure in *Amor Vincit Omnia* is clearly a creature of this world, an "earthly Amor" who is aware of the role he is playing and of the homoerotic connotations of his nakedness. It is all the more astonishing that Caravaggio, the innovative artist, drew on previous models: while the upper body of Amor is probably inspired by the *Belvedere Torso,* an ancient sculpture which was often copied during Caravaggio's time, the boy's seated position possibly goes back to Michelangelo's sculpture *Victory,* or his painting *The Rape of Ganymede,* a copy of which was owned by the Marchese Vincenzo Giustiniani, for whom Caravaggio's painting was intended.

The absence of a specific setting makes it easier to locate this Amor in the world of myths. The objects scattered around the figure are described in the 1638 inventory of the Marchese's collection as symbols of the world at Amor's feet, to which he pays little attention. Here Amor (love) presides over the things people strive for: learning, art, fame (the laurel wreath), and power (the crown, scepter, imperial purple drapery). The violin, lute, and scores represent music, while the pair of compasses and set square stand for geometry, and the manuscript with reed pen for literature. The armor embodies the art of war, and the astrological globe alludes to astronomy. Caravaggio's *Amor* seems to be a visual translation of a line from Virgil's *Eclogues:* "Love conquers all things; yield we too to love!" Proof that *Amor* was understood fully in the sense of Virgil's theme can be see in one of Caravaggio's epitaphs: "For Michaele Angelo da Caravaggio, who painted all-conquering Amor."

Giustiniani hung *Amor Vincit Omnia* in a place of honor. The painter Joachim von Sandrart, who spent a few years in Giustiniani's palace from 1630 onwards, describes how the painting was covered with a curtain, and guests were shown it only at the end of their tour, "because otherwise it made all the other rarities seem insignificant, so that with good reason it could be said to eclipse all other paintings."

MICHELANGELO MERISI DA CARAVAGGIO was born in 1571 in Caravaggio. He served an apprenticeship in Milan under Simone Peterzano (c. 1540–c. 1596). In 1592 he moved to Rome, where, after working as an assistant to Giuseppe Cesari (c. 1568–1640), he became a favorite of several wealthy patrons, despite the fact that the earthy realism he brought to religious subjects offended more traditional tastes. His works, which mark the beginning of the stylistic transition from Mannerism to the early Baroque, became characterized by his dramatic use of chiaroscuro, his subjects often suffused with eroticism and violence. He fled Rome in 1606 after killing a man in a brawl, spending the next few years in Naples, Malta and Sicily, always on the run. He died of fever in 1610 in Porto Ercole, while returning to Rome.

"LOVE CONQUERS ALL, AND YOU, THE ARTIST,
CONQUER ALL, BODIES AND SOULS."

From a poem by Marzio Milesi on *Amor Vincit Omnia*, 1610 or earlier

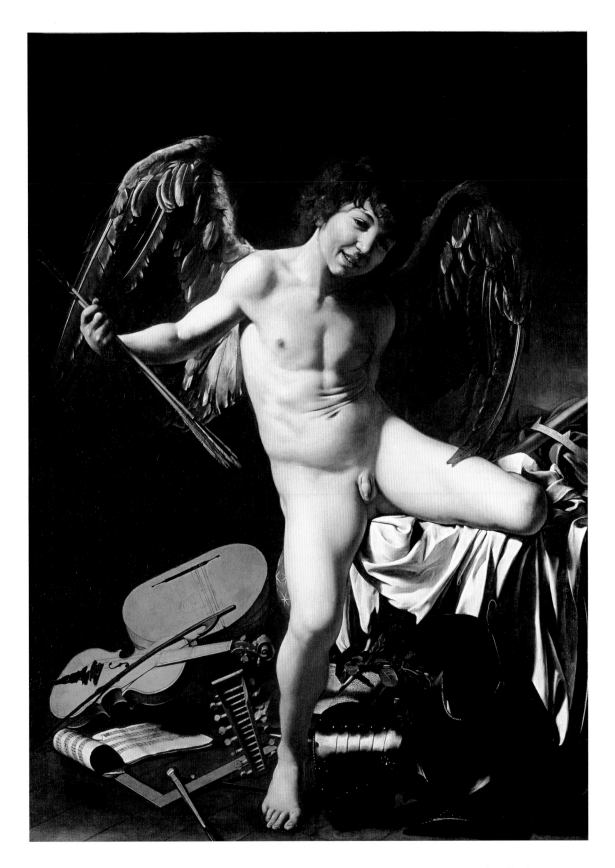

CARAVAGGIO **AMOR VINCIT OMNIA** 1601–1602, oil on canvas, 156 x 113 cm, Gemäldegalerie,
 Staatliche Museen zu Berlin, Preussischer Kulturbesitz

38

PETER PAUL RUBENS
THE RAPE OF THE DAUGHTERS OF LEUCIPPUS

With his dramatic, dynamic paintings, Peter Paul Rubens had a long-lasting influence not only on his Flemish contemporaries such as his pupils Anthony van Dyck and Jacob Jordaens, but also on the painters of the 18th and 19th century across Europe. He is one of the most important Baroque painters of Northern Europe.

A large part of Rubens' work is dedicated to subjects from ancient mythology, one example being *The Rape of the Daughters of Leucippus*. The image shows the moment when Hilaira and Phoebe, daughters of King Leucippus of Argos (and therefore known as the Leucippides), are abducted by the sons of Zeus, the so-called Dioscuri, Castor and Pollux. The mortal Castor, famed as a horse-tamer, dressed in his protective armor, lifts the king's daughter up as she struggles violently. The immortal Pollux, a boxer, has taken hold of her sister, heaving her up to his horse. Despite their violent movements, Rubens arranges the four figures and the horses within the square of the picture plane in such a way that he manages to create a balanced and harmonious composition and thus the most natural representation possible. This is achieved primarily by the skillful interweaving of the movements: beginning with the position of the bodies of the two women, the figure group is stabilized by the way they are interlaced in pairs. Rubens is famous for his natural and precise representation of flesh, and in this picture too his masterful use of color, light, and shadow can be seen in his representation of human flesh.

However, in *The Rape of the Daughters of Leucippus* Rubens was not aiming simply at the illustration of an ancient tale; he was also pursuing a completely different idea. Thus he does not depict the sisters' marriage, nor the fight between their betrothed and the Dioscuri, nor the subsequent pursuit. Both riders lift the two naked virgins up, not so much to lift them onto their horses, but just up in the air; overwhelmed, both girls are looking upwards—not at their abductors but towards heaven. In this way Rubens has also created an image of apotheosis, of deification: the sisters are literally and figuratively raised above the earthly realm into the heavenly heights of Olympus.

PETER PAUL RUBENS was born in 1577 in Siegen, Germany, to where his father, a Calvinist, had escaped from Antwerp. Rubens spent his childhood in Cologne. From 1587 he studied in Antwerp, where he studied with several artists. In 1600 he embarked on his first trip to Italy, where he worked for the Duke of Mantua. In 1609 he became court painter to Albert II, Archduke of Austria (r. 1564–1595). Between 1623 and 1631 he traveled on several diplomatic missions to Madrid and London, where King Charles I (r. 1625–1649) knighted him. His fame grew with each commission, and soon he was the head of a large and busy workshop. In 1626 his wife, Isabella Brant, died of the plague, and in 1630 he married Hélène Fourment, whom he would depict in many portraits and paintings. He died in 1640 in Antwerp.

"THE NAKED FEMALE FORM, HOWEVER,
CAN ... THROUGH THE MERE BEAUTY OF THE SKIN ... EFFECTS
EXERT A MAGIC THAT TRANSCENDS ALL POETIC
CONTENT AND ALL PURITY OF FORM."

Jacob Burckhardt, 1898

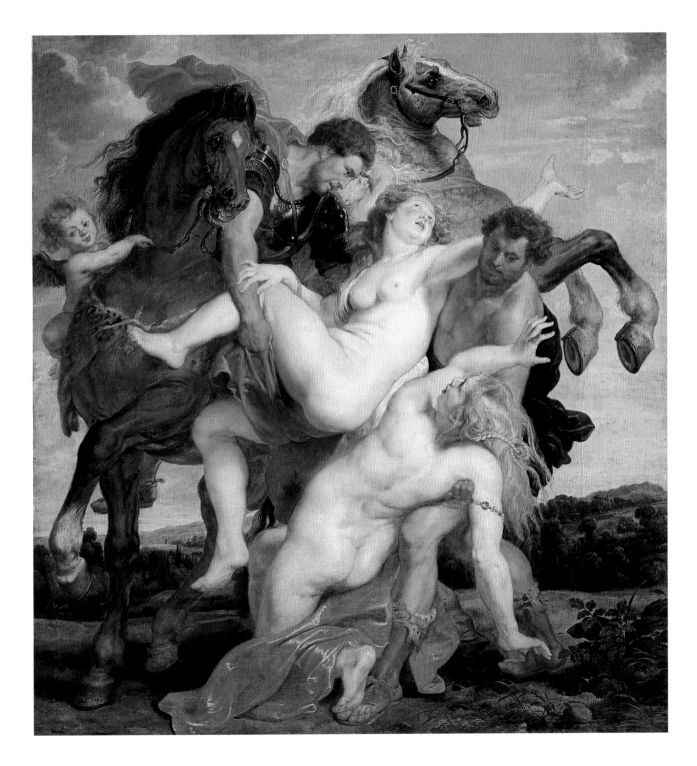

PETER PAUL RUBENS **THE RAPE OF THE DAUGHTERS** c. 1618, oil on canvas, 224 x 210.5 cm,
OF LEUCIPPUS Alte Pinakothek, Bayerische Staatsgemäldesammlungen, Munich

39

PIETER CLAESZ
VANITAS STILL LIFE

At the beginning of the 17th century, paintings of arrangements of fruit and simple meals became very popular. Artists working in the Netherlands in particular specialized in a distinctive version of these still-life paintings, the *vanitas*. Pieter Claez was a master of this genre, using groupings of books, writing materials, musical instruments, snuffed candles, and skulls to symbolize the transience of earthly life.

The Latin word *vanitas* means "emptiness" and came to stand for the worthlessness of earthly possessions and pursuits. Pieter Claesz and another painter, Willem Claeszoon Heda (1593/1594–c. 1680/1682), were the most famous painters of the *ontbijt*, or breakfast piece, and the *vanitas*. They developed a new palette of subdued colors—gray, green, brown, and yellow—to create almost monochromatic paintings.

The *Vanitas Still Life* by Pieter Claesz, painted in 1630, is a prime example of this style and subject matter. On a table covered by a rough cloth are assembled a skull atop a book, a timepiece, a snuffed-out candle, and a glass on its side. The objects are painted so realistically that it is easy to think that we could reach out and take hold of the watch key hanging over the edge of the table. The skull is a reminder of human mortality and the other objects refer to the passage of time and the vanity of earthly possessions. Claesz used a simple color range, the only bright spot being the blue ribbon holding the key to wind the watch. The brighter color brings emphasis to the watch, symbolizing the brevity of human life and the pointlessness of frivolous pursuits.

The message of these *vanitas* paintings was clear to the contemporary viewer: do not become attached to material things, but rather focus on higher aims such as living a virtuous life. Although today this may seem a gloomy message, Claesz was well patronized by Haarlem's wealthy citizens, who, with a keen appreciation of his ability to capture reality while at the same time conveying a reflection on life, would have proudly displayed his paintings on the walls of their fine homes.

PIETER CLAESZ was born in 1597 in Berchem, near Antwerp. He married in 1617 and in 1620 moved to Haarlem, where many artists lived and worked. There he won the patronage of the wealthy citizens, many of them buying his paintings. Pieter Claesz had a son, Claes Pieterszoon Berchem (1621/1622–1683), who became a well-known landscape painter, and who initially trained with his father. Pieter Claesz died in 1660 in Haarlem.

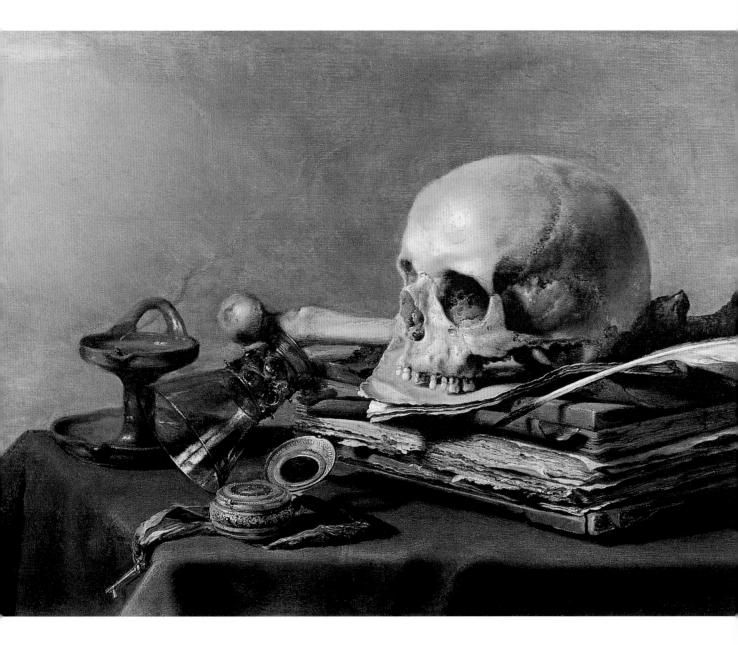

PIETER CLAESZ **VANITAS STILL LIFE** 1630, oil on canvas, 39.5 x 56 cm,
Mauritshuis, The Hague

40

ARTEMISIA GENTILESCHI
JUDITH BEHEADING HOLOFERNES

One of the most extreme images of the Old Testament heroine Judith, who saves her people by killing a tyrant, was painted by Artemisia Gentileschi. Her work speaks of the self-confident struggle of a woman painter at a time when women artists were still the rare exception.

Even Gentileschi's contemporaries regarded the painting with "not a little horror," as her 17th-century biographer Filippo Baldinucci writes. The subject of the Israelite widow, Judith, who beheads the Assyrian leader Holofernes, was a favorite during the Baroque, but was rarely dramatized as mercilessly as here. Holofernes struggles with all his might against his attackers. While Judith's maid Abra (probably a portrait of the artist herself) bears down with her upper body, Judith applies the sword, blood spurting up at her. We can feel the effort being put into this act of beheading: unlike traditionally delicate female figures, this Judith is a powerful woman who could be relied on to do what was needed, however gruesome. Even in a painting on the same subject by Caravaggio, who was famous for the realism of his representations, we see a dainty girl on her own beheading the man from a safe distance and without a great deal of exertion. How much more realistic is Gentileschi's picture by comparison!

Gentileschi's painting is artfully composed. If we look at an earlier version of c. 1612–1613, it becomes clear how much the painter intended to show off her skill in the later version. Following classical rules, she positioned the figures along a central axis formed by the sword. All of the three protagonists' limbs converge at a point focused on Holofernes' slit throat. The play of light, following Caravaggio's technique of chiaroscuro, is more dramatic than in the early version: the features of Abra and Judith, distorted by their exertions, are highlighted sharply. A contrast to this brutal scene is formed by the exquisite decor, inspired by the taste of the man who commissioned the paintings, Grand Duke Cosimo II de' Medici. Judith is dressed in gilded damask, and the ceiling of the military commander's room glows purple-red. The brutality of the scene, which has been attributed by some art historians to an experience of abuse, can be understood as Gentileschi asserting herself in a male-dominated world. In a prominent position on the blade of the sword we can see her signature: "Ego Artemitia / Lomi Fec" ("I, Artemisia Lomi, made this").

ARTEMISIA LOMI GENTILESCHI was born in 1593 in Rome. She trained under her father, the painter Orazio Gentileschi (1563–1639). After a public trial for rape she brought against a painter colleague, Agostino Tassi (who had taught her alongside her father), Gentileschi moved to Florence, where she was accepted as the first female painter at the Accademia del Disegno. Her oeuvre consists overwhelmingly of portraits, including allegorical self-portraits and depictions of biblical themes, frequently featuring female figures, such as Judith and Susanna, in the central role. She died in 1652 or 1653 in Naples.

"I WILL SHOW WHAT A WOMAN CAN DO. YOU WILL FIND
THE COURAGE OF CAESAR IN THE SOUL OF A WOMAN."

Artemisia Gentileschi

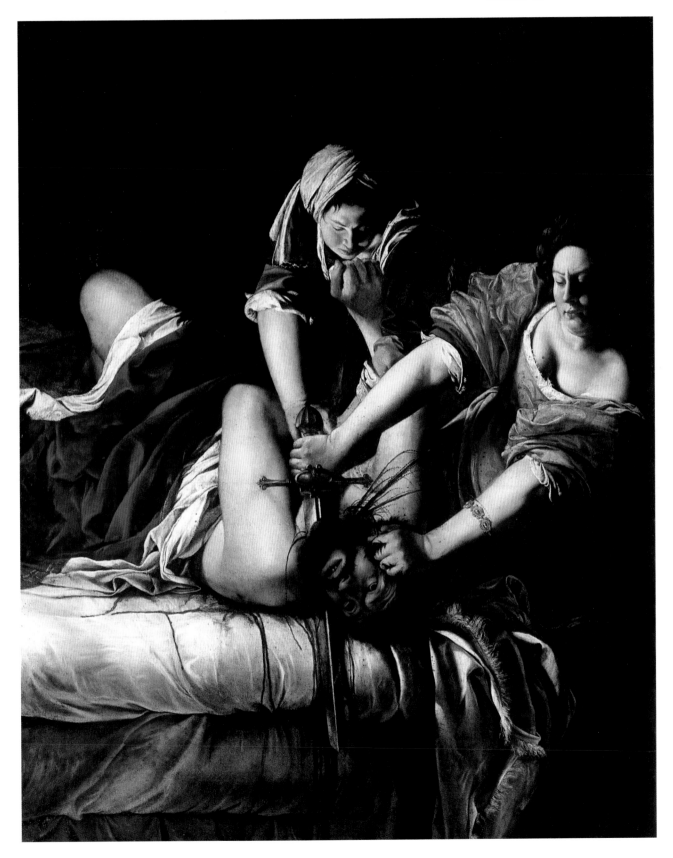

ARTEMISIA GENTILESCHI **JUDITH BEHEADING HOLOFERNES** c. 1620, oil on canvas, 199 x 162.5 cm,
Galleria degli Uffizi, Florence

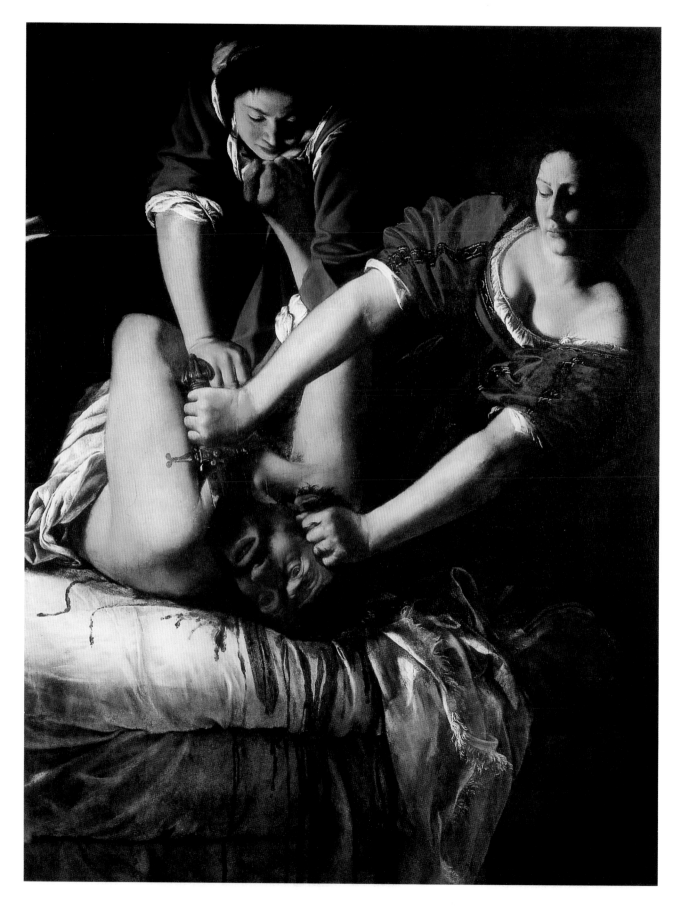

ARTEMISIA GENTILESCHI **JUDITH BEHEADING HOLOFERNES**

left Artemisia Gentileschi, *Judith Beheading Holofernes*, c. 1612–1613, oil on canvas, 160.5 x 127.5 cm, Museo di Capodimonte, Naples
The subject of Judith beheading Holofernes appears several times in Gentileschi's oeuvre. This early version resembles the later one in its composition and use of light, though the scene's extreme nature and the detailing of the interior are toned down.

below Caravaggio, *Judith Beheading Holofernes*, 1597–1600, oil on canvas, 145 x 195 cm, Galleria Nazionale d'Arte Antica, Palazzo Barberini, Rome
Caravaggio's use of chiaroscuro (contrasts of light and dark) in his paintings would find many imitators, including Artemisia Gentileschi and her father Orazio. Caravaggio too interpreted the beheading scene as one of relentless brutality, but his heroine still draws on the tradition of beautiful young women.

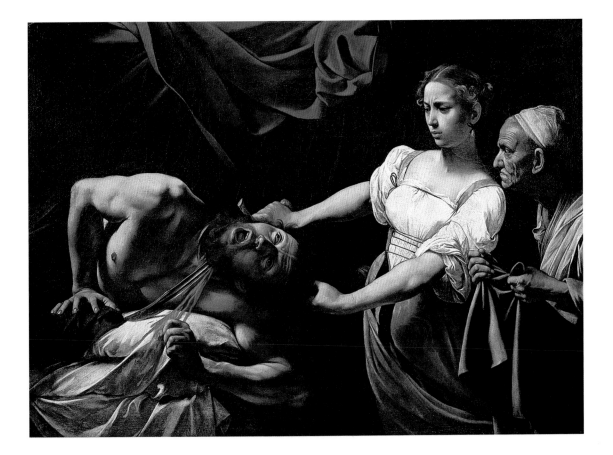

ARTEMISIA GENTILESCHI **JUDITH BEHEADING HOLOFERNES**

41

REMBRANDT
THE NIGHT WATCH (MILITIA COMPANY OF CAPTAIN FRANS BANNING COCQ)

Rembrandt has long been considered one of the greatest artists who ever lived. There was a tradition of painting group portraits in a somewhat static way, with the figures lined up so that all would be fully visible. Rembrandt changed everything in *The Night Watch*. In his painting, which is rich in movement, light, and color, Rembrandt created a scene full of life and action.

Completed in 1642, this group portrait was not originally called *The Night Watch*. It is more correctly named *The Militia Company of Captain Frans Banning Cocq*, after the main figure. It was Sir Joshua Reynolds who named the painting the *Night Watch*, for by the 18th century the varnish had darkened so much that the scene appeared to be set at night. The scene is actually set during the day, with the militia stepping out of a dark space into the bright sunshine. Rembrandt's composition was unique for group portraits of the time. Although 17 members of the militia contributed to the 1,600 guilders Rembrandt was paid, not all of them are easily seen. Captain Cocq, in black with a red sash, and his lieutenant, Willem van Ruytenburch, in yellow with a white sash, are about to stride out, leading the company. Other members are preparing to file out behind them, perhaps to join a parade. Rembrandt's use of light and shadow, as well as color, creates a feeling of motion and highlights the three main figures, the captain, the lieutenant, and a small girl. This young girl, who serves as a mascot for the militia, holds symbols of the group—the claws of the chicken, for example, represent arquebusiers, another name for the militiamen, after the long-barreled gun, or arquebus, they carry. She also carries a pistol and the militia's goblet. The lines formed by the halberds and staffs held by some of the men animate the scene and link the figures. Rembrandt created a new genre of group painting, with figures full of movement—with men gesticulating, loading muskets, holding up the militia's banner. This new format did not influence other artists, however, as later group portraits tended to revert to the more static composition. Although not the traditional composition they may have expected, the militia appears to have accepted the painting, as it was hung in the Great Hall of the Civic Guard. It was moved to Amsterdam town hall in 1715 and unfortunately cut down to fit the new space, so the figures are no longer centered as they were originally. Now in the Rijksmuseum, *The Night Watch* suffered more damage in 1975, when an unemployed schoolteacher cut it with a knife. The zig-zag tears were repaired but traces of damage are still visible close-up.

REMBRANDT HARMENSZOON VAN RIJN was born in 1606 in Leiden. He entered the University of Leiden in 1620. His studies included science and theology but the only thing that interested him was painting. He began an apprenticeship as a painter with Jacob van Swanenburgh (1571–1638), an admirer of Italian art. In 1625, Rembrandt studied with Pieter Lastman (1583–1633) in Amsterdam for four months. Upon returning to Leiden, he set up his own studio and soon acquired a reputation for both his paintings and his prints. In 1629 the statesman Constantijn Huygens so approved of Rembrandt's work that he helped to get him commissions from the court of The Hague. Rembrandt moved to Amsterdam and in 1634 married Saskia van Uylenburg, often one of his models. Rembrandt always lived beyond his means, and eventually had to sell most of his paintings and antiquities to avoid bankruptcy. He died in 1669 in Amsterdam.

"REMBRANDT ASSERTED THAT ONE SHOULD LET ONESELF
BE GUIDED BY NATURE ALONE
AND BY NO OTHER LAW."

Joachim von Sandrart, 17th century

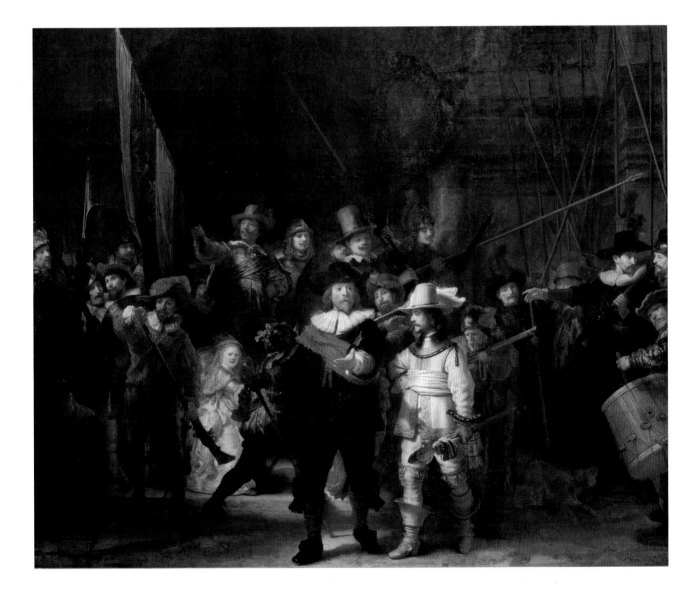

REMBRANDT THE NIGHT WATCH (MILITIA COMPANY OF 1642, oil on canvas, 363 x 437 cm,
CAPTAIN FRANS BANNING COCQ) Rijksmuseum, Amsterdam

Carrying the militia's distinctive symbols, the young girl is their mascot. In terms of color and light, her figure balances the figures in the foreground.

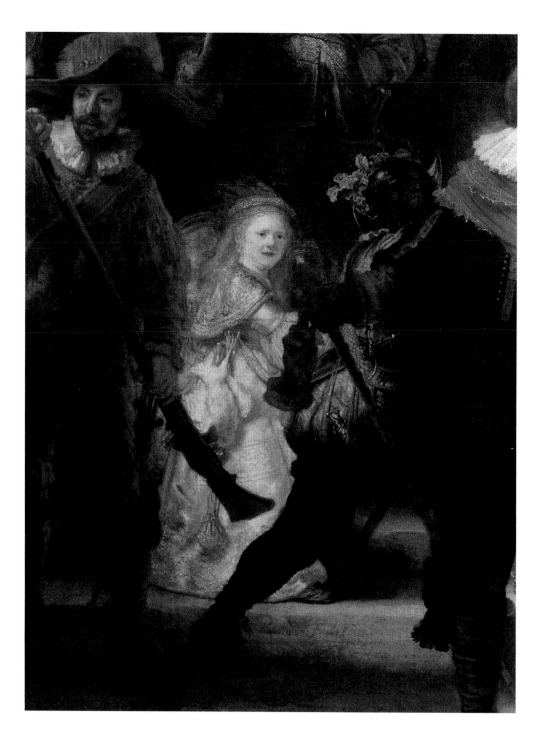

REMBRANDT **THE NIGHT WATCH (MILITIA COMPANY OF CAPTAIN FRANS BANNING COCQ)**

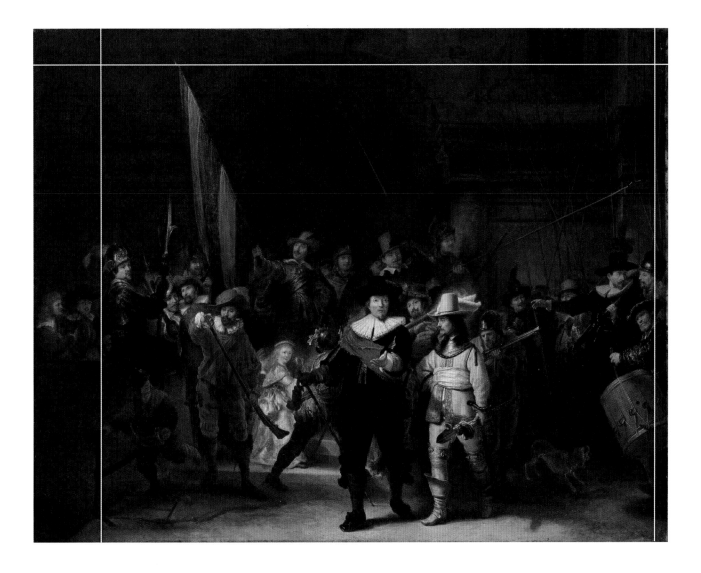

Gerrit Lundens, *The Night Watch
(Militia Company of Captain Frans
Banning Cocq)*, after 1642, oil on
wood, 66.8 x 85.4 cm, The National
Gallery, London
This 17th-century copy of *The Night
Watch* shows how the painting looked
originally, with lines indicating where
it was cut down.

REMBRANDT **THE NIGHT WATCH (MILITIA COMPANY OF
CAPTAIN FRANS BANNING COCQ)**

42

DIEGO VELÁZQUEZ
LAS MENINAS (THE FAMILY OF PHILIP IV)

A complex painting, *Las Meninas* has given rise to a wide range of interpretations. Here Velázquez created a work that is at once an official portrait, a self-portrait, and an intimate court scene set in the artist's studio. He also created a work in which, as though incidentally, we are shown the nature of painting itself.

The painting's original title, *The Family of Philip IV,* which was in common use until the 1840s, provides us with information about what we can plainly see in the image: several members of King Philip IV's royal household, who at the time were treated as family. Occupying a central position—emphasized by the use of light and her pale clothing—we can see the King's five-year-old daughter, the Infanta Margarita Theresa, who is attended by two maids of honor. In the right foreground are portraits of two dwarves, permanent features of the royal household. On the left we can see the painter himself, recognizable by his painter's palette and the large canvas. At first sight, it seems that the most important figure in the royal household, the King, is absent. On closer examination, however, we can see a mirror in the background in which the King and his second wife, Maria Anna, are reflected, albeit indistinctly. They seem to be observing the scene. Velázquez broke with the tradition of portrait painting by integrating the King into the picture through an extraordinary act of deliberate sleight of hand. Also in the background, next to the mirror, a door opens to another room, admitting both a shaft of light and the appearance of the Queen's chamberlain. But it is not just the King, Queen and chamberlain who are observing the scene: the fact that Velázquez, the Princess, the maid of honor on the right, and the dwarf seem to be looking directly out at us (though "in reality" at the King and Queen) draws us into the scenes as witnesses and participants. In addition, the imposing size of the painting and the life-size depiction of the characters help to break down the barrier between the viewer and the painting. Finally, the picture is fascinating as it has raised questions that remain unanswered even today: what inspired the painting in the first place? Is Velázquez painting a portrait of the royal couple, or of the Infanta, or is he painting the maids of honor, *las meninas*? And what is the viewer's role in all this?

DIEGO RODRÍGUEZ DE SILVA Y VELÁZQUEZ was born in 1599 in Seville. At the time the city was a major trading center, and spent the first 24 years of his life there. He was apprenticed to Francisco Pacheco (1564–1654), and was working independently by 1617; in 1618 he married Pacheco's daughter. In his first creative period he focused mainly on religious themes. In 1623 he was made court painter to King Philip IV (r. 1621–1665), a position he held for the rest of his life; as part of his duties he visited Italy 1629–1631, and 1648–1651, to obtain works of art for the royal collections. He died in 1660 in Madrid.

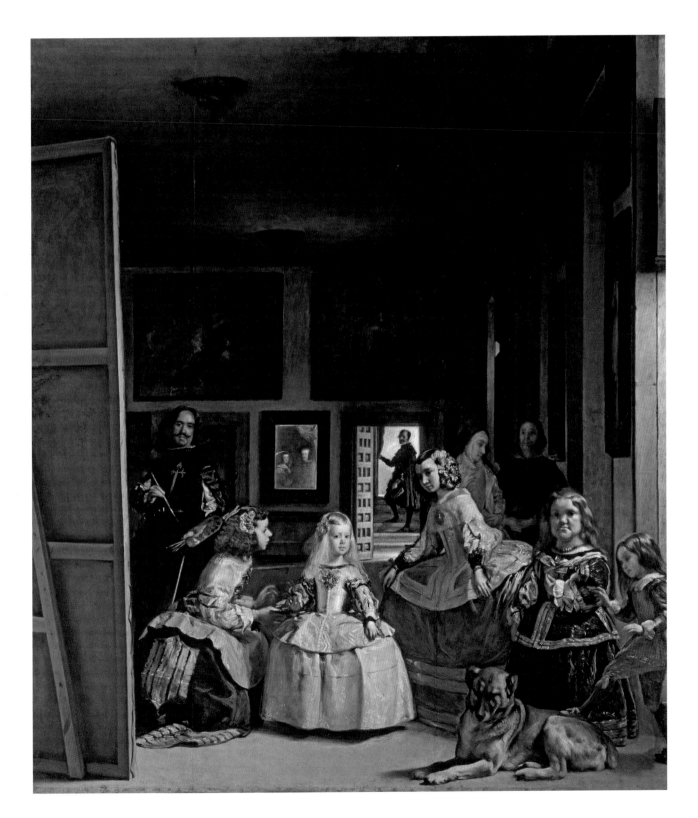

DIEGO VELÁZQUEZ **LAS MENINAS** c. 1656, oil on canvas, 318 x 276 cm,
 (THE FAMILY OF PHILIP IV) Museo del Prado, Madrid

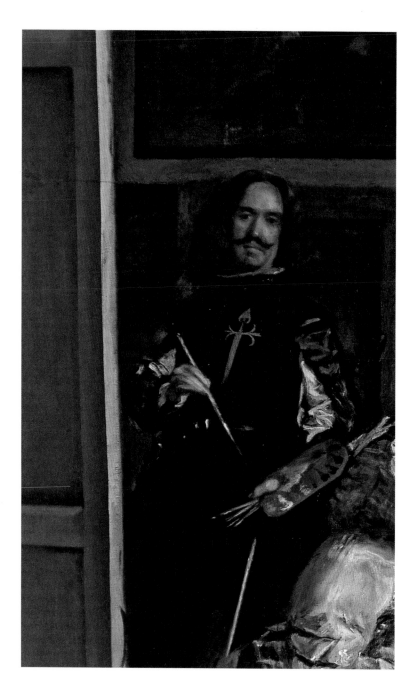

Here the artist is shown as a member of the royal household: the Cross of the Order of Santiago is a clear attribute which points to this being Velázquez himself. It is thought that the king had the Cross added to the picture later on, as Velázquez was only admitted to the order of knights in 1658, two years after he finished the painting.

DIEGO VELÁZQUEZ **LAS MENINAS (THE FAMILY OF PHILIP IV)**

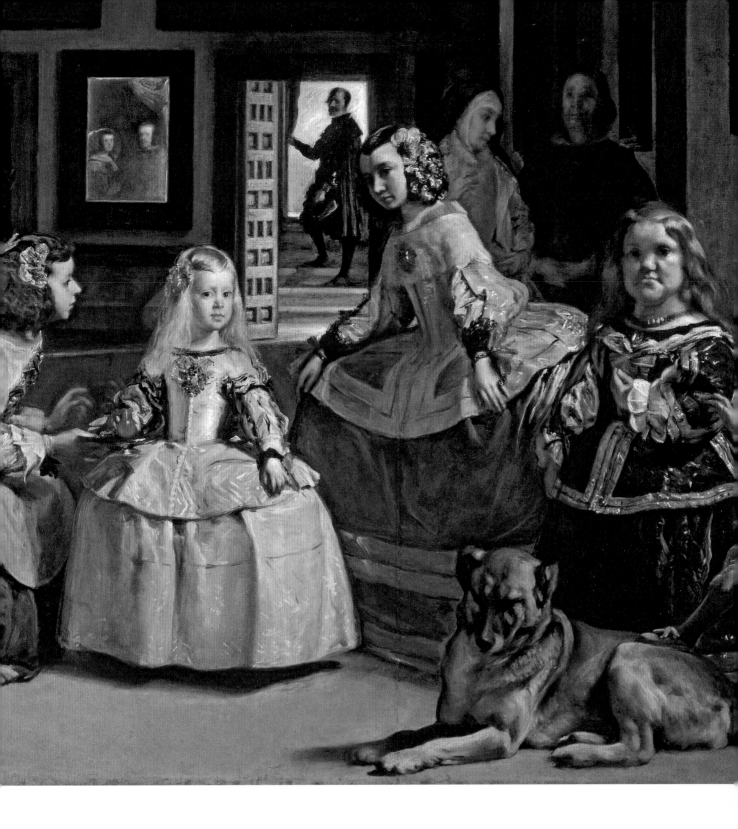

The direct gaze of the Infanta, next
in line to the throne, one of the maids
and one of the dwarves, invite the
viewer into the world depicted in the
painting.

DIEGO VELÁZQUEZ **LAS MENINAS
(THE FAMILY OF PHILIP IV)**

43

JOHANNES VERMEER
GIRL WITH A PEARL EARRING

Johannes Vermeer is considered one of the greatest Dutch painters, yet little is known about him. He left no more than 31 paintings and no drawings. Most of his paintings are domestic interiors, while the celebrated *Girl with a Pearl Earring* comes from a Dutch tradition of studies of heads, without a setting or identification, called *tronies*.

The *Girl with a Pearl Earring*, painted around 1665, was originally called the *Girl with a Turban*, the present title emerging in the mid-20th century. The identity of the girl is unknown, although suggestions include Vermeer's daughter, Maria, or Magdalena van Ruijven, the daughter of his patron. She looks out over her shoulder almost as if we, the viewer, had caught her attention and made her turn. Her figure, set against a dark background, calls out to us. The elaborate Oriental headdress supports the supposition that this is not meant to be a portrait in the traditional sense. Made with just a few deft brushstrokes, the pearl earring is the focal point. The paint has a soft, fluid quality rather than the detail of fine brushstrokes, yet the pearl seems real. In modern times, Vermeer's paintings have been likened to photographs, and it is generally accepted that he was familiar with, or owned, a *camera obscura*, an early optical device that could project an image on to paper or a screen. Certainly the way Vermeer captured subtle changes of light and focus seems to anticipate photography: some features appear in focus, while others seem out of focus, and objects are depicted with a foreshortening that resembles that seen in photographs—this is perhaps one reason why he appeals to us today. Yet Vermeer could not have simply reproduced a *camera obscura* image: his paintings have too much artistry, too strong a power to draw the viewer into a scene, to be mere mechanical reproductions of a projected image. With subtle touches such as her liquid eyes and the way the light falls on her open mouth and bright earring, Vermeer gave his sitter an extraordinary naturalness and vivacity.

Despite his skill, it does not appear that Vermeer was financially successful as an artist. The only evidence of who bought Vermeer's paintings comes from inventories of collections, and it seems that he did not sell his works very widely. Not a single painting can be definitively documented back to his studio, and authentication of his paintings ultimately depends on judgment. Currently, scholars have identified only 31 paintings as almost certainly by his hand.

JOHANNES VERMEER was born in 1632 in Delft. Other than his baptism in October 1632, there are no records of him until April 5, 1653, when the banns for his marriage to Catharina Bolnes were read. Eight months later, the register of the Delft Guild of St. Luke listed his payment to become a master (it is not clear where or with whom he trained). He appears to have had some reputation as a painter, for he was twice elected as vice-dean of the guild, and was also called on as an expert during arbitration over disputed works of art. Economic success, however, seems to have eluded him, and after his death his works had to be sold to pay debts. He died in 1675 in Delft, aged 43.

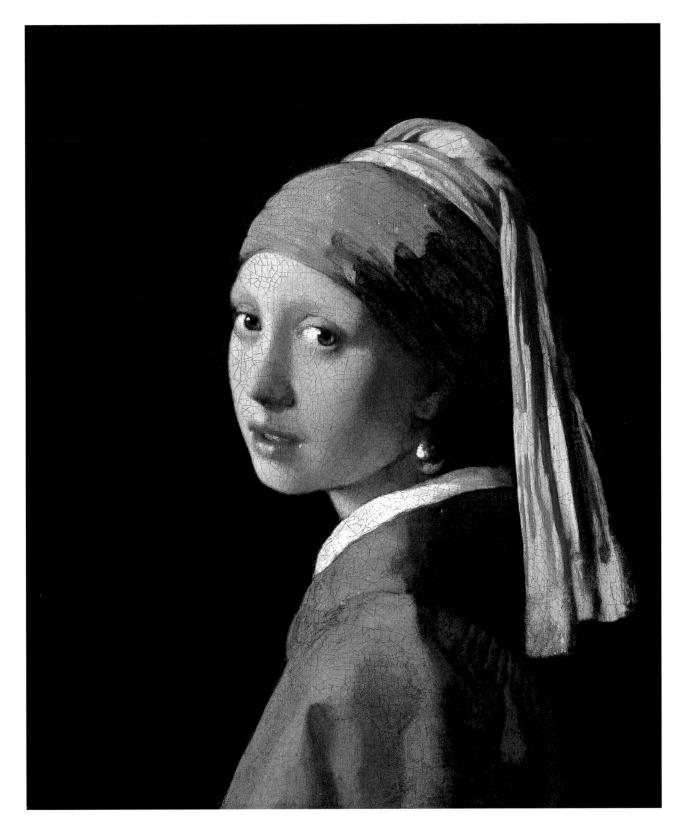

JOHANNES VERMEER **GIRL WITH A PEARL EARRING** c. 1665, oil on canvas, 44.5 x 39 cm,
Mauritshuis Gallery, The Hague

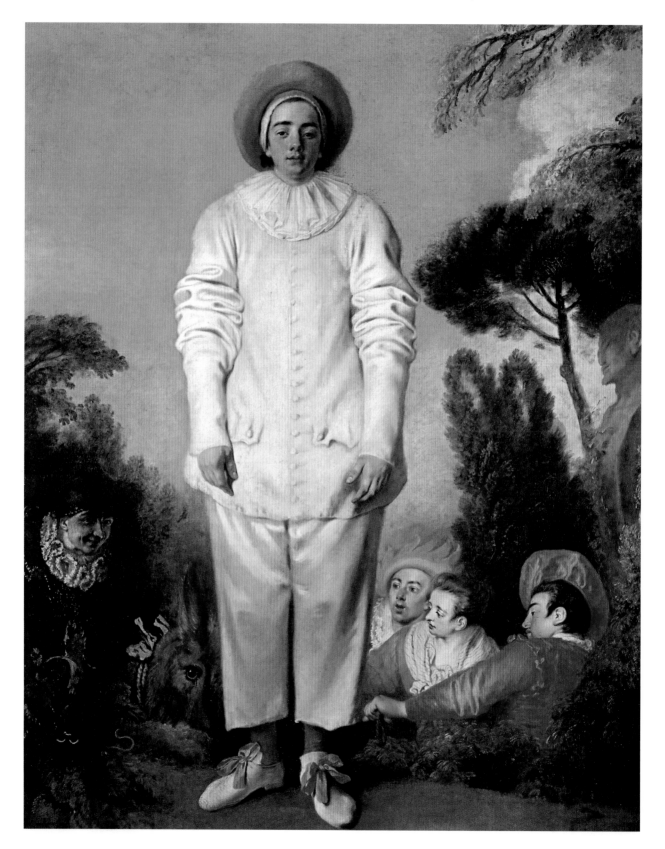

JEAN-ANTOINE WATTEAU **PIERROT, FORMERLY KNOWN** 1718–1719, oil on canvas, 185 x 150 cm,
 AS GILLES Musée du Louvre, Paris

44

JEAN-ANTOINE WATTEAU
PIERROT, FORMERLY KNOWN AS GILLES

This mysterious painting was a bargain. According to the story, the then director of the Louvre bought it in 1804 from a Parisian junk dealer for next to nothing. On the picture there hung the label: "Buy me, I'm so lonely!" In 1869, more than a century after Watteau's death, *Gilles* was exhibited publicly in the Louvre, launching a lively debate that has persisted to this day.

This depiction of a man, unusually large for Watteau, was formerly named *Gilles* after a figure from Parisian carnival. Today it is usually known as *Pierrot*, the French name for the archetypical sad clown Pedrolino or Pagliaccio in Italian Commedia dell'Arte. The picture raises many questions: is it a self-portrait of Watteau as a clown, or a homage to the Italian actors who were allowed to perform again in Paris after the death of Louis XIV? It is possible that the former actor named Belloni commissioned the painting, using it as a shingle hung outside his café. It is also uncertain whether the painting is a portrait or an allegorical depiction. In fact, even its attribution to Watteau is controversial: the work is not mentioned in contemporary sources, nor was it ever seen in Watteau's studio.

Standing in front of a stormy Italian landscape, which resembles a theater backdrop, this life-size Pierrot takes us by surprise: he stands in the foreground, as if he wants to step out of the picture, offset slightly to the left (either a brilliant trick by the artist, or a chance accident of cropping when the painting was framed). His expression is inscrutable: perhaps deeply melancholic, but also, perhaps, just vacant. The repetition of round shapes surrounding his oval head emphasizes his dreaminess, and his pose seems to suggest he might be a hunchback; his posture is that of a whipping boy. Behind him, with no less puzzling attitudes and outfits we can see the *innamorati*, the lovers Leandro and Isabella, and the blustering busybody *Capitano*, characters from the Commedia dell'Arte, as well as a stubborn donkey on a leash, ridden by the *Dottore*. A sculpture bust of a sinister faun peers out of the pine forest.

With his dangling arms, badly cut costume, and smart satin shoes with pink ribbons—what is this clown trying to tell us? That life is a piece of theater? Is his helpless expression the artist's judgment on the futility of life?

ANTOINE WATTEAU was born in 1684 in Valenciennes in northern France, and trained there from the age of 14 to 18. He then moved to Paris, where from c. 1704 to 1708 he was an assistant to Claude Gillot (1673–1722), under whom he developed a preference for Italian theater. He quickly made a name for himself in artistic circles that did not share the aristocratic tastes of the period. As an assistant to the interior decorator Claude Audran III (1658–1734), he had access to the Palais du Luxembourg gallery, where he studied work by Rubens and watched fashionable society promenading in the gardens. He became a member of the Académie in 1712, but only submitted his reception piece, *The Embarkation for Cythera* (1717, Louvre, Paris), five years later. In 1719 he traveled to London. His works helped to establish the genre known as the *fête galante*. He died in 1721 in Nogent-sur-Marne, aged 37.

45

JEAN-BAPTISTE-SIMÉON CHARDIN
THE WASHERWOMAN

Even during his lifetime, Jean-Baptiste-Siméon Chardin's works were highly sought-after collector's items. His still lifes and scenes of everyday life were particular prized, prosaic subjects that acquired a new dignity and meaning through his subtle use of color, texture, and composition, features that can be traced back to Netherlandish painting.

The Washerwoman is one of Chardin's earliest genre paintings, which he began exhibiting in 1737 at the annual Salon in Paris. It is a prime example of the restrained, muted colors and sophisticated play of light for which he became famous. We are looking at a dimly lit laundry room where a young woman, a *blanchisseuse*, has paused briefly over her exhausting work at the washtub and looks up, apparently at a visitor who has just entered. In front of her there sits a child dressed in ragged clothes blowing soap bubbles, and behind him a cat crouches in wait for its prey. In the right-hand corner at the back, a door opens inwards and affords a view of another laundry room, which appears considerably brighter probably because of the fire in a stove. There we see a second woman, her back turned towards us, hanging up washing.

Chardin has depicted the boy in particular in great detail. His use of pale colors draws the viewer's attention directly towards the boy's head. The ragged and colorful array of clothing clearly points to his lowly origins and to the impoverished conditions in which he is growing up. Apparently familiar with his mother's place of work, he plays happily with his soap bubbles.

The washerwoman too is closely observed. Chardin depicts the face of a woman who works hard: she looks bloated from the damp conditions she is exposed to daily, and seems tired and worn out. Her state of permanent stress has brought out red spots on her cheeks. Her face is framed by a long headscarf that hangs down and that would probably be knotted up while she worked.

Her workplace too is rendered with fine nuances: the dark, gloomy room, the large tub in which washing is soaking, a wet cloth lying on a chair all convey confinement, drudgery, and disorder. Despite this, Chardin knew how to draw poetry out of the grind of daily life, and manages to convey a sense of dignity and humanity, qualities in Chardin's work that were appreciated only in later eras.

JEAN-BAPTISTE-SIMÉON CHARDIN was born in 1699 in Paris. After a short apprenticeship under the painter Nicolas Coypel (1690–1734), he moved to the Académie de Saint-Luc in 1724. He exhibited paintings in the Exposition de la Jeunesse as early as 1728, and shortly after this was taken on as an "animal and fruit painter" at the Académie Royale. From 1737 on he exhibited every year at the Paris Salon, and in 1755 he was made responsible for the hanging of paintings at the Salon. In 1743 he was elected to the Committee of the Académie Royale. The still-life paintings he produced after 1751 were highly regarded. In 1772, after an illness, he began working in pastels. He died in 1779 in Paris.

"BUT IF WE STUDY [CHARDIN'S WORKS] IN THE ORIGINAL, WE SOON DISCOVER IN THEM AN UNOBTRUSIVE MASTERY IN THE SUBTLE GRADATION OF TONES AND THE SEEMINGLY ARTLESS ARRANGEMENT OF THE SCENE THAT MAKES HIM ONE OF THE MOST LOVABLE PAINTERS OF THE EIGHTEENTH CENTURY."

Ernst H. Gombrich

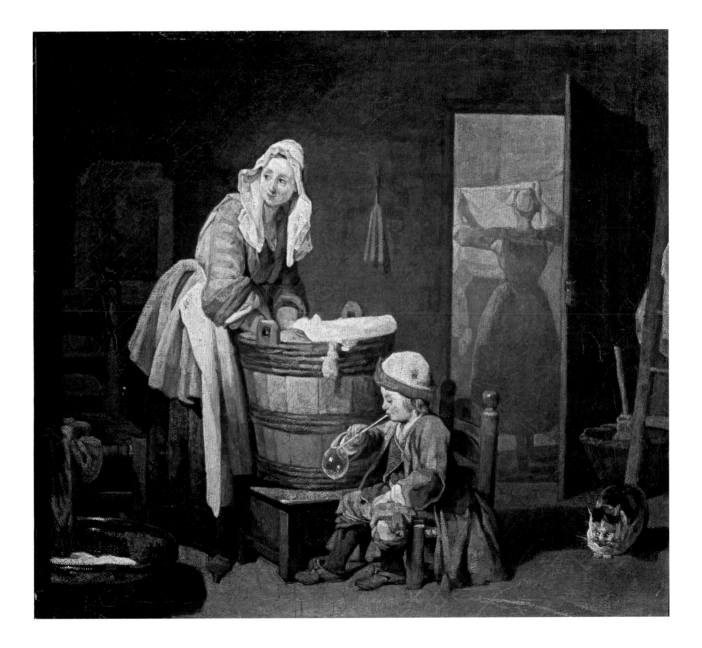

JEAN-BAPTISTE-SIMÉON CHARDIN **THE WASHERWOMAN** c. 1735, oil on canvas, 37 x 42 cm,
The State Hermitage Museum, Saint Petersburg

46

THOMAS GAINSBOROUGH
MR. AND MRS. ROBERT ANDREWS

Thomas Gainsborough is widely considered to be the quintessential English portrait painter of the late 18th century. Although he preferred to paint landscapes, his wealthy patrons wanted portraits. *Mr. and Mrs. Robert Andrews* is an early work by Gainsborough, yet it clearly reveals that his skill in depicting people as well as landscape had already developed. Later, he became a favorite portrait painter of King George III and his circle.

Robert Andrews, a member of the landed gentry, married Frances Mary Carter in Sudbury, Suffolk, in 1748. In doing so, Andrews added to his estate and Gainsborough was soon commissioned to paint a portrait of the newly married couple—and their estate. They are portrayed outside, in front of an oak tree. Mr. Andrews stands with a gun under his arm and Mrs. Andrews sits on a Rococo-style bench. There is an unfinished area in Mrs. Andrew's lap, possibly meant for a child or a dog to be added later. The figures are set off to the left, to better reveal the landscape, the orderly fields, trees and hills. The oak was a symbol of stability and continuity, qualities that would appeal to a landowner. These are real people in a real landscape—the oak tree is still there. In his letters, Gainsborough made his dislike of the upper classes very apparent. They commissioned paintings, however, so he swallowed his pride and became a fashionable portraitist.

Scholars have expressed conflicting interpretations of the portrait *Mr. and Mrs. Andrews*. Some see it as an expression of the pride English landowners felt in their estates and farms. Others see Mr. Andrews as stern, standing assertively with his gun, as if to defend his property, and Mrs. Andrews, dressed in her fancy gown, as quite out of place in the natural world. Yet others suggest Gainsborough moved the couple off to the side so there would be more room for him to show off his ability to paint a landscape. There is no question that *Mr. and Mrs. Andrews* demonstrates Gainsborough's skill in landscape painting as well as in portraiture, even at the young age of 23. While his preference may have been to paint landscapes, his skill in depicting the fabrics and accessories of English life are apparent. Although his skill developed in later portraits, this early work remains one of his most famous, creating a lasting image of the landed gentry of 18th-century England.

THOMAS GAINSBOROUGH was born in 1727 in Sudbury, Suffolk. He trained as a painter in London and set up his studio in Ipswich around 1752. He then moved to the fashionable spa town of Bath in 1759, where more society patrons were to be found; by 1774 he was back in London. His portraits of King George III and the Queen, painted in 1780, soon led to further royal commissions. Gainsborough was a founding member of the Royal Academy, though he often disagreed with other members. After a prosperous career, he died in 1788 in London, aged 61.

"I AM SICK OF PORTRAITS
AND WISH VERY MUCH TO TAKE MY VIOL DA GAMBA
AND WALK OFF TO SOME SWEET VILLAGE
WHERE I CAN PAINT LANDSKIPS AND ENJOY
THE FAG END OF LIFE IN QUIETNESS AND EASE."

Gainsborough, letter

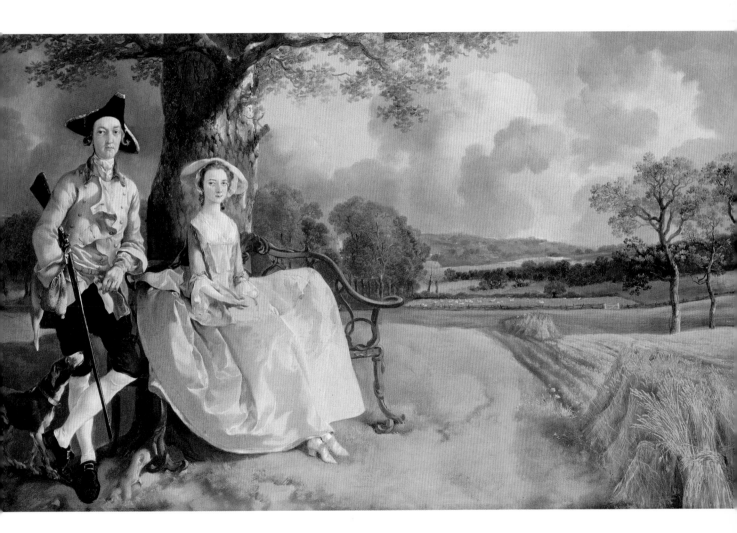

THOMAS GAINSBOROUGH **MR. AND MRS. ROBERT ANDREWS** c. 1750, oil on canvas, 69.8 x 119.4 cm,
The National Gallery, London

47

JEAN-HONORÉ FRAGONARD
THE SWING

Jean-Honoré Fragonard began his career painting historical subjects, but soon adopted the more frivolous, voluptuous style popular at the court of Louis XV of France. Suffused with a carefree sensuality, Fragonard's *The Swing*, perhaps his best-known work, is one of the finest examples of the Rococo style.

The term Rococo comes from the French word *rocaille*, meaning pebble or shell, and came to refer to the decorative motifs used on interiors and grottoes popular in the second half of the 18th century. The style spread to the other arts, including painting. Fragonard became a popular artist with the pleasure-seeking court of King Louis XV, painting scenes of love and playful eroticism. *The Swing* is considered a masterpiece of the Rococo style. In the scene, a young man hidden in the bushes watches a woman being pushed on a swing by an older man, perhaps her husband. The young lover is positioned perfectly to catch a glimpse under the woman's skirts as she flies up on the swing, kicking off her shoe. The shoe flies in the direction of a statue of cupid and the young woman appears complicit in the exchange, as she and her lover deceive the older man. Fragonard painted the scene in glowing pastel colors with soft lighting, which adds to its sensuality. The French aristocrats were enormously wealthy and many chose a life of leisure and romantic trysts. A painting like *The Swing* reflects this spirit of refined and decadent court life on the eve of the French Revolution. It exemplifies Fragonard's skill with delicate brushwork, soft colors, and the subtle use of light and shadow. As the appeal of the Rococo faded after the Revolution, Fragonard tried to adapt to the new Neoclassical style, but without success. He faded into obscurity and died almost forgotten, though today he is considered one of the greatest painters of pre-revolutionary France. The British critic Clive Bell wrote that Fragonard's "personality is not lost in his infatuations: a Fragonard is always a Fragonard, brilliant, lively, succulent, and sometimes bewitching. It would be impossible to fling paint on to a canvas more seductively."

JEAN-HONORÉ FRAGONARD was born in 1732 at Grasse, France. At the age of 18 he began training as a painter, mostly under François Boucher (1703–1770). Fragonard won the Prix de Rome in 1752 but it was not until 1756 that he was able to go to Italy, where he studied and toured. After one of his paintings was bought by Louis XV (r. 1715–1774), Fragonard was in demand with the wealthy aristocrats of the French court. The French Revolution put an end to these patrons. The painter Jacques-Louis David tried to help Fragonard get work in the Neoclassical style popular after the Revolution, but his attempts were largely ignored. He died in 1806 in Paris.

THE COMMISSIONER OF THE PAINTING
INSTRUCTED FRAGONARD TO PLACE HIM
"IN A POSITION WHERE I CAN OBSERVE
THE LEGS OF THAT CHARMING GIRL."

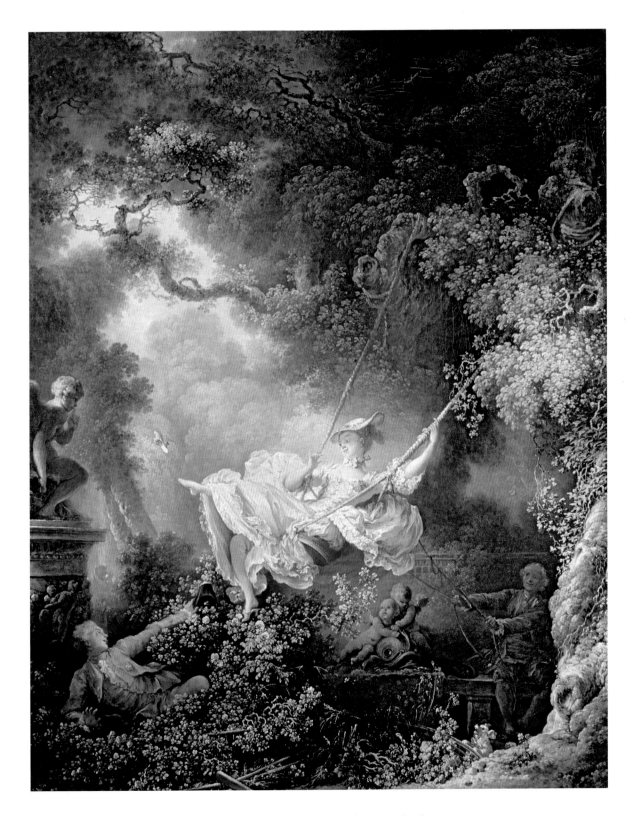

JEAN-HONORÉ FRAGONARD **THE SWING** c. 1767, oil on canvas, 81 x 64.2 cm,
Wallace Collection, London

The young man in the bushes gazes up, peeking under the skirts of his ladylove, while the cupid statue above his head holds a finger to his lips, complicit in their secret romantic tryst. The light focuses gently on the woman, who is depicted in soft, pastel colors to bring out the sensuous nature of the scene.

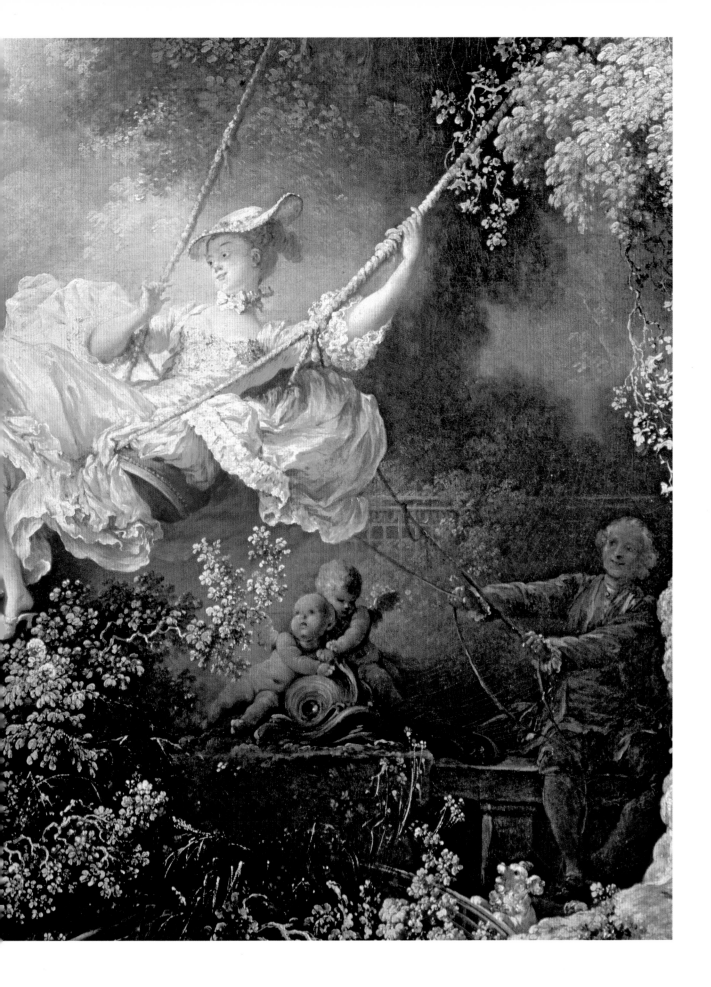

48

JOSEPH WRIGHT OF DERBY
AN EXPERIMENT ON A BIRD IN THE AIR PUMP

The mid-18th century was a time of scientific advances and experimentation referred to as the Age of Enlightenment. In its subject, its precise attention to accurate detail, and its depiction of emotions and ideas, Joseph Wright's *An Experiment on a Bird in the Air Pump* is one of the most striking expressions of the changing character of the age.

Wright was essentially a provincial painter, but had contact with the leading industrialists and thinkers in the English Midlands. His painting of people centered around a bird and an air pump comes out of a tradition of "conversation pieces"—informal group portraits—though Wright's fondness for artificial lighting took this genre in a different direction. *An Experiment on a Bird in the Air Pump* depicts a group of adults and children who have gathered to watch a "philosopher" or traveling scientist demonstrate the use of an air pump to create a vacuum. A white bird flutters inside a globe as the air is withdrawn. Reactions to this experiment vary. The girls are alarmed or sad, the men seem absorbed; the two lovers on the left ignore the experiment altogether. The philosopher, in the center, looks out at the viewer, almost as if asking whether he should continue with the experiment or spare the bird. The only light in the room comes from a candle and the moon outside the window, creating a dramatic effect. Wright's depiction of the scientific apparatus is detailed and correct and the figures are individuals, probably known to him, though the painting was not meant to be a group portrait. Chiaroscuro—contrasts of light and shadow—is used to great effect and adds to the drama of the scene. He was a highly skilled painter, whose attention to details and surfaces was appealing. Wright painted such scenes to appeal to the wealthy, scientific circles in which he moved, which included industrialists Josiah Wedgwood and Richard Arkwright, and the physician and philosopher Erasmus Darwin (grandfather of Charles Darwin). The painting *An Experiment on a Bird* was popular enough to have been copied and circulated in mezzotint engravings, though because of its subject, and because Wright did not live and work in the capital, this type of scene, though admired, had little impact on other artists of the time. Today, this painting, along with other scenes of scientific pursuits by Wright, are considered classic images of the Age of Enlightenment at the beginning of the Industrial Revolution.

JOSEPH WRIGHT was born in 1734 in Derby, England, the son of a lawyer. He taught himself to draw by copying prints and left for London in 1751 to study painting under Thomas Hudson, who also taught Joshua Reynolds. Back in Derby in 1753, Wright painted portraits, landscapes, and scenes illuminated with artificial light, such as candles or lanterns. He lived in Liverpool from 1768 to 1771, painting portraits of the prominent citizens of the city. After traveling to Italy, and then a brief period in the spa town of Bath, Wright returned to Derby, where he remained for the rest of his life, though he sent works to London for exhibition. He died in 1797 in Derby.

"A FOOL IS A MAN WHO
NEVER TRIED AN EXPERIMENT
IN HIS LIFE."

Erasmus Darwin

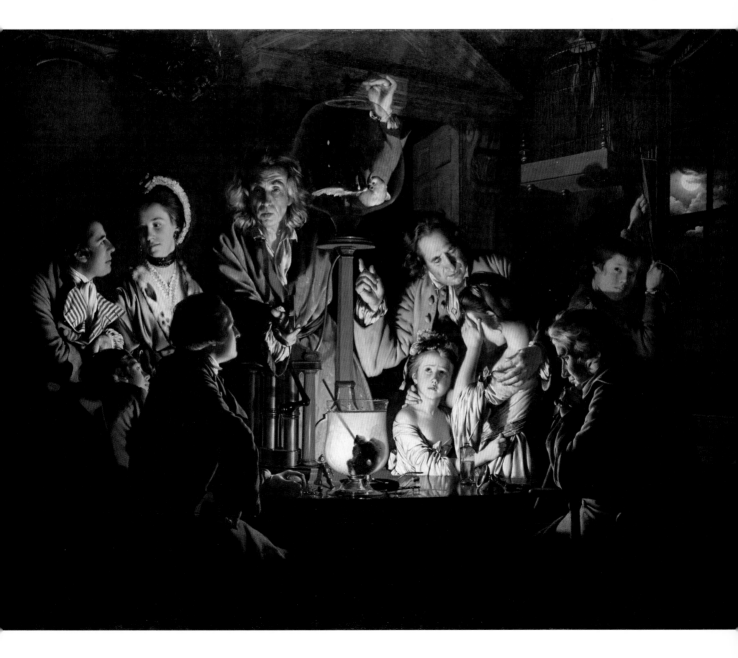

JOSEPH WRIGHT OF DERBY **AN EXPERIMENT ON A BIRD** 1768, oil on canvas, 183 x 244 cm,
 IN THE AIR PUMP The National Gallery, London

right The scientist looks out at the viewers, as if they should decide whether the bird lives or dies.

below The two lovers are more interested in each other than the experiment. The artificial light source throws dramatic shadows on the figures.

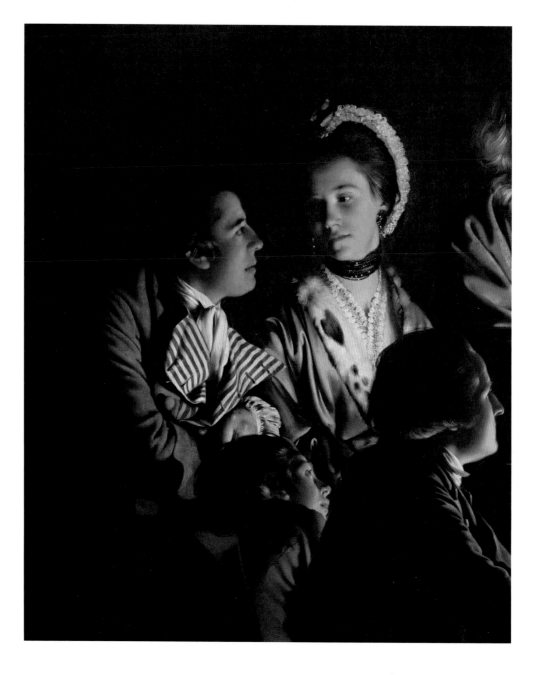

JOSEPH WRIGHT OF DERBY **AN EXPERIMENT ON A BIRD IN THE AIR PUMP**

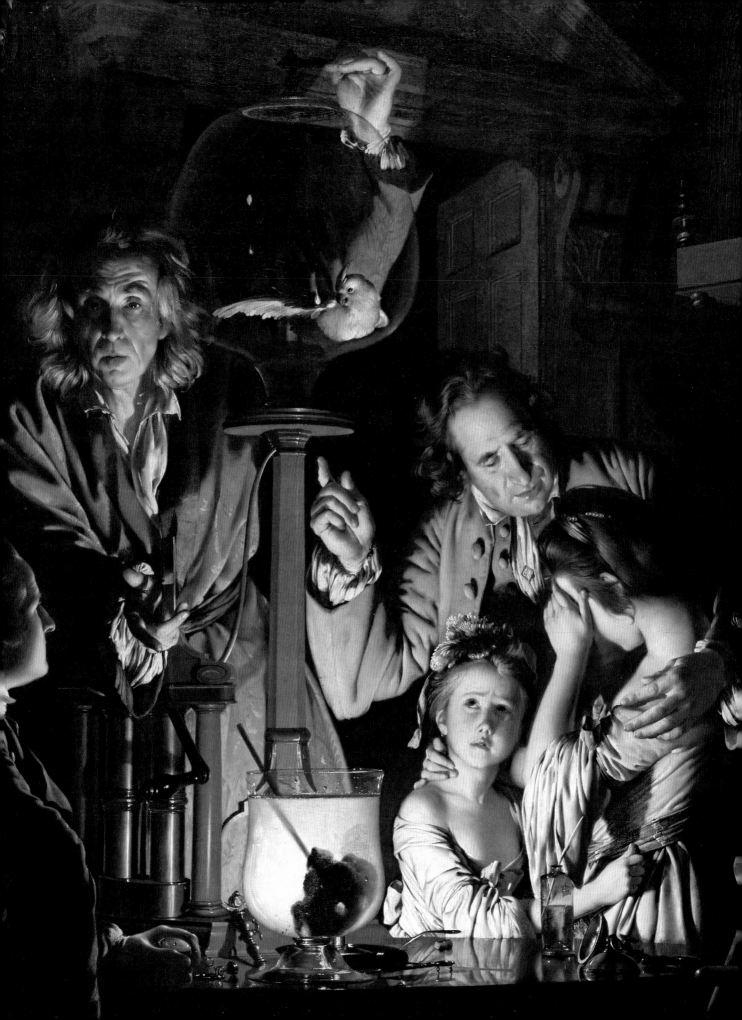

"SHE WAS THERE, LIFELESS AND INANIMATE,
THROWN ACROSS THE BED, HER HEAD HANGING DOWN,
AND HER PALE AND DISTORTED FEATURES
HALF COVERED BY HAIR."

Allusion to *The Nightmare* in Mary Shelley's novel *Frankenstein,
or, The Modern Prometheus*, 1818

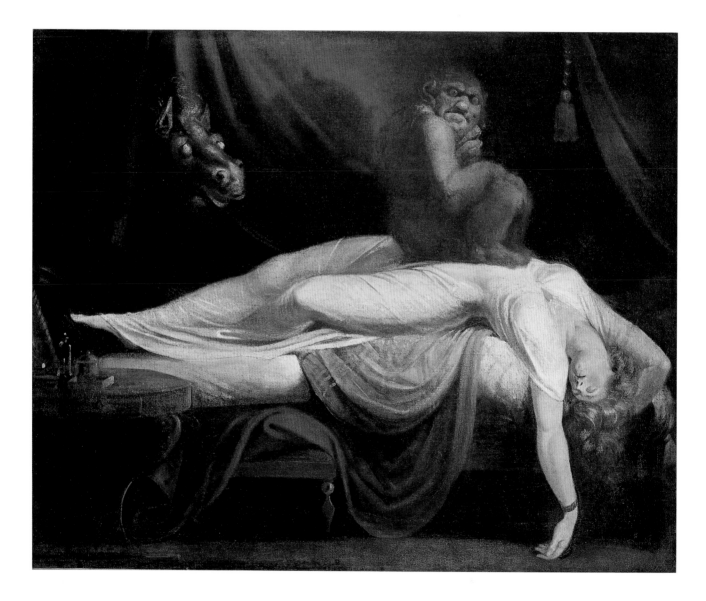

HENRY FUSELI **THE NIGHTMARE** 1781, oil on canvas, 101.6 x 127 cm,
 Detroit Institute of Arts

49

HENRY FUSELI
THE NIGHTMARE

Henry Fuseli was not trained as an artist, originally intending to join the Church. Born in Switzerland, he turned to painting while living in London, becoming a key representative of early Romanticism. With its dramatic, bizarre, and sexually charged depiction of a dreamer and her dream, *The Nightmare* quickly became his most famous work.

While living in London, Fuseli supported himself primarily by writing on art, until persuaded by Sir Joshua Reynolds to try his hand at painting. Supernatural subjects appealed to Fuseli and he believed that exaggeration is sometimes necessary to convey a work's meaning. The first of his paintings to attract attention was *The Nightmare*, exhibited in 1781. The painting was controversial, yet so popular that it made Fuseli's name and he subsequently painted several versions of the scene. In *The Nightmare*, a young woman, dressed in white, lies on her back, her head hanging down over the side of her bed, her pale neck exposed. An incubus, or male demon, sits on her and looks out at the viewer. A horse with wild eyes peers from behind a curtain. Both figures refer to the meaning of the word "nightmare." Fuseli portrays the sleeper and her dream at the same time. Some contemporary critics were shocked by the erotic nature of the painting. Later interpretations of the image have varied greatly, ranging from the belief that it was inspired by Fuseli's rejected marriage proposal, to the claim that it anticipates Freud's concept of the unconscious. Fuseli himself offered no explanations. The woman's vulnerable position and her white nightdress may represent innocence, in contrast to the dark, shadowy incubus and the wild horse, which represent her nightmare. The painting was so famous in its day that may have influenced literature as well as art. A scene in Mary Shelley's *Frankenstein* (1818) recalls Fuseli's painting and in Edgar Allan Poe's *Fall of the House of Usher* (1839) a painting in Usher's home recalls the work of Fuseli. Although he was a respected painter in his lifetime, Fuseli's work was later considered eccentric and unimportant, until he was rediscovered in the 20th century by the Expressionists and Surrealists as a precursor to their own work.

HENRY FUSELI was born Johann Heinrich Füssli in 1741 in Zurich, the son of a successful painter. He was intended for the Church and took holy orders in 1761. However, for political reasons he had to leave Switzerland and in 1765 settled in England. Initially supporting himself by writing, after showing his drawings to Sir Joshua Reynolds, Fuseli began to paint for a living. In 1770 he went to Italy to study the art there, returning to England in 1779. Fuseli's dramatic, emotionally charged paintings and drawings gave him a successful career. He died in 1825 in London.

right Henry Fuseli, *The Nightmare*, 1781, oil on canvas, 76.5 x 63.6 cm, Goethemuseum, Frankfurt am Main
The sleeping woman's position was thought to evoke nightmares and is quite sensuous.

below In mythology, an incubus is a male demon who visits women while they are asleep to have sexual relations with them.

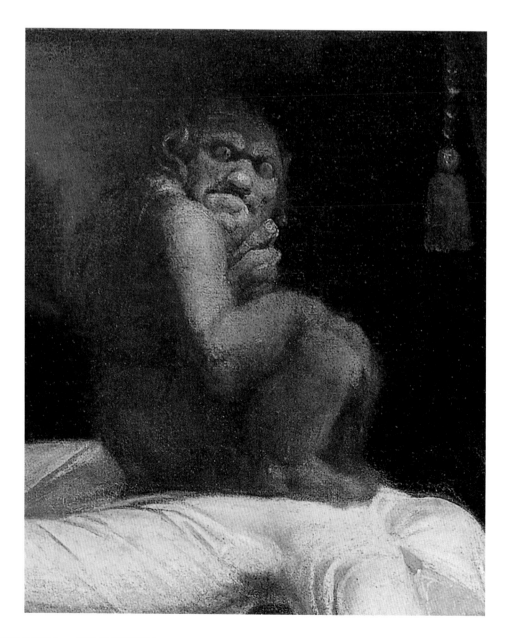

HENRY FUSELI **THE NIGHTMARE**

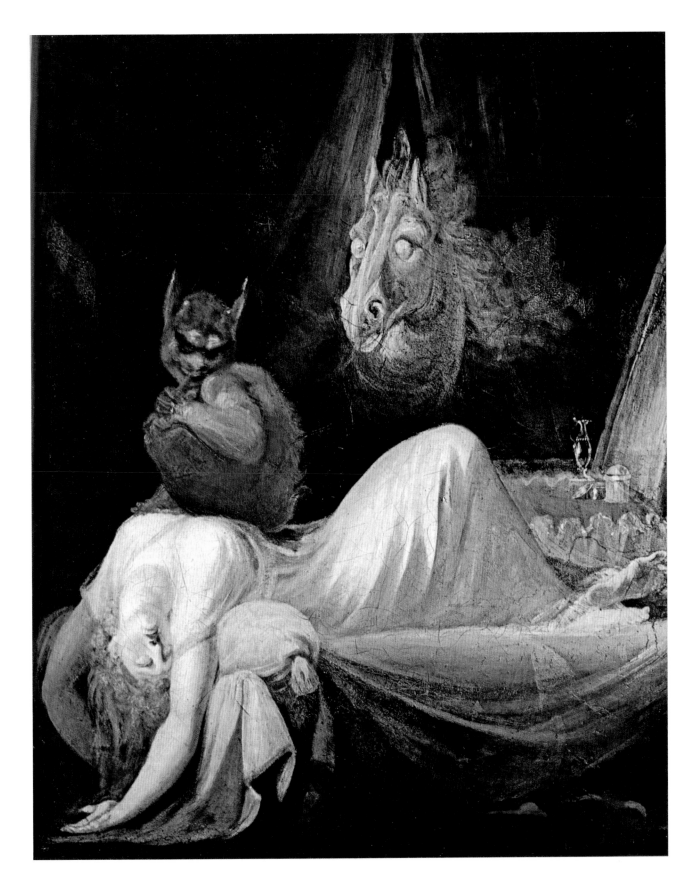

HENRY FUSELI **THE NIGHTMARE**

"THESE ARE THE MOST LIFELIKE PICTURES THAT HAVE EVER BEEN MADE AND I WOULD LIKE TO HAVE MORE OF THEM."

Marie-Antoinette

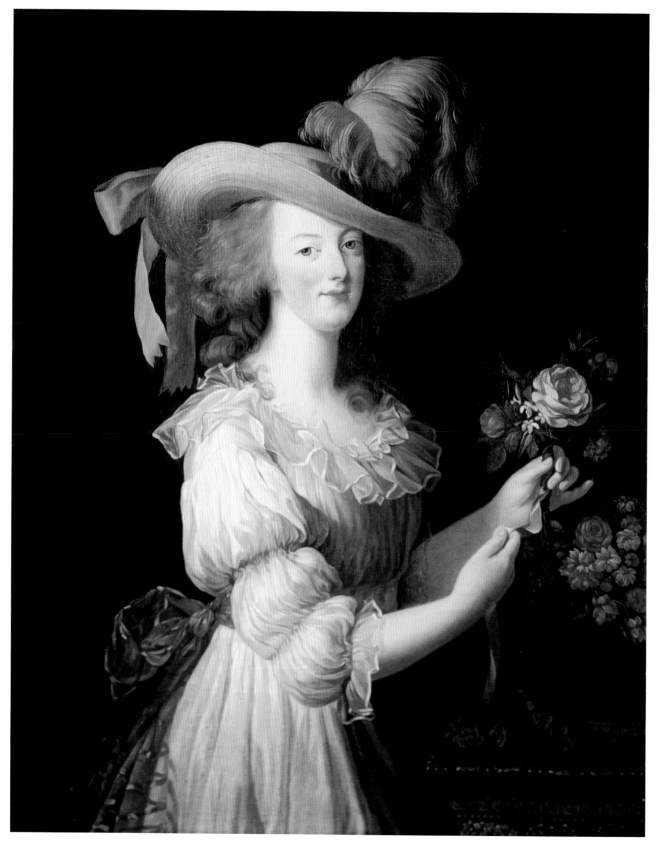

ÉLISABETH VIGÉE-LEBRUN **MARIE ANTOINETTE EN GAULLE** 1783, oil on canvas, 93.5 x 79 cm, Hessische Hausstiftung

50

ÉLISABETH VIGÉE-LEBRUN
MARIE ANTOINETTE EN GAULLE

In this picture a young woman looks directly, perhaps questioningly, at the viewer. Dressed in a fashionable *chemise à la reine*, she is tying a bouquet of roses. What looks like an elegant, informal portrait of an upper-class daughter is actually a portrait of the French Queen Marie-Antoinette. When it was first seen it caused a sensation in France, with visitors to the Paris Salon accusing the artist of *lèse-majesté*—it was swiftly replaced by another, official, portrait.

As a new member of the Académie, Élisabeth Vigée-Lebrun exhibited for the first time at the Paris Salon in 1783, showing this portrait of the then 27-year-old Marie-Antoinette. In it the queen is wearing a simple, frilled muslin dress, tied at the waist with a golden gauze sash, and a straw hat with ostrich feathers. Critics found fault in the fact that the queen had allowed herself to be painted in her blouse, and they considered her majesty's "informal look" unsuitable for public display. In her role as a member of the royal family, style-conscious Marie-Antoinette was not actually permitted very much leeway in experimenting with fashion. Indeed, she was not allowed to appear in public as a private individual. Her role was public. Vigée-Lebrun's portrait fulfills no political function and the royal context is played down in favor of a delicate portrayal of a young woman. It matters little in this context that this half-length portrait was one of the queen's favorite paintings (she had four copies made and gave them away as gifts) and that Vigée-Lebrun was her favorite painter. In the eyes of the public, and in the tradition of the *ancien régime*, the royal portrait had to follow an established iconography, with rich fabrics, expensive jewelry, elaborate décor, and a well-established symbolism being used to maintain the dignity of the monarchy and therefore of France. Vigée-Lebrun also painted official portraits of the queen, but she preferred private depictions. These were clearly not suitable for public display, but they allowed Vigée-Lebrun to show that she was not only Marie-Antoinette's portrait artist, but also her intimate friend, who had access to the queen's private life as part of her circle of confidants.

She was very well aware of the prospective scandal surrounding this casual portrait, perhaps accepting it gratefully as a form of self-promotion. After the start of the French Revolution, however, her good relations with the court became her downfall. When the crowds stormed the Palace of Versailles in October 1789, Vigée-Lebrun was forced to flee abroad with her daughter.

ÉLISABETH VIGÉE-LEBRUN was born in 1755 in Paris. At a time when women artists were rare, she first received training under her father, the portrait painter Louis Vigée (1715–1767). She became a member of the Académie de Saint Luc in 1774 and of the Paris Académie in 1783. From the completion of her first portrait of Marie-Antoinette to the start of the French Revolution, Vigée-Lebrun enjoyed the protection of the queen. She was a masterly colorist and also produced history paintings and nudes, though these were only a minor part of her oeuvre. In 1789 she escaped into exile with her daughter and became a sought-after portraitist to European nobility. Returning to Paris in 1802, she was unable to recreate her former successes, as by then her style was considered dated. She died in 1842 in Paris.

"THIS WORK CONTAINS SOMETHING BOTH POIGNANT AND TENDER;
A SOUL IS FLOATING IN THE COLD AIR OF THIS ROOM,
ON THESE COLD WALLS, AROUND THIS COLD FUNERARY TUB."

Charles Baudelaire

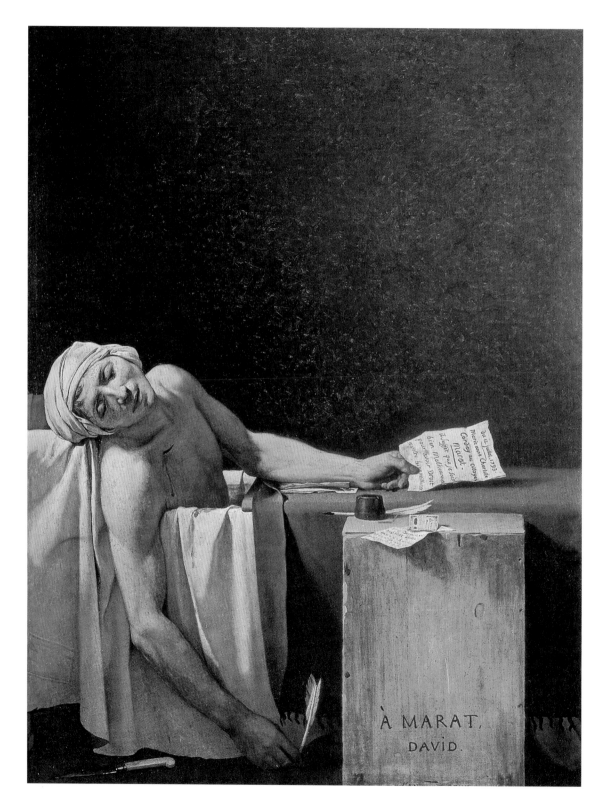

JACQUES-LOUIS DAVID **THE DEATH OF MARAT** 1793, oil on canvas, 165 x 128 cm,
Musées Royaux des Beaux-Arts de Belgique, Brussels

51

JACQUES-LOUIS DAVID
THE DEATH OF MARAT

The Death of Marat cast politician and journalist Jean-Paul Marat in the role of a martyr and folk hero. One of the most famous images of the French Revolution, and an icon of the political events that unfurled after 1789, its influence was felt in numerous later paintings, including one by Edvard Munch, and also in works for the stage.

A physician and natural scientist, Swiss-born Jean-Paul Marat (1743–1793) became one of the major figures of the French Revolution. A leading journalist in the newly founded French Republic, he was elected as a member of the National Convention that, after the abolition of the monarchy, governed the country between 1792 and 1795. During the evening of July 13, 1793, as he was taking one of the cooling baths that he had to take several times a day to ease a skin disease, a Girondin sympathizer, Charlotte Corday, stabbed the defenseless Marat: she regarded him as the cause of the Reign of Terror being waged against political opponents of the Revolution.

Immediately after his death a cult sprang up around Marat, such as had only previously been accorded to Christian saints or kings. The cult was expressed in this painting by party member Jacques-Louis David. The painting depicts Marat against a bare interior in his dying moments. His right hand still holds his quill pen, and his left clutches the letter from his murderess. The dramatic lighting and complete lack of a figurative background—the upper half of the picture is a dark, diffuse plane of color—create a kind of theatrical set against which Marat is presented to the viewer. In the lower half of the picture every detail underscores the picture's intended message: the sheet against which the upper body rests, the overly long, limp right arm, and the stab wounds are all motifs borrowed from Christian iconography. On the wooden packing case, on which we can read the artist's signature as well as his dedication to Marat, there lies Marat's last letter, a donation of money to a widow of the Revolution: thus the dead man was transformed into a hero and savior, a secular saint.

In *The Death of Marat*, David created an icon of the newly secularized France that was immediately used for propaganda purposes: four months after the assassination, David gave the finished painting to the National Convention, where it hung in the assembly hall until 1794. The letter in Marat's outstretched left hand is addressed to "citoyen Marat": in the artist's vision the citizen becomes the redeemer of the revolutionary movement. Just a few years later it seemed that the movement was still alive, as David was elevated to the position of First Court Painter to the Emperor Napoleon.

JACQUES-LOUIS DAVID was born in 1748 in Paris. After studying in Italy, where he encountered the art of ancient Rome, Raphael, and Guido Reni, he was admitted to the Académie Royale de Peinture et de Sculpture in Paris, where he produced paintings on themes from antiquity, including his *Oath of the Horatii* (1784, Louvre, Paris). During the French Revolution he was a member of the National Convention, and responsible for its feasts and celebrations. After Napoleon seized power David became *premier peintre* to the imperial court. In 1816 he was driven from France, and went to live in exile in Brussels. He died in 1825 in Brussels.

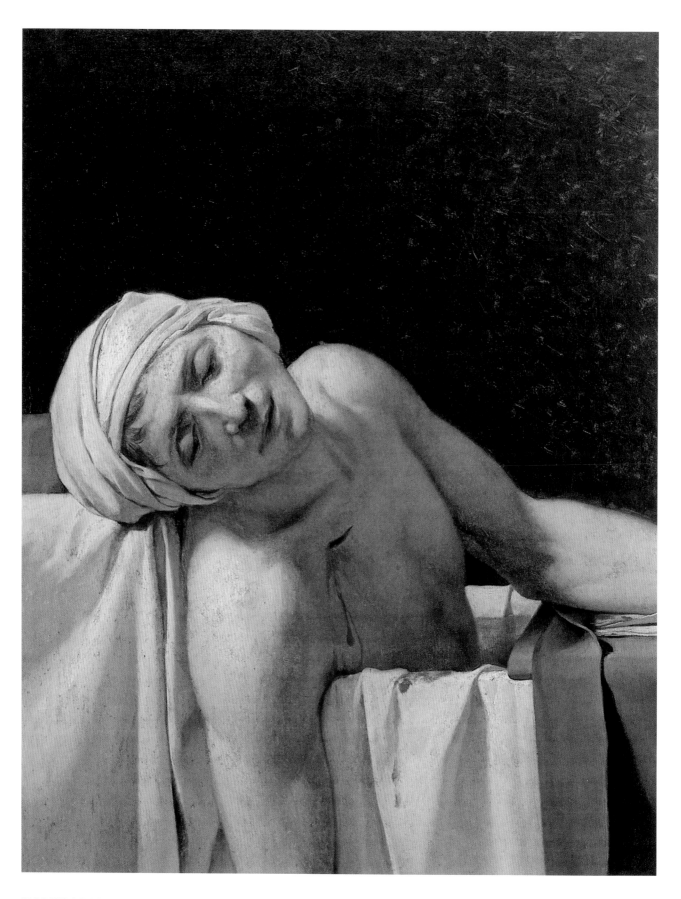

JACQUES-LOUIS DAVID **THE DEATH OF MARAT**

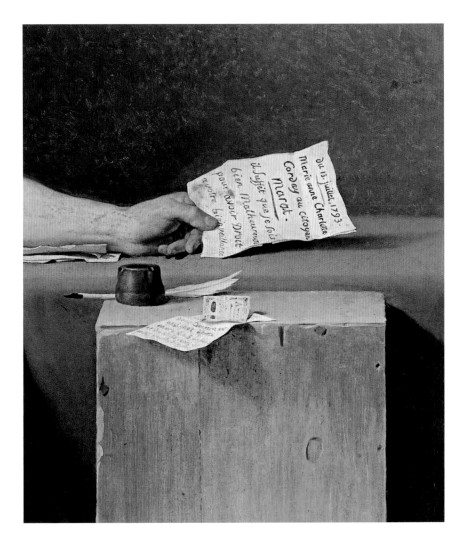

above Charlotte Corday's letter that Marat holds in his left hand, and that in reality never existed, reads: "July 13, 1793. Marieanne Charlotte Corday to Citizen Marat. Because I am unhappy I have the right to call on your goodwill." Among Marat's papers we can read his answer to the begging letter: "Give this money to the mother of five children whose husband died for his country."

left The position of the dead man, as well as the stab wound below his right collarbone, recall depictions of the Entombment of Christ.

JACQUES-LOUIS DAVID **THE DEATH OF MARAT**

52

JEAN-BAPTISTE REGNAULT
FREEDOM OR DEATH

A young man, depicted in the form of Mercury, shows the world the two sides of a heroic decision, presenting a choice that is not in fact a real choice: freedom or death. The idea of freedom and its destructive power are made clear in Jean-Baptiste Regnault's allegory of revolution, while also leaving much open to misinterpretation.

Through this allegory, which he completed in 1793–1794 during the Jacobins' Reign of Terror and which was commissioned by the National Convention, Jean-Baptiste Regnault expressed his whole-hearted enthusiasm for the Revolution. Personified in the form of a Mercury-like boy, the Spirit of France hovers over the globe, encouraging devotion to the motherland. While the young man's task began in Republican France, he is literally addressing the entire world from his heavenly sphere. Bearing the colors of the French tricolor, his wings allow him to hover between personifications of Death and Freedom. His pose recalls that of Christ on the Cross, and burning above his head is the flame of passion for a great ideal. On his right, Freedom, dressed in a white antique-style costume, sits on a fragment of an equally ancient column: a bundle of sticks, the fasces, symbol of the Republic, lies at her feet. She carries a setsquare and holds up a Phrygian cap (symbol of the French Revolution). Opposite her, also on a cloud, sits Death, his scythe resting on his shoulder, his hand holding a laurel wreath. Regnault offers Freedom or Death, only to remove the alternatives at once: the Spirit of France turns to the viewer with open arms, embracing the images both of Freedom and of Death with his wings: "He who embraces the Spirit of France, also embraces the Republic, and Death." Freedom, just as much as Death, is worth striving for, indeed Death is the foundation of the Revolution, which requires sacrifice for the motherland.
Contemporary critics disliked the painting: in the first instance they disapproved of the freedom of choice presented by the "or" of the title. Later, the image of Death brought back memories of the Terror under Robespierre. The original painting was never shown in public; it disappeared into storage, and remains lost. A smaller version, made for a competition, ended up in Hamburg, and was later gifted to the city's Kunsthalle.

JEAN-BAPTISTE REGNAULT was born in 1754 in Paris. He was apprenticed to the history painter Jean Bardin (1732–1809), who took him to Rome in 1768. Back in Paris in 1772, he worked first in the studio of Nicolas-Bernard Lépicié. However, when in 1776 he won the Prix de Rome with his *Alexander and Diogenes* (École National Supérieur, Paris), he returned to Rome, spending the next four years alongside Jacques-Louis David and Jean-François-Pierre Peyron at the Académie de France. Until 1787 he signed his pictures "Renaud de Rome" in order to distance himself from the Mannerist style of French painting, which was popular before David. He died in 1829 in Paris.

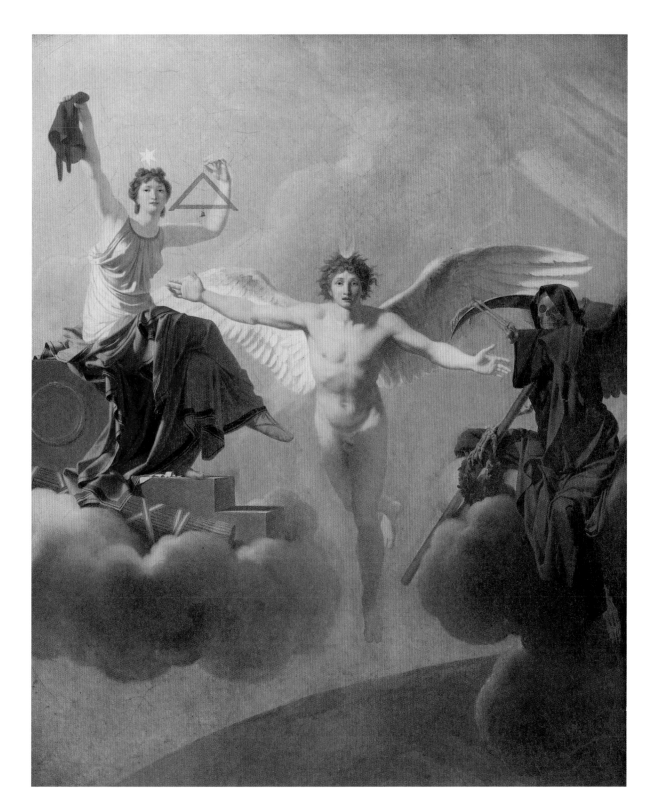

"NO ONE DEPLORES THE SPILLING OF BLOOD MORE THAN I;
BUT TO PREVENT RIVERS OF BLOOD FROM BEING SPILT,
I URGE YOU TO SPILL JUST A FEW DROPS."

Marat on the continuation of the Revolution,
August 10, 1792

JEAN-BAPTISTE REGNAULT **FREEDOM OR DEATH** 1795, oil on canvas, 60 x 49 cm,
Kunsthalle, Hamburg

53

PHILIPP OTTO RUNGE
THE HÜLSENBECK CHILDREN

In *The Hülsenbeck Children,* Philipp Otto Runge depicted the three children of his friend Friedrich August Hülsenbeck in their garden in Eimsbüttel, just outside Hamburg: five-year-old Maria and four-year-old August are seen pulling two-year-old Friedrich in a handcart behind them. Though it might seem to present a simple scene, this painting revolutionized the representation of children, who for the first time in art are seen as independent individuals.

The portrait shows energetic children who, without any parental supervision, are masters of their world—and even of the natural world beyond their garden fence. Runge's conception of what it was to be a child was completely new: the adult world is not imposed on these children, and they are neither idealized nor prim, neither precocious nor affected. Rather, they demonstrate how consciousness develops in different age groups. Thus the world of children is seen as something they create themselves, consciously opposed to the world of grown-ups. The senses of the youngest child in the handcart are still uncoordinated, and he takes in impressions of his surroundings without reflection. With no real understanding of what is happening, he looks wide-eyed at the viewer, clutching intuitively at a sunflower. By contrast, his older brother is already able to act in a coordinated and planned way. He raises his hand to crack the whip, seeking out the viewer's gaze directly. At the same time, his left hand grips the shaft of the handcart firmly. The oldest of the three children, on the other hand, takes on a controlling role. She too holds onto the shaft, and with her outstretched hand seems to want to indicate to the youngest to let go of the flower. By contrast with her brother standing alongside her, she is not only aware of her own actions, but is already able to think through the consequences of actions and to take responsibility, which prompts her to intervene. In her rational behavior she has left the complete naturalness of childhood behind.

The large format of the painting means that the viewer is not looking down on the children from above, but enters into their world, where sunflowers are just as big for the viewer as they are for the children. This monumental effect is striking. Daily life is frozen and raised to a higher, more universal, level. At this level, the painting embodies the morning of life, an archetype of origins and beginnings, innocence and becoming. The children are starting their lives on an inescapably prescribed course, which leads them from the untamed natural paradise of childhood to the socialized existence of the adult world.

PHILIPP OTTO RUNGE was born in 1777 in Wolgast, in eastern Germany. In 1795 he was apprenticed to a shipping company, but took private art lessons and later studied at the Academy in Copenhagen. In 1801 he settled in Dresden, where he mixed in literary as well as artistic circles. A leading figure in the development of German Romanticism, he rejected the rules of academic painting and appealed to sensibility as the source of his art. He is best known for allegorical works, such as *Morning,* which took as its subject the start of the day and of an individual's life. He also produced silhouettes, developed a system of colors harmonies, and wrote fairy tales, including a story published by the Brothers Grimm, *The Fisherman and his Wife.* He died in 1810 in Hamburg.

"A CHILD LIVES AS IF IN PARADISE, UNAWARE AND BLESSED;
BUT WHEN IT STARTS TO LEARN, SIN ARRIVES.
THIS IS ORIGINAL SIN, WHICH EXISTS ONLY IN THE WORLD,
SINCE LEARNING SEPARATES BODY AND SOUL."

Philipp Otto Runge

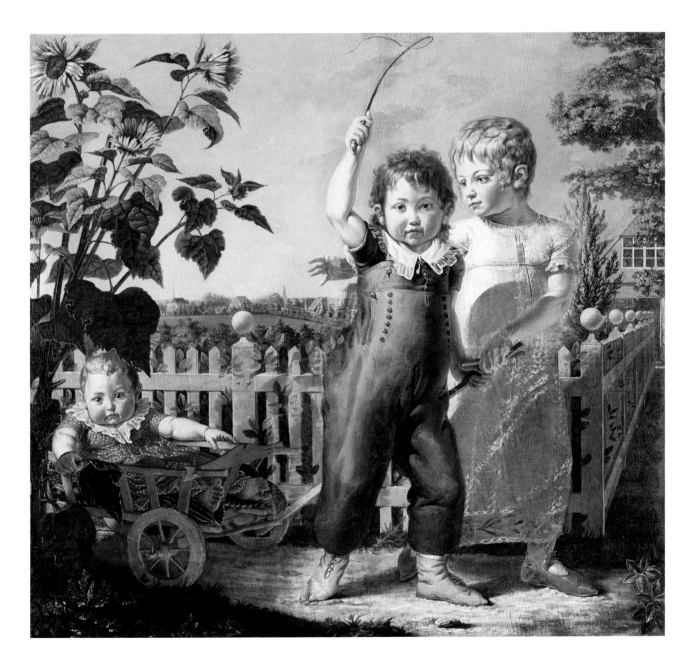

PHILIPP OTTO RUNGE **THE HÜLSENBECK CHILDREN** 1805–1806, oil on canvas, 131.5 x 143.5 cm,
Kunsthalle, Hamburg

"FOR, WERE YOU TO PONDER FROM MORNING UNTIL EVENING,
FROM EVENING UNTIL DEEP MIDNIGHT, YOU COULD NEVER UNDERSTAND,
NEVER FATHOM THE UNINVESTIGABLE HEREAFTER!"

Caspar David Friedrich on *The Monk by the Sea*

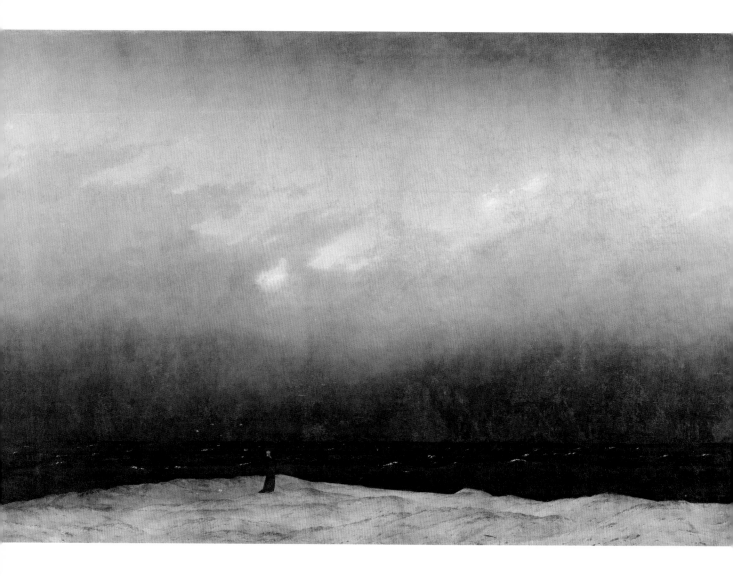

CASPAR DAVID FRIEDRICH **THE MONK BY THE SEA** c. 1808–1810, oil on canvas, 110 x 171.5 cm,
Alte Nationalgalerie, Staatliche Museen, Berlin, Preussischer Kulturbesitz

54

CASPAR DAVID FRIEDRICH
THE MONK BY THE SEA

When, at the Berlin Academy exhibition in the fall of 1810, Caspar David Friedrich showed his *Monk by the Sea* for the first time, public opinion was sharply divided. The Prussian King Friedrich Wilhelm III liked the painting so much that he bought it, together with its pendant, *The Abbey in the Oakwood.* Others, however, found it disconcerting, and even today it is still one of Friedrich's most controversial paintings.

With its enigmatic and starkly reduced subject matter, this was perhaps the most radical picture of its time. Friedrich re-worked it fundamentally at least four times, reducing the focus more and more. But the figure seen from behind, typical of Friedrich's work, is not part of the scenery here: the man, small and unimposing, stands facing the immensity of nature itself, his head resting on his hand in profound reflection.

Friedrich's own opinion of the painting—it is one of the few for which a commentary by the artist has survived— reveals a deeply religious sense that characterizes his entire oeuvre: thus the man, lost in thought, surrounded by anxiously screeching seagulls flying around him, is an image of human hubris in the face of the overpowering nature of God. "Wantonly presumptuous, you have delusions of becoming a beacon to the afterlife, of deciphering the darkness of the future! Which is only ever sacred intuition, to be seen and recognized only in belief; to know and to understand clearly at last! … Your footprints in the bleak, sandy shore may be deep, but a quiet wind wafts across them and your tracks are no more to be seen; foolish man filled with vain presumption!" Thus, in his struggle, man comes to grief. All that is left is humble self-restraint, alongside the hope, represented in the pendant, *The Abbey in the Oakwood* (1808–1810, Schloss Charlottenburg, Berlin), of reaching eternal life through faith. But the wide-open space of the picture leaves ample room for the viewer's own projections, as there are no clear symbols or allegories to indicate a specific interpretation. In this way, Friedrich's paintings remain an open book for each generation and for the ideas of the individual viewer. In the *Berliner Abendblätter,* the news-paper edited by the playwright and poet Heinrich von Kleist, there appeared in 1810, under the title "Thoughts on Friedrich's Seascape," a description of the painting that remains striking: "No situation in the world could be more sad and eerie than this—as the only spark of life in the wide realm of death, a lonely center in a lonely circle … since in its monotony and boundlessness it has no foreground except the frame, when viewing it, it is as if one's eyelids had been cut away."

CASPAR DAVID FRIEDRICH was born in 1774 in Greifswald, northern Germany. He began his art studies at the University of Greifswald and then moved to the Academy in Copenhagen, where he studied 1794–1798. He settled in Dresden in 1798, and his first major (and controversial) work was *The Cross in the Mountains* (1807, Gemäldegalerie, Dresden). Occasionally Friedrich enjoyed great success: in 1805 he won a prize in Weimar organized by Goethe, in 1810 he was made a member of the Berlin Academy of Arts, and one of his admirers was the Russian Grand Duke Nikolai Pavlovich. However, during his lifetime his Romantic landscapes frequently provoked heated critical debates. He died in 1840 in Dresden.

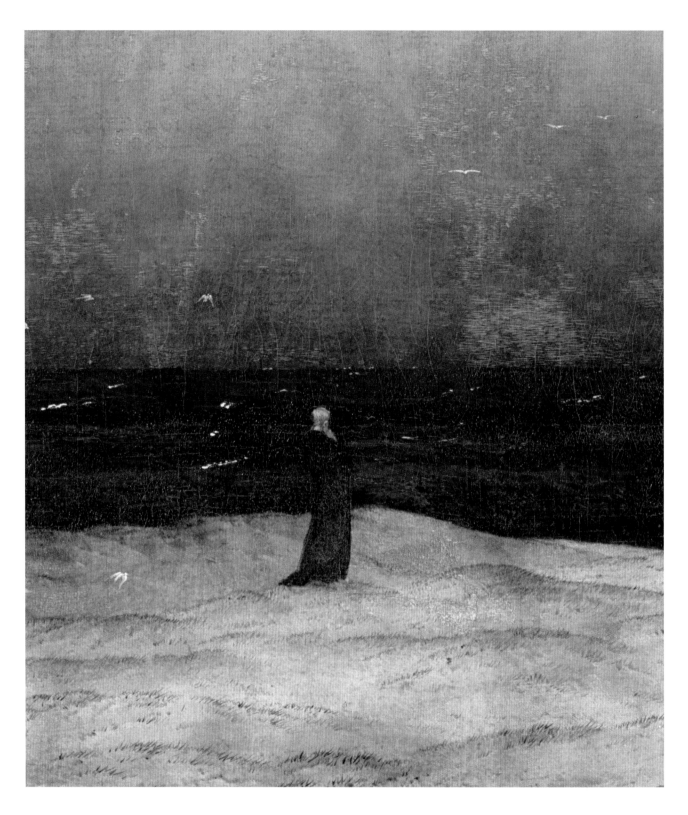

According to Friedrich, the seagulls
circling the monk are crying out
to warn him not to venture into the
turbulent sea.

CASPAR DAVID FRIEDRICH **THE MONK BY THE SEA**

Caspar David Friedrich, *The Abbey
in the Oakwood,* 1808–1810, oil on
canvas, 110.4 x 171 cm, Alte
Nationalgalerie, Staatliche Museen,
Berlin, Preussischer Kulturbesitz
The Abbey in the Oakwood was
created as a pendant to *The Monk
by the Sea.* In contrast to the
hopelessness of human struggle, it
conveys the hope of divine salvation.

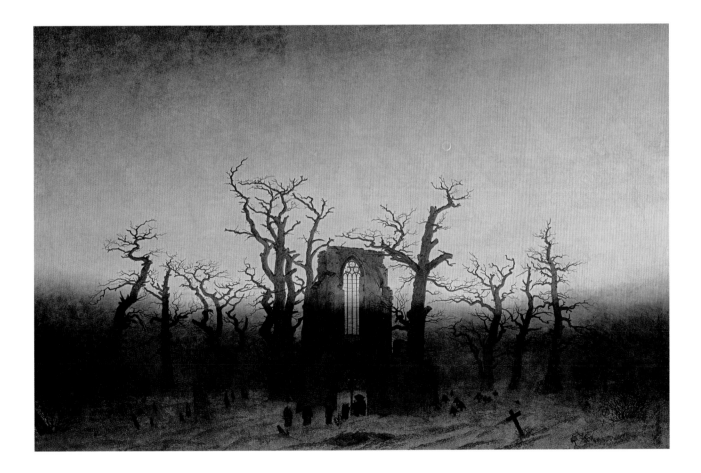

"A PECULIAR ... FACT ABOUT THE TALENT OF M. INGRES IS
THAT HE SEEMS TO PREFER PAINTING WOMEN;
... HIS EYE FOLLOWS THE MOST DELICATE CURVES
IN THEIR OUTLINES WITH THE SLAVISHNESS OF A LOVER."

Charles Baudelaire

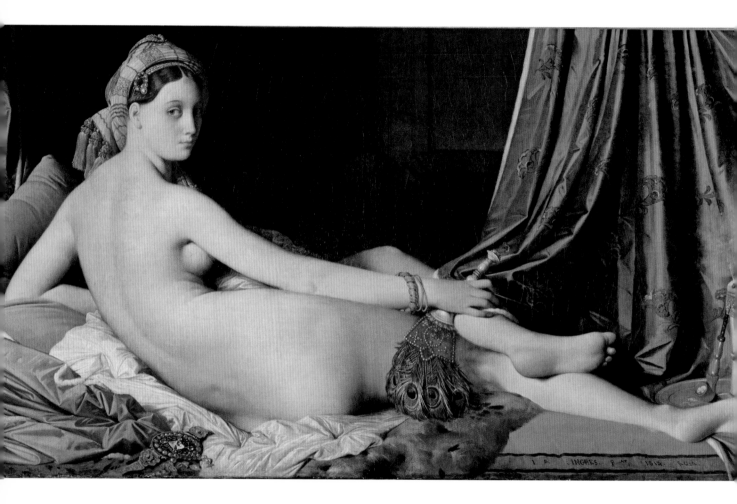

JEAN-AUGUSTE-DOMINIQUE INGRES **LA GRANDE ODALISQUE** 1814, oil on canvas, 91 x 162 cm,
Musée du Louvre, Paris

55

JEAN-AUGUSTE-DOMINIQUE INGRES
LA GRANDE ODALISQUE

Jean-Auguste-Dominique Ingres was known initially for working in the Neoclassical style. His painting *La Grande Odalisque* of 1814, however, marked a transition to the Romantic style. Its distortions of anatomy and space, though criticized when first exhibited, are now seen as anticipating aspects of modern art.

An odalisque is a concubine living in a harem, and this painting is a European idea of what a harem would look like, a fantasy of sensuality and exoticism. By the early 19th century, tales of travel were popular, and as a result of international exhibitions and Napoleon's campaigns in Egypt and Syria, Oriental scenes were very fashionable; *La Grande Odalisque* was commissioned by no less a person than Queen Caroline of Naples, Napoleon's sister. Working in Rome, Ingres may have drawn on the works of Italian painters Giorgione and Titian for inspiration, as well as on the *Portrait of Madame Recamier* (1800, Louvre, Paris) by his teacher, Jacques-Louis David, for the pose. The odalisque in Ingres' painting, lying on luxurious fabrics, looks back over her shoulder. There is a tension between, on the one hand, the luxuriousness of the textiles and the softness of the body on display for the viewer to gaze at, and, on the other, the somewhat hard expression with which the figure stares back. Though an odalisque, she may not want the viewer intruding upon her private world. She is reclining, yet there are elements of tension in the line of her neck and the bent arm on which she rests. By the time Ingres completed *La Grande Odalisque*, Napoleon had been deposed and Caroline was no longer Queen of Naples. The painting was shown at the Paris Salon of 1819, but poorly received. The figure's anatomy was widely seen as impossible, critics claiming that Ingres had painted three extra vertebrae, and that the figure lacked muscle or bone. The anatomy of *La Grande Odalisque* is unquestionably not correct, with an impossibly long back and a leg bent unnaturally. But Ingres has purposely abandoned anatomical reality in order to create a sensuous and languid mood. At the same time, the details of the fabrics, peacock fan, and turban are depicted in very realistic detail. His work was criticized until the mid-1820's, when Romanticism began to gain in popularity. He influenced many later painters, including Degas, Picasso and Matisse, for his use of color as well as his forms.

JEAN-AUGUSTE-DOMINIQUE INGRES was born in 1780 in Montauban, southern France. His father encouraged him to study drawing and music, but the French Revolution interrupted his education. In 1791 he enrolled in the Académie Royale de Peinture, Sculpture et Architecture in Toulouse. After winning a prize, he moved to Paris to study with Neoclassical artist Jacques-Louis David. Ingres later won the Prix de Rome and went to study in Rome in 1806. He worked in Italy for many years, finally returning to France in 1841. Though his popularity fluctuated, Ingres produced many important works during his last years. He died in 1867 in Paris.

56

FRANCISCO GOYA

THE 3RD OF MAY 1808 IN MADRID: THE EXECUTIONS ON PRINCIPE PIO HILL

The 3rd of May 1808 in Madrid, which Goya painted only six years after the actual event, is a powerful indictment of the barbarism and horrors of war. Even today it has lost nothing of its relevance. By contrast with other images of war of the time, there is no heroic martyr as the focus of this painting, but rather a victim who expresses nothing but fear and desperation.

The historical background to the painting is the uprising of the Spanish people against Napoleon's invasion, which began in 1807. After the population had defended themselves against Napoleon's troops on May 2, 1808, some 400 allegedly insurrectionist Spaniards were executed by French troops on the following day, hence the title of the painting, which shows the moment just before one of the insurrectionists is shot by French troops. Goya achieves its shocking effect through a dramatic use of light and an innovative composition. A lantern bathes the victims in a bright beam of light. In the lower right-hand side of the painting, there are uniformed French troops, positioned on a diagonal and with their backs turned to the viewer. As a result, we are unable to see the emotional reactions of the perpetrators. They have no faces, and because of their identical poses they are perceived as anonymous, literally faceless. The victims stand diagonally opposite them, their main representative a man in a white shirt and yellow trousers who is adopting an attitude of surrender and despair. The gun barrels are trained on him, and we can see desperation in his eyes. To his right, the first to be shot are already lying on the ground covered in blood, while those still alive crowd around him. By contrast with the perpetrators, the facial expressions of the victims are depicted in detail: each one can be perceived as an individual. Some hide their faces behind their hands; for others, their sense of shock and horror is all too clear. The painting's background is rendered in deepest dark blue, intensifying the grim and tragic nature of the scene. There is not a star in the sky. Goya does not take sides in this, but depicts the scene using his powers of imagination, though based on the facts. It is unlikely that he witnessed the scene with his own eyes, however. For Goya it was not a question of glorifying a heroic victory, but of representing the terrible deeds that people are capable of during wartime. In a radical and gripping way, he gave suffering a face.

FRANCISCO JOSÉ DE GOYA Y LUCIENTES was born in 1746 in the northern Spanish village of Fuendetodos, near Zaragoza. It was there that he received his first painting lessons and fulfilled commissions for the Church. In 1774 he began making tapestry designs for the Royal Tapestry Factory in Madrid (until 1792), which were received positively at court and helped him to find more commissions. In 1786 he was called to the royal court in Madrid, where in 1792 he became court painter to Charles IV (r. 1788–1808). On a journey through Andalusia in 1792, he fell very ill, and as a result became permanently deaf. He died in 1828 in Bordeaux, France.

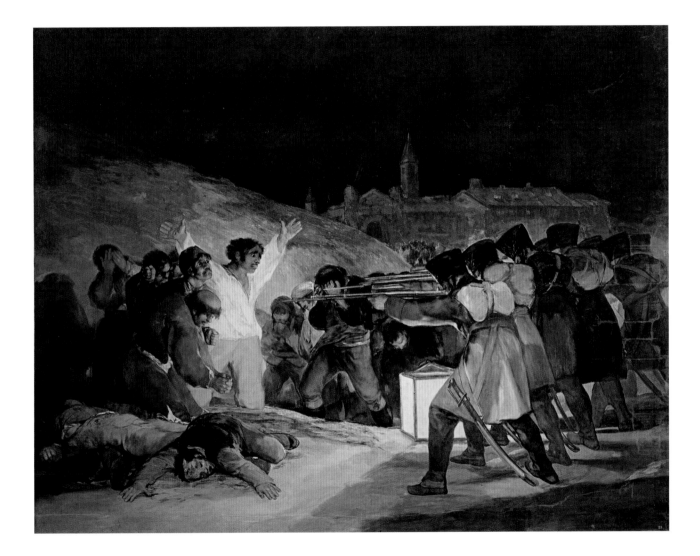

FRANCISCO GOYA **THE 3RD OF MAY 1808 IN MADRID: THE** 1814, oil on canvas, 268 x 347 cm,
EXECUTIONS ON PRINCIPE PIO HILL Museo Nacional del Prado, Madrid

The expression on the victim's face and his attitude of surrender vividly convey the horrors of war and its hopelessness.

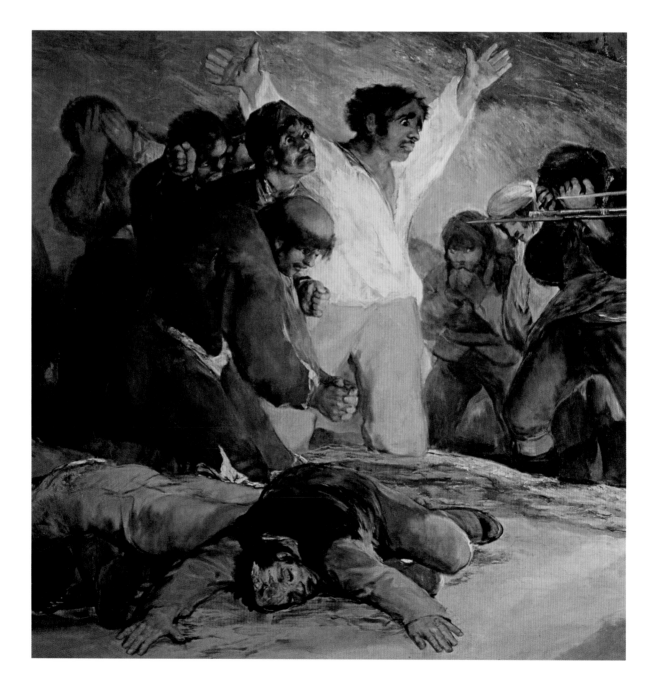

FRANCISCO GOYA **THE 3RD OF MAY 1808 IN MADRID: THE EXECUTIONS ON PRINCIPE PIO HILL**

By representing the perpetrators in a neutral way, Goya abdicates any unambiguous attribution of guilt, making it clear that the perpetrators and their victims may well be interchangeable.

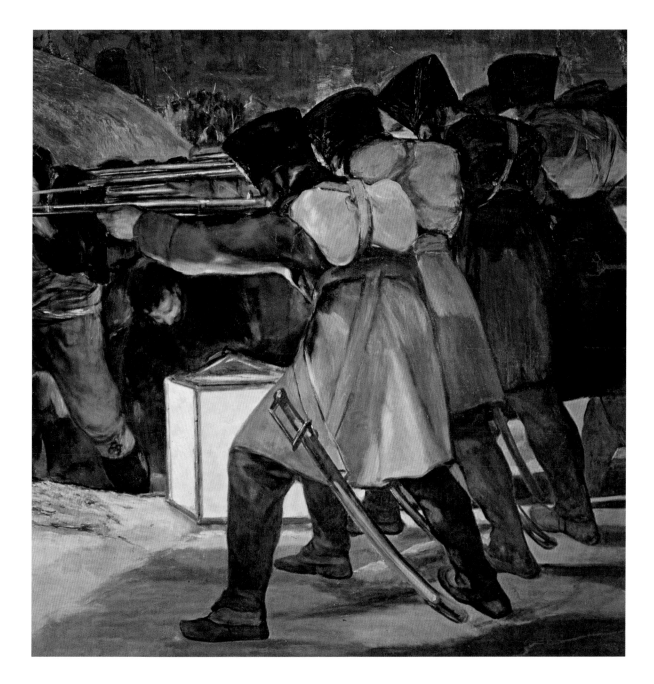

FRANCISCO GOYA **THE 3RD OF MAY 1808 IN MADRID: THE EXECUTIONS ON PRINCIPE PIO HILL**

57

THÉODORE GÉRICAULT
THE RAFT OF THE MEDUSA

Géricault's painting *The Raft of the Medusa* marked a transition from Neoclassicism to Romanticism in art. Monumental in size, it is also monumental in its ambition and composition, depicting the survivors of a shipwreck adrift on a raft. The circumstances of the wreck caused a scandal in French society and the government. The painting tells the story not of ancient heroes, but of contemporary men caught up in tragic events.

The *Medusa* was a French frigate that struck a sandbank off the coast of Africa while transporting soldiers and colonists to Senegal. The captain, who had not been to sea for 20 years, and who had received his post through government connections, quickly abandoned the ship, along with his officers. There were not enough lifeboats to hold the passengers and 150 were left to fend for themselves on a wooden raft. Finally rescued after 13 days adrift, only 15 had survived. Two of them published an account of their horrific days on the raft, the brutal conditions and eventual cannibalism making it a national scandal. By way of preparation for his vision of the events, Géricault studied the movement of water, made models and wax figures, and even sketched cadavers. Casting off the heroic tradition of Neoclassical history painting, Géricault preferred to paint contemporary scenes, though the figures on the raft are generally muscular and ideal in form. He cast the scandalous episode as an epic scene. The figures form a triangle, beginning with the pale corpses at the bottom, continuing with those trying to stand up, and topped by the man waving a rag to catch the attention of a passing ship. The play of light and dark over the bodies, the water, and the sky adds to the dramatic depiction of hope and despair. The painting combines a contemporary tragedy resulting from a corrupt government with the universal theme of man's struggle against nature. *The Raft of the Medusa* was the star of the Paris Salon of 1819, though opinions about it were divided. Some were fascinated with the horror of the subject, but those more devoted to Neoclassicism were offended by Géricault's depiction of what they saw as a "pile of corpses" rather than the "ideal beauty of heroes." Géricault was disappointed with the mixed reactions and took the painting to London and Dublin, where it was far more favorably received. The Louvre bought the painting from Géricault's heirs in 1824, where it is now displayed as one of the most important works of French Romanticism.

JEAN-LOUIS ANDRÉ THÉODORE GÉRICAULT was born in 1791 in Rouen. His initial training in art came from the classicist Pierre-Narcisse Guérin (1774–1833), but Géricault soon left to follow his own ideas about painting. He spent time in the Louvre, studying and copying the works of Rubens, Titian, Velázquez, and Rembrandt. When one of his early works was not well received, he joined the army and served in the garrison at Versailles for a time. *The Raft of the Medusa* made Géricault's reputation. After showing the painting in Britain and Ireland, he returned to France in 1821 and painted a series of portraits of the insane, patients of a friend of his who was a doctor. Weakened by a riding accident, and having suffered from tuberculosis for a number of years, he died in 1824 in Paris.

"THE DREADFUL ACCOUNT OF THE 'SHIPWRECK OF THE MEDUSA'
AFFORDS A DISTRESSING PICTURE OF CALAMITOUS
AND HIDEOUS CIRCUMSTANCES TO THE IMAGINATION;
BUT A PAINTER HAZARDS MUCH IN ATTEMPTING
TO CONVEY THE PARTICULARS OF THAT EVENT TO THE CANVAS."

David Carey, 1820

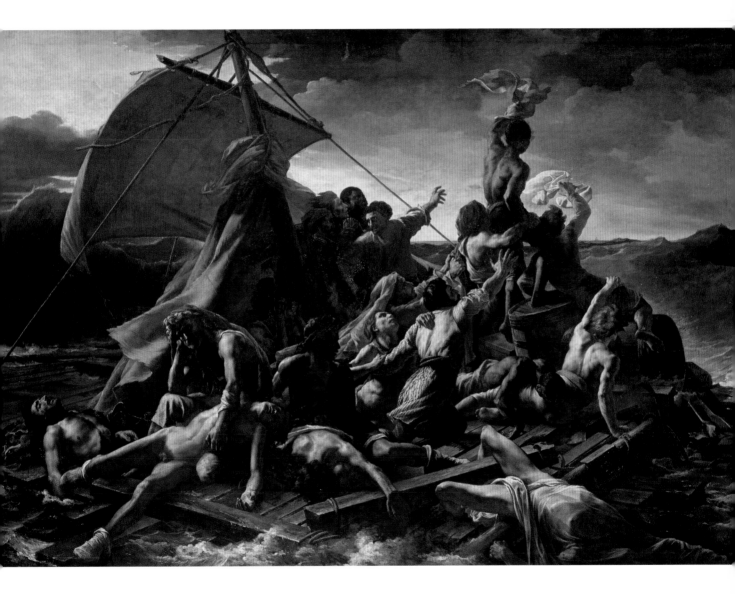

THÉODORE GÉRICAULT **THE RAFT OF THE MEDUSA** 1819, oil on canvas, 491 x 716 cm,
Musée du Louvre, Paris

58

EUGÈNE DELACROIX
THE DEATH OF SARDANAPALUS

The French painter Eugène Delacroix favored dramatic subjects full of passion, eroticism, and violence. Often depicting scenes drawn from literature, he created works whose expressive colors, dynamic compositions, and troubled figures make them the embodiment of a turbulent Romanticism.

Because of their subject matter and the intensely colorful nature of their rendering, many of the pictures Delacroix exhibited at the Salon encountered a great deal of criticism. This was even more the case for the picture he based on Lord Byron's drama *Sardanapalus* (published in 1821). In the play, the Assyrian King Sardanapalus, besieged by his enemies for many weeks in his palace, decides to take his own life. He also orders his guards to destroy or kill everything that had once been dear to him, including his slaves and harem. After the bloodbath, the king himself is immolated on his bed.

Delacroix relates this story in his richly colored painting: he depicts Sardanapalus watching all the women of his harem, his slaves, and his favorite horses being put to the sword by officers of his bodyguard and eunuchs. The king watches the awful events impassively from his bed, while a servant girl, transfixed with fear, brings him wine. The horrific scene is translated into theatrical spectacle far removed from normal life, which is intended to transport the terrorized viewer to an exotic fairy-tale world. In this depiction, the king is not the protagonist of a heroic suicide, but rather a cold, decadent libertine who, even at the moment of his greatest pain, shows no emotion towards the most extreme distress of those he once loved. In their turn they are depicted in erotic poses, leaving no room for doubt as to what Delacroix's intention was: to show the connection between Eros and Thanatos, Love and Death. Around the turn of the 20th century, the painting became the iconic image of Symbolism and the Decadent movement. The Surrealists too saw the painting as a key work representing a neurotic, aggressive sensuality.

When it was exhibited at the Paris Salon in February 1828, the picture caused a scandal that shook the Parisian art world. The critics maintained their negative attitude to Delacroix and neither state honors nor public commissions were forthcoming. Delacroix never completely recovered from this set back, even in his later years when he finally achieved fame and renown.

EUGÈNE DELACROIX was born in 1789 in Charenton-Saint-Maurice, France. After the death of his parents, he registered at the École des Beaux-Arts in Paris. He was greatly influenced by the work of Théodore Géricault, whose painting *The Barque of Dante* (1822, Louvre, Paris) caused a great commotion at the Salon in 1822. Delacroix's *Massacre at Chios* (1824, Louvre, Paris) was a failure with critics and public alike at the Salon, being described as a "massacre of painting." In 1831 Delacroix painted his image of the 1830 Revolution, *Liberty Leading the People* (Louvre, Paris). In 1832 he traveled to Morocco, the sketches and watercolors he produced there forming an inspiration for his richly colored paintings. He died in 1863 in Paris.

"I THINK THE *SARDANAPALUS* IS A VERY IMPORTANT PICTURE,
HISTORICALLY AND PSYCHOLOGICALLY, BECAUSE IT SHOWS
THE EROTICIZED IDEAL OF MILITARY GLORY ...
BEING TURNED INWARD, BACK TOWARD DOMESTIC LIFE."

Jeff Wall, 1987

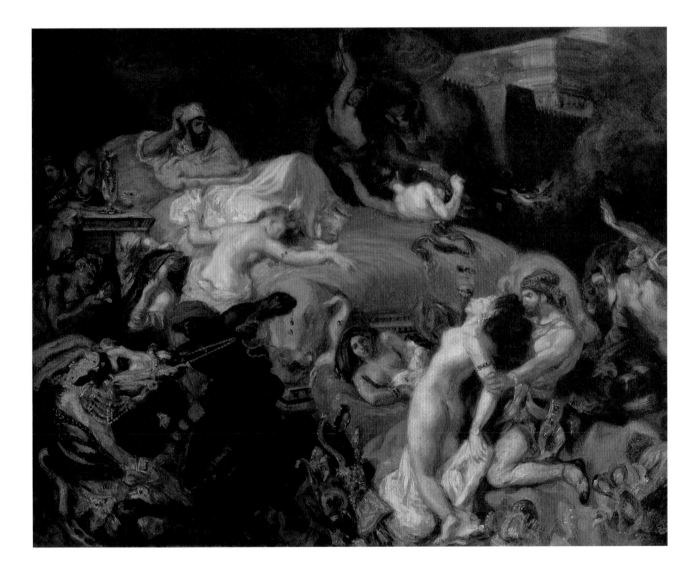

EUGÈNE DELACROIX **THE DEATH OF SARDANAPALUS** 1827, oil on canvas, 392 x 496 cm,
Musée du Louvre, Paris

above The precise observation of this richly decorated white horse, its eyes staring in fear of death, demonstrates the artist's flair for drama and intense passion.

right Delacroix made careful preparatory sketches of this female figure. Taken together with the soldier behind who is stabbing her, she forms a synthesis of pain and voluptuousness, horror and sensuality.

EUGÈNE DELACROIX **THE DEATH OF SARDANAPALUS**

59

KATSUSHIKA HOKUSAI
THE GREAT WAVE OFF KANAGAWA

It is said that he only owned one teapot and a couple of tea bowls. In spite of his success and status, Katsushika Hokusai preferred the simple life. *The Great Wave off Kanagawa* belongs to his series of woodcuts *36 Views of Mount Fuji*, which have been reproduced so frequently that in Europe they are considered the quintessential expression of Japanese art.

Three fully laden fishing boots are being tossed around in the middle of the roaring sea, while through the trough of the wave we can catch a glimpse of snow-capped Mount Fuji. Behind the fishermen, the last wave they breasted swells up. Immediately ahead of them, the great wave of the title towers over them, its fringes looking like grasping claws. It seems impossible for them to survive. Immensely popular, this image was reproduced so many times that the rectangular box containing the title (top left) began to show signs of wear. The Prussian-blue ink Hokusai used was the latest discovery, a synthetic pigment from faraway Europe, which was more permanent than the traditional natural indigo pigment, which tended to fade. Hokusai was delighted by his experiments with the ink, and wanted to use the color for his views of Mount Fuji. This made Hokusai's prints something completely new. But this new chemical pigment clung to the woodblocks, which is why subsequent prints had black contours. The first versions of *The Great Wave off Kanagawa* are considered the finest. A tireless perfectionist, Hokusai was always keen to do better, to experiment with new subjects, techniques, and compositions. Throughout his long life he traveled ceaselessly in search of subjects and his inner vision. He also had many artistic periods, which inspired him each time to change his name: he had more than 30 names. In his repertoire he could draw on all forms and techniques of painting and woodcut, depicting not only traditional Japanese themes such as fighting samurai, but also, above all, everyday, erotic, and mythological scenes. His pictures of nature and the landscape made him famous, in particular his woodcuts series *36 Views of Mount Fuji*, which shows Fuji from many different standpoints (and which ultimately included 46 prints).

Today *The Great Wave* seems to us to be the symbol of a tsunami: it can be found on sweaters, T-shirts, and placemats, and has inspired the logo of an international manufacturer of surf-and-board sportswear. It is so ubiquitous that it is often seen in the West as a synonym for Japanese art.

KATSUSHIKA HOKUSAI was born Nakamura Hachiemon in 1760 in Edo (present-day Tokyo). He began training as a woodcutter at the age of 15, and three years later he entered the workshop of Katsukawa Shunshō (1726–1793). Becoming bored of this life after a while, Hokusai left his master's school. There followed several footloose years in which he traveled throughout Japan, changing teachers as often as his location. This long journey helped to develop his stylistic variety. His huge oeuvre comprises 500 illustrated books, as well as 30,000 colored woodcuts (*ukiyo-e*) and a number of silk paintings. He created his *36 Views of Mount Fuji* in the 1830s. He died in 1849 in Edo, aged 88.

"HE IS AN ISLAND, A CONTINENT,
A WHOLE WORLD IN HIMSELF."

Edgar Degas on Hokusai

KATSUSHIKA HOKUSAI **THE GREAT WAVE OFF KANAGAWA** 1830–1832, colored woodcut, 24.4 x 35.7 cm (variable according to print)

The wave appears particularly threatening because Hokusai gave the fringes of the wave a claw-like appearance. Mount Fuji, Japan's highest peak, seems to withdraw into the background in the face of this seemingly irresistible force of nature.

60
CARL SPITZWEG
THE POOR POET

The wit and gentle irony of Carl Spitzweg's Romantic images made him one of Germany's favorite painters and a leading example of the Biedermeier style. But the nuances of resignation, skepticism, and contemporary commentary he brought to his work often go unnoticed.

The Poor Poet is one of Carl Spitzweg's earliest works, and is also the picture that made him famous. The scene is set in a shabby garret. The poet sits in bed, dressed in nightgown and nightcap against the coldness of his quarters and, unperturbed by his living conditions, he is scanning out a hexameter that he has written on the wall. Above him hangs an umbrella, used to protect him from the rain dripping through the leaking roof, and beside his bed there are piles of books. Among the latter we can see one entitled *Gradus ad Parnassum*, or "A Step to Parnassus," probably Jesuit Paul Aler's introduction to writing Latin texts published in Cologne in 1702. Such steps to poetry, however, can prove hard and cold. On the other side of the room, we can see an old tiled stove on which the poet's clothes have been hung to dry. In front of the stove the poet's own writings lie ready and waiting to be used to warm the room.

Spitzweg's model for this painting was the poet Mathias Etenhueber, who had lived in Munich between 1722 and 1782, usually in dire financial straits. Spitzweg's predecessors in this style of painting were works by William Hogarth (1697–1764) and J.M.W. Turner. He probably took the title from August von Kotzebue's play *The Poor Poet* of 1812.

The hexameter being recited by Spitzweg's poor poet was the form used in epic verse, and thus the highest form of poetry at that time. Spitzweg uses this contrast between the poet's grand aspirations and his humble surroundings to highlight the discrepancy between the ideal and reality which brought about the downfall of so many artists. At the same time, the painting's colorful and tenderly detailed realism, along with its ironic representation of the high art of Spitzweg's contemporaries, were taken to be an attack on all kinds of idealizing art, even the genre of history painting, which was then highly regarded. As a result the picture became the subject of negative criticism, which caused Spitzweg to stop signing his work with his name, from then on signing his paintings with just a symbol, a stylized *Spitzweck*, a kind of lozenge-shaped bread roll.

CARL SPITZWEG was born in 1808 in Munich. Although trained as a pharmacist, he took up painting during the 1820s. His paintings frequently derive their humor from their ironic depiction of the aspirations of the little man in the face of reduced circumstances. In 1851 he traveled with painter friends from Munich to Paris and London, being particularly impressed by the works of the Barbizon School painters and John Constable. As a result he took up landscape painting, his images of people becoming amusing marginal figures and no longer the central theme of his paintings. He died in 1885 in Munich.

"THE WORLD MUST BECOME ROMANTIC,
THEN WE WILL RECOVER ITS ORIGINAL MEANING."

From the diary of Carl Spitzweg

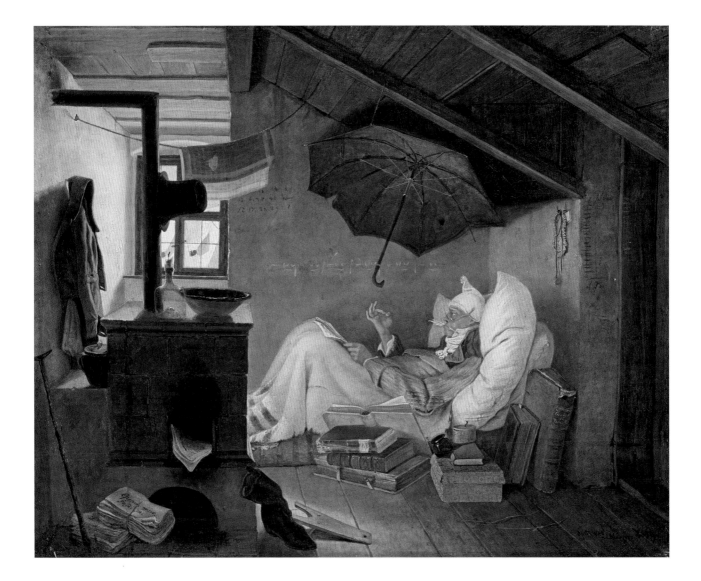

CARL SPITZWEG **THE POOR POET** 1839, oil on canvas, 36.2 x 44.6 cm, Neue Pinakothek,
Bayerische Staatsgemäldesammlungen, Munich

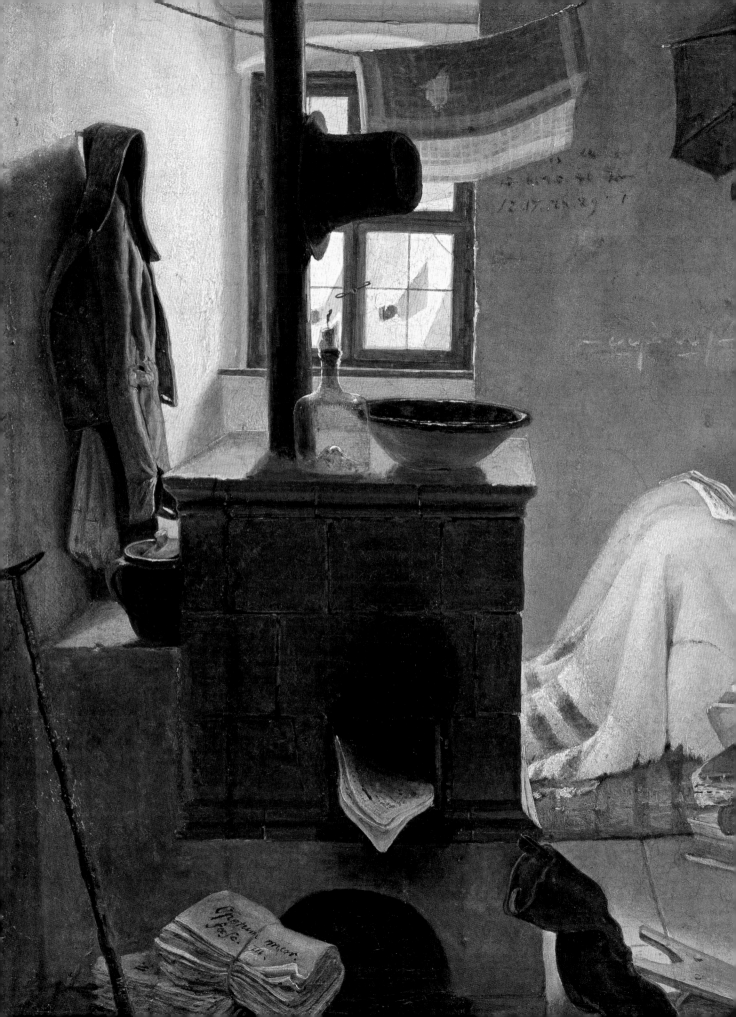

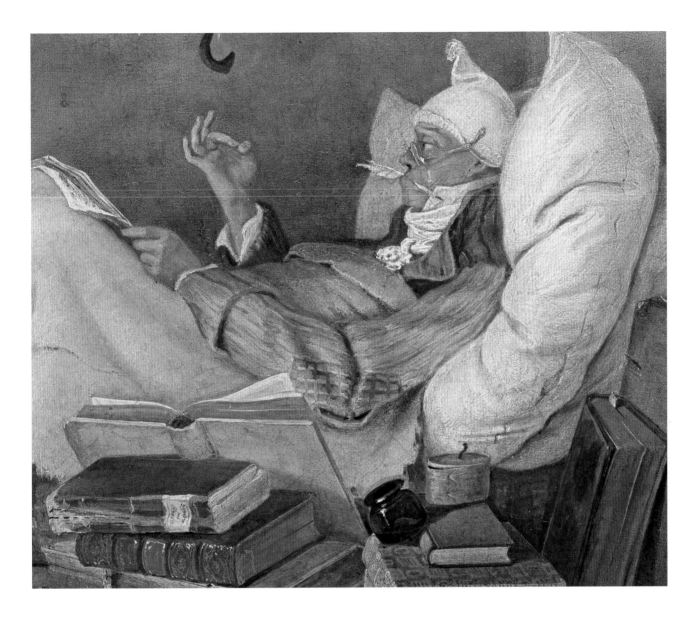

left As heating for the room, the stove only works if fed with the poet's superfluous writings. We can see this from the papers sticking out of the stove door, papers with Latin writing on them which indicate poems already published by the poor poet. The top hat hanging from the stove's chimney adds another comical dimension to the scene.

above With his quill pen in his mouth and nightcap on his head, the poor poet looks totally ridiculous, contradicting the usual image of the heroic struggling and suffering artist. His pointed fingers are sometimes interpreted as the poet squashing a flea.

CARL SPITZWEG **THE POOR POET**

"HE HAS MADE A PICTURE WITH REAL RAIN,
BEHIND WHICH IS REAL SUNSHINE,
AND YOU EXPECT A RAINBOW EVERY MINUTE.
MEANWHILE, THERE COMES A TRAIN DOWN UPON YOU,
REALLY MOVING AT THE RATE OF FIFTY MILES AN HOUR,
AND WHICH THE READER HAD BEST MAKE HASTE TO SEE,
LEST IT SHOULD DASH OUT OF THE PICTURE ...
THE WORLD HAS NEVER SEEN ANYTHING LIKE THIS PICTURE."

William Makepeace Thackeray

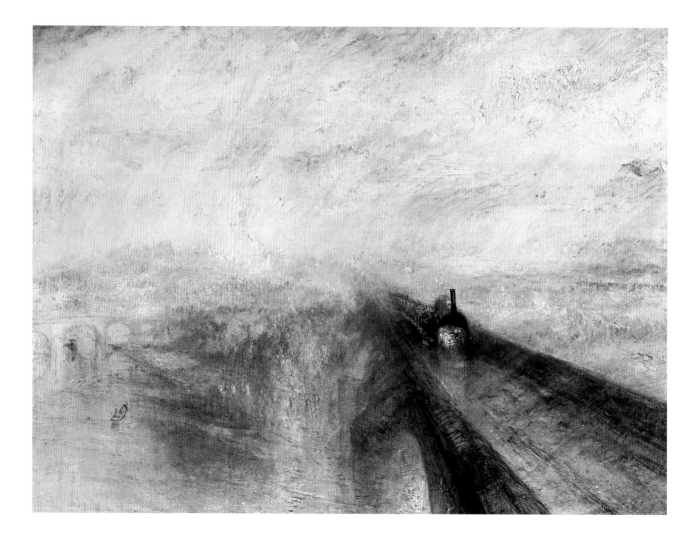

JOSEPH MALLORD **RAIN, STEAM, AND SPEED—THE GREAT** 1844, oil on canvas, 91 x 121.8 cm,
WILLIAM TURNER **WESTERN RAILWAY** The National Gallery, London

61

JOSEPH MALLORD WILLIAM TURNER
RAIN, STEAM, AND SPEED—THE GREAT WESTERN RAILWAY

I n *Rain, Steam, and Speed*, Turner produced a work that creates an astonishing effect. Instead of a realistic representation of nature, the artist captures through the act of painting the atmospheric impression of a landscape and the subjective feeling it creates. The elements of rain, steam, and speed are not just painted from nature but are made tangible through the way they interact.

In this painting Turner combined his particular love of landscape painting with his interest in technical innovations. Symbolically, the railway stands for the coming of the modern world. In this scene we can see the rail line that crossed the iron bridge over the River Thames at Maidenhead not far from London. The idea for the work probably came to Turner when, during a train journey, he put his head out of the window and felt the steam of the locomotive, the rain, and the speed of an oncoming train. Here we can make out a train emerging from the middle of the picture and seeming to race off into infinity. While the painting still shows some signs of a vague relationship to classical landscapes—for example in the boat proceeding along the Thames against the backdrop of a bridge— Turner's new style of painting reflects the modern, ever-changing world of the dawning industrial age. His fascination with this theme led to the development of a way of painting that could capture the dynamics of air, light, and in the weather, three factors that determined his subjective perception of nature. For example, he looked at how the movement of the wind or the speed of a train could be expressed using artistic techniques. Turner's answer is to be found in the painting *Rain, Steam, and Speed*. The subjects in the painting cannot be unambiguously identified as such, but rather they blur together, only becoming vaguely recognizable when the painting is viewed from a distance. This effect comes not from the subject itself but from the carefully thought-out way in which color is chosen and applied, and in the use of light. The use of one and the same color in different shades, quick visible brush strokes, with pigment splashed on the picture like raindrops, leaving thick, encrusted bands of paint, as well as the conscious use of effects of light and shadow reflect the dynamism of rain, steam, and speed as they interact. Because of his innovative use of artistic techniques, Turner is regarded as a forerunner of modern painting and in particular a precursor of Impressionism.

JOSEPH MALLORD WILLIAM TURNER was born in 1775 in London, the son of a barber. He started to train as an architectural draftsman at the age of 13, and because of his extraordinary talent he was admitted to the Royal Academy Schools in London at the early age of 14, where he would later become Professor of Perspective. His work was influenced by numerous journeys in Europe, including to Scotland, Wales, Ireland, France, Switzerland, Germany, and Italy, which allowed him to experience the most diverse landscapes. His talent was recognized early, and he was hailed as an artistic genius even during his own lifetime. He died in 1851 in Chelsea, London.

62

GUSTAVE COURBET
A BURIAL AT ORNANS

In the middle of the 19th century, Gustave Courbet's monumental painting *A Burial at Ornans* launched a new artistic movement, Realism. Courbet became controversial both for his views on art and his radical politics.

The Paris Salon of 1850–1851 was hit by a scandal to an extent scarcely seen before in the almost 200 years of the distinguished art exhibition's existence. The cause was a painting of a burial in the countryside in which there appear life-size portraits of over 40 people making up the public and religious life of Ornans, painter Gustave Courbet's birthplace, including the artist's own family. The picture represented a complete break with the conventions of painting at that time. According to these conventions, such a huge format was reserved for history painting, which traditionally presented historical, religious, and mythological themes in an idealized, transfiguring form. Scenes of daily life among peasants and agricultural workers, such as Courbet was painting more and more during this period, were not new but were as a rule restricted to small-format genre scenes usually characterized by humor or sentimental moralizing. Depicting such a banal (as it was perceived) scene life size was a novelty and openly flouted conventional aesthetic values. A further shocking element in the eyes of contemporary viewers was the style of representation: Courbet did not prettify the mourners, nor draw a pious moral from the scene; he depicted the figures in all their earthy realism. Any conventional rhetoric of gesture or expression, as was usually the case in genre painting, is completely absent—Courbet took Dutch group portraits of the 17th century as his model—and instead of mere types he presents dignified individuals. Moreover, his style of painting was unconventional: he applied his paint roughly and thickly with a palette knife, a technique which, along with the prevailing dark color scheme, lent gravitas to the image; it was a firm rejection of the light, elegant style of painting preferred by Salon-goers. The respectable citizens of Paris were presented with a rural scene with figures of peasants—even when in fact the people were the rural middle classes of Ornans—on a scale and with a wealth of characters that would otherwise have been reserved for coronation scenes. And in doing this, Courbet refused any kind of romanticization. All this led to a storm of disapproval—but also to Courbet's ultimate artistic success.

GUSTAVE COURBET was born in 1819 in Ornans, eastern France. Abandoning his legal studies in Besançon, he went to Paris, where he encountered the Spanish masters (notably Diego Velázquez and Francisco de Zurbarán), 17th-century Dutch painting, and such contemporaries as Géricault and Delacroix. During the 1850s he developed a style characterized by his new, programmatic kind of realism, and it was this that formed the basis of his artistic breakthrough. A member of the Paris Commune, he was instrumental in the toppling of the Vendôme Column. After the fall of the Commune, Courbet served time in jail before escaping to Switzerland. He died in 1877 in La Tour-de-Peilz, Switzerland.

"I PREFER THE *BURIAL* TO ALL HIS OTHER PAINTINGS BECAUSE OF
THE IDEAS CONTAINED WITHIN IT, BECAUSE OF THE COMPLETE
AND HUMAN DRAMA WHERE THE GROTESQUE, TEARS, SELFISHNESS
AND INDIFFERENCE ARE GIVEN SUCH A MASTERLY TREATMENT.
A BURIAL AT ORNANS IS A MASTERPIECE."

Jules Champfleury, 1857

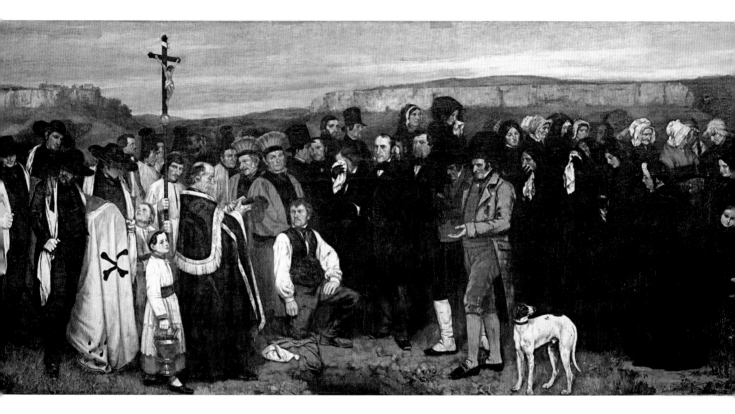

GUSTAVE COURBET **A BURIAL AT ORNANS** 1849–1850, oil on canvas, 315 x 668 cm,
Musée d'Orsay, Paris

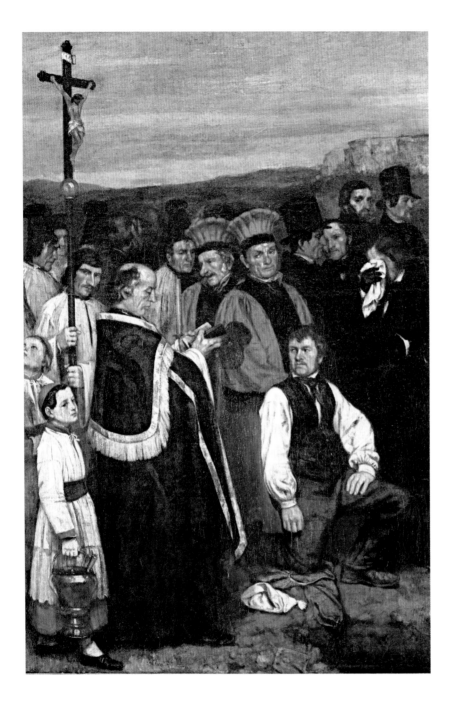

left Courbet pushed his realistic style of depiction as far as to characterize the two churchwardens as drinkers—they are recognizable by their red noses.

right Among the mourning party in a prominent position on the right-hand side of the painting, we can see Courbet's grandfather, father, three sisters, and mother. The inspiration for the painting was probably the burial of Courbet's great-uncle, who died in 1848.

GUSTAVE COURBET **A BURIAL AT ORNANS**

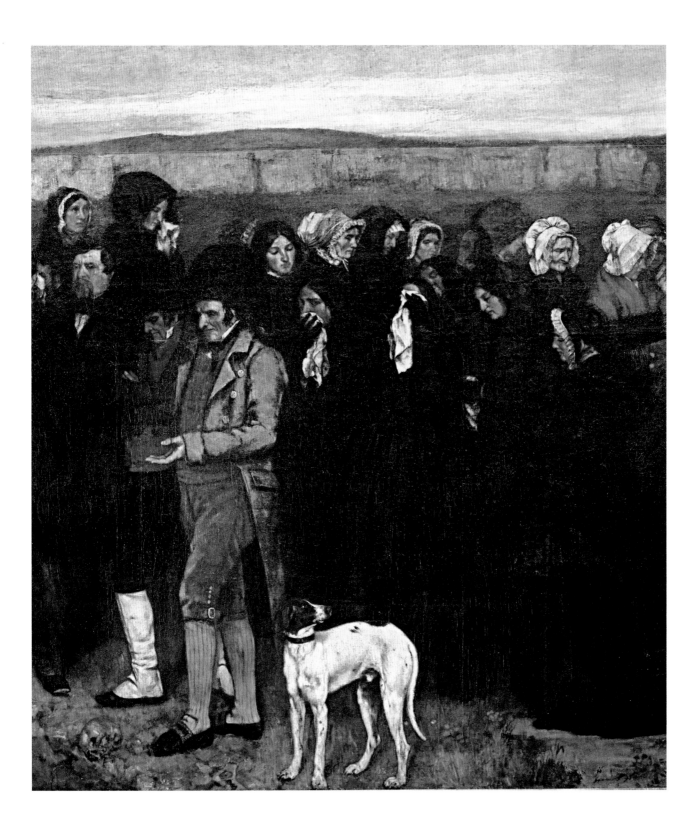

GUSTAVE COURBET **A BURIAL AT ORNANS**

63

ARNOLD BÖCKLIN
VILLA BY THE SEA II

Arnold Böcklin returned again and again to the subject of the *Villa by the Sea* for almost two decades. One sketch and five painted versions have survived and can be seen in museums in Munich, Frankfurt, Stuttgart, and Winterthur. They differ only in compositional details and atmospheric nuance, but not in their basic composition or message.

Villa by the Sea is a mysterious picture. It does not tell an obvious story, and its melancholy and gloomy atmosphere is unsettling. A first sketch of it was probably made at the end of the 1850s. Instead of a woman standing at the water's edge, it shows a romantic couple sitting on the park wall. It was probably this sketch that prompted the art collector and patron Adolf Friedrich, Graf von Schack, to commission an oil painting on the same theme from Böcklin.

However, the first version, which emerged from the artist's studio in 1864, did not find favor with von Schack. Böcklin had experimented with materials and techniques that, in Schack's opinion, had produced "a highly unfortunate result." It was suggested that Böcklin paint "the same composition" once more, this time using conventional methods. This version, dating from 1865 (and shown here), can be found today alongside the unsatisfactory first version in the Schack Collection in Munich.

Overgrown with bushes and trees that bear witness to a once magnificent, well-tended garden, the villa by the sea stands on a rocky outcrop. We can make out only sections of the building: a portico with sculpted figures on the balustrade faces the sea, while crumbling, overgrown walls and trees hide the main residence. The sky is a leaden blue-gray, and a strong wind blowing onshore bends the powerful cypress trees (traditionally a symbol of sorrow) that stand on the edge of the embankment. Against this backdrop, looking small and lost, we can see a woman dressed in a black robe, her head in her hand. She has walked down the dilapidated stone steps to the water, and leans on a wall while gazing sadly at the sea. Böcklin indicated that this unknown woman was "probably the last in the line of an ancient family." Some interpreters saw her as Iphigenia, the daughter of King Agamemnon, who was banished by the goddess Artemis to the land of sorrow—an interpretation that Böcklin rejected, however.

The picture's message lies beyond any identification of this female figure. It conveys a poignant sense of the transitory, symbolized by the decline and fall of human endeavors.

ARNOLD BÖCKLIN was born in 1827 in Basel. After studying at the Arts Academy in Düsseldorf, he began traveling in Europe. From 1850 onwards he worked mainly in Rome, before he returned to settle seven years later in his hometown. The following years saw him traveling and taking up longer working residences, including in Munich and Italy. From 1885 onwards he lived in Hottingen near Zurich. He became one of the leading exponents of Symbolism. After a stroke in 1892 he moved to Florence, and later to Fiesole. He died in 1901 in Fiesole.

"IT IS A PICTURE WHICH WE CANNOT GET OUT OF OUR HEADS,
WHICH BRINGS TOGETHER THREADS FROM ALL SIDES.
WHEREVER THE SENSIBILITY OF OUR CENTURY IS DISCUSSED,
THE *VILLA BY THE SEA* MUST BE MENTIONED."

Heinrich Wöfflin, 1897

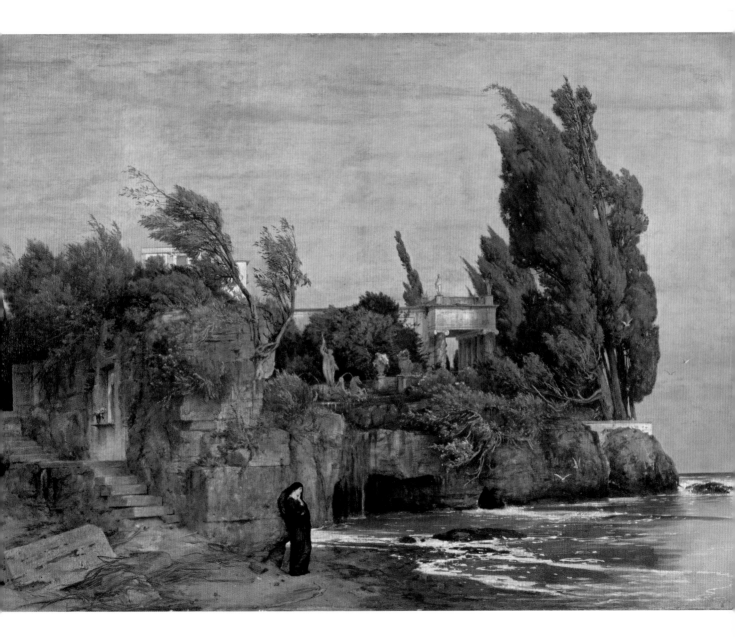

ARNOLD BÖCKLIN **VILLA BY THE SEA II** 1865, oil on canvas, 123.4 x 173.2 cm,
Schack Collection, Bayerische Staatsgemäldesammlungen, Munich

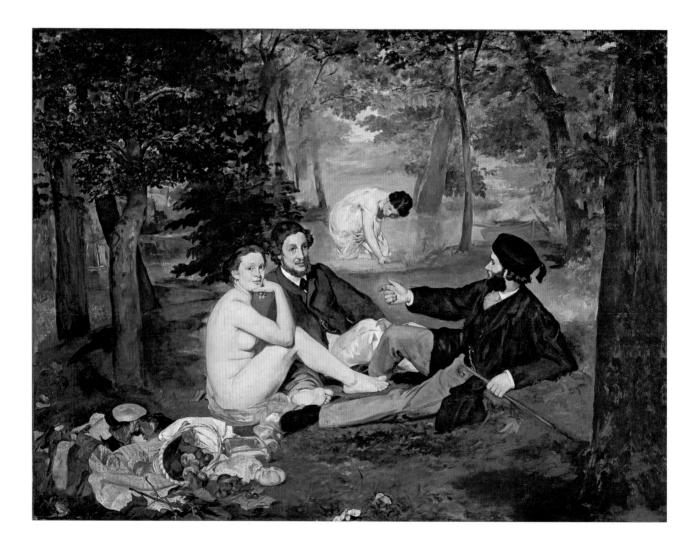

ÉDOUARD MANET **LE DÉJEUNER SUR L'HERBE** c. 1863, oil on canvas, 207 x 265 cm,
Musée d'Orsay, Paris

64

ÉDOUARD MANET
LE DÉJEUNER SUR L'HERBE

Manet's *Le Déjeuner sur l'herbe* is one of art history's best-known *succès de scandale*. Rejected by the official Paris Salon, the painting shocked visitors to the Salon des Refusés not only because of its juxtaposition of naked women and clothed men, but also because of its unusual painting technique. Manet's sketch-like style and modeling of forms using color contrasts made him a precursor of Impressionism.

Manet's *Le Déjeuner sur l'herbe* was first exhibited in 1863 as *Le Bain* at the Salon des Refusés, which, running parallel to the official Paris Salon, showed works that had been rejected by the latter. It attracted a great deal of violent condemnation from visitors to the exhibition, who criticized it for being offensive in its mixture of naked and clothed figures in the same picture. In itself, nudity was not taboo if it was justified by a mythological subject. Indeed, Manet was making a thematic reference to Titian's (Giorgione's?) *Pastoral Concert* (c. 1509, Musée du Louvre, Paris) and borrow the composition of the group of figures from Raphael's *Judgment of Paris* (lost, but known through an engraving). But here he was re-working the older models using modern content: the dark, elegant clothing of the two men identify them clearly as Parisian dandies on a Sunday excursion; and the naked women between them is by no means an idealized nymph but a self-confident and unabashed modern woman who looks out of the picture directly at the viewer.

Manet's style and technique were considered almost as shocking as his offensive subject matter: the sketch-like contours and the modeling of the forms using strong light and dark contrasts, along with rapid brush strokes that blurred the details, were misinterpreted by the Salon-going public as evidence of an unfinished work. The painting's perspective and proportions also seemed to have been worked in a careless way: the bather in the background appears too big by comparison with her surroundings.

Through its unconventional style of representation and its unashamed subject matter, *Le Déjeuner sur l'herbe* became one of the most famous scandals in art history. For Manet's young painter friends it became an icon. His flat painting style and rapid brush strokes, through which he captured the dynamic, ever-changing impressions of life in Paris, inspired key members of the Impressionist movement, including Claude Monet, Pierre-Auguste Renoir, and Camille Pissarro. Although he never took part in one of their exhibitions, Manet influenced these artists in a lasting way, and is today rightly considered a precursor of Impressionism, as well as, alongside Paul Cézanne, "the man who invented modernity."

ÉDOUARD MANET was born in 1832 in Paris, into an upper middle-class family. He joined Thomas Couture's studio in 1850, and opened his own in 1856. In 1863 he exhibited at the Salon des Refusés. He married the Dutch pianist Suzanne Leenhoff, who had already borne him a son in 1852, in 1863. In 1866 he became a regular at the Café Guerbois alongside the Impressionist circle around Cézanne, Monet, and writer Émile Zola. In 1867, at the same time as the Paris World's Fair, he organized his own one-man exhibition. In the following years he exhibited at the Salon, with varying degrees of success. In 1874 he decided not to take part in the first Impressionist exhibition. He painted his last large-format work, *A Bar at the Folies-Bergère* (Courtauld Institute of Art, London) in 1882. He died in 1883 in Paris.

right Claude Monet, *Le Déjeuner sur l'herbe*, 1865–1866, oil on canvas, 248.7 x 218 cm, Musée d'Orsay, Paris Monet challenged Manet, who was eight years older than he was, through a life-size response to his *Déjeuner sur l'herbe*. He criticized the original, saying that the figures "are lit by studio lighting, even though the scene takes place in a summer landscape."

below Manet composed the remains of the picnic as a still life at the bottom left edge of the picture. For Cézanne, this detail was evidence of Manet's masterly "painting for painting's sake."

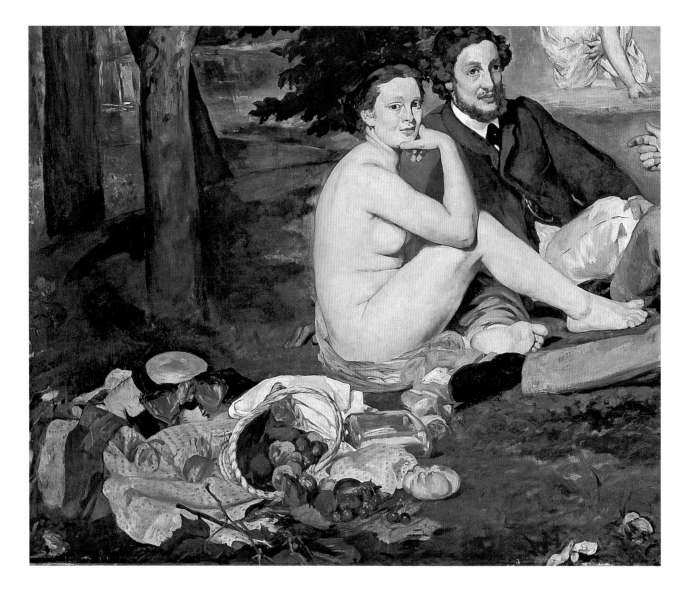

ÉDOUARD MANET **LE DÉJEUNER SUR L'HERBE**

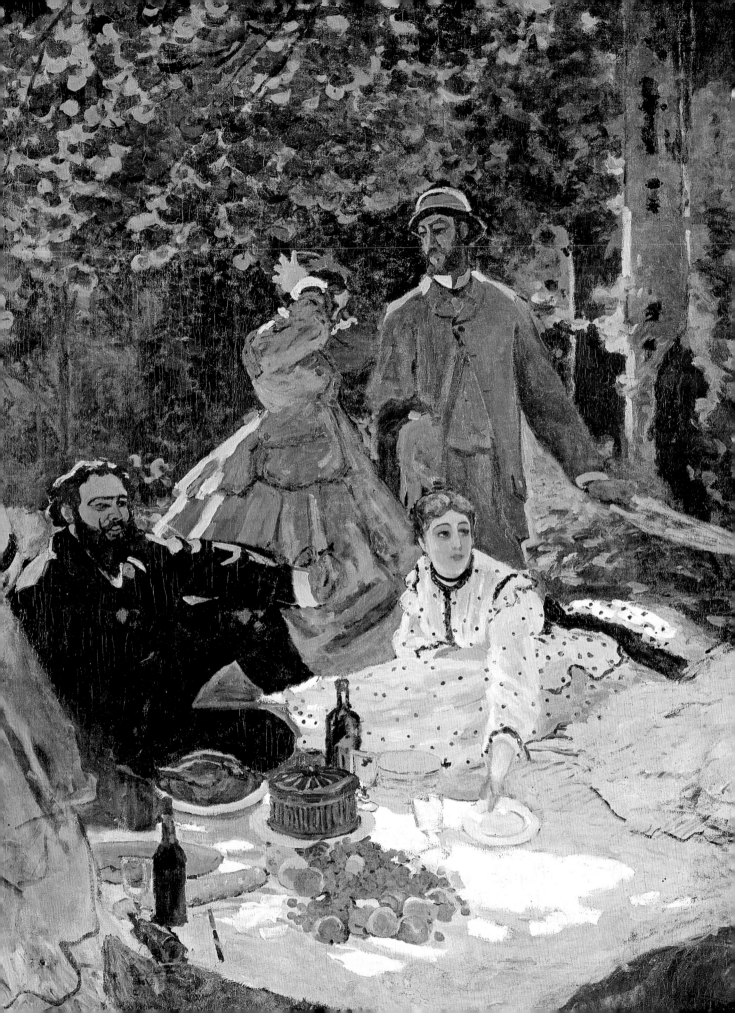

65

JAMES ABBOTT MCNEILL WHISTLER
ARRANGEMENT IN GREY AND BLACK NO. 1: THE ARTIST'S MOTHER

Whistler was flamboyant in dress and manner, yet his art was always a serious matter, delicate and subtle. Born in Lowell, Massachusetts, Whistler spent most of his career in London and Paris. The portrait of his mother, *Arrangement in Grey and Black No. 1: The Artist's Mother*, is perhaps his most famous painting, reflecting his credo of "Art for Art's sake."

Whistler's mother, Anna, came to live with him in London in 1864. On a day when a model did not show up, Whistler suggested he paint his mother instead. Anna was a very proper, very pious woman, but there was an affectionate bond between her and her unconventional son. The composition is deceptively simple, yet carefully thought out. The rectangles of the walls, curtains, painting, and floor contrast with the curves of the face, dress, and chair. The colors are almost monochromatic and the pose reserved, yet his mother's character is subtly revealed. At this time in his career, Whistler was influenced by Japanese prints and often called his portraits *Arrangements* or *Nocturnes*, purposely linking them to music and harmony rather than narrative. This was contrary to the prevailing Victorian taste for paintings that were sentimental or morally uplifting. His philosophy was that art was concerned solely with beauty, nothing more. This brought Whistler into conflict with many of the art critics of the day. When he submitted the portrait of his mother for exhibition at the Royal Academy in London in 1872, it was initially rejected. Only after pressure from Sir William Boxall, Director of the National Gallery, was it finally shown, though hung in an out-of-the-way position. Many saw it as something to be mocked, but a few critics saw the work as conveying "the dignified feeling of old lady-hood." The portrait was parodied from the start, much as it is today. A closer look reveals the delicacy and subtlety of Whistler's painting, his purpose more to work with colors and shapes than to depict the sitter realistically, yet we can nevertheless discern her personality. Whistler hungered for success and approval and took rejections badly. In 1877 he sued critic John Ruskin for libel over his criticism of another painting, *Nocturne in Black and Gold: The Falling Rocket* (1872–1877, Detroit Institute of Art). Although Whistler won the case, the expenses so taxed his already weak finances that he had to auction off his paintings, collections, and house—even the portrait of his mother.

JAMES ABBOTT MCNEILL WHISTLER was born in 1834 in Lowell, Massachusetts, the son of a military engineer, George Washington Whistler, and Anna Matilda McNeill. The family moved to Saint Petersburg, Russia, when the Major was offered the job as an engineer on railroad construction. On being discharged from West Point Military Academy, he trained as a cartographer with the US Navy. In 1855 he went to Paris to study art, soon adopting the lifestyle of a bohemian artist and becoming fascinated by Japanese prints. In 1859 he settled in London, where his friends included Oscar Wilde, but frequently returned to Paris. He dressed like a dandy and was known for his wit and confrontational manner. He set out his views on art in *Ten O'Clock Lectures* (1885); published in 1890, *The Gentle Art of Making Enemies* is in part and account of his dispute with Ruskin. He died in 1903 in London.

"THE MASTERPIECE SHOULD APPEAR AS
THE FLOWER TO THE PAINTER—PERFECT IN ITS BUD
AS IN ITS BLOOM—WITH NO REASON
TO EXPLAIN ITS PRESENCE—NO MISSION TO FULFILL."

James Abbott McNeill Whistler

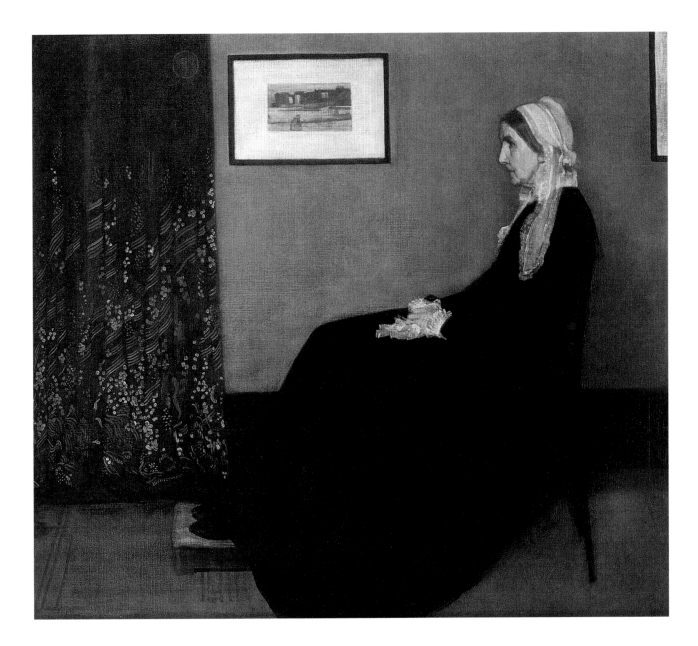

JAMES ABBOTT
MCNEILL WHISTLER

ARRANGEMENT IN GREY AND BLACK NO. 1:
THE ARTIST'S MOTHER

1871, oil on canvas, 144.3 x 162.4 cm,
Musée d'Orsay, Paris

"MONET IS ONLY AN EYE,
BUT MY GOD, WHAT AN EYE!"

Paul Cézanne

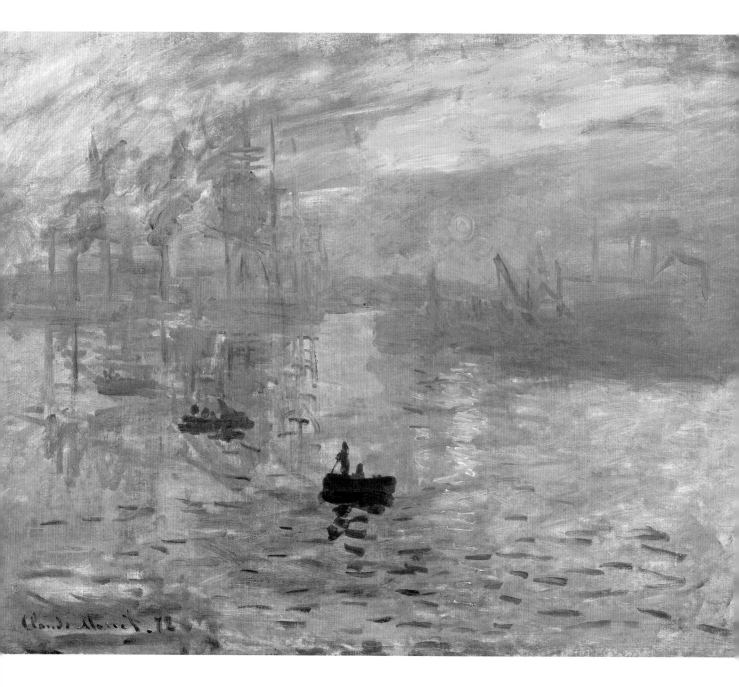

CLAUDE MONET **IMPRESSION, SUNRISE** 1872, oil on canvas, 48 x 63 cm,
Musée Marmottan Monet, Paris

66

CLAUDE MONET
IMPRESSION, SUNRISE

In 1874, rejected by the Paris Salon, Monet and his friends organized their own exhibition. At first Monet called his picture of the port of Le Havre at dawn *Marine*, but when he was asked for a more distinctive title, he answered "Impression!" Critics used the word "Impressionists" to ridicule the exhibition, and thus gave Impressionism its name.

When *Impression, Sunrise* was shown for the first time in an exhibition at the studio of photographer Nadar, it aroused a storm of criticism within the Paris art world. Monet's spontaneous approach to representation was a reaction against the dominant academic painting of the time. He wanted to capture his "impressions" of the world in a picture, inspired by the way effects of light could transform objects—he was trying to capture reality through its fleeting, ever-changing phenomena. Critics accused him of having produced an unfinished sketch, and the neologism *Impressionisme* would remain burdened with negative connotations for many years to come. Through *Impression, Sunrise*, Monet broke with the pictorial conventions of his time. Following the examples of Camille Corot (1796–1875) and Édouard Manet, he painted everyday life in the port of his hometown. Monet did not make technically perfect history paintings characterized by noble themes, somber colors, and clear outlines, but rather works in which light and color play a leading role; and all this was created by the "Impressionist comma," a short, curved brushstroke. Influenced by the color theories of the chemist Eugène Chevreul, Monet combined colors on the canvas, as an exercise for the eye of the beholder, rather than on a palette: orange, for example, he created by juxtaposing red and yellow on the painted surface. The sketch-like character of his painting corresponds to Monet's desire to reproduce a unique moment: just a few minutes later the sun will be higher in the sky, the waves will break differently, and the boats will be sailing on a different part of the sea. By comparison with stiff academic painting, this picture was a revolution. In Monet's work everything is relative: the moment captured is the artist's immediate impression at a specific moment, and the picture becomes real only in the eyes of each individual viewer. Though recognized quite late by most of his contemporaries, Monet was a trailblazer in modern art and his influence was immense, seen for example in the work of Wassily Kandinsky, in Pointillism, and, later on, in abstract art.

CLAUDE MONET was born in 1840 in Paris. He spent his childhood in Le Havre, on the Normandy coast, where he was introduced to landscape painting by Eugène Boudin (1824–1898). As a student in Paris he met Camille Pissarro and Paul Cézanne, and in 1861 he embarked on further artistic education under Johan Jongkind (1819–1891). During the Franco-Prussian War of 1870–1871, he found refuge in London. On his return, he founded the Impressionists group with other enthusiasts of openair painting. Until his art was recognized around a decade later, he lived in extreme poverty. In 1883 he moved to Giverny, a village about 80 kilometers (50 miles) from Paris, where he tended his garden and, though half blind, worked obsessively on his world-famous series *Water Lilies* until his death. He died in 1926 in Giverny.

67

ADOLPH MENZEL
THE IRON-ROLLING MILL (MODERN CYCLOPS)

Amid the haze and confusion of bodies in a cramped factory interior, workers pull a glowing white-hot iron bar on to the first section of the rolling mill, where it will be processed into a length of railroad track. The change of shifts is fast approaching. Some of the workforce are already busy washing and eating, while in the left foreground a worker trundles a block of iron off to be cooled.

At the time of its creation, shortly after the German Empire was established, this depiction of an industrial manufacturing process in Adolph Menzel's painting *The Iron-Rolling Mill* was something completely new. Menzel was then almost 60 years old, and had become one of the best-known and highly regarded painters in Prussia, famous above all for his pictures of scenes from the life of Frederick the Great. In light of his position as a kind of state artist, it seems quite astonishing that Menzel should have turned his attention to the world of the proletariat and tried out new approaches to this subject matter. In 1872 he traveled to Königshütte in Upper Silesia, and in the ironworks there, which was at the time one of the most modern in Germany, he made hundreds of preparatory sketches. The finished painting of 1875 caused a sensation. But he did not intend it to be an indictment of the hard working conditions in iron manufacturing, as is often presumed. Rather, it is a record of a process, depicted as realistically as possible, with an emphasis on representing light, steam, and heat through the medium of painting. Even though the simple factory worker is placed in the foreground, and shown undertaking his various tasks—even washing and eating—the work's manager or factory owner, easily overlooked at first glance, is given a central position in the painting. The picture's vanishing point, which is easily found by means of the converging pipes on the ceiling, coincides exactly with the point where the silhouette of a bearded man with a hat stands out against a bright patch of light. When ownership of the painting was transferred to the National Gallery in Berlin shortly after its completion, it was given the title *Modern Cyclops* (after the assistants of the Roman god of the forge, Vulcan). This mythological elevation was intended to prevent any interpretation of the painting as social criticism during a time when social tensions caused by industrialization were intensifying. Whether we now see it as a critique or a sober documentary, *The Iron-Rolling Mill* remains one of the earliest depictions of the relationship between man and machine.

ADOLPH FRIEDRICH ERDMANN VON MENZEL was born in 1815 in Breslau, Prussia (today Wrocław in Poland). The family moved to Berlin in 1830 and just two years later Menzel's father died, as a result of which he had to take over the running of the family's lithography business. After a disappointing period at the Berlin Academy of Arts, he continued to educate himself independently, and worked as an illustrator. His first success came in 1839 with his illustrations for a multi-volume history of Frederick the Great. Soon his paintings on historical themes were also highly sought-after. Many of his early, almost Impressionistic works, which are today also among his best-known, were discovered only after his death in 1905 in Berlin.

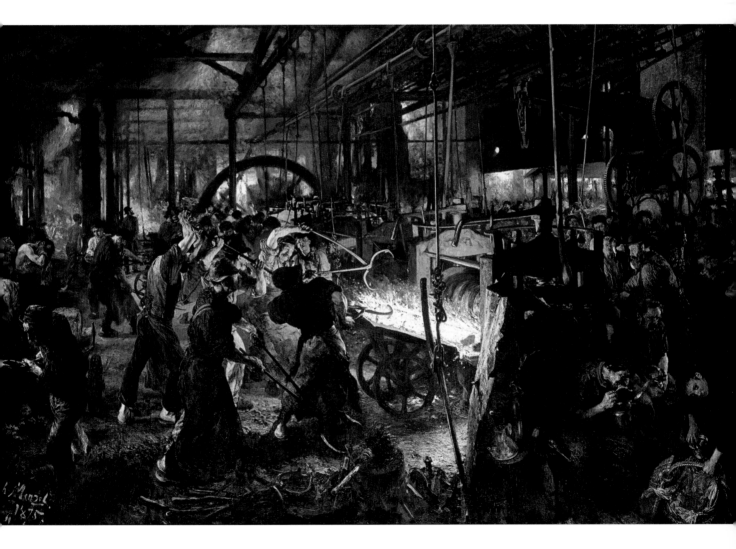

ADOLPH MENZEL **THE IRON-ROLLING MILL
(MODERN CYCLOPS)** 1872–1875, oil on canvas, 158 x 254 cm, Alte Nationalgalerie,
Preussischer Kulturbesitz, Staatliche Museen zu Berlin

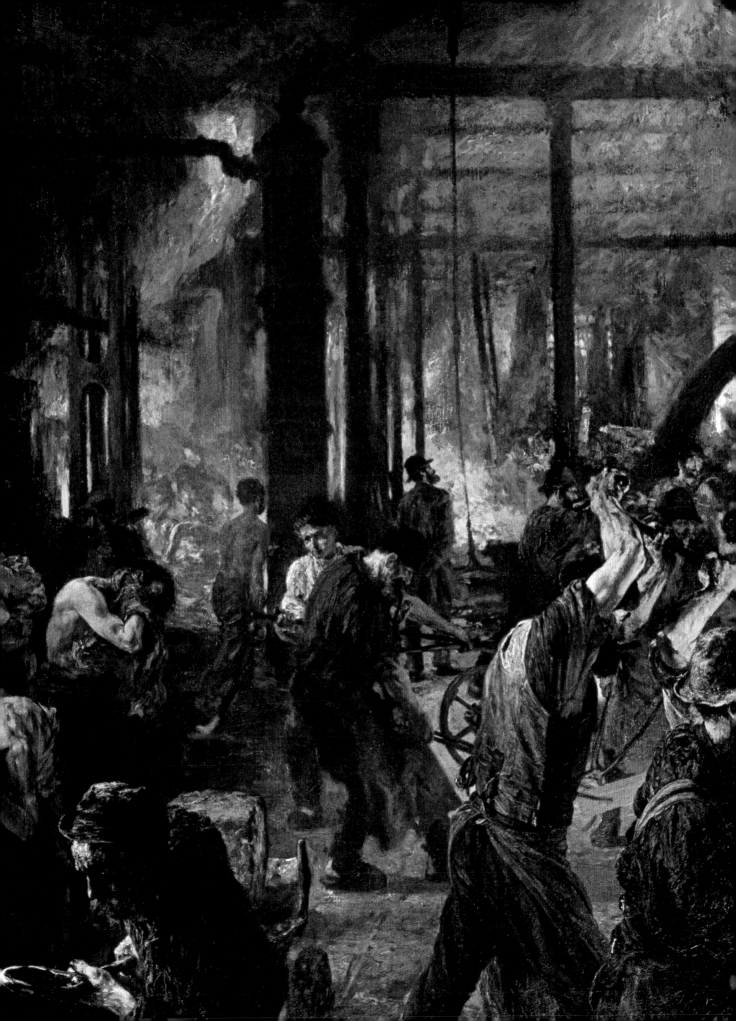

left The work's manager or factory owner, inconspicuous at first glance, occupies a central position in the painting's composition.

below The girl with the food basket on the right-hand edge of the picture is the only figure who makes direct eye contact with the viewer.

ADOLPH MENZEL **THE IRON-ROLLING MILL (MODERN CYCLOPS)**

"IT IS A GREAT SUCCESS OF CURIOSITY;
PEOPLE FIND IT ATROCIOUS. FOR ME IT IS PERFECT PAINTING,
MASTERLY, TRUE. BUT HE HAS DONE WHAT HE SAW."

Marie Bashkirtseff on *Madame X*

JOHN SINGER SARGENT **MADAME X** 1884, oil on canvas, 234.95 x 109.86 cm,
(MADAME PIERRE GAUTREAU) Metropolitan Museum of Art, New York

68

JOHN SINGER SARGENT
MADAME X (MADAME PIERRE GAUTREAU)

John Singer Sargent was one of the leading portrait painters of the late 19th century, a period often referred to as the Gilded Age. His paintings of the rich and socially prominent were fashionable in France, Britain, and America. Sargent's *Portrait of Madame Pierre Gautreau*, also known as *Madame X*, is one of his most famous—and scandalous—works.

Sargent was an American who never lived in America. He was born in Florence to parents from Philadelphia. He trained in Paris and quickly became a popular portrait painter of the glamorous, wealthy upper classes. One of the leading beauties of Parisian society was Virginie Amélie Avegno Gautreau, an American married to French banker Pierre Gautreau. Sargent asked to paint her portrait in an attempt to boost his career. Madame Gautreau is portrayed standing in a low cut, black gown, with her body facing forward and her head turned in profile. Very conscious of her beauty, she used a lavender skin powder, and this color appears in the pale skin tones Sargent painted. Her white skin contrasts with the dark dress and background. While showing the portrait, Sargent labeled it *Madame X* in an attempt to preserve his subject's anonymity, though her face was well known to the public. Contrary to his expectation that critics would see references to classical statues and Renaissance profile portraits, the painting caused a scandal. The gown was considered too revealing for good taste, exposing far too much skin. Originally, Sargent painted the strap on her right shoulder hanging down. This too was seen as sexually suggestive and considered outrageous. Crowds gathered to mock the portrait and Madame Gautreau's mother even asked Sargent to withdraw it from the exhibition, a request he declined. He did repaint the shoulder afterwards, however, with the strap in a more decorous position, perhaps in an attempt to regain his standing with critics. The outcry over *Madame X* probably influenced Sargent's decision to move to London shortly thereafter, where he continued his successful career as a portraitist, creating lasting images of the wealth and luxury of the Gilded Age. Although his virtuosity and skill with the brush was sometimes seen as referring back to masters of the past, rather than contemporary painting, admiration for Sargent's work has grown. *Madame X* remains his most famous portrait.

JOHN SINGER SARGENT was born in 1856 in Florence, where his parents had traveled to help his mother recover her health. Mrs. Sargent ultimately persuaded her husband to remain in Europe and the family traveled from city to resort to spa according to the season. Sargent's father, a doctor, hoped his son would enter the navy, but art was his great passion. In 1874 Sargent passed the exam to enter the École des Beaux-Arts, the best art school in Paris, and also trained with portrait artist Carolus-Duran (1838–1917). By the 1880s, Sargent was exhibiting portraits and soon became fashionable and successful. After the scandal of *Madame X*, he moved to London and eventually regained his popularity. In 1907 he closed his studio to travel and paint watercolor landscapes. He died in 1925 in London.

69

PAUL CÉZANNE
MONTAGNE SAINTE-VICTOIRE

The limestone Mont Sainte-Victoire, which is located in his native region of Provence, fascinated Cézanne throughout his life. In nearly 80 works he captured the mountain from various perspectives, at different times of the day, and in different seasons, and weather conditions. From these pictures, which belong to one of the most famous series in art history, we can trace the development of Cézanne's unique style of painting from the 1880s right through to the 1910s.

Over many years, Paul Cézanne used this series to get closer and closer to what he considered to the essence of Mont Sainte-Victoire. The sun bathes the mountain in ever-changing light, and thus provided the artist with a subject through which he could experiment with form and color. Abandoning the rules of perspective and other conventions of representation, he tried to transfer his own impressions directly onto the canvas: "Painting from nature does not mean copying the object; it is realizing one's sensations," he said, describing the process he called "realization." He painted Mont Sainte-Victoire at all times of the day and year, under the most diverse weather conditions and from all angles. In his 1870 painting *The Railway Cutting* (Neue Pinakothek, Berlin), the mountain figures merely as a background motif; but by the 1880s it had become more and more the focus of Cézanne's panoramic landscapes. This version, now in the Courtauld Gallery, which was painted c. 1887, breaks up the mountain scenery into simple geometric shapes: the viewer's gaze is led from the cubic farmhouses, across rectangular fields, up to the conical mountain. Cézanne's luminous color palette animates the individual shapes, which seem to shimmer before the viewer's very eyes. The framing device of the pine tree with its horizontal branches connects the foreground with the background. Cézanne is looking westwards towards the mountain chain, from the vantage point of his family home, Le Jas de Bouffan, east of Aix-en-Provence. The elevation of his standpoint raises the entire painting to eye-level with the mountain.

Between 1902 and 1906, Cézanne painted a last series focusing on Mont Sainte-Victoire, viewed from the north in his new studio in the Chemin des Lauves, located in close proximity to the mountain. His subject matter dissolves more and more into colored mosaics. He was the first artist to dissect objects into simple geometrical shapes and to treat nature "by means of the cylinder, the sphere, and the cone," as he once wrote to the artist and critic Émile Bernard. Because of this, Cézanne was not only the forefather of Cubism, but also one of the most important figures in modern art. In 1907 the Salon d'Automne in Paris paid him posthumous homage with a retrospective exhibition.

PAUL CÉZANNE was born in 1839 in Aix-en-Provence, the son of a banker. In 1861 he began studying at the free art school, the Académie Suisse, in Paris. Over the following years he shuttled between Provence and Paris, where he exhibited in 1863 at the Salon de Refusés. During this time he got to know Claude Monet, Camille Pissarro, Auguste Renoir, and Alfred Sisley. In 1869 he met his future wife Hortense Fiquet; their son, Paul, was born in 1872. Between 1874 and 1877 he took part in the exhibitions organized by the Impressionists. In 1902 he set up his studio in Les Lauves, on a hill above Aix-en-Provence. He died in 1906 in Aix-en-Provence.

"LOOK AT SAINTE-VICTOIRE THERE. HOW IT SOARS,
HOW IMPERIOUSLY IT THIRSTS FOR THE SUN! AND
HOW MELANCHOLY IT IS IN THE EVENING
WHEN ALL ITS WEIGHT SINKS BACK ..."

Paul Cézanne to Joachim Gasquet

PAUL CÉZANNE **MONTAGNE SAINTE-VICTOIRE** c. 1887, oil on canvas, 67 x 92 cm,
The Courtauld Gallery, London

Montagne Sainte-Victoire, c. 1904–
1906, oil on canvas, 63.5 x 83 cm,
Kunsthaus Zurich
In a letter to the artist and art critic
Émile Bernard, Cézanne described
his late works as follows: "Now, being
old, nearly 70 years, the sensations of
color, which give the light, are for me
the reason for the abstractions which
do not allow me to cover my canvas
entirely nor to pursue the delimitation
of the objects where their points of
contact are fine and delicate; from
which it results that my image or
picture is incomplete."

PAUL CÉZANNE **MONTAGNE SAINTE-VICTOIRE**

Montagne Sainte-Victoire, 1905–1906,
watercolor on paper, 36.2 x 54.9 cm,
Tate, London
Cézanne depicted the limestone
massif in more than 30 oil paintings
and 45 watercolors. This watercolor,
with its dominant white tones, captures
the light-drenched mountain with
such delicacy that it seems to float
above the valley of the River Arc.

PAUL CÉZANNE **MONTAGNE SAINTE-VICTOIRE**

70

VINCENT VAN GOGH
THE STARRY NIGHT

Vincent van Gogh is known as much for his troubled life as for his art. Although unsuccessful during his lifetime, he is now widely considered one of the most gifted, most profound artists of modern times. Full of movement and intense feeling, his iconic *The Starry Night* is among his greatest works.

Vincent van Gogh painted for only ten years and sold only one painting. He suffered throughout his adult life from periods of extreme anxiety, depression, and possibly epilepsy. These bouts of illness interrupted his painting; he had to work during his calmer, more lucid periods. He painted *The Starry Night* in 1889 during a stay at an asylum in Saint-Rémy near Arles, in the south of France, looking out of the window of his room. The scene depicts a swirling, star-filled night sky above a quiet town, with a church steeple in the middle. In the foreground stand tall cypress trees connecting the sky and the town. It was described by his friend and fellow painter Émile Bernard: "One feels sad in the presence of cypresses, somber as magnetic lances piercing the stars; such nights strew comets in the dense ultramarine darkness." Cypress trees were associated with cemeteries and death, at times an obsession of van Gogh's. The stars almost explode in the sky, in contrast to the quiet, silent town below. Van Gogh used thick, sweeping brushstrokes that emphasize the sense of movement in the sky and move the eye continually through the painting. With its intense yellow tones, even the moon seems alive, looking almost like the sun. The town below, however, is depicted in cooler hues to reflect the quiet of night, with only the glow from the windows to bring it to life. In *The Starry Night*, van Gogh departed from the earlier influence of Impressionism and its truth to nature. Instead, he painted with intense colors and broad strokes to convey a restless yet profound and timeless feeling. Van Gogh eventually sent the painting in a group of work to his brother Theo in Paris. He wrote to Theo of his feelings: "Looking at the stars always makes me dream ... Just as we take the train to get to Tarascon or Rouen, we take death to reach a star." Like most of his paintings, *The Starry Night* remained unsold, though it is now one of the most well-known and reproduced images in art.

VINCENT VAN GOGH was born in 1853 in Groot-Zundert, the Netherlands, the son of a pastor. After completing his schooling, he began a series of unsuccessful jobs; between 1869 and 1880 he worked for a bookseller, an art dealer, and tried, unsuccessfully to become a preacher. He also had a number of intense but unrequited love affairs. He had begun to draw in childhood and by 1882 settled in The Hague to pursue painting. In 1886 he traveled to Paris to live with his brother Theo, who worked for a firm of well-known art dealers. Van Gogh's emotional temperament made him difficult to live with and he moved to Arles in the south of France for his health, and to find new subjects. Near the end of 1888, after arguing with Paul Gauguin, he cut off part of his own ear and was taken into the asylum in Saint-Rémy. In May of 1890 he moved to Auvers-sur-Oise in northern France to be near his physician, Dr. Paul Gachet. He died in 1890 in Auvers-sur-Oise, from a gunshot wound. He left a note that read: "For the good of all."

"STARRY, STARRY NIGHT
FLAMING FLOWERS THAT BRIGHTLY BLAZE
SWIRLING CLOUDS IN VIOLET HAZE ...
THEY WOULD NOT LISTEN, THEY DID NOT KNOW HOW
PERHAPS THEY'LL LISTEN NOW"

from Don McLean's song
Vincent (Starry, Starry Night), 1971

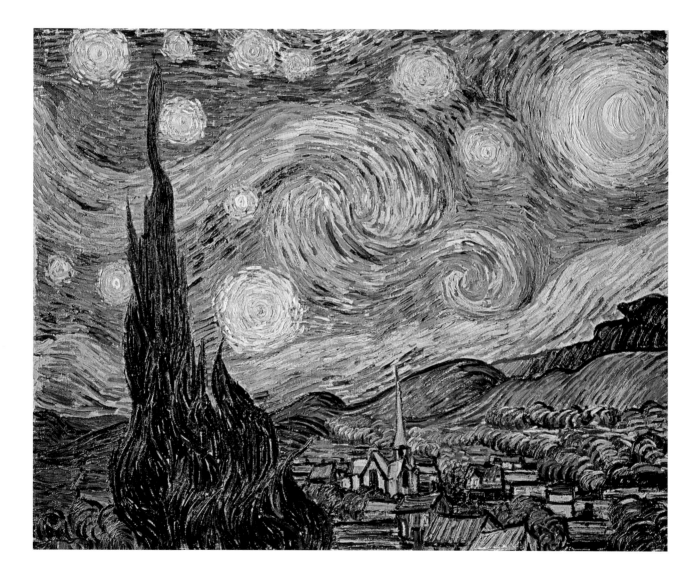

VINCENT VAN GOGH **THE STARRY NIGHT** 1889, oil on canvas, 73.7 x 92.1 cm,
Museum of Modern Art, New York

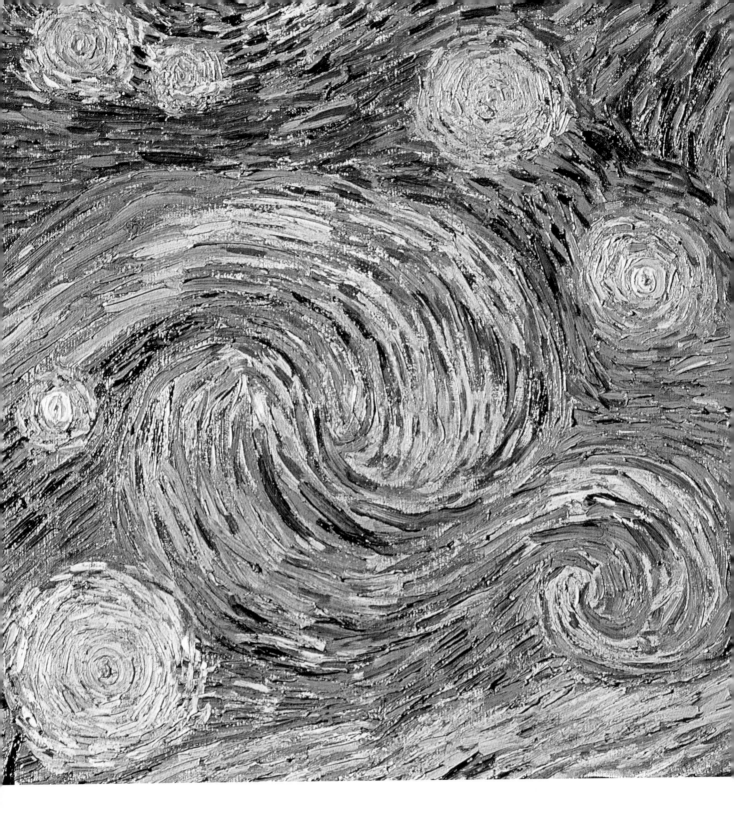

The colors and broad, sweeping brush strokes bring emotion and energy to the image.

VINCENT VAN GOGH **THE STARRY NIGHT**

The town, painted in darker colors, with only touches of yellow at the windows, contrasts with the intense, swirling night sky.

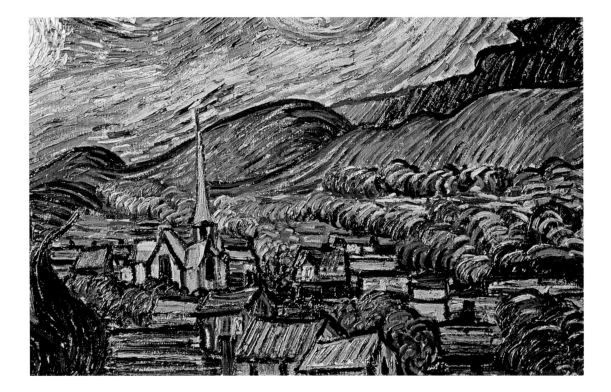

"AND ALL THE VOLUNTARY SOLITUDE,
THE ABANDONMENT OF OTHERS FOR THE RECOVERY OF ONESELF,
REST IN THIS FIGURE WITH FIXED EYES, GAUNT FEATURES,
IMMOBILE AND TENSE POSE, WHILE THE DILAPIDATED WALLS,
THE DRIED UP LILIES, THE FADED WOOD AND COLOURS,
AND ABOVE ALL THIS ESCAPE TO THIS PLACE OF SILENCE
AND MUSTINESS, FRAMING THE OLD-FASHIONED
SORROW OF THINGS CLOSE TO THEIR RUIN."

Émile Verhaeren

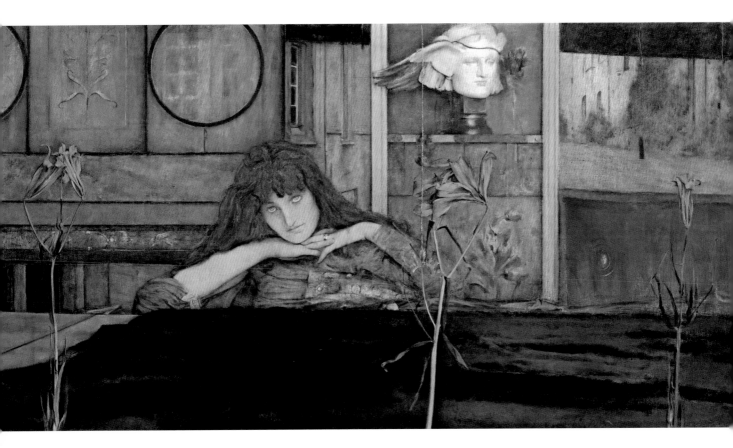

FERNAND KHNOPFF **I LOCK MY DOOR UPON MYSELF** 1891, oil on canvas, 72.7 x 141 cm, Neue Pinakothek,
Bayerische Staatsgemäldesammlungen, Munich

71

FERNAND KHNOPFF
I LOCK MY DOOR UPON MYSELF

The issue of ambiguity in artistic subject matter is the central theme of this painting. The female figure who gazes hypnotically from the painting, her appearance recalling the red-haired, androgynous women of the Pre-Raphaelites, wears an obscure, dreamy expression. In his Symbolist paintings, Khnopff frequently depicted female figures who exude a strange and disturbing enchantment.

In this painting the Belgian artist Fernand Khnopff paid homage to the British Pre-Raphaelite Brotherhood. He enhanced the image's dreamlike or meditative mood by adding a sculpture that depicts Hypnos, the god of sleep. On the right, the unreal-looking interior seems to afford a view onto a street scene (which may be a painting) in which there is a solitary figure. In the foreground, the picture is dominated by a surface covered with a black cloth, in front of which three red lilies seem to be growing up out of nowhere, depicting (from right to left) the states of becoming, flowering, and dying. On the left, we can make out two circles that may be windows or mirrors, and between them a decorative panel. The painting's contradictory lines of perspective take no account of the rules of central perspective adopted since the Renaissance: instead of a traditional view opening on to a landscape, the sightlines are hemmed in by walls.

The picture is full of signs and symbols, but it subverts their function, since they do not clarify the picture's meaning, but instead make it all the more obscure. The aim of representation is no longer to impart a clear message or story; here, subjective emotion, a moment of isolation, and the introspection of the female figure are the actual subjects of the picture. The work's title refers to the poem *Who Shall Deliver Me?* written in 1864 by Christina Rossetti, sister of the Pre-Raphaelite artist Dante Gabriel Rossetti. The poem too expresses a subjective feeling of loneliness and internalization: "I lock my door upon myself, / And bar them out; / but who shall wall / Self from myself, most loathed of all?"

Symbolism was a Europe-wide art movement of the late 19th century that was characterized by a desire to evoke moods and states of mind rather than by any unity of artistic style. Symbolism highlighted the problematic and subjective experience of reality. Turning inwards for inspiration, Symbolist artists produced complex, barely decipherable images as reactions to the world.

FERNAND KHNOPFF was born in 1858 in Grembergen, Belgium. He spent his childhood in the medieval town of Bruges, which would go on to play a key role in his later work. From 1876 to 1879 he studied at the Académie Royale des Beaux-Arts in Brussels, and at the Académie Julian in Paris. In 1883 he co-founded the Symbolist group of artists, Les XX (Les Vingt). After periods living in England and Austria, he settled in Brussels. He died in 1921 in Brussels.

72

EDVARD MUNCH
THE SCREAM

Edvard Munch developed a highly personal style that reflected his own strong emotions and troubled personality. But his painting *The Scream*, in which a skull-like figure screams in agony, has also come to represent the anxiety and fear of the modern age and is now an icon, often quoted and parodied.

Edvard Munch had a difficult life growing up in Norway. His mother died of tuberculosis when he was only five, leaving him and his siblings to the care of a puritanical father and an aunt. Munch was often ill himself and kept home from school, and these difficult times had a strong impact on his art. Initially a more naturalistic painter, Munch came to believe painting should clearly reflect the mood and emotions of the painter. *The Scream*, painted in 1893, is associated with the Expressionist movement in art, which was based on distorting reality for emotional effect. Broad strokes of reds and yellows swirl in the sky above a wooden pier that recedes sharply into the background, where two elongated figures approach in a vaguely threatening manner. The figure in the foreground, more a skull atop dark clothing, clutches its head in agony, the mouth wide open in a scream. The garish colors and the swirling lines, which seem to dissolve the figures, create a strong impression of intense pain and anguish—even nature itself seems affected. Munch wrote that he was inspired by a sunset over a fjord with a blood-red sky that evoked "a scream passing through nature ... I painted this picture, painted the clouds as actual blood. The color shrieked." Some critics of the time found *The Scream* simplistic and crudely unrealistic, but it has since become one of the best-known images in art, widely seen as representing the psychological state of man in the modern world. Munch continued to paint, but his life in Bohemian circles, with binge drinking and brawling, took its toll on his health, which had never been strong. In 1908, after suffering hallucinations and feelings of persecution, he entered a clinic and eventually emerged more stable, his art becoming brighter and less pessimistic. *The Scream* remains his most famous work and at a sale in New york in 2012 the pastel version reached the highest price ever paid for a painting at auction, almost 120 million dollars.

EDVARD MUNCH was born in 1863 in Ådalsbruk, a small village in Norway. His family moved to Christiania (called Oslo from 1925) in 1864. After his mother's death, his father became more reclusive and religious. An aunt, brought in to help with the family, was the only source of affection in the household. The oppressive atmosphere and puritanical religion dominating the household, coupled with his father's vivid ghost stories, may have helped form the visions and nightmares in Munch's work. Initially entering technical college in 1879, Munch left because of ill health and also because of a desire to follow his artistic leanings. He studied in Christiania and lived in Paris and Berlin, before finally returning home. His last years were spent in solitude, painting scenes of farm life. He died in 1944 in Christiania (then Oslo), at the age of 80.

"DISEASE, INSANITY, AND DEATH WERE
THE ANGELS WHO ATTENDED MY CRADLE, AND SINCE THEN
HAVE FOLLOWED ME THROUGHOUT MY LIFE."

Edvard Munch

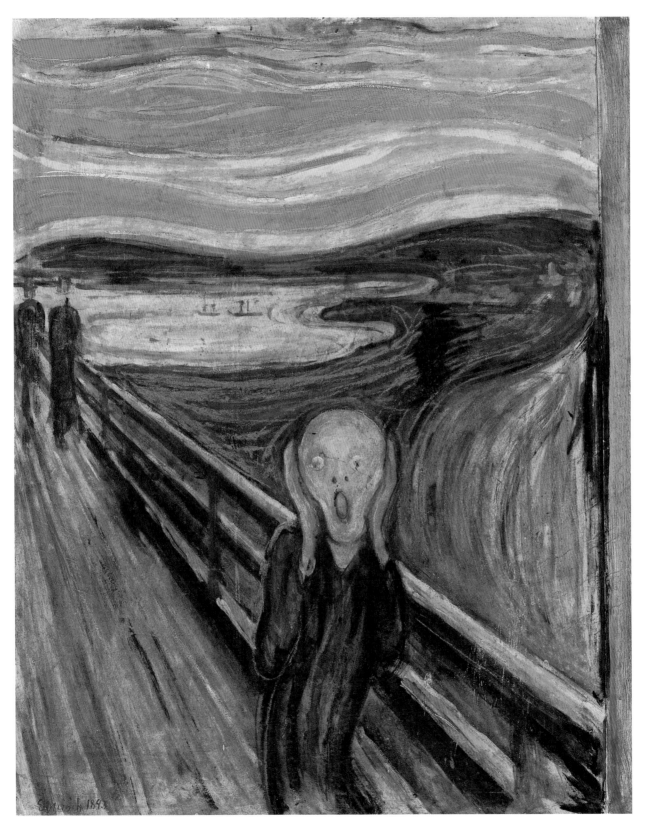

EDVARD MUNCH **THE SCREAM** 1893, oil on canvas, 91 x 73.5 cm,
 National Gallery, Oslo

73

MARY CASSATT
THE BOATING PARTY

In the late 19th century, painting was seen as a man's world. But a few women did manage, against the odds, to gain the recognition of artists, critics, and public. One was Mary Cassatt. She came from an upper-middle-class American family, and had to overcome her father's disapproval in order to live and paint in Europe. One of her best-known works, *The Boating Party* demonstrates her originality.

Mary Cassatt lived much of her life in France, making a life for herself as an artist, despite little or no support from her father. She struggled to get her paintings seen or sold until Edgar Degas helped her to exhibit with the Impressionists. They became lifelong friends, and remained close even after Cassatt left the Impressionist circle. Early on, Cassatt decided that marriage and a career in the arts would not mix and so she concentrated on painting. *The Boating Party* was painted from 1893 to 1894 in Antibes, southern France. It depicts a mother and child, images with which she is often associated, though this work also includes a male figure. The style reflects the influence of Japanese prints, which became popular after being exhibited in Paris in 1890; this can be seen in the painting's high vantage point, and its flat, off-center composition. The mother and her sprawling child are painted in soft pastel colors, in contrast to the dark silhouette of the boatman. Cassatt's style had by this stage evolved away from Impressionism towards a simpler approach to painting. There are no unnecessary details to crowd the forms. The lines of the sail, oar, and boat point to the child, while the sail itself balances the large figure of the boatman. Although she painted in simple, almost geometric forms, Cassatt still creates a connection between the woman and the boatman, who could be her husband. The brushwork is broad and flat and the color scheme high-keyed, perhaps reflecting the bright sunlight of the south of France. While still depicting a family outing, *The Boating Party* is not a specific moment in time, caught on canvas, as in Impressionism, but an experiment in shape, color, and composition. Cassatt's work was recognized in Europe more than in America, and her reputation today rests in great part on her beautifully observed portraits of mothers with their children. *The Boating Party* clearly demonstrates Cassatt's skill and creativity.

MARY STEVENSON CASSATT was born in 1844 in Allegheny City, Pennsylvania. The family was well-traveled and Cassatt learned French, German, and drawing while in Europe. Although her very traditional father objected, Cassatt began studying art at the Pennsylvania Academy of the Fine Arts at the age of only 15. The male students were patronizing and resentful of a female in their midst, and Cassatt eventually left to study in Paris—privately, as women were not allowed to study at art schools. Cassatt settled in Paris permanently in 1874. Paintings by women were often shown little respect and she struggled until befriended by Edgar Degas in 1877. She exhibited with the Impressionists for several years, then moved away from the group as her own style developed. Cassatt continued to work until she went almost blind from cataracts in 1914. She died in 1926 in Paris.

"I HAVE TOUCHED WITH A SENSE OF ART SOME PEOPLE—THEY FELT
THE LOVE AND THE LIFE. CAN YOU OFFER ME ANYTHING
TO COMPARE TO THAT JOY FOR AN ARTIST?"

Mary Cassatt

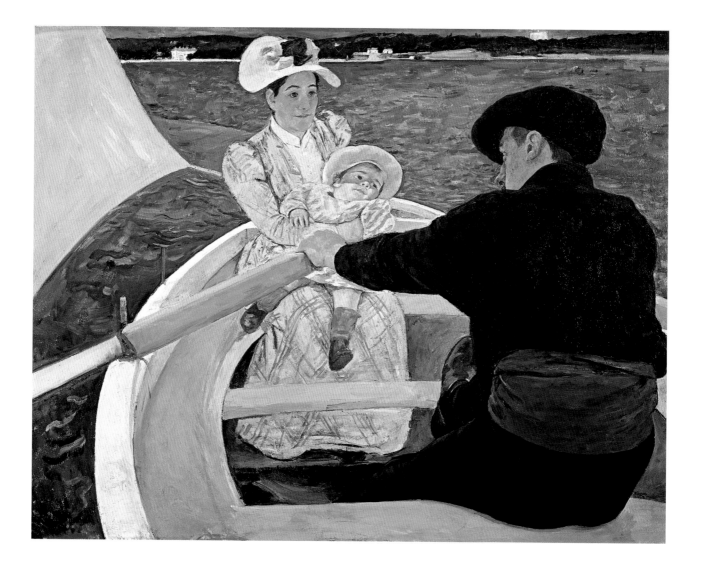

MARY CASSATT **THE BOATING PARTY** 1893–1894, oil on canvas, 90 x 117.3 cm,
National Gallery of Art, Washington, DC

74

PAULA MODERSOHN-BECKER
SELF-PORTRAIT ON HER SIXTH WEDDING ANNIVERSARY

A precursor of Expressionism, Paula Modersohn-Becker occupies a unique place in modern German art. In part influenced by French art, above all that of Paul Gauguin and the Nabis, she combined simplified forms with a focus on portraits and figure paintings, notably of women and children.

With her intense, almost questioning gaze, this young woman, depicted against a pale yellow background, looks directly out at the viewer. She is dressed in just a skirt, with a necklace of large amber pearls around her neck. She has placed her hands in a protective gesture across her apparently pregnant belly. Modersohn-Becker was not pregnant when she was working on this self-portrait, however. *Self-Portrait on Her Sixth Wedding Anniversary* was painted during a difficult period of transition, while Modersohn-Becker was on a prolonged visit to Paris in 1906. She had left her husband in order to reflect on her role as an artist as she worked in a studio on the Avenue de Maine in Montparnasse. At the same time she longed to be a mother, a wish that would be fulfilled, though with tragic consequences: just a short time after the birth of her daughter Mathilde in 1907, Modersohn-Becker died of an embolism, aged just 31.

This semi-nude self-portrait was very unusual for the time: it was unimaginable that a woman should portray herself almost life size and naked. Until then, the naked woman was a model for others. Even among male artists (apart from the Viennese Modernists such as Egon Schiele, Oskar Kokoschka, Max Oppenheimer, and Richard Gerstl), topless images were rare. This is possibly the reason why this self-portrait became well known only after the artist's death. Nevertheless the fascination with herself outweighed any modesty in the face of unusual nude portraits, and Modersohn-Becker continued her work on nude self-portraits in the summer of 1906 in Paris. A large number of images of herself, mostly portraits showing her full-face, half-length images as well as partial and full nudes, often accompanied by symbolic attributes such as flowers and fruits, testify to Modersohn-Becker's struggle with her own identity as a woman and as an artist.

PAULA BECKER was born in 1876 in Dresden; she and her family moved to Bremen in 1888. After studying at a private art school in Berlin, in 1897 she visited the Worpswede artists' colony, moving there a year later; in 1901 she married fellow artist Otto Modersohn, whose style was one of the early influences on her work. However, after several visits to Paris, during the period from 1899 to 1906, she soon moved on to new forms of expression influenced primarily by French artists, apparent in particular in her simplified forms. By contrast with the Worpswede landscape painters, she was mainly interested in portraits, through which she tried to express the timeless human essence of her models. She died in 1907 in Worpswede.

"FOR THAT IS WHAT YOU UNDERSTOOD: RIPE FRUITS. YOU SET THEM
BEFORE THE CANVAS, IN WHITE BOWLS, AND WEIGHED OUT EACH ONE'S
HEAVINESS WITH YOUR COLORS. ... AND AT LAST YOU SAW YOURSELF
AS A FRUIT, YOU STEPPED OUT OF YOUR CLOTHES AND BROUGHT YOUR NAKED BODY
BEFORE THE MIRROR, YOU LET YOURSELF INSIDE DOWN TO YOUR GAZE;
WHICH STAYED IN FRONT, IMMENSE, AND DIDN'T SAY: I AM THAT; NO: THIS IS."

Rainer Maria Rilke, 1907

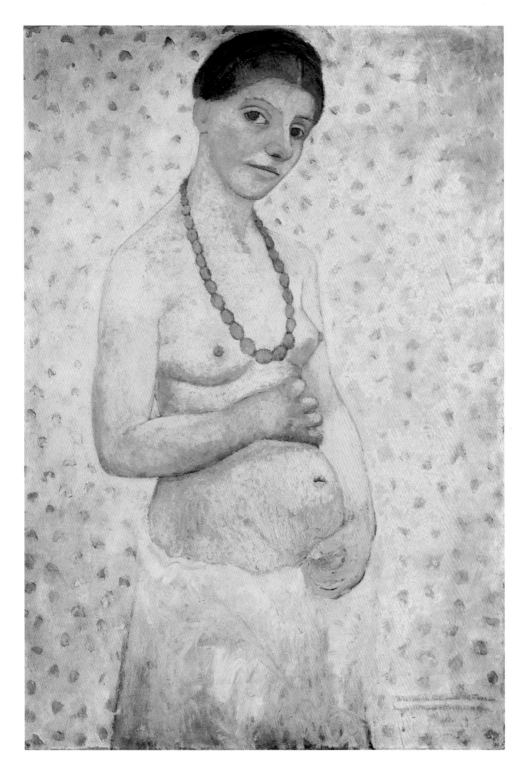

PAULA MODERSOHN-BECKER **SELF-PORTRAIT ON HER SIXTH** 1906, oil on cardboard, 101.8 x 70.2 cm, Paula Modersohn-Becker Museum,
WEDDING ANNIVERSARY Kunstsammlungen Böttcherstrasse, Bremen

75

GUSTAV KLIMT
ADELE BLOCH-BAUER I

Gustav Klimt's love of women knew no bounds. It took many preparatory studies over several years and more than a square meter of gold and silver leaf for him to create an image of the wife of the most important sugar magnate in Austria at the time. Inspired by the Byzantine mosaic image of the Empress Theodora in Ravenna, Klimt created "golden Adele" in all her glory, turning her into an icon.

Adele Bloch-Bauer was not only one of the most important collectors of Klimt's work, she was probably also his mistress. Klimt painted her twice: in this, the first version of 1907, his so-called Golden Phase reached its peak. We cannot fail to notice his exuberant use of gold: Adele wears a gold dress, a gold cloak, gold earrings, and a gold bracelet. She sits on a gold seat and the wallpaper behind her looks like gold rain. She seems encased in the precious metals, almost paralyzed by it, as if her own wealth were crippling her. Was Adele happy? According to her niece, the rich society hostess longed for more intellectual stimulation, and was unfulfilled by her marriage of convenience. Klimt's depiction of her shows a sickly, weak woman. Her half-open mouth, rosy cheeks, and heavy-lidded eyes might carry some erotic connotations, but her expression seems tired and her thin, elongated hands betray a sense of distance from the outside world. They are nothing like the claw-like fingers of a *femme fatale* such as Klimt depicted in his *Judith II* (1909, Galleria d'Arte Moderna, Venice). The queen, grown weary of her world of splendor, seems to melt into the decor with its Mycenaean spiral motifs on the arms of her throne, its flowing lines, vaginal semi-circles, Egyptian eye motifs, and sharp triangles. In this kind of mosaic-like painting, it is striking how well the realistic portrait is anchored into the gold background, as if the adored goddess were but an additional or merely decorative element.

The work's history has been controversial. In 2006, after six years of legal wrangling, Maria Altmann, Adele's niece, took possession of *Adele Bloch-Bauer I* and four other Klimt paintings that had been stolen by the National Socialists, and that had hitherto been hanging on the walls of the Belvedere in Vienna. The works had been bequeathed to the museum in Bloch-Bauer's will, which was declared invalid, while in the will of Adele's husband's they were left to Maria Altmann. *Adele Bloch-Bauer I* was sold in 2006 for the record amount of 135 million dollars, and today it can be seen at the Neue Galerie in New York.

GUSTAV KLIMT was born in 1862 in Baumgarten, near Vienna. After studying at the Vienna School of Arts and Crafts, he and his brother Ernst (together with artist Hans Makart) opened a successful workshop specializing in interior decoration, which he closed after Ernst's death in 1892. In 1897, along with 18 other artists, he resigned from Vienna's conservative Künstler-haus, and became a founding member of the Vienna Secession, a movement affiliated with Art Nouveau (known as Jugendstil in German-speaking countries). A mixture of ornament, mythology, and eroticism Klimt's works were considered shocking. His key works include his well-known, and no less sexually charged, paintings *Judith* and *The Kiss*. In 1908 he withdrew from the Secession, devoting his energies to drawing nudes and Impressionist landscape painting. He died in 1918 in Vienna.

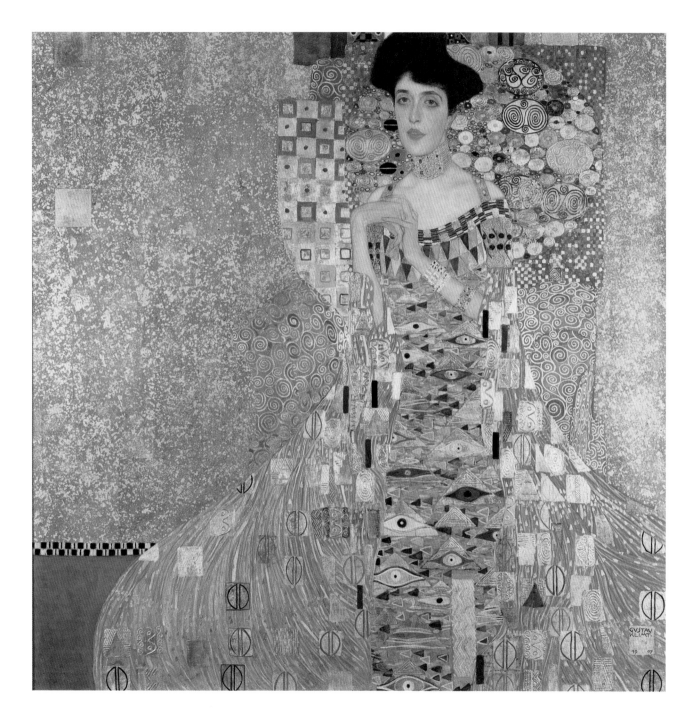

GUSTAV KLIMT **ADELE BLOCH-BAUER I** 1907, oil, silver, and gold on canvas, 140 x 140 cm,
Neue Galerie, New York

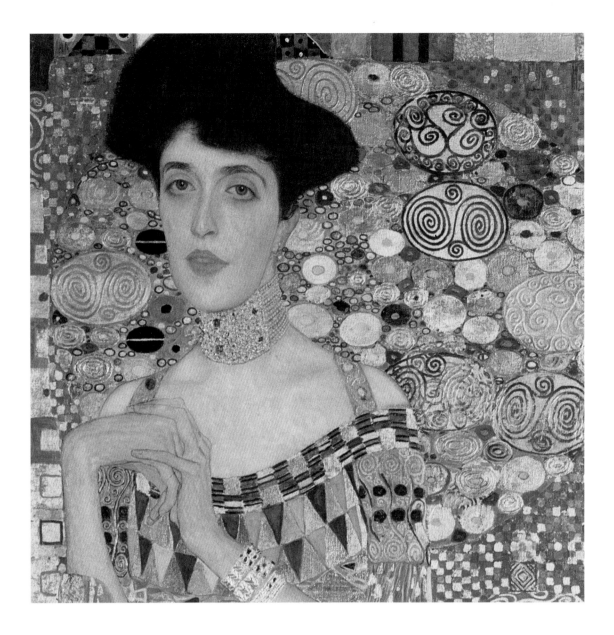

above The highly realistic depiction of Adele's face appears to be a collage against the gold background. Following the tradition of the Vienna Secession, Klimt's works combine the fine and applied arts.

right Klimt's talent for decoration is illustrated by his mixture of motifs from different cultures, such as the Egyptian "Eye of Horus" with Adele's initials set against a wave of S-shaped lines.

GUSTAV KLIMT **ADELE BLOCH-BAUER I**

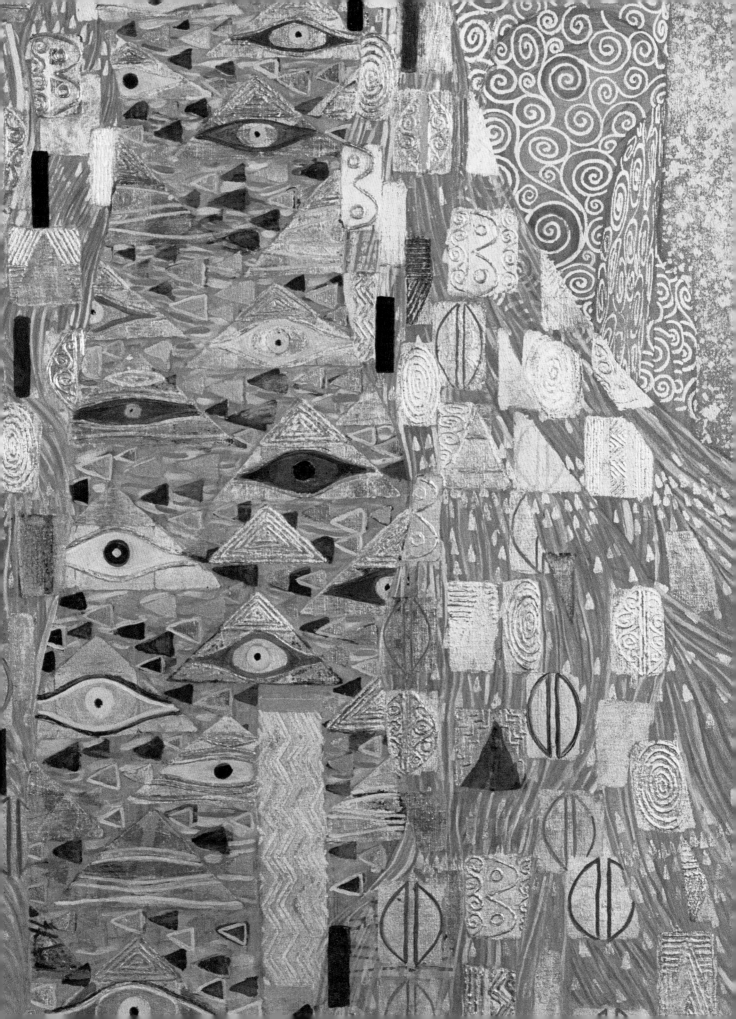

76

HENRI MATISSE
HARMONY IN RED (THE RED ROOM)

Russian collector Sergei Shchukin bought a painting called *The Blue Table* at the Salon d'automne in Paris, but when he took delivery of it the same picture had been painted over in red. Henri Matisse had completely changed the colors of his picture, as the interaction of blue tones did not sufficiently bring out the contrast with the spring landscape visible through the window.

This interior by Henri Matisse is one of the most important of his early works. His preference for intense colors and decorative shapes makes his pictures a real joy. Matisse had seen a similar motif in the works of the Spanish painter Diego Velázquez, whose *Christ in the House of Martha and Mary* (1610, National Gallery, London) also features a servant and a laden table; but while Velázquez painted a religious scene, Matisse was interested solely in decorative, painterly purposes. At first sight, the viewer's gaze seems to bounce off the red surface, which covers almost the entire picture, and which is decorated with luxuriant ornamentation: blue tendrils and baskets of fruit extend across the table and wall, forming a dynamic rhythm. The table, abundantly covered with fruit, carafes, and bowls, is separated from the rest of the space by a thin black line. Nevertheless, this is all integrated into a composition parallel to the picture plane. Even the maid is depicted through a simplified form that merges into the surface, albeit given greater emphasis by the strong contrast of black and white. Only the view out of the window into the blossoming landscape, its green tones complementing the red of the interior, offers any respite from the intensity of the dominant red. The painting's flatness is interrupted only by the chair, cropped by the edge of the picture, as its seat is depicted moving back into the depths of the picture's perspective. The yellow of the chair's seat combines harmoniously with the yellow tones of the carafes, fruit bowls, and fruits, which are depicted as if in a still life, forming a harmony of primary colors. Matisse's admiration for Oriental art, with its rich ornamentation and arabesques, is reflected here in a painting that is almost monochrome. The warm red tones can perhaps be seen as a metaphor for the body, the system of arabesques on the wall and tablecloth suggesting the network of veins and arteries circulating the blood.

HENRI MATISSE was born in 1869 in Le Cateau-Cambrésis, northern France. After studying law, his first job was in a lawyer's office. He began to paint in 1890, while convalescing after an appendix operation, and studied at the Académie Julian in Paris and then the École des Beaux-Arts. His stylistic development via Impressionism and Neo-Impressionism towards Fauvism led him to search for perfection and harmony in color and composition. He studied the intrinsic value of color, whose expressive power he emphasized in his own writings as a central factor in painting. In 1910 he began to use a brighter color palette, giving rhythm to his works through the depiction of arabesque lines and simplified shapes. He died in 1954 in Nice.

"WHAT I DREAM OF IS AN ART OF BALANCE, OF PURITY AND SERENITY, DEVOID OF TROUBLING OR DISTURBING SUBJECT MATTER, AN ART WHICH COULD BE FOR EVERY MENTAL WORKER, FOR THE BUSINESSMAN AS WELL AS THE MAN OF LETTERS, FOR EXAMPLE, A SOOTHING, CALMING INFLUENCE ON THE MIND, SOMETHING LIKE A GOOD ARMCHAIR WHICH PROVIDES RELAXATION FROM PHYSICAL FATIGUE."

Henri Matisse, 1908

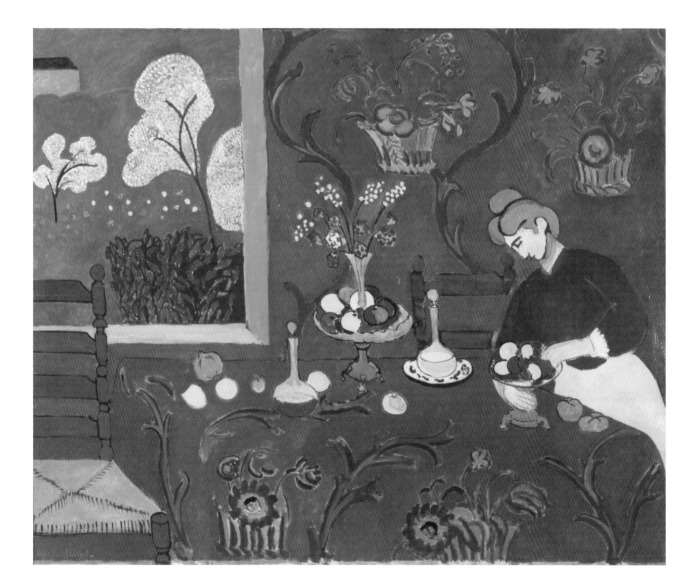

HENRI MATISSE **HARMONY IN RED (THE RED ROOM)** 1908, oil on canvas, 180.5 x 201 cm,
The State Hermitage Museum, Saint Petersburg

77

HENRI ROUSSEAU
THE DREAM

Derided by critics and the public as the works of a "naive Sunday painter," Rousseau's dream-like images were nevertheless recognized by the Parisian avant-garde, including Pablo Picasso, who found his work an inspiration.

Rousseau's so-called "jungle pictures" were inspired by his walks in the Botanical Gardens in Paris, as well as by his particular love of albums of animal photographs and popular magazines such as the *Magasin Pittoresque.* They depicted "other worlds" to which Rousseau escaped in his imagination, fleeing the oppressive reality of obscurity and neglect. *The Dream* is the last of these "jungle pictures." Here we see an extraordinary encounter: in the middle of a lush jungle, full of tall, fleshy plants among which several animals hide, a naked woman is lying on a French-style sofa. She points to a native emerging from the jungle wearing a colorful, striped loincloth, and playing a kind of flute.

It is unclear whether this music has a pacifying effect on the wild animals who are crowding round the flute-player—as in the myth of Orpheus to which the poet and critic Guillaume Apollinaire (1880–1918), one of Rousseau's few supporters, had just dedicated a work of literature (*Bestiary*, or *The Parade of Orpheus*, Paris, 1911)—or whether this deep sense of peace emanates from the naked woman, who is apparently dreaming all this with her eyes still open. The scene is bathed in a surreal moonlight that turns night into day and that forms a pale glow around the flowers and leaves. Rousseau used a wide range of greens to create the lush leaves: he must have mixed around 40 different shades of green on his palette. The other colors are muted and are used merely as accents, for example the orange of the plump fruits and a cool, delicate blue in some of the flowers.

Time and again, paintings such as this, exhibited in the annual Salon des Indépendants in Paris, made Rousseau a laughing stock, but a number of modern artists understood what he was trying to do. They saw in him the authentic expression of the poetic soul of an artist. Despite being misunderstood, Rousseau was posthumously honored in Germany when his work was included in the first exhibition mounted by the *Blue Rider* group of artists at the end of 1911, and by his inclusion in their *Blue Rider Almanac.*

HENRI ROUSSEAU was born in 1844 in Laval, northern France; he was later known as "Le Douanier" because of his job as a tolls collector. He began painting in his spare time, teaching himself to paint by copying works in the Louvre. From 1886 on he exhibited regularly at the Salon des Indépendants, though his paintings were ridiculed as "naive." It was only when the influential mother of painter Robert Delaunay, along with the German art collector and critic Wilhelm Uhde, made his name known that a chain reaction began within the Paris art scene. Even Pablo Picasso bought Rousseau's paintings, and in 1908 organized a legendary dinner in Rousseau's honor at which important people in the Parisian art world celebrated "Le Douanier." He died in 1910 in Paris, still poor and unknown outside his small circle of friends and supporters.

"YADWIGHA, FALLING INTO SWEET SLEEP, HEARD IN A LOVELY DREAM
THE SOUNDS OF A FLUTE PLAYED BY A KIND ENCHANTER.
WHILE THE MOON SHONE ON THE FLOWERS, THE VERDANT TREES,
THE WILD SNAKES LENT AN EAR TO THE INSTRUMENT'S GAY AIRS."

Henri Rousseau, in a note on the frame of *The Dream* when it was exhibited in 1910

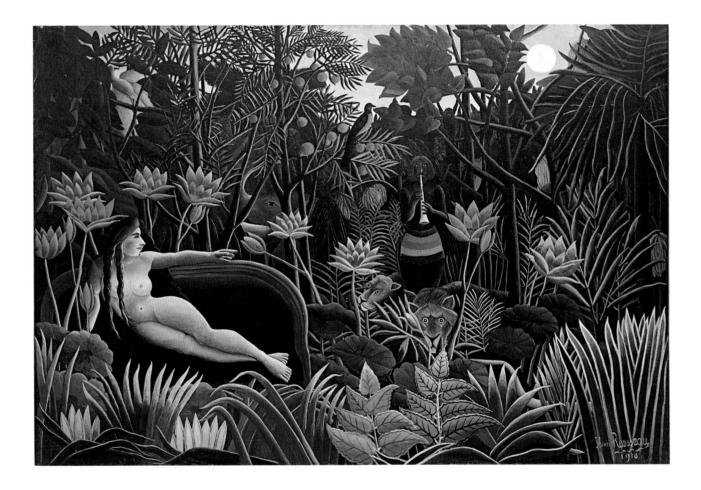

HENRI ROUSSEAU **THE DREAM** 1910, oil on canvas, 204.5 x 298.5 cm,
The Museum of Modern Art, New York

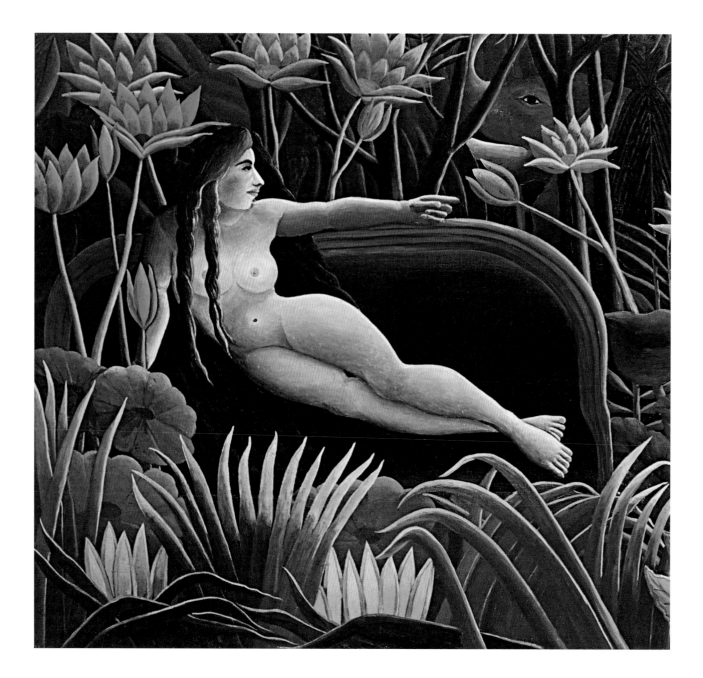

Rousseau depicts the figure of "Yadwigha" using clumsy proportions, a strongly stylized face, and girlish plaits. She points to the flute-playing "magician" who emerges from the jungle to pacify the wild animals around him with his music.

HENRI ROUSSEAU **THE DREAM**

Rousseau never saw the animals in
his picture in real life; he copied
them from illustrations in magazines.
Similarly, the many different kinds of
leaves were not just a product of his
imagination but were also sourced
from his favorite popular illustrated
magazines.

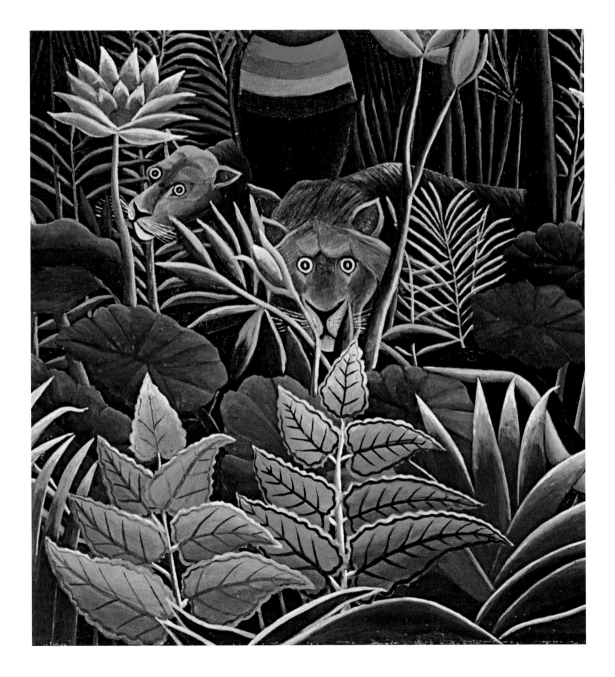

HENRI ROUSSEAU **THE DREAM**

78

WASSILY KANDINSKY
IMPRESSION III (CONCERT)

Impression III was painted shortly after a visit to a concert. Wassily Kandinsky was so impressed by the bold innovations of the twelve-tone music he heard at the concert, that he began a lively exchange of letters with the composer of the pieces, Arnold Schoenberg. He was inspired by the freedom of Schoenberg's music to liberate painting from what he considered its figurative restrictions.

The painting is dominated by a broad area of graduated yellow that arouses no figurative associations. For Kandinsky, yellow is a color that radiates joy and spiritual warmth towards the viewer. Even without referring to the theosophical idea of aura or to synesthetic experiences (it is thought Kandinsky himself was capable of such experiences) the yellow field can be interpreted as a depiction of the immaterial sound of the piano, as a symbol of music itself. Placed right up against the yellow we can see a black patch that suggests a concert piano, but which also connects with the other patches and shapes to form a diagonal that draws the viewer's gaze into the picture. The concert audience is also vaguely recognizable, but their shapes are starting to break up. A composition based on color fields gives the structure of the picture a strong dynamic movement towards the top right. A dissonant struggle between black and yellow characterizes the composition: the flowing wave of yellow develops an electrifying dynamic, which is not held back by the embedded black shapes, but rather is intensified. Thus the power of music is visualized by means of color and shape in this painting. Shortly after the turn of the 20th century Kandinsky was the first artist to take the crucial step towards abstract art. The paintings he made after 1900 became increasingly more abstract, his aim being to represent the pure sensory impression of music through colors and shapes independently of figurative representation. The pictures in the series of so-called *Impressions* do not represent "direct impressions of 'external' nature" but are the combination of optical impressions with inner experience. As Kandinsky wrote in 1935: "The 'flight from the object' does not mean the flight from nature in general. Every true art is subject to its laws. It is not necessary to cling to 'nature' as she is only a part of nature in general. One can abstain from communicating 'nature' if one can relate directly to the whole."

WASSILY KANDINSKY was born in 1866 in Moscow. He first studied and later taught law and economics; it was not until 1896 that he first studied art, in Munich. He became a founding member of the artists' group Phalanx, and also of the New Artists' Association in Munich, and later collaborated with Franz Marc (1880–1916) on the editing of the *Blue Rider Almanac* (1912). Their exhibition of the same name featuring contemporary artists did not bring the breakthrough they had hoped for. Nevertheless, Kandinsky remained faithful to his path towards abstract painting even after the war. An invitation to join the Bauhaus in Weimar in 1922 enabled him to develop an abstract style. When the Bauhaus was forced to close by the Nazis in 1933, he soon moved to Paris, where he focused on his later, biomorphic style. He died in 1944 in Neuilly-sur-Seine, France.

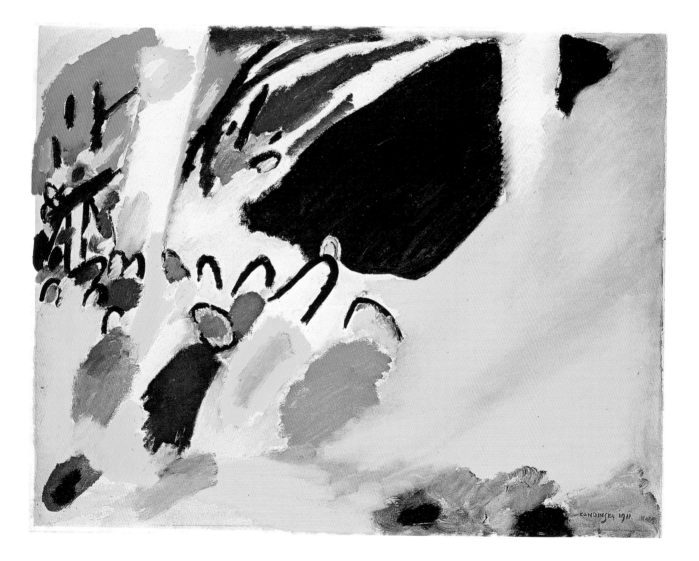

WASSILY KANDINSKY **IMPRESSION III (CONCERT)** 1911, oil on canvas, 77.5 x 100 cm,
Städtische Galerie im Lenbachhaus, Munich

79

LUDWIG KIRCHNER
POTSDAMER PLATZ

Kirchner's provocative series of Berlin street scenes created 1913–1915 depicts an elegant but disreputable metropolis, epitomized in the repeated motif of the prostitute. Like Franz Biberkopf, the hero of Alfred Döblin's novel *Berlin Alexanderplatz* (1929), modern man in this Expressionistic *Potsdamer Platz* is in thrall to the "whore of Babylon."

Kirchner created his series of paintings depicting street scenes shortly after he moved to Berlin. He had certainly found inspiration in Dresden, but in the imperial capital, whose charms he found both attractive and repellent, his talents reached their peak. Like his friend Alfred Döblin with *Berlin Alexanderplatz*, Kirchner uses his painting to depict modern, urban life in all its variety and with all its vices. This large-format depiction of Berlin nightlife shortly after war broke out shows two scrawny prostitutes on a traffic island in Potsdamer Platz. A hub of swirling traffic and endless pleasure, Potsdamer Platz at that time was considered the quintessence of metropolitan life. In the background we can see the Café Piccadilly and the Berlin–Potsdam railroad station. Black-clad clients are hanging about outside the buildings, or are marching quickly across the green, river-like street towards the two prostitutes. All the characters have greenish, sick-looking faces, and the figures of the men and women in flamingo-pink suits (matching the color of the station) are expressionless and without individuality. The two prostitutes hide behind corpse-like masks. Everyone seems completely isolated and alienated from their surroundings and from others. The road between the sidewalks seems unbridgeable, and even the two prostitutes on their stage-like island have no relationship with each other; one is shown in veiled profile while the other stares out at the viewer with empty eyes. Men rush forward like dislocated, distorted marionettes, and the whole dehumanized scene threatens to swamp the viewer. Kirchner handles the perspective very freely, with the result that the architecture seems aggressive, angular, and flexible.

His restless, jagged brushstrokes and the harsh colors emphasize the hectic, nervous rhythm of the metropolis, creating an alienating effect. This Expressionist street scene is a product of its time: Kirchner took up the myth of the "whore of Babylon," which was popular at the beginning of the century, and with it celebrates the anonymous, frenetic, and libidinous world that existed just before the chaos of war broke out.

ERNST LUDWIG KIRCHNER was born in 1880 in Aschaffenburg, Germany. He studied architecture in Dresden, and taught himself to paint. He was a co-founder of the Dresden artists' group Die Brücke (1905), which was established in Berlin in the 1910s. As a soldier during World War I, he suffered a nervous breakdown and was sent to a Swiss sanatorium; by 1918 he had settled in Switzerland, though he frequently visited Germany. In 1931 he became a member of the Prussian Academy of Arts, but was quickly expelled in 1933. The National Socialists denigrated his art as "degenerate" and almost 700 of his works were confiscated, destroyed, or sold. He took his own life in 1938 in Davos, Switzerland.

"MODERN CITY LIGHTS, ALONGSIDE THE MOVEMENT
IN THE STREETS, GIVE ME NEW INSPIRATION.
THEY SPREAD A NEW BEAUTY ACROSS THE WORLD
THAT DOES NOT LIE IN THE INDIVIDUALITY OF OBJECTS."

Ludwig Kirchner

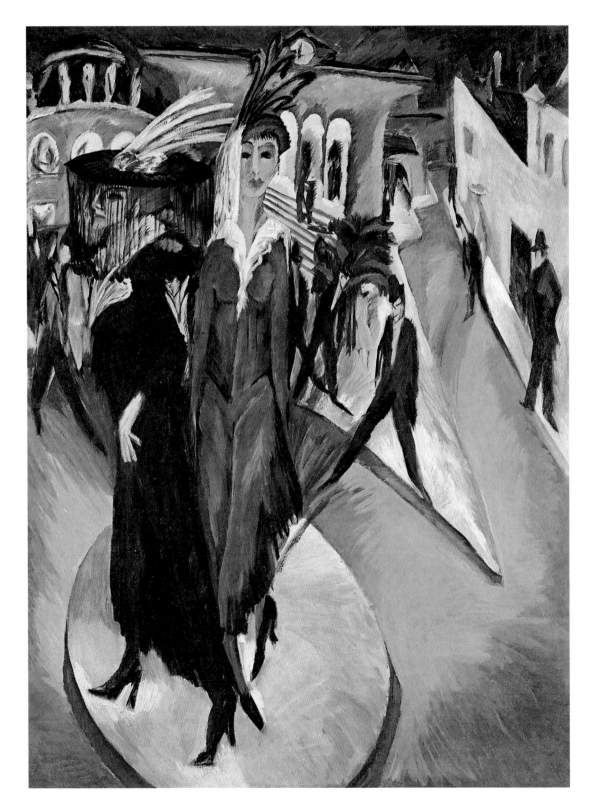

LUDWIG KIRCHNER **POTSDAMER PLATZ** 1914, oil on canvas, 200 x 150 cm,
Neue Nationalgalerie, Berlin

80

TAMARA DE LEMPICKA
TAMARA IN THE GREEN BUGATTI (SELF-PORTRAIT)

With her innovative images of women and of the glamorous world of the 1920s and 1930s, Tamara de Lempicka brought a particular flair to art in Paris. She painted her portraits of the upper classes in Paris in a graphic style in which echoes of late Cubism were combined with the decorative Art Deco of the mid-1920s.

It was above all her self-portrait *Tamara in the Green Bugatti*, commissioned in 1929 by the German women's magazine *Die Dame*, which brought Tamara de Lempicka fame in Germany. She had already designed several cover images for this magazine, including a self-portrait as a skier. At this time, Lempicka was already an internationally successful portrait painter who merged aspects of her own personality and appearance, as well as her luxurious and eccentric lifestyle, with her art, thus cleverly portraying herself as the focus of attention. She also used her talent as a portrait painter to gain access to the elevated circles of Paris society. Her portraits usually depict women, often nude, in a unique style of representation in which they are shown in monumental form against a cityscape. Her own portrait, showing her at the wheel of a sports car, expressed the new freedom of the modern woman, but was also part of the self-dramatization of the artist.

In this self-portrait, Lempicka sits at the wheel of a green car, gazing at the viewer with half-closed eyes and cool, emotionless features. She holds the black steering wheel in her light-brown-gloved left hand. Her body is completely enveloped in a gray-brown cloak that forms an oversize collar around her neck. On her head she wears a similarly colored driving cap with chinstrap, from which a wisp of her blond hair peeps out just in front of her left ear. Her lips are deep red, her eyes emphasized with eye shadow and mascara.

Lempicka's inspiration for this cool yet somehow sexually charged self-portrait came from photographs taken in their cars by photographers such as the American Thérèse Bonney (1894–1978). This painting, which Tamara de Lempicka exhibited in Paris around the middle of the 1920s, caught the spirit of the age profoundly.

TAMARA DE LEMPICKA (*née* Maria Górska) was born in 1898 in Warsaw. After the Russian Revolution, she emigrated from Saint Petersburg to Paris with her husband, Tadeusz Lempicki, who was a lawyer. In 1918 she studied at the Académie de la Grande Chaumière under Maurice Denis and Andre Lhote. She began painting in order to earn a living for her family (a daughter), and quickly found her feet in the Paris art world, enjoying her first successes at the Paris Salon. During the Art Deco period she became a sought-after portrait painter. Her eccentric lifestyle led to her divorce from her husband in 1928, and in 1933 she married Hungarian industrialist Baron Raoul Kuffner, with whom she emigrated to the USA in 1939. In 1947 she moved to Mexico. She died in 1980 in Cuernavaca, Mexico, aged 81.

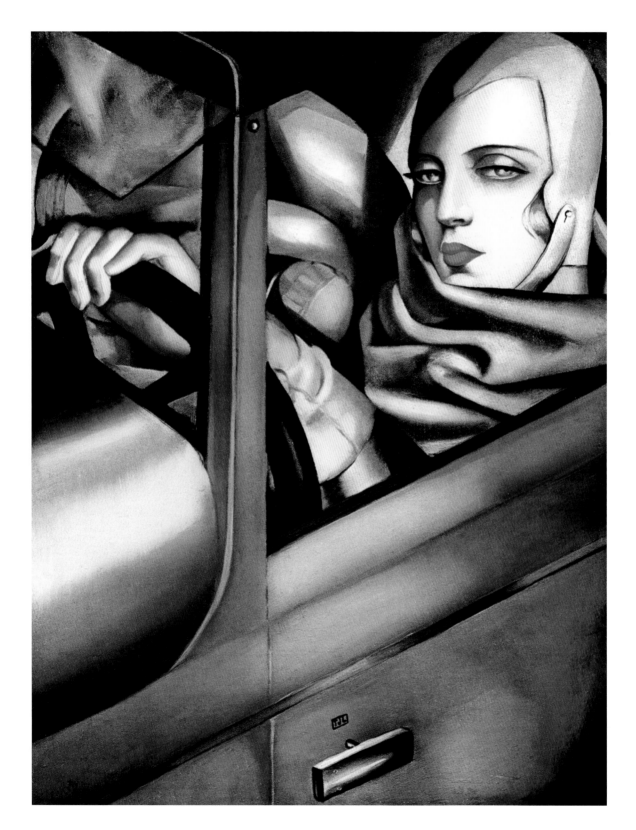

TAMARA DE LEMPICKA **TAMARA IN THE GREEN BUGATTI** 1915, oil on panel, 35 x 26 cm, private collection
(SELF-PORTRAIT)

81

KAZIMIR MALEVICH
BLACK SQUARE ON A WHITE GROUND

When Kazimir Malevich subversively painted a black square on a white ground, he was surely unaware of the influence his action would have on subsequent generations. He had got to the very heart of something that no one had addressed in such a masterful way before: everything and nothing, a zero point in the possible reduction of form and color which became an icon of its time.

Though Cubism had a profound impact on subsequent art movements—on Suprematism and Constructivism, De Stijl, Dada, and the Bauhaus— it had not thought through the logical consequence of its own discovery, non-objectivity: it had not pushed art to the point of abstraction. In 1913 Kazimir Malevich was pursuing his debate with the European avant-garde as a stage and costume designer working on the futuristic opera *Victory over the Sun* by composer Mikhail Matyushin. His costumes were made from simple fabrics and were limited to geometrical forms; the backdrop showed just a black square. Malevich elaborated on these ideas in his paintings, creating the ultimate not only in his own but in all painting: *Black Square on a White Ground* depicts absolute abstraction, nothingness, and despite or perhaps because of this it brings together an energy which had never existed before: the potential of an unequivocal new beginning. Malevich was describing a zero point from which one could invent art from scratch and create a new understanding of the order of the world. His place in art history is as the founder of Suprematism, a movement that took color and geometrical form as the ultimate properties of painting, properties that were superior to illusionistic depictions of the visible world. In Malevich's theory, the beauty of mathematical forms is coupled with a passion for cosmic meaning: the basic shapes with which he constructed his pictures—the square, the circle, and the cross—were intended to be signs moving in infinite space, the movement towards infinity itself. According to this interpretation, Malevich's paintings represent individual parts of an infinite whole, and the structure of his white canvases must be pursued into limitlessness. *Black Square* illustrates a meditative, almost mystical philosophy, which had a profound influence on both 20th-century architecture and Russian Constructivism. It also prepared the way for abstract and technology-based images and reliefs, Kinetic art, and Minimalism. Even today *Black Square on a White Ground* remains Malevich's most boldly radical work.

KAZIMIR MALEVICH was born in 1878 in Kiev. He studied at the Kiev School of Fine Arts 1895–1901, and the Moscow School of Fine Arts in 1903. He created several highly original stage designs, works that helped him move towards abstraction. In 1915 he founded Suprematism with the publication of the manifesto *From Cubism to Suprematism*. A supporter of the Russian Revolution, he taught at the Vitebsk Art institute 1919–1922, and in 1920, with El Lissetzky and others, formed the Unovis group to promote new forms of art. During the 1930s, as a result of the New Economic Policy, his work fell into disfavor in the Soviet Union, and it was only in the 1950s—in the West— that his paintings began once again to exert an influence. He died in 1935 in Leningrad (now Saint Petersburg).

"MALEVICH NEITHER KNEW NOR UNDERSTOOD
WHAT THE BLACK SQUARE CONTAINED. HE THOUGHT IT SO IMPORTANT
AN EVENT IN HIS CREATION THAT FOR A WHOLE WEEK
HE WAS UNABLE TO EAT, DRINK OR SLEEP."

Anna Leporskaya, Malevich's former student and colleague

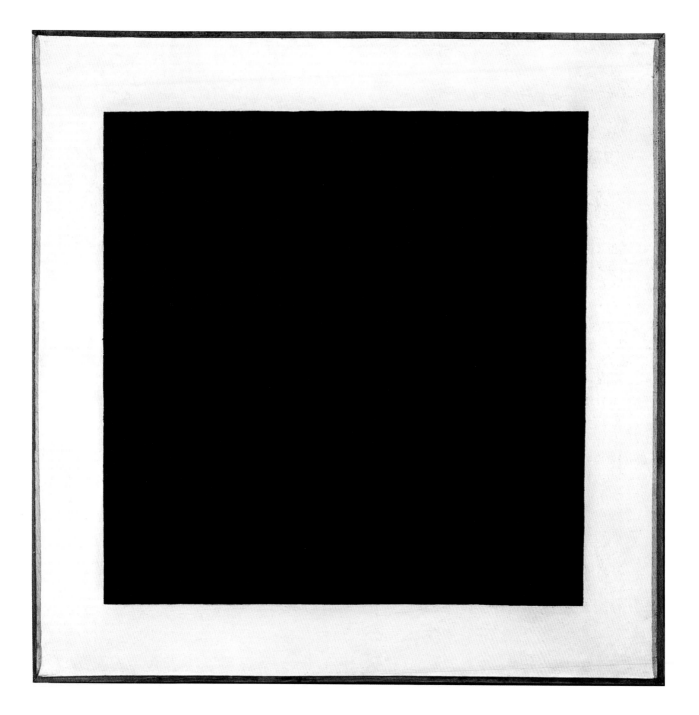

KAZIMIR MALEVICH **BLACK SQUARE ON
A WHITE GROUND** dated 1913 but painted after 1920, oil on canvas, 106.2 x 106.2 cm,
The State Russian Museum, Saint Petersburg

82

OTTO DIX
THE DANCER ANITA BERBER

In *The Dancer Anita Berber,* Otto Dix created a portrait of a celebrated 1920s *femme fatale* whose life was beset by scandal. In a mercilessly realistic depiction, Dix paints Berber as the old woman she would never become. Her sunken face, pale skin, and dark-rimmed eyes contrast disturbingly with the fact that she was only 26 years old.

Painted in 1925, this Otto Dix portrait is captivating in its expressive color palette and its unsparing anticipation of Anita Berber's early demise. Dressed in a red, figure-hugging dress, the dancer stands in a similarly red, monochrome, undefined space. Her hair too is a fiery red. With heavily made-up lips and eyes, her livid face and blank expression, she seems less like a young woman and more like a symbol of vice and self-destruction. Marked by her excessive lifestyle, Berber does not look self-confidently out at the viewer, but directs her expressionless gaze lethargically into the distance. At odds with her aura of morbidity is her exaggerated physicality. Her floor-length dress is so tight that we can clearly discern her breasts and belly, and this makes her seem almost naked. Because of her otherwise fragile appearance, this portrait acquires a shocking, almost obscene character through this sexual resonance.

As a young artiste, Anita Berber quickly made a name for herself on the Berlin cabaret scene, not only through her style of dancing, but first and foremost through her unconventional lifestyle. Berber was as provocative in her daily life as she was on the stage, radically rejecting dominant conventions and bourgeois etiquette. With her excessive drug use and homoerotic love affairs, as well as the aggressive and sensual style of her choreography, Berber caused many scandals and attracted the attention of the police. Cocaine and alcohol were her constant companions, and led ultimately to her downfall. Berber died in Berlin in 1929 following a tuberculosis-related illness. Otto Dix shows the human abyss behind the glamorous façade. His art did not idealize his subjects, it demystified them through his remorseless images and unerring clarity. As the main proponent of the Neue Sachlichkeit (New Objectivity) movement, he favored low-life, often obscene, subjects.

The Dancer Anita Berber was bought by the city of Nuremberg in 1928 for its municipal art collection, and only five years later was banned by the National Socialists as "degenerate" art.

OTTO DIX was born in 1891 in Untermhaus (today a district of Gera, Germany) and grew up in a modest household. First apprenticed to a painter-decorator, he then studied at the Academy of Applied Arts in Dresden and later (after World War I) at the Art Academy in Dresden. Strongly influenced by World War I, he first depicted the results of war with merciless realism, painting portraits of the war-wounded, prostitutes, and beggars, and later well-known personalities, too, all in the style of the Neue Sachlichkeit. The National Socialists forbade him from exhibiting, and many of his works were labeled "degenerate." His later work depicts mainly religious subjects. He died in 1969 in Singen, Germany.

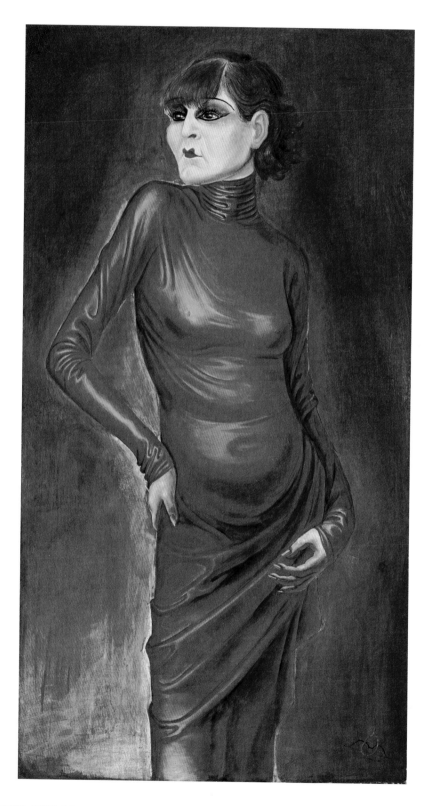

OTTO DIX **THE DANCER ANITA BERBER** 1925, oil and tempera on wood, 120 x 65 cm, Kunstmuseum, Stuttgart

83

GEORGE GROSZ
THE PILLARS OF SOCIETY

George Grosz found the themes of his pictures in the big city, with its social divisions, excesses, marginal existences, and continual change. *The Pillars of Society* epitomizes his view of the world and his criticism of social conditions during the Weimar Republic. It is at the same time a profile of the ruling classes at the beginning of the 20th century.

In *The Pillars of Society*, Grosz sought to depict the social strata that supported the capitalist system he hated: the petty bourgeoisie, the press, the German Social Democratic Party (SPD), the Church, and the military. The types he satirized can be classified according to specific attributes. For example, the scars on the cheek of the man in a suit in the near foreground, as well as the colored ribbon across his chest, indicate his membership of a dueling fraternity; the swastika he wears betrays his political allegiances. Next to him, on the left, the political alignment of the press is revealed through the newspapers, which range from the liberal to the nationalist camps. The third pillar of the apparatus of power is the SPD government, whose slogan "Socialism Means Work" clearly indicates their allegiance. This figure carries in his hand a flag bearing the colors of the defunct German Empire, thus implying a conservative stance. The overall tone of the picture underlines the impression of a dark and somber world. In the dark background we can see a fire blazing. Gesturing with his hands, the priest seems at once to be giving his blessing to the prevailing social order, and also to be pointing the way directly to hell. Nearby, soldiers add to the mayhem.

In order to represent the social conflict and political chaos, Grosz breaks up any sense of order in the painting's proportions and perspective. The individual figures are placed alongside each other and overlap; they act but not in relation to one another. Each individual pillar of society is portrayed separately then assembled alongside the others, as if in a collage. This interplay produces the morbid impression of a doomed society. With this provocative painting, Grosz lambasted those in political power and those who unthinkingly supported them. For Grosz, art was an effective means of condemning the outrages of society directly and without restraint—of expressing his own criticism of the state and of encouraging the viewer to think critically.

GEORGE GROSZ was born Georg Ehrenfried Gross in 1893 in Berlin, the son of a restaurant owner; it was his dislike of Germany's warmongering that led him to Anglicize his name. He studied art in Dresden (1909–1911), Berlin (1912–1916), and Paris (1913). Worked as a successful illustrator and cartoonist in Berlin, though accused of obscenity. Moved to New York in 1932 as the political situation in Germany worsened; the works he produced in America, where he taught at the Art Students League and later Columbia University, were less extreme. He returned to Germany in 1959, and died the same year in Berlin.

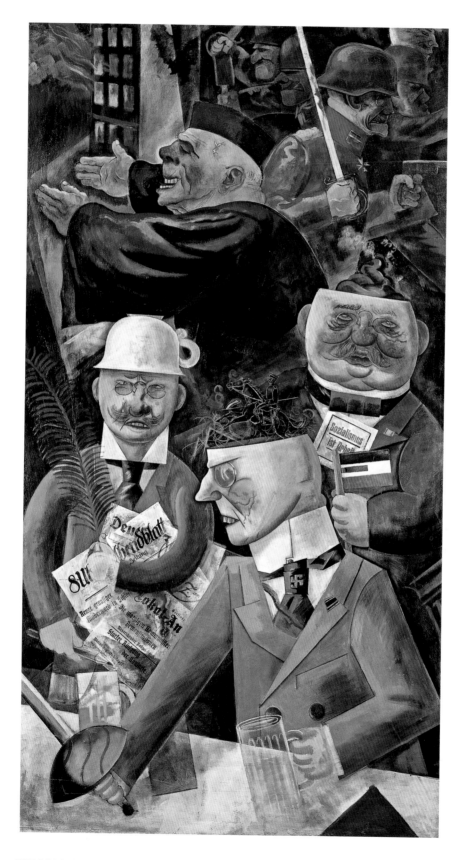

GEORGE GROSZ **THE PILLARS OF SOCIETY** 1926, oil on canvas, 200 x 108 cm, Nationalgalerie, Staatliche Museen zu Berlin, Preussischer Kulturbesitz

"THE PAINTER MAX ERNST IS EXCOMMUNICATED FROM THE CHURCH
AND I CALL UPON THE CONGREGATION TO UTTER
A THREEFOLD CRY OF 'SHAME!'"

A representative of the Archbishop of Cologne,
on the subject of Ernst's painting in 1926

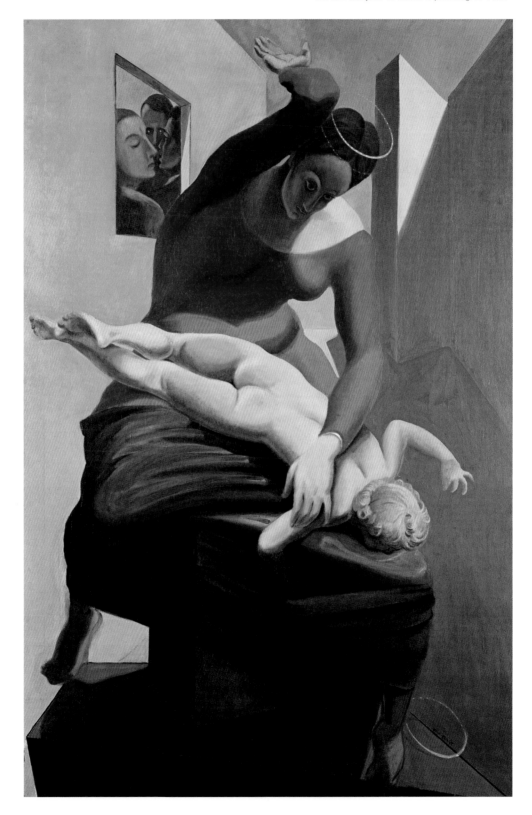

MAX ERNST **THE VIRGIN MARY CHASTISING THE BABY JESUS BEFORE THREE** 1926, oil on canvas, 196 x 130 cm,
WITNESSES: ANDRÉ BRETON, PAUL ÉLUARD, AND THE ARTIST Museum Ludwig, Cologne

84

MAX ERNST

THE VIRGIN MARY CHASTISING THE BABY JESUS BEFORE THREE WITNESSES: ANDRÉ BRETON, PAUL ÉLUARD, AND THE ARTIST

When it was exhibited at the Paris Salon des Indépendants, *The Virgin Mary Chastising the Baby Jesus Before Three Witnesses: André Breton, Paul Éluard, and the Artist* caused a enormous outcry and led to Max Ernst's excommunication from the Catholic Church for blasphemy. Ernst's Surrealist painting of 1926 broke with all the conventions associated with traditional representations of the Virgin Mary.

At the time, the subject itself—a mother spanking her child—was not scandalous; the problem was that Ernst's parody related this domestic scene to a Christian theme. In the middle of the picture, dressed in red and blue, the colors traditionally associated with the Virgin, we see a woman whose halo marks her out as the Mother of God. Her pose is almost identical to that of one of the peripheral figures in Michelangelo's Sistine Chapel ceiling, and the position of the Christ Child mirrors that of a figure of Venus in a painting by Tintoretto (*Mars and Venus Surprised by Vulcan*, c. 1545, Alte Pinakothek, Munich). But here these classical models reappear in a provocative context. Her hand lifted ready to strike, the Virgin does not look out at the viewer, as is traditional, but down at the reddened backside of the naked child lying on her lap. On the left of the painting there is a small opening through which three men are witnessing the action: André Breton and Paul Éluard, famous Surrealist writers and friends of Max Ernst, along with the artist himself. Despite their presence, they seem detached, visibly keeping their distance. They show an obvious ignorance of the shocking scene. In many aspects Ernst abandons tradition in favor of a scene of caricature. The Virgin does not look at her Child, nor does she look out at the viewer. Unusually, the Infant Jesus is depicted naked, despite being somewhat older. And not least, the style of the painting is completely untraditional: as well as the depiction of the violence against the Infant Jesus, the fact that his halo has slipped to the ground was provocative.

Max Ernst was brought up in a Catholic family. Scholars often point to Ernst's ambivalent relationship with his father, a teacher and self-taught painter, as the key to this painting. What is clear is that Ernst's childhood was characterized by a close relationship between religion and family. This theory is supported by paintings by Ernst's father, who was an amateur artist, that depict five-year-old Max as the Infant Jesus. *The Virgin Mary Chastising the Baby Jesus* can thus be seen as documentation of Ernst's emancipation from his strict Catholic parents, a Surrealist amalgam of both profane and religious themes.

MAX ERNST was born in 1891 in Brühl, Germany. After studying art history and philosophy in Bonn, he joined forces with Hans Arp and Johannes Baargeld in 1919 to create the Cologne Dada movement. In 1924 he left Germany and moved to Paris, joining the group of Surrealists the same year. He developed various artistic techniques, including *frottage* and *grattage*. At the beginning of World War II he was interned first by the French and then by the Germans; in 1941 he moved to the USA, returning to France in 1954. He died in 1976 in Paris.

85

RENÉ MAGRITTE
THE TREACHERY OF IMAGES (THIS IS NOT A PIPE)

The Treachery of Images is one of the most impressive examples of the play between words and images in the paintings of the Belgian Surrealist René Magritte. Magritte created around 40 such "word-image" pictures during his time in Paris between 1927 and 1930. Through unexpected juxtapositions of everyday objects with strange descriptions, these pictures pose questions about the nature of representation and reality.

The Treachery of Images is one of René Magritte's key works. At first his work was influenced by Cubism and Futurism, but while living in Paris between 1927 and 1930 he developed a Surrealist style. Although his relationship to the circle of Surrealists around André Breton was fraught with tensions and break-ups, today Magritte is still considered unarguably one of the most important representatives of the movement outside France. *The Treachery of Images* is the culmination of his series of so-called word-image pictures. The deliberately simple, central composition, and the flat, straightforward representation of the pipe betray Magritte's many years of experience as a commercial artist. The text that reads *Ceci n'est pas une pipe* [This is Not a Pipe] below the image of a pipe is a brilliant yet simple questioning of our perceptual habits. The idea behind this is that even a realistic depiction of an object is not identical with the object itself, but is first and foremost an image with its own rules. Throughout his life, Magritte was concerned with the problem of representation, that is, the relationship between an object, its linguistic designation, and its pictorial representation. In his Surrealistic world, realistically depicted people and objects are removed from their usual context and presented in startlingly new constellations. His essay *Les Mots et les images* [Words and Images] which, he published in 1929 in the Surrealist magazine *La Revolution surréaliste*, summarized the basis of his confrontations between word and image. One of the 18 illustrated sentences in the essay is directly related to *The Treachery of Images*: "Everything tends to make us think that there is little relationship between an object and that which represents it." The painting was first exhibited in 1933 at a solo exhibition of Magritte's work at the Palais des Beaux-Arts in Brussels, and was described enthusiastically by Salvador Dalí in an article about the Paris art scene. In 1936 at the same venue, Magritte took his game of confusion one step further, placing a picture of a piece of cheese in a gold frame under a glass cheese dome, and titling it *Ceci est un morceau de fromage* [This is a Piece of Cheese].

RENÉ MAGRITTE was born in 1898 in Lessines, Belgium. Between 1916 and 1918 he studied painting at the Académie des Beaux-Arts in Brussels, and in 1922 he married Georgette Berger. After his first solo exhibition in Brussels, he spent 1927 till 1929 in Paris, becoming associated with the circle of Surrealists around André Breton. He subsequently returned to Brussels, where he became the focus of a group of artists and writers with Surrealist tendencies. From the 1930s on his work appeared in numerous group exhibitions, and in 1965 MoMA in New York gave him a major retrospective, which brought him international recognition. He died in 1967 in Brussels.

"AN IMAGE IS NOT TO BE CONFUSED WITH AN OBJECT ONE CAN TOUCH.
CAN YOU FILL MY PIPE? OF COURSE NOT! IT IS ONLY A REPRESENTATION.
IF I HAD WRITTEN ON MY PICTURE 'THIS IS A PIPE,'
I WOULD HAVE BEEN LYING. THE DEPICTION OF A JAM SANDWICH
IS QUITE EVIDENTLY NOT SOMETHING YOU CAN EAT."

René Magritte

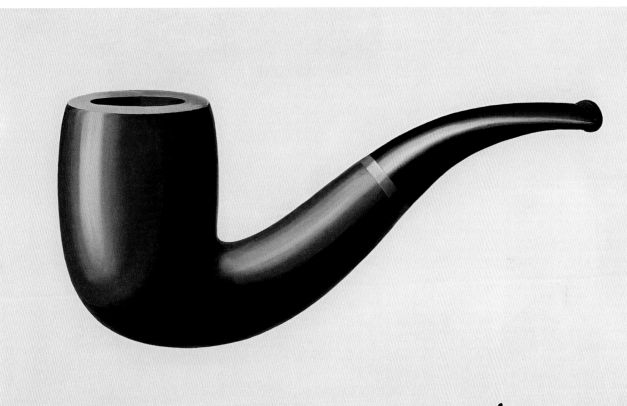

RENÉ MAGRITTE **THE TREACHERY OF IMAGES**
(THIS IS NOT A PIPE)

1929, oil on canvas, 60 x 81 cm,
Los Angeles County Museum of Art

"INCIDENTALLY, I DID NOT INTEND THIS PAINTING AS A SATIRE.
I ENDEAVORED TO PAINT THESE PEOPLE AS THEY
EXISTED FOR ME IN THE LIFE I KNEW."

Grant Wood, in a letter to Nellie Sudduth, 1941

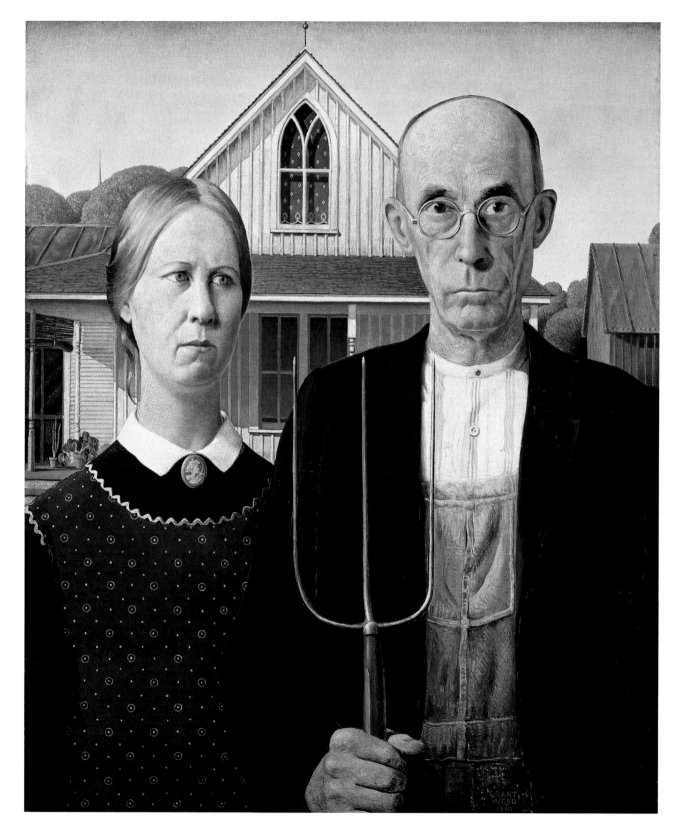

GRANT WOOD **AMERICAN GOTHIC** 1930, oil on beaver board, 78 x 65.3 cm,
 The Art Institute of Chicago

86

GRANT WOOD
AMERICAN GOTHIC

Grant Wood is one of the few artists whose fame is based almost entirely on a single work of art: *American Gothic*, which has become a universal icon of 20th-century American art. Its popularity is demonstrated by the numerous parodies that have appeared in movies, advertising, and comic strips, and which still continue to flourish decades after the painting was first created.

When Grant Wood showed this painting for the first time in 1930 at the Art Institute of Chicago, and won a prize for it, it caused quite a stir. At first the minutely detailed painting of a farmer and his daughter—Wood used as his models his own sister and his dentist—provoked contradictory reactions. Wood was accused of ridiculing the Puritan lifestyle of people living in the American Midwest through this humorless double portrait. Wood, who had himself grown up and lived in Iowa, always firmly rejected this assertion. In fact, he campaigned for the traditions of his region and for rural communities, and in a radical departure from the abstract art movements of his time, he founded a school of painting he called Regionalism. Wood traveled to Europe on several occasions, studying in Paris and Munich, among other places, and this brought him into contact with the most recent developments in art. On his visits to museums, however, he was more impressed with the works of the Flemish Old Masters, and this contributed fundamentally to his realistic style of painting. Thus Wood followed a path similar to that of the contemporary painters of the New Objectivity (Neue Sachlichkeit) movement in Germany.

In this tightly composed painting, both figures are shown frontally in half-length portraits. While the woman gazes into the distance, the man looks the viewer directly in the eye. He holds a pitchfork, a symbol of his occupation, whose three-pronged form is echoed in the seams of his overalls. This motif can also be found inverted in the Gothic-style window of the building in the background, from which the title of the painting is also derived: this style of architecture is called "Carpenter Gothic" or "Gothic Revival," as these primarily wooden buildings recall the forms of Gothic architecture.

The painting was bought by the Art Institute of Chicago the year it was made, and it quickly became famous throughout America via the press. During the Great Depression of the 1930s in particular, *American Gothic* became increasingly seen as the expression of the determined will to survive on the part of may hard-hit rural communities, who often saw themselves as the inheritors of the "pioneering spirit" of the early settlers.

GRANT WOOD was born in 1891 near Anamosa, Iowa. After the death of his father, the family moved to Cedar Rapids, where Wood finished his high school education. He studied art in Minneapolis and Chicago and traveled frequently to Europe in the 1920s. After being initially influenced by Impressionism and Post Impressionism, his later style drew heavily on the old Flemish masters, whose work he studied in various museums, including Munich's Alte Pinakothek. From 1934 until shortly before his death Wood taught at the School of Art and Art History of the University of Iowa. He died in 1942 in Iowa City, aged 50.

87

SALVADOR DALÍ
THE PERSISTENCE OF MEMORY

Even today Salvador Dalí is considered the undisputed master of Surrealist *trompe-l'oeil* painting, trans-forming elements from dreams and the unconscious into mysterious visual puzzles. Around 1930 he developed his "Paranoiac-Critical" method through which he incorporated delusions and hallucinations into the artistic process.

The Persistence of Memory is one of Dalí's most famous paintings. Here we see a bare landscape, resembling that of Catalonia, with a high horizon and a mountainous coastline projecting into the sea. In the center lies an amorphous entity whose profile recalls that of Dalí himself. In the foreground on the left, a kind of podium rises up, out of which grows a tree stump with a melting watch hanging from a branch. Similarly shaped watches are draped over the podium and also over the amorphous self-portrait of the artist. Ants crawl over a large gold pocket watch, symbols of decline and decay. The painting takes as its subject the opposition between "hardness" and "softness." The shape of the melting watches recalls that of floppy tongues. Tongue-like entities often appear in Dalí's pictures, propped up on crutches, expressions of a deep-seated fear of impotence that tormented the artist. However, this fear did not undermine his love for Gala, his muse and mistress. The image of melting watches soon became the trademark of the egomaniac, neurotic painter, as he repeated it in many of his pictures, combined with bare landscapes and mysterious dream figures. Dalí's discovery of this frequently repeated image came about, however, through a very mundane experience, namely looking at a hot, runny Camembert cheese. *The Persistence of Memory* was first shown in public in 1931 at Pierre Colle's gallery in Paris. It was then acquired in 1934 by the Julien Levy Gallery in New York. The same year an anonymous buyer purchased the painting and gifted it to the Museum of Modern Art in New York, where it has formed the focus of the Museum's collection of Surrealist paintings ever since.

SALVADOR DALÍ was born in 1904 in Figueres, Catalonia. He studied art first in Figueres and then at the Academy of Fine Arts in Madrid 1922–1926 (expelled for misconduct). In 1929 he moved to Paris. There he met Gala (Elena Ivanovna Diakonova), who would become his wife and muse, became closely associated with the Surrealists, and collaborated with director Luis Buñuel on the film *Un Chien Andalou* (1929). He soon developed an idiosyncratic style of painting in which he depicted with meticulous realism images from dreams and the unconscious. His eccentricities led to his expulsion from the Surrealist movement in 1937. He moved to the USA in 1940, taking up a more classical style of painting. In 1949 he moved back to Port Lligat in Spain, where he returned to the Catholic Church. He died in 1989 in Figueres.

"WE HAD TOPPED OFF OUR MEAL WITH A VERY STRONG CAMEMBERT,
AND AFTER EVERYONE HAD GONE I REMAINED FOR A LONG TIME
SEATED AT THE TABLE MEDITATING ON THE PHILOSOPHIC PROBLEMS
OF THE 'SUPERSOFT' THAT THE CHEESE PRESENTED TO MY MIND."

Salvador Dalí

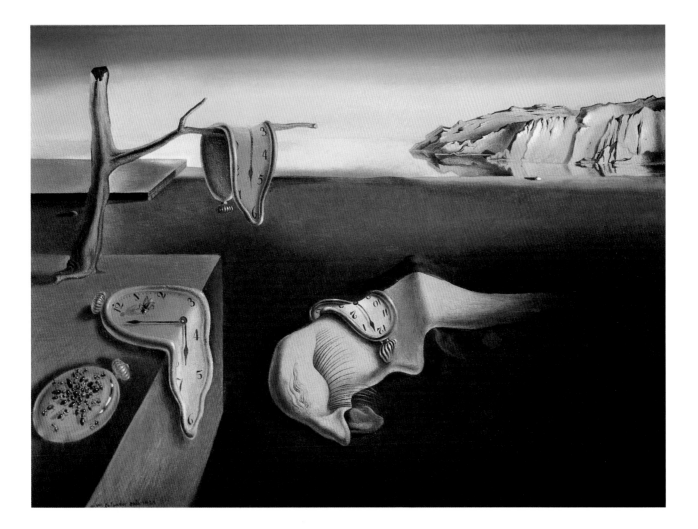

SALVADOR DALÍ **THE PERSISTENCE OF MEMORY** 1931, oil on canvas, 24.1 x 33 cm,
The Museum of Modern Art, New York

Within this amorphous entity we can see a stylized self-portrait of Dalí, albeit without a mouth. The Surrealists often used the mouth as a synonym for female genitalia, and thus the lack of a mouth can be seen as a fear of impotence.

SALVADOR DALÍ **THE PERSISTENCE OF MEMORY**

This coastline shows features that recall Dalí's home town of Figueres. The rugged cliffs, for example, resemble Cap de Creus, which Dalí frequently used as a backdrop in his pictures.

SALVADOR DALÍ **THE PERSISTENCE OF MEMORY**

88

PABLO PICASSO
GUERNICA

*G*uernica is considered the most important history painting of the first half of the 20th century and, alongside *Les Demoiselles d'Avignon*, numbers among Pablo Picasso's most famous paintings. It depicts the bombing of the Basque town of Guernica by the Condor Legion of the German Luftwaffe during the Spanish Civil War.

With the bombing of Guernica on April 26, 1937, for the first time in the history of war a systematic air attack was launched against a civilian target. As a result, most of the town was destroyed and hundreds of people lost their lives. In his painting, however, Picasso did not document the actual attack, focusing instead on its brutal consequences. Painted only in shades of black, white, and gray, the picture shows eight figures who are not so much acting as suffering. In the center of the triangular composition we can see a horse writhing in agony, a metaphor for absolute suffering that we find again and again in Picasso's work. Between the horse's hooves a dying fighter clutches his broken sword. On the left, a bull, an image Picasso liked to use as a symbol of brutality, turns its stony gaze towards the viewer. The bull can also be interpreted as a symbol of Franco's dictatorship, and of Fascism in general. Beneath the bull we can see a desperate mother with her dead child, a grouping that recalls a *Pietà*, the image of the Virgin Mary holding the body of Christ, removed from the Cross, on her lap. The conflagration that resulted from the bombing is symbolized by seven flames, between which a woman, her arms reaching upwards and her face distorted in pain, succumbs to her fate. In front of her, an escaping figure creates an impression of movement through the disproportionate depiction of a leg. The figure carrying the lamp has a particular significance, for it is usually understood as representing the Enlightenment and political liberation. An unusual and striking aspect of the painting is that the enemy remains anonymous. The painting's expressive power and emotion, as well as its imposing length of almost eight meters (over 25 feet), is unsurpassed. Through this combination of painted allegory and historical reality, Picasso created a distinctive symbolic world that makes this picture one of the Spanish artist's most important works.

PABLO PICASSO was born in 1881 in Málaga, southern Spain. While still a child he took drawing lessons from his father, and at the age of 15 he went to art school in Barcelona. He first visited Paris in 1900 and settled there in 1904. The years 1901 to 1904 are described as his "Blue Period," which was followed by his "Rose Period" (till 1906); around 1907 he began to develop his most radical style, Cubism. A key work was *Les Demoiselles d'Avignon* (1907, Museum of Modern Art, New York). As they dissolved the figurative world little by little, Picasso's paintings of the subsequent period gradually (but not entirely) made their way towards abstraction. Over a long career that embraced many styles and media, Picasso had an extraordinary impact on modern art. He died in 1973 in Mougins, France.

"DID YOU DO THAT?" ASKED A GERMAN SOLDIER
WHEN LOOKING AT *GUERNICA* IN 1944.
"NO, YOU DID!" PICASSO

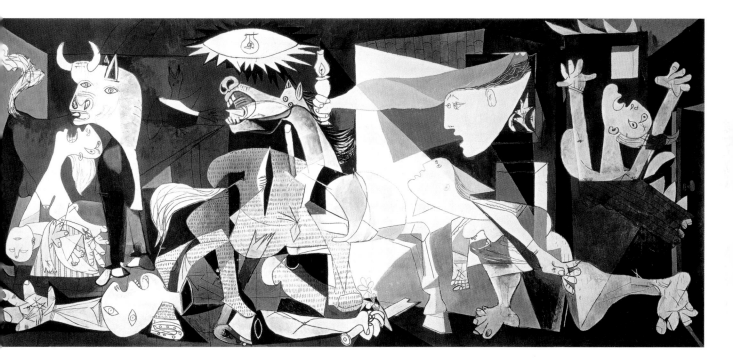

PABLO PICASSO **GUERNICA**
1937, oil on canvas, 349.3 x 776.6 cm,
Museo Nacional Centro de Arte Reina Sofía, Madrid

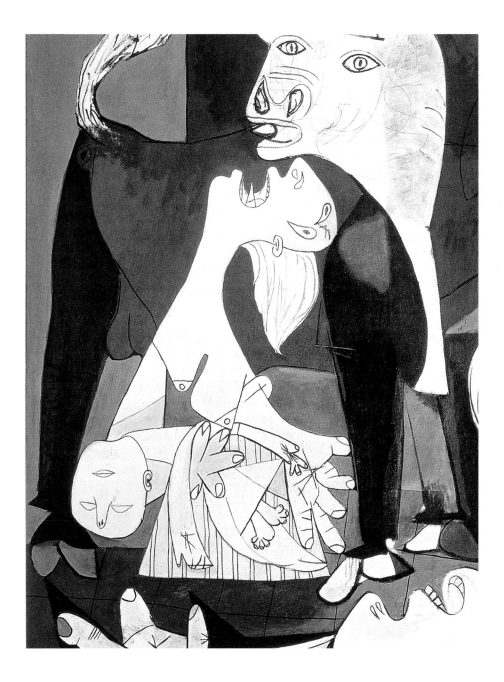

above The woman mourning her dead child recalls the image of the Virgin Mary as a *Pietà,* with the body of Christ, removed from the Cross, cradled in her lap.

right The dying horse, a symbol of absolute suffering, can be found again and again in Picasso's oeuvre.

PABLO PICASSO **GUERNICA**

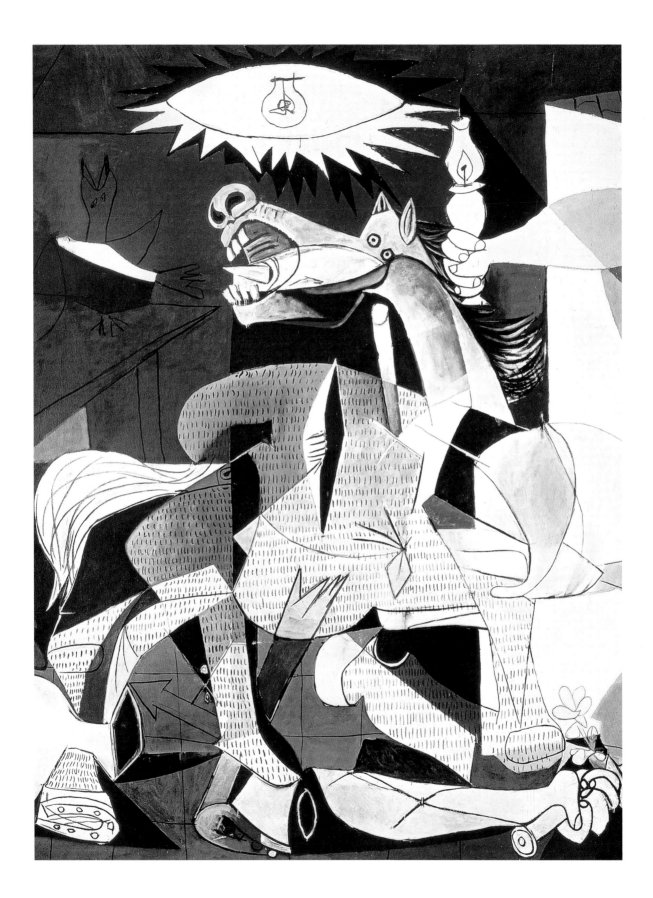

PABLO PICASSO **GUERNICA**

89

FRIDA KAHLO
THE TWO FRIDAS

When Frida Kahlo was painting *The Two Fridas*, one of her most famous works, she was contemplating the ruins of her marriage to Diego Rivera. Kahlo's works are often explicitly and harrowingly autobiographical. In this painting the rollercoaster of her emotions, torn between love and deep hurt, becomes her very personal and haunting subject matter.

Frida Kahlo had an eventful life. Born and raised in revolutionary and post-revolutionary Mexico as the daughter of an upper-middle-class family, Kahlo had the world at her feet. When she was still a young woman, however, she suffered a major street accident, which seriously impaired her health for the rest of her life. Over the long period of her convalescence, she discovered art and began to paint. In her early twenties she married Diego Rivera, who at that time was already known as an established artist and champion of Communism. The relationship between the two may well have been artistically fruitful, but emotionally it was undoubtedly demanding, and in addition Kahlo's desire for children remained unfulfilled.

In 1939, and after ten turbulent years of marriage, the couple divorced. Leading up to this were Diego's many affairs, to which Frida responded with her own romantic liaisons. For Frida, the final break with Diego was something she could barely cope with: her body reacted to the emotional suffering with illnesses, and her long hair fell victim to her emotional pain. In *The Two Fridas*, the left-hand Frida symbolizes this pain: the heart is exposed—not only is her blouse ripped open, exposing her body, but the organ itself seems to be cut in half. The right-hand Frida holds in her hand a locket with a photo of Diego as a child wrapped in an artery from her uncut heart. In the left-hand Frida, this locket, which was found among Kahlo's possessions after her death, seems to have been cut off, and instead the artery drips blood onto her white dress.

After their divorce, contact between Kahlo and Rivera did not cease, but actually became more intense. Just a year later they married for a second time, but were unable to bring any more stability into their relationship. Despite both parties enjoying extra-marital affairs, Kahlo's love for Rivera remained unwavering until she died. Rivera mourned the loss of his "Fridita, apple of my eye" enormously; nevertheless, just a year later he married the actress Emma Hurtado.

FRIDA KAHLO was born in 1907 in Coyoacán, a suburb of Mexico City. She was attending the Escuela Nacional Preparatoria, in preparation for a university career, when she suffered a serious traffic accident on September 17, 1925. Forced to spend several months in hospital, it was there she began to paint. In 1929 she married Diego Rivera who supported her in her artistic endeavors. Subsequently she took part in exhibitions and became associated with the Surrealist movement. In 1939 the couple divorced, remarrying just a year later. At the end of the 1940s Kahlo's health deteriorated rapidly. She died in 1954 in Coyoacán.

"IT HAS LONG BEEN ACCEPTED AMONG EXPERTS THAT THIS
UNUSUALLY LARGE-SCALE PAINTING IS FRIDA'S MASTERPIECE."

Helga Prignitz-Poda

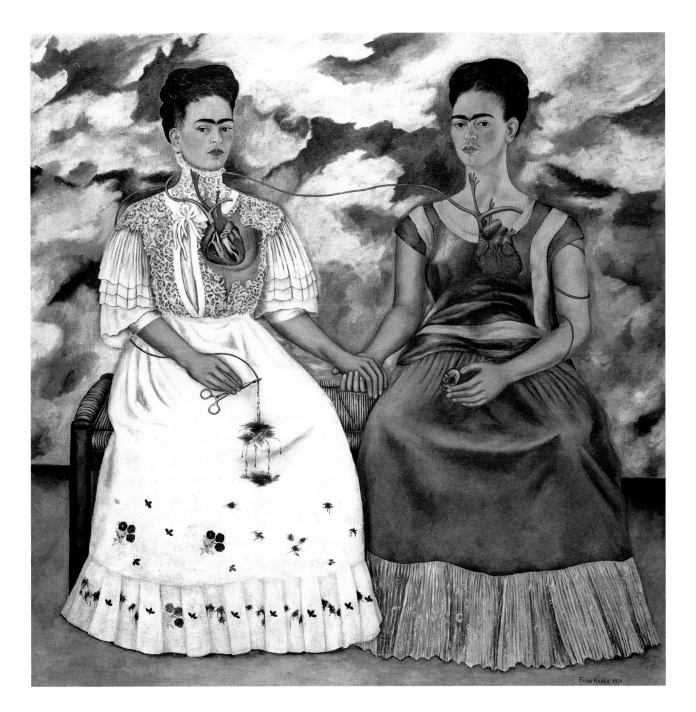

FRIDA KAHLO **THE TWO FRIDAS** 1939, oil on canvas, 173.5 x 173 cm,
Museo de Arte Moderno, Mexico City

"UNCONSCIOUSLY, PROBABLY, I WAS PAINTING
THE LONELINESS OF A LARGE CITY."

Edward Hopper

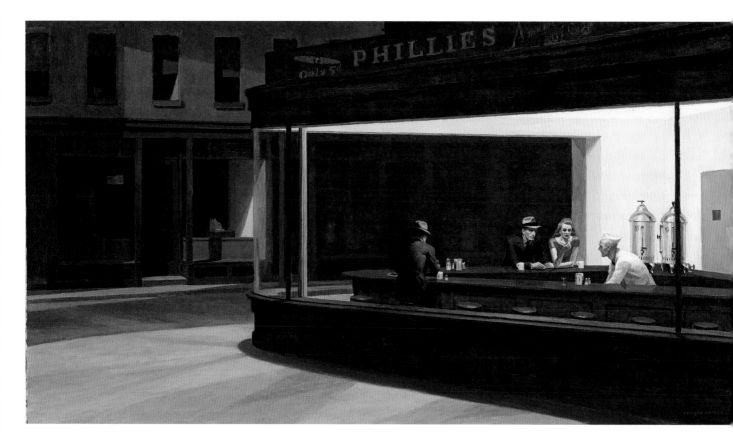

EDWARD HOPPER **NIGHTHAWKS**

1942, oil on canvas, 84.1 x 152.4 cm,
Art Institute of Chicago

90

EDWARD HOPPER
NIGHTHAWKS

A lonely street corner in a big city at night, a brightly lit diner behind huge glass windows, a barkeep, three night-owls at the counter: these are the sparse elements out of which Edward Hopper composed his 1942 painting *Nighthawks*, a work that has become one of the artist's most famous creations and an endlessly reproduced icon of American Realism.

Here, as in most of his paintings, Hopper depicts a simple scene of modern American life. Understated architecture, austere perspectives, intense lighting, and stripped-down colors combine to create an unmistakable atmosphere of heavy, almost oppressive melancholy.

The viewer takes in the scene from the deserted street outside. Around the bar are three customers: with his back to the window, there sits a man with his hat pulled right down over his face. He looks withdrawn and lost in his thoughts, unnoticed by the other customers, a man and a woman who sit alongside each other in silence. Her hand reaches out towards him but they do not touch; their faces are expressionless, and they gaze into space. Even the barkeep seems to be caught in suspended animation behind his bar. The isolation of these introspective figures and their lack of contact with one another create a chill feeling of anonymity and loneliness from which the viewer finds it hard to escape. This atmosphere is underscored by the strict geometrical composition of the image. The hard horizontal and vertical lines of the architecture are interrupted only occasionally by the figures and the sparsely laid-out objects on the bar. The atmosphere is also reinforced by the cool, artificial light, which creates an emphatic contrast between the interior of the bar and the surrounding gloomy street, highlighting the stranded night-owls behind the doorless plate-glass windows.

Hopper painted this picture shortly after the USA's sudden entry into World War II, a time of heightened anxiety and pessimism. He said that he had been inspired to paint *Nighthawks* by a diner he had seen in New York. What he ultimately painted, however, is an anonymous scene that could have taken place anywhere in America in the early 1940s—an existential snapshot of the American soul.

EDWARD HOPPER was born in 1882 in Nyack, New York State. After studying illustration and painting in New York he made several visits to Europe, in 1906, 1907, and 1909. He earned his living as an illustrator in advertising from 1905 onwards, working on his painting during his spare time. In 1923 a group exhibition at the Brooklyn Museum brought him his breakthrough as an artist. A year later he married Josephine Nivison, who appears frequently as a model in his pictures. Over the following years he established himself as a recognized painter in the USA, and his prize-winning work was exhibited in various retrospectives in the major American museums. He died in 1967 in New York.

91

FRANCIS BACON
THREE STUDIES FOR FIGURES AT THE BASE OF A CRUCIFIXION

Being self-taught, Francis Bacon was free to develop a unique style perfectly suited to his exploration of dark and often violent subjects. Dating from around 1944, his triptych *Three Studies for Figures at the Base of a Crucifixion*, created during a phase in which he was finally defining himself as an artist, marked the emergence of his tormented vision of life.

Bacon's first steps as an artist, however, came much earlier. In 1933 he took part in a group exhibition, showing the painting *Crucifixion* (private collection), and through this he was included in a book on contemporary art by the influential English critic Herbert Read. The overwhelming critical reaction, however, was negative, and it was a long time before Bacon exhibited another work in public. When he showed *Three Studies for Figures at the Base of a Crucifixion* in a collective exhibition at London's Lefevre Gallery in 1945, the public's reaction was again one of shock and disbelief. Critic John Russell states that most visitors found Bacon's painting "so unrelievedly awful that the mind shut snap." The ungainly, long-necked creatures against an alarmingly orange background convey an elusive sense of anxiety in their demeanor, culminating in the screaming mouth of the right-hand panel. Bacon would later explain that, despite the biblical title, his direct inspiration were the Furies in the *Oresteia*, the Greek tragedy by Aeschylus. The screaming figure also presents an example of Bacon's focus on the human mouth, and on the scream as a manifestation of despair. And last but not least, Bacon cited Nicolas Poussin's *Massacre of the Innocents* (c. 1628, Musée Condé, Chantilly), in which a screaming mother appears, as one of his key inspirations.
In the context of 20th-century art, Bacon's work remains outside any movement or fashion, yet it has left indelible traces. His artistic obsession led him to search for ways of expressing that which cannot be communicated through words. In his figurative works, the impulse to represent reality goes far beyond the depiction of the physical world. Bacon's subject matter was the deeper layers of perception, the metaphysical structures, the complex "palimpsest" of life. The brutality and rawness of his pictures, their distortions and alienations, speak of his fundamental, extremely sensitive perception of his models and subjects—of being in itself.

FRANCIS BACON was born in 1909 in Dublin, into a family whose life shuttled between Ireland and London. He left his parents' house early on, setting up on his own in London, where he became a designer and a self-taught artist. His first public exhibition was in 1933, with the work *Crucifixion*. His breakthrough came finally in 1944 with the painting *Three Studies for Figures at the Base of a Crucifixion*. His extreme, often unsettling, paintings occupy a unique position in 20th-century art, and his work enjoyed major retrospectives during his lifetime. He died in 1992 in Madrid.

"COMMON TO ALL THE FIGURES WAS A MINDLESS VACUITY,
AN AUTOMATIC UNREGULATED GLUTTONY, A RAVENING
UNDIFFERENTIATED CAPACITY FOR HATRED.
EACH WAS AS IF CORNERED."

John Russell

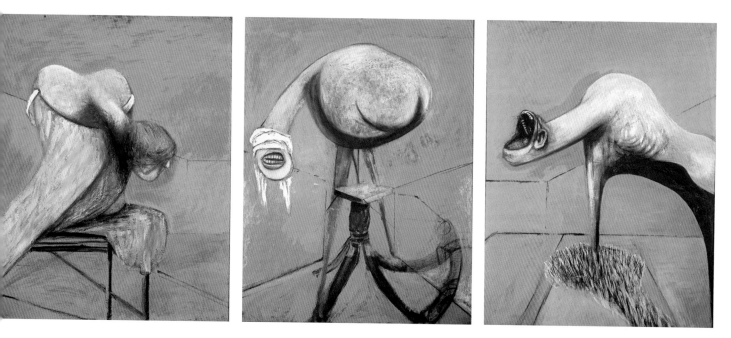

FRANCIS BACON **THREE STUDIES FOR FIGURES
AT THE BASE OF A CRUCIFIXION** c. 1944, oil on canvas, 94 x 73.7 cm,
Tate, London

92

JACKSON POLLOCK
FULL FATHOM FIVE

The pre-eminent painter of American Abstract Expressionism, Jackson Pollock was the founder of the style known as Action Painting. In his new technique, also called Drip Painting, he made an independent and original contribution to a new kind of art that in terms of both form and content was completely independent from its European predecessors.

It was in the mid-1940s that Jackson Pollock first began to move away from works that drew on myths and that were executed in an Expressionistic, semi-abstract way. Abandoning motifs entirely, he finally lay large canvases flat on the floor and began covering them with paint that he poured or dripped in web-like patterns. *Full Fathom Five* is the first work to which he applied this new technique of Drip Painting in a consistent way.

He painted using black and shiny silver household paint (a brand called Duco) with broad gestures using a stick or the handle of a paintbrush, on canvases that were still primed in the traditional way using a thick coat of oil paint. The result is a labyrinthine skein of paint traces that extend rhythmically across the entire surface of the picture. Into the still-wet paint, Pollock embedded nails, buttons, cigarette ends, matches, coins, and a key, all of which are partly covered by the paint, but which also create part of the structure and texture of the picture's surface. We can make out no compositional center to the painting. Pollock covered the painting's surface with a think, pulsating web of paint traces that overlap to create an inextricable network of gestural layers that are impenetrable to the eye. The canvas becomes a sphere of action that demands from the viewer a reaction to the dialogue between paint and gesture. In this "arena of painting" nothing happened by chance, but rather, according to Pollock, it was directed by what he experienced during the application of the paint, by internal structures, by energy and movement made visible, as well as by awakened memories. On this basis Pollock created a complex form of visibility that documents both spiritual aspirations and psychical sensitivities.

The work's unusual title is taken from a line of verse in Shakespeare's play *The Tempest*, in which the spirit of the air, Ariel, describes a death by drowning: "Full fathom five thy father lies / Of his bones are coral made / Those are pearls that were his eyes." The shimmering sea-green that permeates the painting's color scheme could refer to this quotation.

JACKSON POLLOCK was born in 1912 in Cody, Wyoming. A difficult upbringing, accompanied by educational and social problems as well as bouts of depression, led Pollock into alcoholism at an early age. He discovered art as a way of finding a new purpose in life. Between 1925 and 1929 he studied in Los Angeles, then under Thomas Hart Benton (1889–1975) at the Art Students League in New York. Between 1938 and 1942 he worked for the WPA (Works Progress Administration). Pollock invented Drip Painting in the mid-1940s, and became famous because of his new technique. However, the speed of his success overwhelmed him and he sank back more and more into alcoholism. He died in 1956 in East Hampton, New York State, in a car crash.

"PAINTING IS A STATE OF BEING ...
PAINTING IS SELF-DISCOVERY.
EVERY GOOD PAINTER PAINTS WHAT HE IS."

Jackson Pollock, 1956

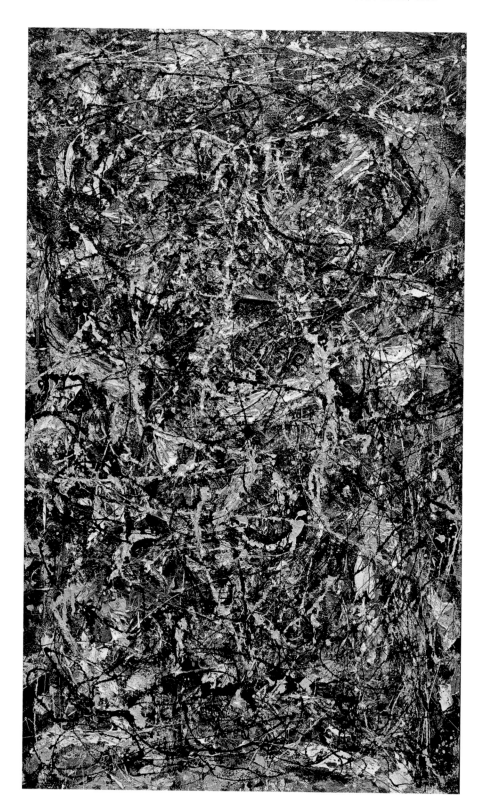

JACKSON POLLOCK **FULL FATHOM FIVE** 1947, oil on canvas with nails, tacks, buttons, key, coins, cigarettes, matches, etc., 129.2 x 76.5 cm, The Museum of Modern Art, New York. Gift of Peggy Guggenheim

"SOMETIMES I SEE IT AND THEN PAINT IT.
OTHER TIMES I PAINT IT AND THEN SEE IT.
BOTH ARE IMPURE SITUATIONS, AND I PREFER NEITHER."

Jasper Johns, 1959

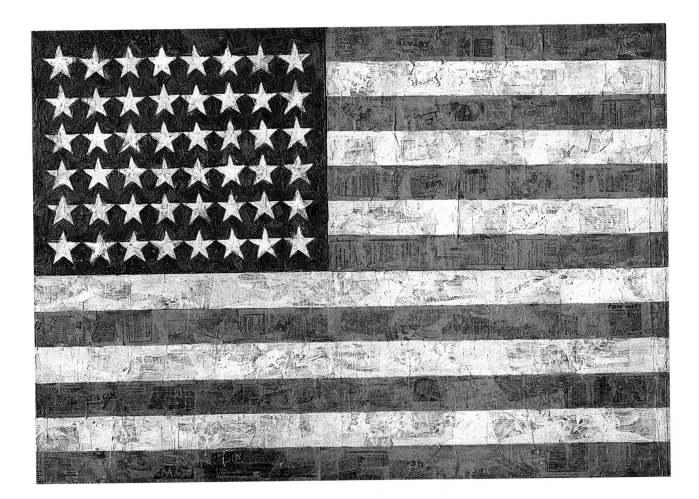

JASPER JOHNS **FLAG** 1954–1955, encaustic, oil, and collage on fabric mounted on plywood,
107.3 x 153.8 cm, The Museum of Modern Art, New York

93

JASPER JOHNS
FLAG

In 1954, 24-year-old Jasper Johns, who had been living in New York for just two years, destroyed everything he had created up till then. Shortly after this he painted *Flag*, a work that would take the development of modern art in a new direction.

The subject of this painting is the American flag, the Stars and Stripes, with seven red and six white horizontal stripes and 48 white stars on a blue background. The painting respects the colors and proportions of the national flag itself, and the image fills out the format of the painting exactly. So is the picture itself a flag? Or is the flag a picture? Looking close up, we can immediately see that this is not a real flag but a painting. Its surfaces are neither homogenous nor monochromatic in the way they have been painted, but rather they consist of a colored, uneven, sculptural mass, made up of encaustic wax applied with a palette knife on a ground of thick layers of oil paint. Through the use of the technique of encaustic painting, which in this case is also built up underneath with elements of collage (newspaper clippings), Johns removed the ordinary object from its practical function and elevated it to a new, artistic level, freighted with historical significance. The painting seems almost three-dimensional: *Flag* is not a depiction of the national flag, but turns the latter into an art object. Only its materiality and surface texture distinguish the representation from the real object. It is both a figurative image whose subject is the national flag, and a real, material object that looks like a flag. Thus Jasper Johns managed to empty this everyday object of its historical significance, re-creating it in paint and through the art of painting.

Johns worked in a similar way using other motifs such as targets, numbers, and letters of the alphabet, existing objects that are widely known and that he did not have to invent. The abstract sign is turned into the concrete, sensory reality of painting. But both signs and painting can be perceived ambivalently. We recognize the motif and know what it means, but at the same time we can see the work as a painting and can perceive the tactile quality of what has been painted. In his flag paintings Johns reflected on the relationship between object and image and between pictorial reality and an image of reality; on the nature of the image as material reality and as depiction; and on being and appearance. By taking everyday objects as his subject matter, Johns anticipated the new stylistic developments of the postwar era that led to the Pop Art revolution.

JASPER JOHNS was born in 1930 in Augusta, Georgia. After studying at the University of South Carolina in 1947–1948, he moved to New York and worked as a commercial artist. From 1952 onwards he worked in New York as a bookseller and, alongside Robert Rauschenberg, decorated store windows at Tiffany's. From 1967 to 1978 he worked for the Merce Cunningham Dance Company designing sets and costumes. His first flag, target, and number pictures emerged in the mid-1950s, revolutionizing developments in art. As well as paintings, Johns created assemblages and sculptures in bronze, often casting from real objects that became bearers of artistic meaning through their translation into another material.

"THE OBJECTIVE HERE WAS TO THROW INTO THE CRAMPED SPACE
OF A LIVING ROOM SOME REPRESENTATION OF ALL THE OBJECTS AND IDEAS
CROWDING INTO OUR POST-WAR CONSCIOUSNESS ... THE COLLAGE HAD A
DIDACTIC ROLE IN THE CONTEXT OF A DIDACTIC EXHIBITION,
THIS IS TOMORROW, IN THAT IT ATTEMPTED TO SUMMARIZE
THE VARIOUS INFLUENCES THAT WERE BEGINNING TO SHAPE POST-WAR BRITAIN."

Richard Hamilton

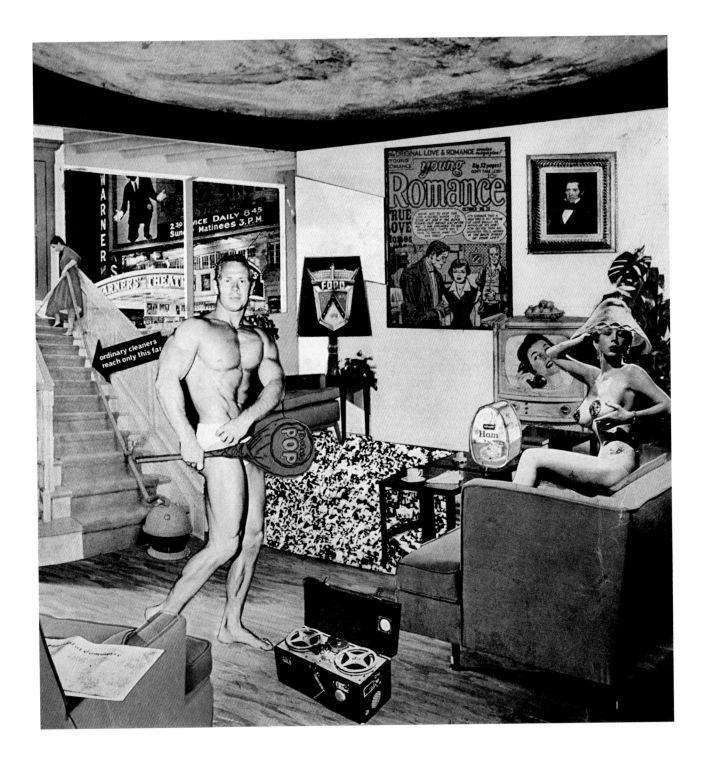

RICHARD HAMILTON · **JUST WHAT IS IT THAT MAKES TODAY'S HOMES SO DIFFERENT, SO APPEALING?** · 1956, collage, paper, 26 x 25 cm, Zundel Collection, Kunsthalle, Tübingen

94

RICHARD HAMILTON

JUST WHAT IS IT THAT MAKES TODAY'S HOMES SO DIFFERENT, SO APPEALING?

With his collage *Just What Is It That Makes Today's Homes So Different, So Appealing?*, made from images taken from the worlds of consumption and the mass media, Richard Hamilton created one of the first manifestos of Pop Art. Using details cut out of illustrated magazines, he created in concentrated form an ironic picture of postwar society in the 1950s.

Just What Is It That Makes Today's Homes So Different, So Appealing? is considered the first work of Pop Art in history, and led to Richard Hamilton being dubbed the "father of Pop Art." The collage was made in 1956 as an image to be used on the catalogue and posters for the exhibition *This is Tomorrow*, held at London's Whitechapel Gallery. Taking as his basis a linoleum advertisement from the American magazine *Ladies' Home Journal*, Hamilton added images taken from other illustrated magazines to create an "interior." This interior shows an ordinary living room with a sofa and a rubber plant, inhabited by a contemporary version of Adam and Eve in the forms of a body-builder and a pin-up girl. The couple strike poses surrounded by symbols of "the American way of life"—from the new technical achievements of television and tape recorder to the comic and movie industries. On the left, a spatially distorted staircase taken from a vacuum-cleaner advert leads up to the front door, the hose of the cleaner reaching up to a smartly dressed woman standing at the top of the stairs. This is Hamilton's ironic image of the emerging mass media and consumer society, and reflects, in miniature, the economic and social dreams of postwar Britain and America in the 1950s. After he had finished the collage, Hamilton found among the remaining scraps of newspaper the advertising copy that went with his original motif, and he used its first line as the title of his picture. However, Hamilton's work became the icon of international Pop Art primarily because of the word "POP" adorning the giant lollypop in the middle of the image, which serves as the body-builder's fig leaf. Through his techniques of collage and quotation, Hamilton anticipated the postmodern aesthetic. Again and again in his work he used photographs, posters, or computer-generated images ironically in traditional pictorial genres such as interiors, still lifes, or portraits. For Hamilton, who started out working in advertising and industrial design: "Pop Art is: popular, transient, expendable, low-cost, mass-produced, young, witty, sexy, gimmicky, glamorous, and Big Business."

RICHARD HAMILTON was born in 1922 in London. After Westminster Technical College and Saint Martin's School of Art, he attended the Royal Academy Schools from 1938 to 1940. Between 1941 and 1945 he worked as a technical draftsman, and he studied at the Slade School of Art from 1948 to 1951. He began his career illustrating James Joyce's novel *Ulysses*. In 1956 he took part in the exhibition *This is Tomorrow*. Between 1957 and 1961 he taught interior design at the Royal College of Art. In 1965 he embarked upon a reconstruction of Marcel Duchamp's *Large Glass*. In 1968 he produced graphic designs for the Beatles' *White Album*. London's Serpentine Gallery honored him with a major retrospective of his work in 2010. He died in 2011 in Henley-on-Thames.

«TO OPEN EYES. THAT WAS MY AIM, AND IT STILL IS. THIS IS PRECISELY WHAT
I WANTED TO ACHIEVE WITH ALL MY PICTURES: SEEING SHOULD BE ACTIVE.
NOT JUST A PASSIVE PROCESS OF BEING CARRIED ALONG WITH IT,
BUT SEEING FOR ONESELF, SEARCHING, FEELING, RECOGNIZING,
EXPERIENCING. ONE CAN INDEED LEARN TO SEE CREATIVELY!»

Josef Albers, 1970

JOSEF ALBERS **HOMAGE TO THE SQUARE** 1967, oil on masonite, 101.5 x 101.5 cm ,
Josef Albers Museum, Bottrop, Museumszentrum Quadrat

95

JOSEF ALBERS
HOMAGE TO THE SQUARE

Josef Albers' approach to art was radically experimental. Throughout his career he systematically explored the various permutations that could be derived from a few basic visual elements—simple geometrical forms and subtle changes of color. It was an approach that was widely influential.

In the series *Homage to the Square,* which he began in 1949, Josef Albers was concerned with the infinity of relationships between colors. He understood these relationships as "experiments with color" through which one could increase the sensitivity of one's perception. The illustration left shows a study that consists of four nested squares. They appear to form graduated tonal depths, proceeding from the innermost dark yellow shape via two further degrees of lighter yellow tones up to the light yellow square that determines the borders of the picture's format. The carefully chosen nuances of the yellows create the optical impression of a floating three-dimensionality that can be perceived both as receding into the picture and as emerging from it.

For this series, Albers invented a system of layering different-sized squares within a square picture format. The squares are centered symmetrically along the vertical axis, but move downwards in two or three steps along the horizontal axis. The relationship between the squares was the result of a geometrical grid based on units of 10 x 10. Albers applied the paint directly from the tube with a palette knife onto hardboard. In spite of the rigorous basis and the sequence of the series, Albers managed to demonstrate the interaction of color beyond all conventional rules of harmony and composition.

After he emigrated to the USA in 1933, Albers developed his famous theory of color in his book *Interaction of Color* (1963). At the heart of his course he placed the interactions between colors themselves, as demonstrated in the so-called simultaneous contrasts between adjacent areas of color. Depending on which color it is next to, a color can have a different effect on the viewer because of the effect the colors have on each other. A teacher at the Bauhaus and later at several American universities, Albers was an important influence on several generations of abstract artists and prepared the way for Op Art.

JOSEF ALBERS was born in 1888 in Bottrop, Germany. He was educated at the Royal Art School in Berlin (1913–1915), the School of Arts and Crafts in Essen (1916–1919), at the Art Academy in Munich (1919–1920), and at the Bauhaus in Weimar (1920–1923). He worked at the Bauhaus in the glass and furniture workshops, and from 1928 he was director of the preliminary course. In 1933 he and his wife, the Bauhaus textile designer Anni Albers, emigrated to the USA. He taught at various institutions in the USA, including Black Mountain College, North Carolina, and Yale University, New Haven, and also (in the 1950s) at the Hochschule für Gestaltung in Ulm, Germany. His book on color theory, *Interaction of Color* (1963), is among the most influential studies of color undertaken in the 20th century. He died in 1976 in New Haven, Connecticut.

96

ANDY WARHOL
CAMPBELL'S SOUP CANS

*C*ampbell's Soup Cans **is one of the best-known works in American Pop Art. The original version consists of 32 individual images, each representing a flavor of the famous tinned soup. Warhol used the serial repetition of this image to question the traditional concept of originality.**

When *Campbell's Soup Cans* were first exhibited on July 9, 1962, in Walter Hopps' Ferus Gallery in Los Angeles—hung in a row to suggest a shelf in a supermarket—opinion was sharply divided. However, Warhol soon succeeded in turning the simple everyday object into a sought-after collector's piece. Apart from the different labels, the 32 *Campbell's Soup Cans* are almost identical; it is only on closer examination that smaller modifications and variations become apparent.

In 1962 Warhol had produced realistic images in original color palettes, as well as numbered drawings and sketches. He then moved on to his soup cans in many different variations, a development that had three phases. First, he began transforming the image, producing silk-screen prints in different sizes that depict the cans with damaged labels and in combination with other objects, such as can openers. Then, after 1965, Warhol abandoned the cans' original colors, using instead a wider chromatic spectrum. Finally, he produced many images of the famous soup cans up until the end of the 1970s. *Campbell's Soup Cans* can be seen as a modern interpretation of the classical still life, even though the selection and grouping of the objects do not follow particular criteria with regard to content, symbolism, or aesthetics. Rather, in the highly graphic quality of his series Warhol displays an important design feature of American Pop art that, in the years to come, would exert an influence on many other artists.

Andy Warhol is now regarded the leading American Pop artist. He used enlarged photographs culled from the mass media, details taken from advertising, reproductions of banknotes, and consumer items, and created serial images out of the mundane subject matter of everyday life. Through this he was not only referring to the automation and dehumanization of modern society, he was also denying art's claim to originality. Using the technique of silk-screen printing, Warhol would sometimes produce over 4,000 pictures a year. And he always focused on his favorite subject—the ordinary objects of daily life.

ANDY WARHOL was born Andrew Warhola in 1928 in Pittsburgh, the son of Slovakian immigrants. He began his career as a commercial draftsman and illustrator, before emerging in the 1960s as the early exponent of American Pop Art. In 1962 Warhol opened his studio in New York called the Factory, and began producing large editions of serial images using the technique of silk-screen printing for which he became known. He also began producing films in 1963. After being shot several times by Valerie Solanas in 1968 (in connection with a movie project), he turned to his paintings and prints with renewed energy. He died in 1987 in New York.

"I THINK **THE LESS** SOMETHING HAS TO SAY,
THE **MORE PERFECT** IT IS."

Andy Warhol

ANDY WARHOL **CAMPBELL'S SOUP CANS**

1962, synthetic polymer paint on canvas, each 50.8 x 40.6 cm,
The Museum of Modern Art, New York

97

GERHARD RICHTER
EMA (NUDE ON A STAIRCASE)

In his deliberate depiction of out-of-focus images, Gerhard Richter questions the relationship with reality of the newspaper photographs which he frequently uses as the basis of his work. In *Ema (Nude on a Staircase)* he created a homage to Marcel Duchamp, while at the same time contradicting Duchamp's claim that the tradition of the classical nude was at an end.

Depicted at almost life-size, a naked young woman descends a narrow staircase. Her body is turned to face the viewer but she looks down at the steps beneath her. The figure is intensely lit, and seems in places too bright, like an overexposed photograph. Apart from the contouring of the torso and the limbs, the body is not modeled by shadows. All the outlines, shapes, and even the colors of the painting swim out of focus before our eyes.

Richter used a photo of his first wife, Ema, as the basis of this painting. At the same time, he was following in the footsteps of a tradition of nude painting which had developed during the Renaissance, and which had, in Marcel Duchamp's *Nude Descending a Staircase* (1912, Philadelphia Museum of Art) moved in a Futurist, mechanistic direction. Richter took Duchamp's image, which had broken down individual movements into a sequence, and brought it together again in a realistically painted "classical" nude. But this in turn is negated by the out-of-focus painting technique and the obvious use of a photograph as the image's source. Its appeal lies in the gap between the intimacy of a private nude photograph and the tradition of great nude painting, the ambivalence between photographic realism and the transformation worked by the artist.

As early as 1962, soon after he left East Germany, Richter began working on the interaction between painting and photographs. He started to transfer banal images from newspapers and magazines, or from his own private collection, onto canvas. The significance of this was not the painterly reproduction of photographic images, but the critical refraction of photographic representations through the medium of painting.

Gerhard Richter's work oscillates between photographic realism and abstract form. Under the influence of Pop Art, he contributed to the debate about the function of painting between image and reproduction, and also about the role of the artist in constructing an aesthetic reality.

GERHARD RICHTER was born in 1932 in Dresden. At first he worked as a theatrical set and sign painter, before studying at the Dresden Art Academy between 1952 and 1955. After he moved to West Germany he continued his studies at the Düsseldorf Art Academy in 1961. In 1962 he made his first pictures based on newspaper photographs and private snapshots. He collected these sources in an "Atlas" which was shown in exhibitions after 1972. The 1980s saw the start of several new series of works: Landscapes, Clouds, Candles, Aerial Views, and Color Charts, as well as his so-called Abstract Paintings.

"THE PHOTO HAD NO STYLE, NO COMPOSITION, NO JUDGMENT.
IT LIBERATED ME FROM PERSONAL EXPERIENCE; IT HAD NOTHING AT ALL,
IT WAS PURE IMAGE. THAT'S WHY I WANTED TO HAVE IT, TO SHOW IT—
NOT TO USE IT AS A MEDIUM FOR MAKING A PAINTING,
BUT TO USE PAINTING AS A MEDIUM FOR THE PHOTO."

Gerhard Richter, 1972

GERHARD RICHTER **EMA (NUDE ON A STAIRCASE)** 1966, oil on canvas, 200 x 130 cm,
Museum Ludwig, Cologne

98

DAVID HOCKNEY
A BIGGER SPLASH

David Hockney is one of the most important representatives of British Pop Art. His move to California at the beginning of the 1960s inspired him to paint a series of swimming-pool pictures. The pools, villas, and gardens of the rich Californian upper classes became central motifs of his work.

Though painted on a monumental scale, *A Bigger Splash* captures a mere moment in time. A splash of water disrupts the deceptive peace of a pleasant afternoon in the blazing sun. The diving board that enters the picture from the right-hand side suggests that someone has just jumped into the pool to escape the heat of the Californian summer, albeit temporarily. The diver is not to be seen, and only the empty chair in front of the bungalow hints at their presence. There is no one else. The scene appears abandoned, almost sterile. Two palm trees and a patch of grass in front of the bungalow provide an idea of nature, almost like a quotation. The front windows reflect the building and palm trees opposite, which look like dark, threatening silhouettes.

Hockney composed the picture from photographs, using acrylics to create smooth planes of flat, luminous color. Only the splash of water is applied using thick paint. Hockney's painting conjures up a hedonistic leisure culture. The house and swimming pool function as symbols of the Californian lifestyle that Hockney had made his own. While there is no one visible in this idyllic scene, a human presence is perceptible. This apparent return to a "Golden Age" of peace and harmony should not hide the fact that Hockney tried to cut himself off from the political and social issues that characterized the turbulent 1960s and that challenged this hedonism. Whether the picture also conveys a gentle social criticism in its mood of loneliness, isolation, and boredom, remains unanswered. Hockney himself had taken to the Californian way of life much too enthusiastically to take any critical distance on it. His painting style and subjects fascinated a generation of younger artists who preferred a free style of figurative art to the rigid forms of abstraction.

DAVID HOCKNEY was born in 1937 in Bradford, Yorkshire. He studied at Bradford College of Art between 1953 and 1957, then at the Royal College of Art 1959–1962, where he enjoyed his first successes in the *Young Contemporaries* exhibition while still a student. His career embraces painting, printmaking, photography, theater design, and teaching at several American universities. He settled in Los Angeles in 1964. His cool style, painted in acrylics and often referencing the compositions of the Old Masters, had a highly formative influence on developments in art internationally. In 1982 he began to produce collages of Polaroid photographs, followed later by fax-based compositions and computer-aided drawings.

"IT TOOK ME ABOUT TWO WEEKS TO PAINT THE SPLASH. ...
AND I LOVED THE IDEA OF PAINTING THIS THING THAT LASTS
FOR TWO SECONDS; IT TAKES ME TWO WEEKS TO PAINT
THIS EVENT THAT LASTS FOR TWO SECONDS."

David Hockney, 1976

DAVID HOCKNEY **A BIGGER SPLASH** 1967, acrylic on canvas, 243.8 x 243.8 cm,
Tate, London

99

GEORG BASELITZ
THE WOOD ON ITS HEAD

The austere subject of a snowy forest in winter, its bare, charred-looking trees stretching up into the icy morning sky, seems to caricature the idyll of a German forest. In Romant icism, the forest was the refuge of the German soul and an auspicious symbol of safety and salvation, while here the image is completely de-Romanticized, even completely de-naturized, as we see only a black skeleton, bereft of life and hope.

No one would believe that new, green shoots could spring once again from these mutilated branches. But what really unsettles the viewer is the rotation of the image, a technique that Baselitz used in this picture for the first time. This was not only a sure way of attracting the attention of the public, who were as yet unused to such upside-down images, but would at a stroke, and in the simplest as well as most astonishing way, solve Baselitz's problematic search for subject matter, indeed for a genuine style in his painting. From that moment on he turned everything upside down, painting "standing on its head" everything that would otherwise appear rather inconsequential and trivial: landscapes, still lifes, portrait heads, and figures, all captured upside down on the canvas with an expressive verve and dripping colors. Even the difficult decision of whether to be figurative or abstract, which divided artists into factions in the 1960s, was elegantly and cleverly side-stepped by Baselitz. In the mid-1960s he began to dismember his subjects into strips and then re-configure them to create his so-called *Frakturbilder* (Fracture Painting). This then led in 1969 to the upside-down subject of the picture *The Wood on its Head*. Regardless of what Baselitz's subject matter was, it was first turned on its head, its recognizability quickly collapsing into the pieces of a puzzle to leave behind pure painting. However, Baselitz, who was living a solitary life in an old castle near Heidelberg, barricading himself against the art world, was still denied his big breakthrough. It was only with the arrival of the "Neue Wilde" (New Wild Ones) art movement, and with it the return of expressive, figurative painting that people wanted to include Baselitz's pictures in the new wave of what Wolfgang Max Faust called the "hunger for pictures," regarding his upside-down images as a "stroke of genius." From then on Baselitz could count on the public's high opinion, but he continued to work unswervingly on banal subjects which, still depicted upside-down, develop a whole unique potential of color, form, brushwork, and inverted compositions. Baselitz belongs to the group of post-1945 painters who have helped bring international recognition to figurative painting, lending it a vital momentum.

GEORG BASELITZ was born Hans-Georg Kern in 1938 in Deutschbaselitz, Germany. He began his studies in 1956, at the Art Academy in East Berlin, moving a year later to the Academy in West Berlin, where he studied under Hann Trier (1915–1999) until 1962. After a few controversial pictures he started working in 1969 on the inversion of simple subjects, such as landscapes, still lifes, and portraits. He made his first woodcuts in 1966, and his roughly worked wooden sculptures in 1979. In 1978 he became Professor at the Karlsruhe Academy, and from 1983 to 1988 and again from 1992 to 2003 he taught at the Hoch-schule der Künste in Berlin. Today Georg Baselitz lives and works in Inning on the Ammersee in Germany.

"WHEN ONE STOPS THINKING UP IDEAS AND INVENTING SUBJECTS,
BUT NEVERTHELESS WANTS TO PAINT PICTURES, TURNING THE SUBJECT
UPSIDE DOWN IS THE MOST STRAIGHTFORWARD APPROACH."

Georg Baselitz, 1984

GEORG BASELITZ **THE WOOD ON ITS HEAD** 1969, oil on canvas, 250 x 190 cm,
Museum Ludwig, Cologne

100

LUCIAN FREUD
BENEFITS SUPERVISOR SLEEPING

On May 13, 2008, Lucian Freud's *Benefits Supervisor Sleeping* set a new world record: at Christie's auction house in New York, after an intense telephone bidding war, the life-sized painting was sold for 33.6 million dollars, which was at that time the highest sum ever paid for a work by a living artist. The painter, who was 85 years old at the time, died three years later.

The model for this powerful nude was Sue Tilley, a benefits supervisor from London's Charing Cross who became known as "Big Sue" because of Freud's painting. At the time of this painting, Tilley, who also appears in three other works by Freud, weighed around 127 kilos (280 pounds). In *Benefits Supervisor Sleeping* Freud painted his model stretched out and asleep on a battered couch. The chunky, floral-patterned arms and back of the couch create a frame around the resting body, which is completely exposed to the viewer. However, the scene does not seem very exposing, as the body is comfortably nestled into the soft sofa, and seems harmoniously melded into its surroundings. This effect is underscored by the matching colors: the pastel olive-green, beige-gray, and dusty pink of the sofa material are echoed in the tonal variations created by the shadows in the folds and layers of skin.

Freud placed his model in a classic pose. The reclining female nude, idealized with delicate skin, slim limbs, and in an elegant position, can be found throughout art history since the Renaissance. However, Freud's focus is precisely the opposite of this. He emphasizes all that is fleshiness, the mass of the body, painting rough, veiny skin, sagging breasts, all "the sores and chafes made by weight and heat" (Lucian Freud). He makes all this coarseness visible through his broad, rough brushstrokes and thick paint, and through the rich contrasts of layers of color and shadow. The fullness of the body is echoed in the mass of applied paint. This expressive style of painting "suggests the heat and grime of the human body" (Michael Auping), and lends Freud's picture an immediate, intense quality.

Freud was a master of realism: during his entire career as an artist he made not a single abstract work. He traced the physical presence of the human being in order to commit it to canvas, regarding it mercilessly but without judgment. It is this openness and honesty towards human existence that arouses our curiosity as we look at Freud's pictures, which are sometimes disturbing but always fascinating.

LUCIAN FREUD was born in 1922 in Berlin, the grandson of the psychoanalyst Sigmund Freud. In 1933 the family emigrated from Nazi Germany to England, and six years later Freud became a British citizen. Between 1938 and 1943 he studied at the Central School of Art in London, the East Anglian School of Painting and Drawing in Dedham, Goldsmiths College in London, and at the University of London. He was a merchant seaman in an Atlantic convoy in 1941 before being invalided out of service in 1942. After an early Surrealist phase, he was known at the start of the 1950s for his characteristic, realist style of painting, becoming internationally famous above all for his portraits and nudes. In 1982 he began to work more and more on etchings. In 2001–2002 he painted a portrait of Queen Elizabeth II. He died in 2011 in London.

"WHEN WE WERE PAINTING IT WE DIDN'T SIT THERE GOING:
'I BET THIS'LL BE THE BIGGEST SELLING PAINTING IN THE WORLD.'
IT WAS JUST LIKE ONE OF HIS OTHER PICTURES."

Sue Tilley

LUCIAN FREUD **BENEFITS SUPERVISOR SLEEPING** 1995, oil on canvas, 151.3 x 219 cm,
private collection

GLOSSARY

(Numbers at the end of the following texts refer to the numbers given to the works in the body of the book.)

Academy

A society for the promotion of science or art; an art school The name derives from a grove in ancient Athens dedicated to a hero called Akademos, where Plato founded his philosophy school c. 387 BC. From the Renaissance art academies have played a key role in training artists, in promoting art through exhibitions and competitions, and in defining what constitutes the best art—a function increasingly challenged from the 19th century onwards as the role of the →avant-garde became more significant.

Allegory

A form in art or literature in which figures and events are used to represent abstract ideas. This is often achieved through personification, i.e. the representation of a person as a symbols, for example justice depicted as Justitia, a blindfolded woman with a weighing scale in her hand. [6, 32]

Altarpiece

In Christian churches, a painting that decorates an altar. A winged altarpiece has panels on each side that are opened or closed at certain times, and show different images appropriate to the liturgy. Some altarpieces had very elaborate structures that frequently combined sculpture and painting. [27]

Avant-garde

Any group of artists, writers or intellectuals that acts as the precursors of a new idea or movement, anticipating a general development and breaking with traditional forms. The concept of the avant-garde emerged during the 19th century, when its role was frequently to challenge a dominant →academy.

Book illumination

The oldest known book illuminations are to be found in the Ancient Egyptian Book of the Dead (2nd century BC), written on papyrus. In the Middle Ages, monks and nuns created hand-written →codices with miniatures (named after the Latin term for the red pigment, *minium*), richly decorated initials and pictorial representations, in the scriptoria (writing rooms) of monasteries. Some scriptoria, such as the Reichenau school, became famous. Book illumination played an important role in the development of →Early Netherlandish painting. [2]

Codex

(sing.: codices) A manuscript made by binding together single sheets, generally of →parchment; as opposed to a scroll, in which the length of parchment is rolled up. This form of manuscript was used from the 4th century AD.

Collage

(Fr. *coller*: to glue) A 20th-century artistic technique in which pictures are crated by gluing together newspaper cuttings, scraps of fabric, wallpaper, cut-up images, etc. [94]

Encaustic painting
→p. 8

Fresco

(Italian *fresco*: fresh) A wall-painting technique in which pigment is added to wet plaster; as the plaster dries, the pigment bonds with it insolubly, creating a durable surface. Fresco painting is a very old technique, probably known even in →Classical Antiquity. Some of the finest frescoes date from the Early Italian Renaissance.

Genre painting

Depictions of everyday life, typically of peasant or middle-class subjects, and generally with a comic or moral purpose. Genre painting reached its heyday in 17th-century Dutch art, its development influenced by the growing significance of bourgeois culture. The genre continued to flourish in the 18th and 19th centuries.

Gouache (or body color)

A water-soluble paint in which pigment is bound with glue, and in which lighter tones are created by adding white. Unlike →watercolor, gouache is opaque rather than transparent. It was used for medieval →book illuminations and for preliminary studies for large paintings during the →Renaissance. It was used as an independent painting technique from the 19th century onwards.

History painting

Depictions of scenes from history, the Bible, myths, or legends. Seen as expressing moral themes, history painting was long considered the most important genre in art.

Icon

(Greek *eikon*: image) Devotional images for the Eastern Church that developed in →Byzantine art. They are very often depictions of Christ, the Virgin Mary, saints, or scenes from the Bible, typically set against a gold background. The forms are highly and changed little over the centuries. It is thought that the first icons were created in the 5th century. With the fall of the Byzan-

tine Empire, Russia became the main producer of icons. [1]

Landscape painting

Depictions of natural scenery. In medieval and Renaissance art, the landscape simply served as a background, but gradually gained in significance and independence, reflecting in particular Neoclassicism (sites and ruins of classical Antiquity) and then Romanticism (nature as wild and untamed). It was not until the 19th century, with the emergence of Impressionism, which brought a new vitality to the genre, that it became customary to paint in the open air; previously, landscape paintings were created in the studio from earlier sketches and studies.

Oil paint

A paint in which pigments are bound with linseed, poppy seed, or nut oil. The systematic use of oil paints began in the 15th century with Jan van Eyck, and by the 16th century had largely replaced tempera. Oil paints can be translucent or opaque, and can be applied beside or on top of each other without running. This means that the finest of gradations and transitions are possible.

Parchment

A surface for writing on made from animal skin (calves, sheep, goats). The Roman historian Pliny describes how the Ptolemaic rulers of Egypt imposed an export-ban on papyrus in the 2nd century BC in order to protect the unique nature of the Library of Alexandria from external competition. The search for an alternative, in Pliny's account, led to the invention of parchment. The use of parchment spread across Europe in the 4th century AD. Initially, parchments were made into scrolls, according to the model of papyrus scrolls, and later were also made into bound books known as →codices.

Perspective

(Latin *perspicere*: look through, perceive clearly) Perspective is a means of depict a three-dimensional space in a picture. To do this, so-called vanishing lines are drawn in a picture, meeting at an imaginary point, the vanishing point. The most important rule of perspective drawing is that objects that are further are depicted smaller than similar objects that are closer. Perspective construction was unknown in the Middle Ages. It was not until the Early →Renaissance that artists such as Uccello, Mantegna, and Piero della Francesca had a precise knowledge of perspective at their disposal. The principles of perspective were formulated by Leon Battista Alberti in his *Della Pittura* (On Painting) of 1436.

Portrait

(Lat. *portrahere*: to draw forth) Portraits are depictions of particular people. A distinction is made between single, double, and group portraits. They can show the whole of a person (full figure) or part (head, head and shoulders, half figure, three-quarter figure), from the front (*en face*, or frontally) or from the side (profile).

Salon

A yearly prestigious art exhibition in Paris.

Silk-screen printing

A printing process in which ink is pressed through a screen of fine fabric (usually silk) stretched over a frame. The areas that are not to be printed are covered with a template, so that the image to be printed remains open. In photographic screen-printing, a light-sensitive copying layer is applied to the screen and exposed to light. The exposed areas are liquid-resistant and the unexposed areas are washed out of the fabric. For multi-color printing, a new screen has to be made for each color.

Still life

A depiction of inanimate objects, traditionally flowers and fruit, kitchen implements, food, dead game and hunting equipment. So-called *vanitas* still lifes evoke the transience of all things, for example by showing wilting flowers, a watch, or a skull. [39]

Tempera

A painting in which pigment is dissolved in water together with gum, glue, or egg yoke. Tempera is typically applied in thin, semi-opaque or transparent layers that quickly dry to a flat, matte surface. It was widely used until the 15th century, when it was replaced by oil paints. Andrew Wyeth was one of several artists who revived the use of tempera in recent times.

Triptych

A painting consisting of three separate but related parts, typically an →altarpiece. Occasionally used my modern artists, for example Max Beckmann and Francis Bacon. [19, 91]

Watercolor

A water-soluble paint in which pigment is bound in a medium such as gum arabic. Typically applied in thin washes, watercolor is semi-transparent, the white of the paper giving the colors a distinctive luminosity. One of the oldest painting techniques, watercolor appears on papyrus as early as the Ancient Egyptian Books of the Dead (2nd century BC). Artist who have excelled in watercolor include Dürer, Turner, Cézanne, and Paul Klee.

Periods and Movements
(arranged chronologically)

CLASSICAL ANTIQUITY

The term Classical Antiquity refers to Ancient Greece and Rome. It is traditionally thought to begin in the 8th century BC (Homer) and to end with the fall of the Roman Empire, c. AD 500. From the Renaissance onwards, the literature, architecture and art (predominantly sculpture) of Classical Antiquity were considered the highest achievements of Western civilization and were the inspiration for artists for centuries.

Byzantine art

In 330 AD Byzantium became the capital of the Eastern Roman Empire under Constantine the Great, and was renamed Constantinople. Byzantine art grew along with the city and the empire. Its style developed formally from Hellenistic and Oriental traditions, but was devoted to Christian subjects. Its stylistic severity lends it an air of solemnity and exaltation, but also of rigidity. Outstanding examples include metalwork, mosaics, mauscripts, and →icons. The Byzantine Empire lasted for over 1,000 years, from Late Antiquity until 1453, when Constantinople fell to the Ottoman Turks. Its artistic influence continued, however, and influenced the development of medieval art. [1]

Insular art

A style of art that developed in the 6th century AD in the British Isles, particularly in Irish monasteries, and that drew heavily on Celtic ornamentation, such as knot patterns, in the depiction of Christian themes. It was used to embellish metal work and stone carvings, but above all in the illumination of →codices, including the Book of Kells and the Lindisfarne Gospels. [2]

Romanesque

A style of architecture and art, derived largely from ancient Rome, frequently via →Byzantine art, prevailing in Europe c. 950–c. 1250. The period saw a great increase in the number and size of churches and cathedrals, and consequently a flourishing of architectural sculpture. In painting, murals and →book illumination deserve special mention. Figures are typically stylized, austere, and majestic.

Gothic

Gothic art and architecture emerged in northern France in the late 12th century, and soon spread to the rest of Europe, though it never developed fully in Italy. The Gothic era came to an end—and earlier in Italy than in the rest of Europe—with the

beginning of the Renaissance. Developing first in architecture, it brought a new lightness, grace, and range to Romanesque forms. In contrast to the Romanesque, people were depicted in a more lively, human, individual, and accessible manner. In art, it flourished in stained-glass windows, →book illuminations, murals, and panel paintings, particularly in the form of →altarpieces. In the High Gothic period, the so-called "Soft" (or International) Style of painting spread throughout Europe between 1390 and 1420, characterized by idealized works noted for their courtly elegance. [7, 8]

Early Netherlandish painting

The painting school that developed in the early 15th century in the culturally influential Duchy of Burgundy, noted above all for panel paintings and →book illumination. Jan van Eyck and his brother Hubert van Eyck, Rogier van der Weyden, and the Master of Flémalle are among the best-known exponents of Early Netherlandish painting. They demonstrated a mastery of the minutely precise depiction of objects, light, and complex reflections. [10, 11, 15]

Renaissance

(Fr.: rebirth) The Gothic art of the Middle Ages came to an end with the revival of →Classical Antiquity. The beginnings of the Renaissance lay primarily in early-15th-century Florence. A shift from mediaeval to modern painting began earlier than elsewhere, with the so-called Proto-Renaissance, notably the works of Giotto (c. 1267–1337). By c. 1500 two main traditions had formed in Italian painting: the Florentine, in which line played the key role in the creation of form (for example in the work of Botticelli); and the Venetia, in which color and the play of light were central. These two traditions achieved a synthesis in the works of Leonardo da Vinci, Michelangelo, and Raphael during the High Renaissance. This found a new center in Rome, with the popes attracting major artists to the city. The High Renaissance ended with the Sack of Rome in 1527 by the troops of Emperor Charles V. The ideal of Italian Renaissance art was to reflect divine harmony in the meticulously planned structures of buildings, sculptures, and paintings, and through the beauty of the human face and form. Important painters, sculptors and architects of the high Renaissance included—in addition to Michelangelo, Leonardo da Vinci, and Raphael—Giorgione, Correggio, and Titian. [3–6, 9, 14, 16–18, 21–24, 26, 28]
The Renaissance spread to many parts of Europe, frequently influenced by local traditions, and so the term is also used of the period as a whole. [12, 13, 15, 19, 20, 25, 27, 29, 30]

Mannerism

(Italian *maniera*: manner, form) Flourishing c. 1520–1600, Mannerism developed from the High Renaissance style of Michelangelo and Raphael. Elongated, twisted figures and forms full of theatrical movement brought a new emotional intensity to art. Important exponents include El Greco in Spain, and Jacopo da Pontormo, Lorenzo Lotto, Tintoretto, and Parmigianino in Italy. In France, the School of Fontainebleau emerged from a combination of Italian Mannerism and French Gothic. In the Netherlands, its influence can be seen in the works of Marten van Heemskerck, Frans Floris, and Pieter Bruegel the Elder, though his work moved away from Italian Mannerism. [31–34, 36]

Baroque

The Baroque began to emerge in the late 16th century as a reaction against what were seen as the excesses of →Mannerism. Marking a return to classical forms, the Baroque also saw an emphasis on drama, movement, and grandeur. People yearned for clear and simple forms, while also wanting theatrical effects and dynamic movement. The Italians Annibale Carracci and Caravaggio were the pioneers of these new attitudes. Following his time in Italy, the Flemish artist Peter Paul Rubens became one of the most famous Baroque painters north of the Alps, alongside the Dutch painter Rembrandt. English Baroque painting was considerably influenced by Rubens and his pupil Anthony van Dyck, who made a name for himself in England. [35, 37–42]

Rococo

Flourishing c. 1710–c. 1780, Rococo can be seen as a late form of Baroque. The drama and grandeur of the latter were replaced by style that in the decorative arts was strongly influenced by the elaborate and sinuous forms of plants and shells; in painting, the subjects were typically light-hearted, and pastel colors dominated. Pastoral scenes, such as those featuring shepherds in park-like settings, and erotically titillating depictions were popular, though numerous portraits have also survived. It was in France that Rococo painting thrived, though its popularity came to an abrupt end with the French Revolution. [44–47, 50]

Neoclassicism

The trailblazers of the French Revolution considered themselves to be the new Greeks and Romans, and this attitude found expression in the art of the late 18th century. The painters of the time, and most significantly the French artists Jacques-Louis David and his pupil Jean-Auguste Dominique Ingres, dedicated themselves to overcoming Rococo, which was seen as the art form of the ha-ted aristocracy. They admired the simple forms of →Classical Antiquity, and sought a style based on the clear and rigorous use of the line and color. Also inspired by the discoveries at Pompeii and Herculaneum, Neoclassicism flourished throughout Europe and America, and was seen in sculpture, interior design, and architecture. [51, 52, 55]

Romanticism

Emerging soon after →Neoclassicism, Romanticism (the first distinctive signs of which can be seen in the 18th century), sought inspiration not in the order and decorum of classical culture, but in emotional intensity, looking not to →Classical Antiquity but to the Middle Ages, the Orient, and nature (the sublime). Originality and spontaneity became the hallmarks of Romantic art, which often dealt with intense or disturbing subjects; some Romantic artists (such as Francisco Goya, Théodore Géricault, and Eugène Delacroix) turned to contemporary social and political themes. Other key Romantic artists include J.M.W. Turner, the Swiss Henry Fuseli (who worked in Britain), and the German painters Caspar David Friedrich and Philipp Otto Runge. [49, 53, 54, 56–58, 61]

Biedermeier

Influenced by Romanticism, the Biedermeier style flourished in Germany in the period between the Congress of Vienna of 1815 and the Revolution of 1848. This was an era marked by a withdrawal into domestic comfort, which was often criticized as petit bourgeois by the intellectuals of the time. Carl Spitzweg was one of the leading artists of the era. [60]

Realism

As a general term, Realism refers to those styles that aspire to create depictions particularly true to reality, and therefore stands in opposition to →Idealism. All art can be said to move between these two extremes. More specifically, Realism designates a movement in art that developed in France in the 19th century, characterized not by a distinctive style but by an emphasis on achieving the most objective and realistic depiction possible of people and the world (often "low" subject that were generally excluded from art). Its leading exponent was Gustave Courbet, who also contributed to the use of the term by showing his works of art in an exhibition entitled *Le Réalisme*. [62, 67]

Idealism

The counter movement to →Realism during all periods. In the visual arts, Idealism refers to design made in accordance with an intellectual ideal. Realistic features are re-pressed in favor of a heightening or romanticization of reality or the representation of a particular idea. [63]

Impressionism

Like Realism, Impressionism also developed in France, but slightly later, in the 1860s. And like Realism, Impressionism turned to everyday life for subjects, though it rejected Realism's more traditional style (notably its somber colors), and also the formal style of the →Academy. The Impressionists aimed to capture the ever-changing effects of light and color, the transient moment, often painting outdoors. They applied colors directly to the canvas in rapid brushstrokes, without framing them with clear outlines, and banished dark colors. Impressionism lasted from c. 1860 to the 1880s. Important exponents included Auguste Renoir, Edgar Degas, and Alfred Sisley; as well as Max Liebermann, Max Slevogt, and Lovis Corinth in Germany. Édouard Manet played an important role in the development of Impressionism although he was himself not an Impressionist. The style is named for Monet's painting Impression, Sunrise, in which the painter depicted the sun and morning mist in the harbor of Le Havre. [64, 66]

Post-Impressionism

By the 1880s, a number of artists had become dissatisfied with Impressionism's focus on the fleeting effects of light and color, and sought to find different foundations for painting, whether formal (e.g. color) or emotional. Leading figures included Paul Cézanne, Vincent van Gogh, Mary Cassatt, and Paul Gauguin. [69, 70, 73]

Symbolism

Symbolism was a movement that flourished c. 1885–c. 1910 in opposition to →Impressionism and →Realism. Symbolists were united not by a distinctive style, but by a rejection of the everyday world in favor of the spiritual or the imaginative. They typically used allegory >>, obscure symbols, and fantasy to create a sense of what "lies beyond the visible." [71]

Art Nouveau

(French: new art) Largely a decorative style, Art Nouveau (c. 1885 to the end of World War I) was based on the long, sinuous forms of plants: in contrast to the various 19th-century revivalisms, Art Nouveau (as the name suggest) was not based on past models. The style spread throughout Europe and America and in some countries did not disappear until after World War I. It strongly influenced architecture and design, and in painting its impact can be seen above all in the works of Gustav Klimt. [75]

Fauvism

(French *fauves*: wild animals) A term coined in 1905 at the Paris Salon d'Automne to denigrate the works of some of the artists exhibited there, those whose works were characterized by bright colors and vigorous brushwork. Henri Matisse and others adopted this term to refer to their art. [76]

Expressionism

As a specific movement, Expressionism took root in Germany c. 1905 and lasted until the 1930s. Its origins, however, are to be found in the late 19th century, in the works of Vincent van Gogh and Edvard Munch, among others. In contrast to Impressionists, who sought to capture the atmospheric impression of light in nature, the Expressionists aimed to convey their own feelings: "Expressionism" was about "expressing" oneself. Distorted forms, strong colors, energetic brushwork, and seemingly arbitrary perspective and scale are typical. [72, 74, 79]

Cubism

In Paris around 1907, Pablo Picasso and Georges Braque were interested not in "expressing emotion" but in formal issues raised by Paul Cézanne: in effect, how the image was to be created on the picture surface. Both artists fragmented objects (musical instruments, views, faces) into facets which they rearranged in the painting, creating the impression of an object seem from multiple points of view (a rejection of central perspective, which had dominated art since the Renaissance). This early (Analytical) Cubism, noted for its severity and muted colors, soon gave way to Synthetic Cubism, a looser form in which objects such as newspaper cuttings were incorporated into the image and in which the colors became stronger. Other famous Cubists were Robert Delaunay, Juan Gris, Fernand Léger, and (early) Marcel Duchamp. [88]

Abstract painting

Abstract means "non-representational." A non-representational movement in art began c. 1910, when a few artist, notably Wassily Kandinsky, sought to "free" art for subject matter and locate its real meaning in form and color. During the 20th century, abstract paintings was to take many forms, from →Suprematism to →Abstract Expressionism. [78, 81, 92, 95]

Suprematism

A Russian development of →abstract painting, Suprematism was founded in 1915 by Kazimir Malevich. He considered representational painting to be an obstacle that must be overcome. In contrast to fellow Russian Wassily Kandinsky, who typically used dynamic forms and a range of colors in his abstract works, Malevich concentrated on simple geometric forms, the square in particular. [81]

Surrealism

(French: beyond reality) Marking a return to precise figuration, and so opposed to →abstract art and →Cubism, Surrealism emerged in Paris in the 1920. But their leader, the poet André Breton, did not want merely a return to depictions of the visible world: strongly influenced by the ideas of Sigmund Freud, he wanted an art that reveals the world that lies concealed in our dreams, fantasies, and nightmares. And as in a dream, Surrealists typically juxtaposed incongruous elements, often depicted with a striking realism, to shock viewers out of their habitual responses to the world. Important Surrealists included Salvador Dalí, René Magritte, Yves Tanguy, Meret Oppenheim, Joan Miró, Man Ray, and Max Ernst. [84, 85, 87, 89]

New Objectivity

In Germany during the 1920s, the dominant artistic movement was New Objectivity (Neue Sachlichkeit). Inspired by Expressionism, artists of this movement employed a realism that is noticeably exaggerated, sometimes to the point of caricature, their main aim being to expose the social and political corruption of society in the turbulent years following World War I. [82, 83]

American Realism

In America during the first two decades of the 20th century, a distinctive form of →Realism took root. Its development was largely a reflection of the desire to capture the rapid and dynamic growth in American economic, urban, and cultural life. It was essentially an urban art (compare →Regionalism). Its leading figures included George Bellows, John Sloan, and Edward Hopper. [90]

Regionalism

In America during the 1930s, a second form of →Realism developed when some painters, consciously rejecting the influence of European Modernism, strove to develop a distinctive American style and subject matter. Led by Grant Wood, Thomas Hart Benton, and John Steuart Curry, the "Regionalists" advocated a realist style, narrative subjects, and an emphasis on rural life over the urban experience. The popular appeal of Regionalism waned in the years following World War II, as the advent of the New York School ushered in the era of →Abstract Expressionism. [86]

Abstract Expressionism

The term "Abstract Expressionism" was first used in European art criticism as early as 1919 to describe the work of Wassily Kandinsky. After World War II, critics applied it to the painters of the New York School—Arshile Gorky, Willem de Kooning, Jackson Pollock, and Mark Rothko—whose abstract aesthetic stood in stark contrast to American →Regionalism. Inspired by European Modernism and →Surrealism, the Abstract Expressionists explored an automatic and even aggressive manner of applying paint. Throughout the late 1940s and early 1950s, the raw intensity of these paintings attracted widespread international acclaim, effectively making New York City the new center of the art world, displacing Paris. [92]

Pop Art

A self-conscious rejection of the →Abstract Expressionism that dominated the 1950s, Pop Art drew directly on the everyday life of the affluent 1960s: film and pop stars, politicians, cars, road signs, cigarette packets, beer cans, and flags began to appear in art, often used with a sense of fun. The bright colors and striking graphic designs of advertising and comic books were frequently employed. Important Pop artists included Andy Warhol, Richard Hamilton, Roy Lichtenstein, David Hockney, and Claes Oldenburg. [93, 94, 96, 98]

Op Art

(short for "Optical Art") Op Art developed in the late 1950s, a style of →abstract painting that focused on repetitive geometric compositions, flickering color effects, and other optical illusions. Bridget Riley and Josef Albers are considered key representative of Op Art. [95]

Neo-Expressionism

An international movement, though having a particularly strong appeal in Germany and the United States, Neo-Expressionism developed in the 1970s and flourished in the 1980s. It marked a return both to figuration (therefore a rejection of →abstract art) and to German →Expressionism. Along with the use of representation, it featured spontaneous, emotional brushwork and the ironic recycling of borrowings from art-historical subjects. Among its best-known representatives are George Baselitz, Markus Lüpertz, Julian Schnabel, and Francesco Clemente. [99]

Contemporary art

The significant art of the present day by living artists. The term "modern art" is not the same, as it includes art from the early 1900s onwards, i. e. the historical phenomenon known as Modernism. The term "contemporary art" is entirely one of period, and says nothing about a work's concept, artistic style, technique, form, or adhesion to any particular artistic movement or group. [97, 99, 100]

PHOTO CREDITS

The illustrations in this publication have been kindly provided by the museums, institutions, and archives mentioned in the captions, or taken from the publisher's archives, with the exception of the following:

11, 12 The Board of Trinity College, Dublin, Ireland/The Bridgeman Art Library; 13 Trinity College Library, Manuscripts Department (Foto: The Green Studio), Dublin; 18 akg-images/Electa; 20 Paolo Tosi/ARTOTHEK; 27 The National Gallery, Picture Library, London; 29–31 Photographie Girandon, Paris; 32 Archivi Alinari/Giraudon, Florenz; 41 Hans Hinz/ARTOTHEK; 42 Rheinisches Bildarchiv; 49 Hans Hinz/ARTOTHEK; 55–57 Paolo Tosi/ARTOTHEK; 65, 66 Blauel/Gnamm/ARTOTHEK; 67 Joseph S. Martin/ARTOTHEK; 69 ARTOTHEK; 80 Blauel/Gnamm/ARTOTHEK; 83–85 Staatliche Kunstsammlungen Dresden, Gemäldegalerie Alte Meister, Foto: Elke Estel/Hans-Peter Klut; 91 The Bridgeman Art Library; 93 akg-images; 101 The Bridgeman Art Library; 103–105 Hans Hinz/ARTOTHEK; 110 The Bridgeman Art Library; 117 Blauel/Gnamm/ARTOTHEK; 125 Hans Hinz/ARTOTHEK; 129–131 ARTOTHEK; 134 Interfoto München; 137 Peter Willi/ARTOTHEK; 139 Joseph S. Martin/ARTOTHEK; 141–143 akg-images/Erich Lessing; 145–147 The National Gallery, London/akg-images; 152 akg-images; 162–165 bpk/Nationalgalerie, SMB/Jörg P. Anders; 166 akg-images/Erich Lessing; 169–171 Hans Hinz/ARTOTHEK; 173, 175–177 Peter Willi/ARTOTHEK; 179–181 The Metropolitan Museum of Art, H. O. Havemeyer Collection, Bequest of Mrs. H. O. Havemeyer (JP 1847), Foto: 1994 The Metropolitan Museum of Art; 183–185 Bayer&Mitko/ARTOTHEK; 189–191 akg-images/Erich Lessing; 193 Blauel/Gnamm/ARTOTHEK; 199 The Bridgeman Art Library; 200 Peter Willi/ARTOTHEK; 203–205 ARTOTHEK; 213–215 Hans Hinz/ARTOTHEK; 216 Blauel/Gnamm/ARTOTHEK; 221 Joseph S. Martin/ARTOTHEK; 223 Kunstsammlung Böttcherstraße/Paula Modersohn-Becker-Museum; 229 Digital image © 2015 Archives H. Matisse; 231–233 Joseph S. Martin/ARTOTHEK; 243 Kunstmuseum Stuttgart; 245 bpk/Nationalgalerie, SMB/Jörg P. Anders; 246 Peter Willi/ARTOTHEK; 250 The Bridgeman Art Library; 253–255 ARTOTHEK; 262 The Art Institute of Chicago; 268 The Museum of Modern Art, New York/Scala, Florenz; 270 akg-images; 272 Josef Albers Museum Bottrop; 275 The Museum of Modern Art, New York/Scala, Florence; 283 Christie's Images Ltd/ARTOTHEK

IMPRINT

© Prestel Verlag, Munich · London · New York, 2015 (first published in hardback in 2013)

© for the works reproduced is held by the artists, their heirs or assigns, with the exception of: Otto Dix, Max Ernst, Jasper Johns, Tamara de Lempicka, René Magritte with © VG Bild-Kunst, Bonn 2015; Josef Albers with © The Josef and Anni Albers Foundation/VG Bild-Kunst, Bonn 2015; Francis Bacon with © The Estate of Francis Bacon/VG Bild-Kunst, Bonn 2015; Salvador Dalí with © Salvador Dalí, Fundació Gala-Salvador Dalí/VG Bild-Kunst, Bonn 2015; George Grosz with © Estate of George Grosz, Princeton, N.J. /VG Bild- Kunst, Bonn 2015; Richard Hamilton with © R. Hamilton. All Rights Reserved/VG Bild-Kunst, Bonn 2015; Frida Kahlo with © Banco de México Diego Rivera Frida Kahlo Museums Trust/VG Bild-Kunst, Bonn 2015; Henri Matisse with © Succesion H. Matisse/VG Bild-Kunst, Bonn 2015; Pablo Picasso with © Succession Picasso/VG Bild-Kunst, Bonn 2015; Jackson Pollock with © Pollock-Krasner Foundation/VG Bild-Kunst, Bonn 2015; Georg Baselitz with © 2015 Georg Baselitz; Lucian Freud with © The Lucian Freud Archive/The Bridgeman Art Library; David Hockney with © David Hockney; Edward Hopper with © The Art Institute of Chicago; Gerhard Richter with © Gerhard Richter, 2015; Andy Warhol with © 2015 The Andy Warhol Foundation for the Visual Arts, Inc./Artists Rights Society (ARS), New York

Frontispiece: Joseph Mallord William Turner, *Rain, Steam, and Speed—The Great Western Railway* (detail), see p. 186
Page 6: Hieronymus Bosch, *The Garden of Earthly Delights* (detail), see p. 61

Prestel Verlag, Munich
A member of Verlagsgruppe Random House GmbH

Prestel Verlag
Neumarkter Strasse 28
81673 Munich
Tel. +49 (0) 89 4136-0
Fax +49 (0) 89 4136-2335
www.prestel.de

Prestel Publishing Ltd.
14–17 Wells Street
London W1T 3PD
Tel. +44 (0) 20 7323-5004
Fax +44 (0) 20 7323-0271
www.prestel.com

Prestel Publishing
900 Broadway, Suite 603
New York, NY 10003
Tel. +1 (212) 995-2720
Fax +1 (212) 995-2733
www.prestel.com

Library of Congress Control Number: 2015931132; British Library Cataloguing-in-Publication Data: a catalogue record for this book is available from the British Library; Deutsche Nationalbibliothek holds a record of this publication in the Deutsche Nationalbibliografie; detailed bibliographical data can be found under: http://www.dnb.de

Prestel books are available worldwide. Please contact your nearest bookseller or one of the above addresses for information concerning your local distributor.

Texts by:
(Numbers refer to work numbers)
Stefanie Adam: 10, 37, 53, 54
Aurélien Bonnetain: 16, 44, 66, 75, 79
Stephanie Brecht: 7, 59
Anita Dahlinger: 42, 56, 61, 83
Hajo Düchting: 12, 13, 26, 31, 38, 45, 58, 60, 74, 76, 77, 78, 80, 87, 92, 93, 95, 97, 98, 99
Edgar Endl: 67, 86
Brad Finger: 3, 4, 5, 6, 9, 14, 21, 29
Janina Hoffmann: 82, 84, 88, 96
Vivi Kallinikou: 19, 25, 32, 33, 34, 36, 50, 52, 81
Lisa Kent: 2, 8, 11, 15, 17, 18, 20, 22, 27, 28, 30, 35, 39, 41, 43, 46, 47, 48, 49, 55, 57, 65, 68, 70, 72, 73
Julie Kiefer: 90, 100
Katharina Knüppel: 64, 69, 85, 94
Claudia Stäuble: 23, 63, 89, 91
Franziska Stegmann: 1, 24, 40, 51, 62, 71

Translated from the German by: Philippa Hurd
Editorial direction: Claudia Stäuble
Project management: Julie Kiefer
Picture editors: Franziska Stegmann; Dorothea Bethke
Copyedited by: Chris Murray
Glossary and foreword translated by: Jane Michael, Munich
Cover and design: Stefan Schmid Design, Stuttgart
Layout: textum GmbH I Christine Rehmann, Munich
Production: Astrid Wedemeyer
Art direction: Cilly Klotz
Origination: ReproLine Mediateam, Munich
Printing and binding: Print Consult, Munich

Verlagsgruppe Random House FSC® N001967
The FSC®-certified paper *Profibulk*
was supplied by IGEPA.

ISBN 978-3-7913-8153-4